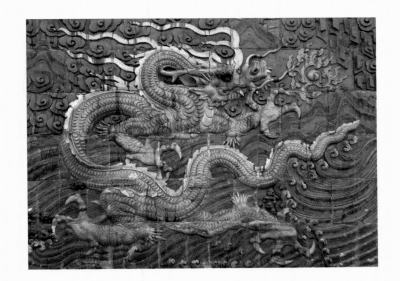

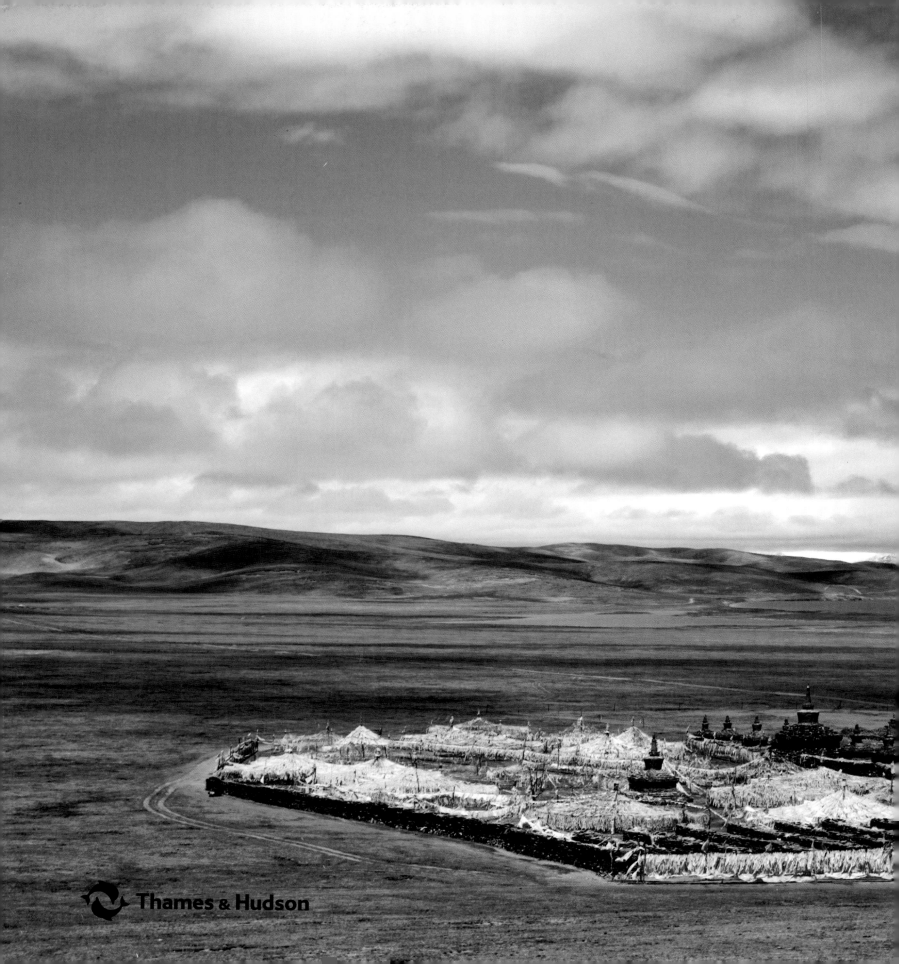

Thames & Hudson

YELLOW RIVER

THE SPIRIT & STRENGTH OF CHINA

ALDO PAVAN

with 209 illustrations, 200 in color

PAGE 1: Detail of the Nine Dragon Screen, Datong.

PRECEDING PAGES: The monastery of Dokangema, near Lake Ngoring, at the source of the Yellow River.

PAGES 6–7: The vast basin of Lake Ngoring on the Tibetan Plateau in the province of Qinghai. The Yellow River flows out of this lake.

PAGES 8–9: The Yellow River flowing between the mountains of the Loess Plateau, between Shaanxi and Shanxi, where it becomes laden with mud and creates the waterfalls at Hukou.

PAGES 10–11: Once out of the mountains, the Yellow River widens disproportionately and proceeds slowly and solemnly towards the sea. Here it is crossing the province of Henan, near Kaifeng.

CONTENTS

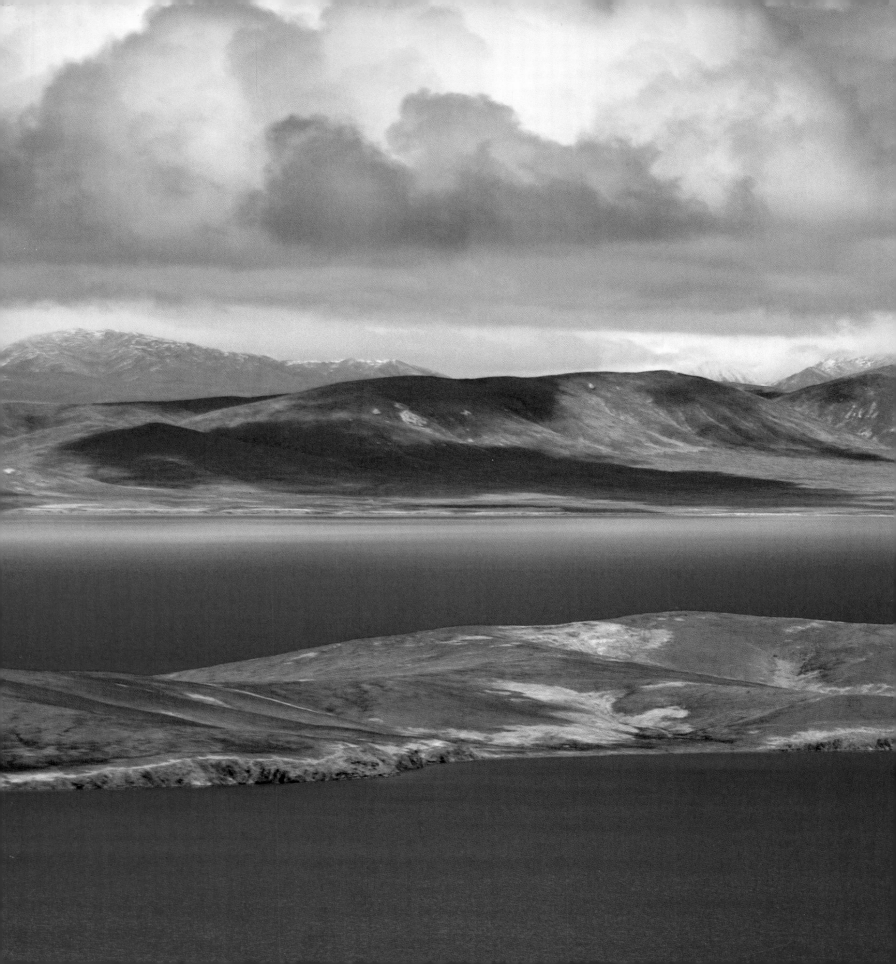

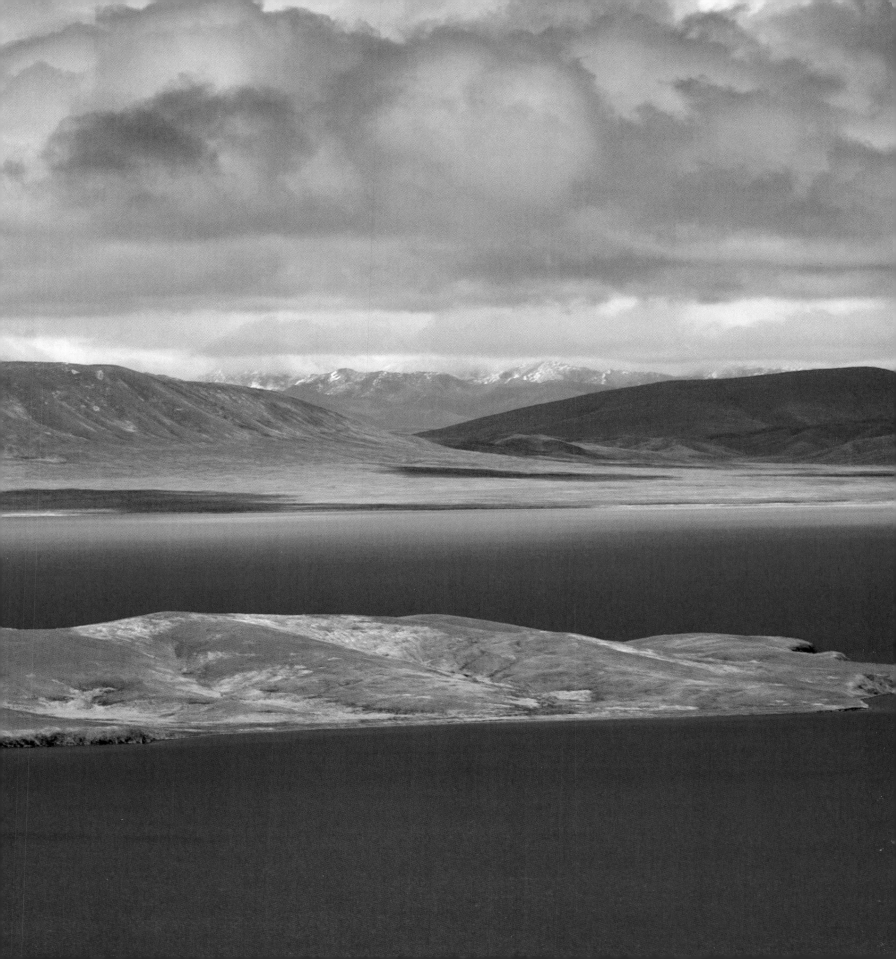

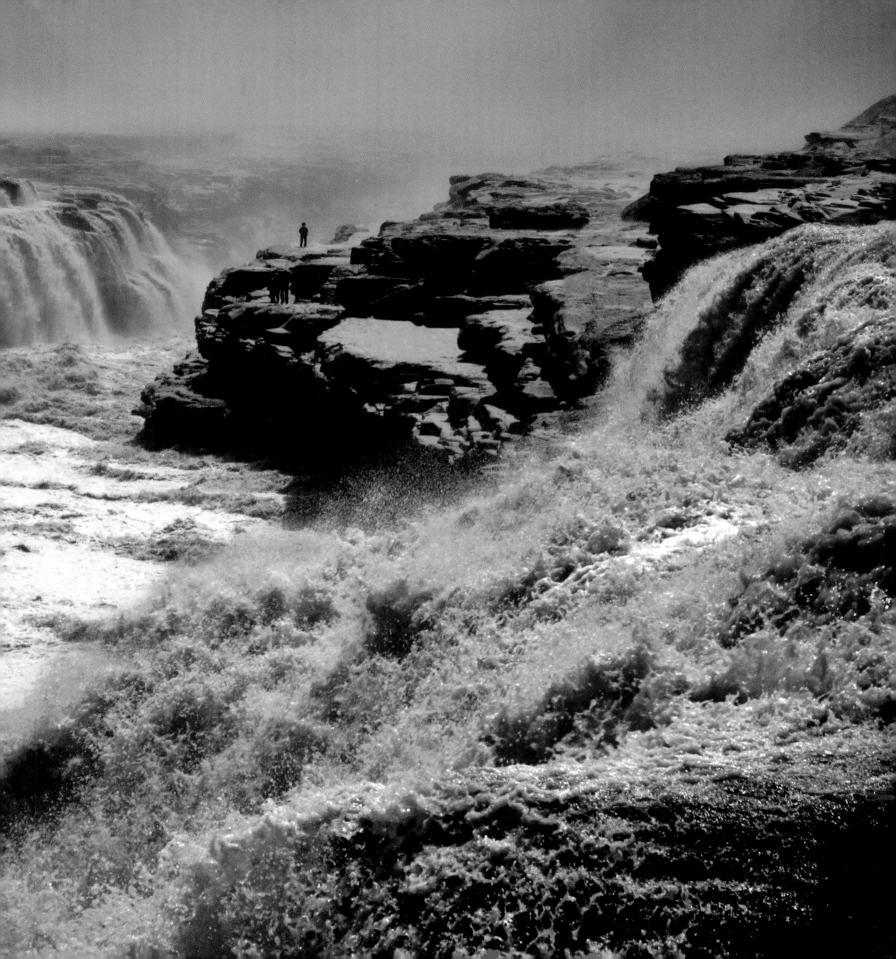

Numbers 1 to 7 on this
map correspond to the
chapter numbers

QINGHAI

Xining

Madoi

TIBET

Yellow River

1

BURMA

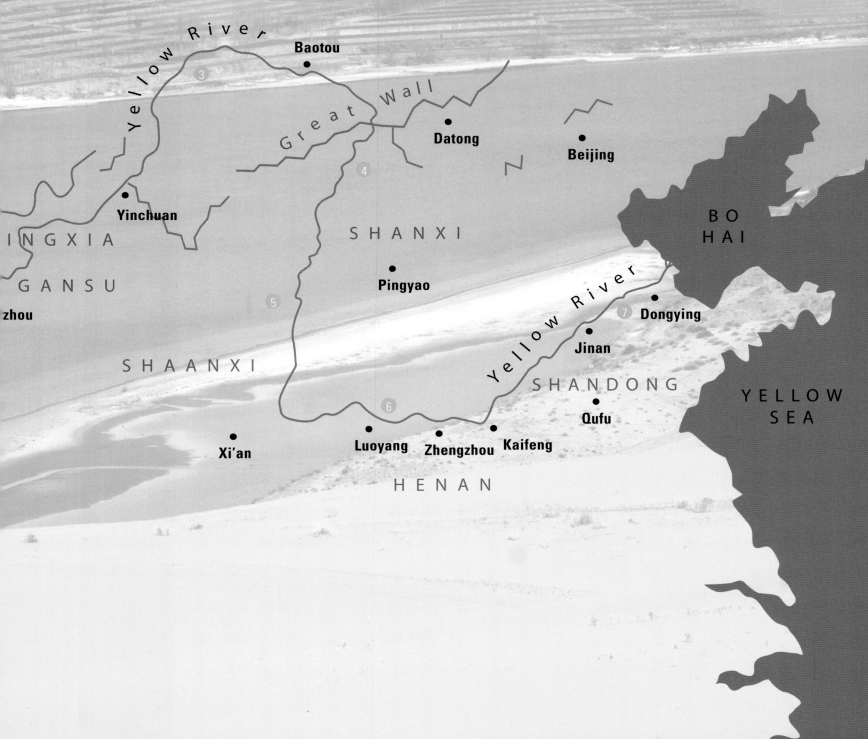

MONGOLIA

INNER MONGOLIA

Yellow River

③

Baotou

Great Wall

Datong

Beijing

④

Yinchuan

NGXIA

GANSU

zhou

SHANXI

Pingyao

⑤

SHAANXI

Yellow River

⑦ Dongying

Jinan

SHANDONG

BO HAI

Qufu

YELLOW SEA

⑥

Xi'an

Luoyang Zhengzhou Kaifeng

HENAN

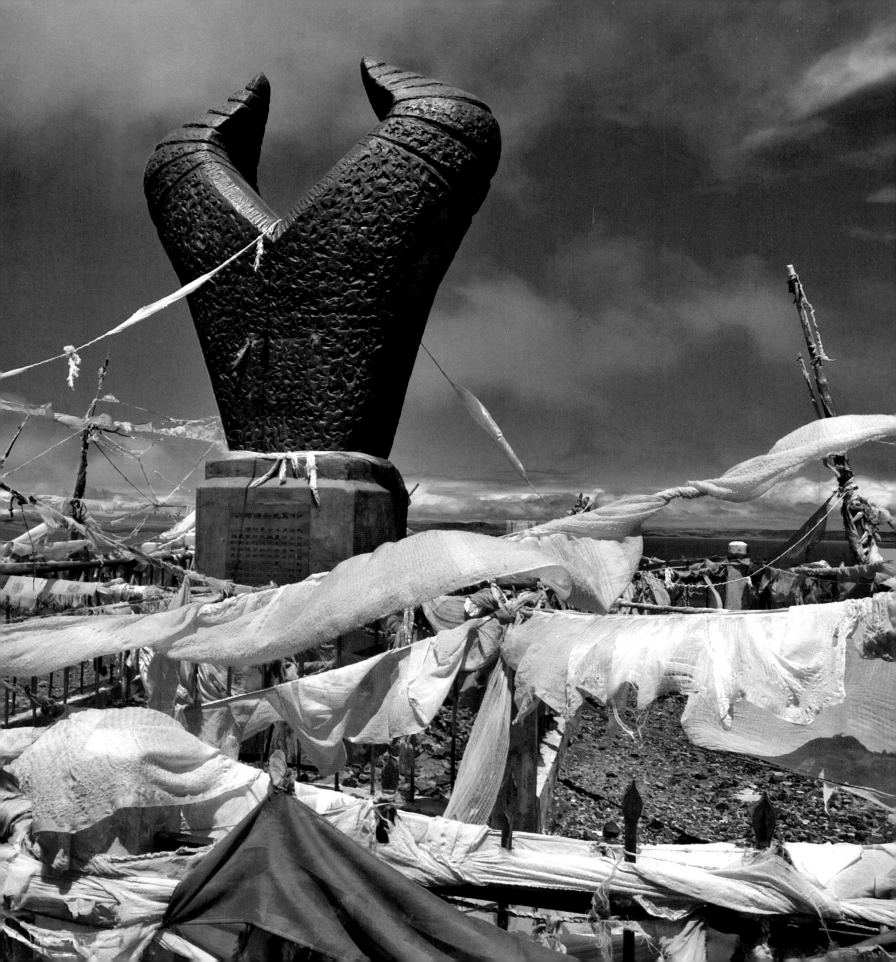

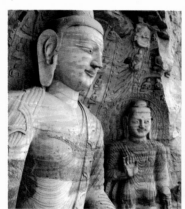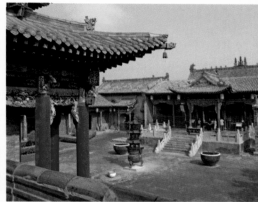

OPPOSITE: A monument in the form of a yak's horns, erected at the source of the Yellow River.

ABOVE, RIGHT: An image of Buddha carved into the rock face at Yungang near Datong. There are 51,000 statues here, carved in the 5th and 6th centuries BC.

ABOVE, FAR RIGHT: The temple dedicated to the City God in the town of Pingyao.

THIS IS NOT MERELY A RIVER, it is a dragon, and no ordinary dragon either. It possesses the mythological qualities beloved of Chinese tradition: the traits of a tiger, a lion and a serpent, all rolled into one. It is also an uncontrollable being, utterly unpredictable and pregnant with future mysteries. This beast is known as the Yellow River, or Huang He in Chinese. Its tail rests on the top of the world, high up on the Tibetan Plateau, where its source is located, and its jaws open wide towards the Yellow Sea, towards the Gulf of Bo Hai, which is the mouth of the river. Its back arches across arid stretches of desert, and the steppes of Inner Mongolia, before cutting across the clay-like terrain of the Loess Plateau (loess is the name given to the type of ochre-yellow, calcareous rock which is found there). The river then flows along an extensive course, encountering vibrant cities, huge dams blocking its path, gentle terraced fields and major industrial plants. Its waters carve out deep valleys and gather up quantities of mud, the yellow mud that gives the river its name. Like the Nile, which is full of silt, this river is rich in sediments. It provides irrigation, and disperses precious humus onto the fields of rice. In addition, it quenches the thirst of one hundred and fifty-five million people. It crosses nine provinces, and supplies water for 15% of China's agricultural land. The river is 5,464 kilometres (3,395 miles) long, one of the longest rivers in the world, and provides for an area as big as Italy, Germany and Great Britain put together. As if that were not enough, the dragon has hidden riches in the form of minerals, including gold. In the Shanxi Province, it is a source of energy, thanks to the presence of precious coal, which provides fuel for dozens of electrical plants. The river is like a Cyclops, fed by some forty tributaries, and the entire economy of northern China is dependent on it. Only this creature, the master of history and the determiner of the future, can quench thirst and satisfy hunger. That is why the dragon can be a dangerous beast.

The river is also known as the 'Mother of China', and indeed its basin was the birthplace of the Han civilization, which is still the most widespread ethnic group in the country. Kingdoms and empires were born and flourished along its banks, and the troops of invading armies rode along them. Traces of these distant civilizations have recently been discovered, after centuries of being buried deep under metres of dried-out mud. The cities of Xi'an, Luoyang, Zhengzhou and Kaifeng were once rich and powerful imperial capitals,

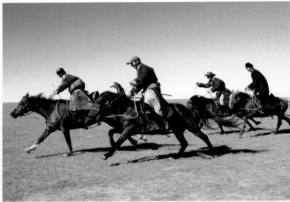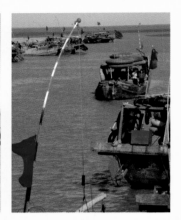

seats of the Yellow Empire, founded by the legendary Huang Di (*r. c.* 2697–2598 BC), the first Han to reign over China. The astonishing Terracotta Army, buried with the Emperor Qin Shi Huang near Xi'an in 210–209 BC, provides us with evidence of such times. However, it is also true that the Chinese call the Yellow River 'China's Sorrow', for they suffer under the scourge of its frequent and catastrophic floods. The dragon is not only the giver of life but also the destroyer of life. For this reason, there are hardly any urban developments along its banks; just a few can be found along the upper reaches, where the river is still relatively harmless. In the 20th century, the river claimed millions of victims. Down the many millennia of Chinese history, the ability to conquer the river and divert its flow towards the sea without causing it to break its banks was seen as the hallmark of good government. Taming the dragon was seen as a sign of power, signifying divine favour. More than 4,000 years ago the legendary emperor Yu the Great, renowned for his skills in hydraulic engineering, said: 'Conquering the Yellow River equates to controlling the whole of China.' In some respects, the problem has been exacerbated by a new enemy – the excessive exploitation of the river due to rapid economic development. As it rushes towards the sea, the dragon may have been restrained between banks which are more secure than in previous times, but its waters are increasingly polluted, and there is an alarming lack of water. It is sad to see the river so exhausted, reduced to a mere trickle of water flowing between immense banks which may be as far as 10 kilometres (6 miles) apart, as is the case when it flows across the vast plain close to the mouth of the river. What a melancholy epilogue for such a great living legend! And what a huge problem it poses for China, which is not only suffering from a water shortage, but also lacking in the precious electrical energy produced by the force of the dragon.

To trace the course of the Yellow River involves really getting under the skin of China. Perhaps that sounds somewhat exaggerated, but it is true. In the course of producing this book, we have observed the caprices of the dragon, and the emotions provoked by this have been as extreme as the country that we have discovered, step by step. By the end of our journey, we have been able to reaffirm that China is not one single country but thousands of different ones, as numerous as the coils and convolutions of the mythical beast.

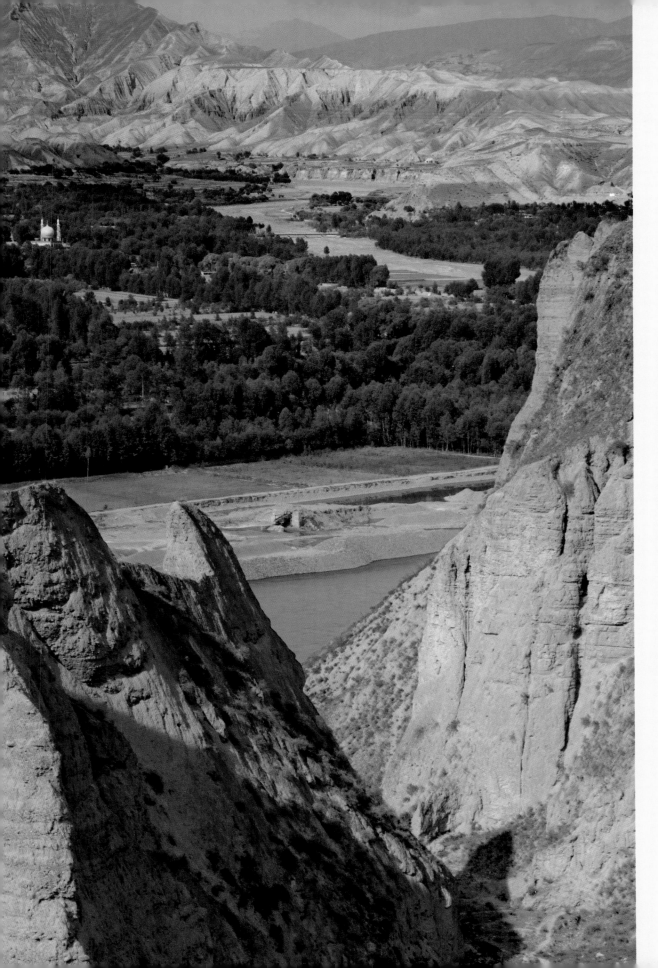

OPPOSITE, FROM LEFT TO RIGHT: The city walls of Pingyao, one of the sites protected by UNESCO; a group of Mongolian horsemen; a glimpse of the Yellow River as it meets the sea at the Gulf of Bo Hai.

LEFT: The Yellow River at Lijiaxia, in the province of Qinghai.

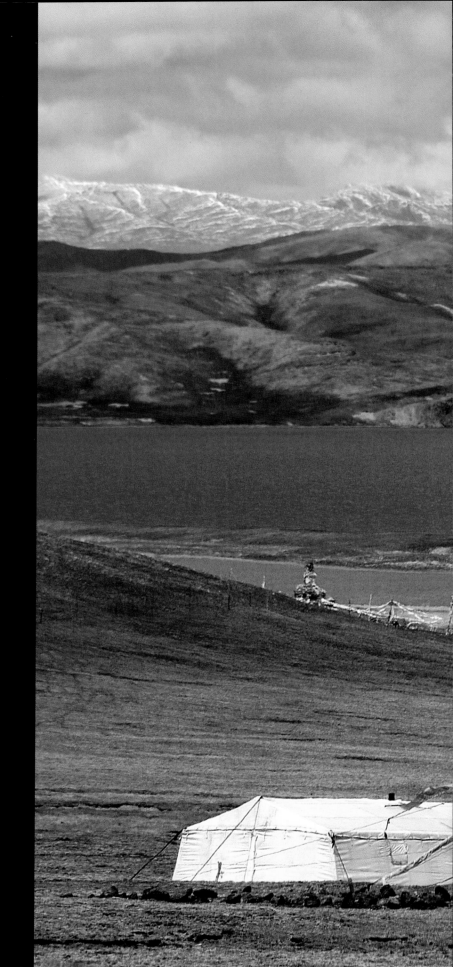

Tibet: The Birthplace
of the Mythical Dragon

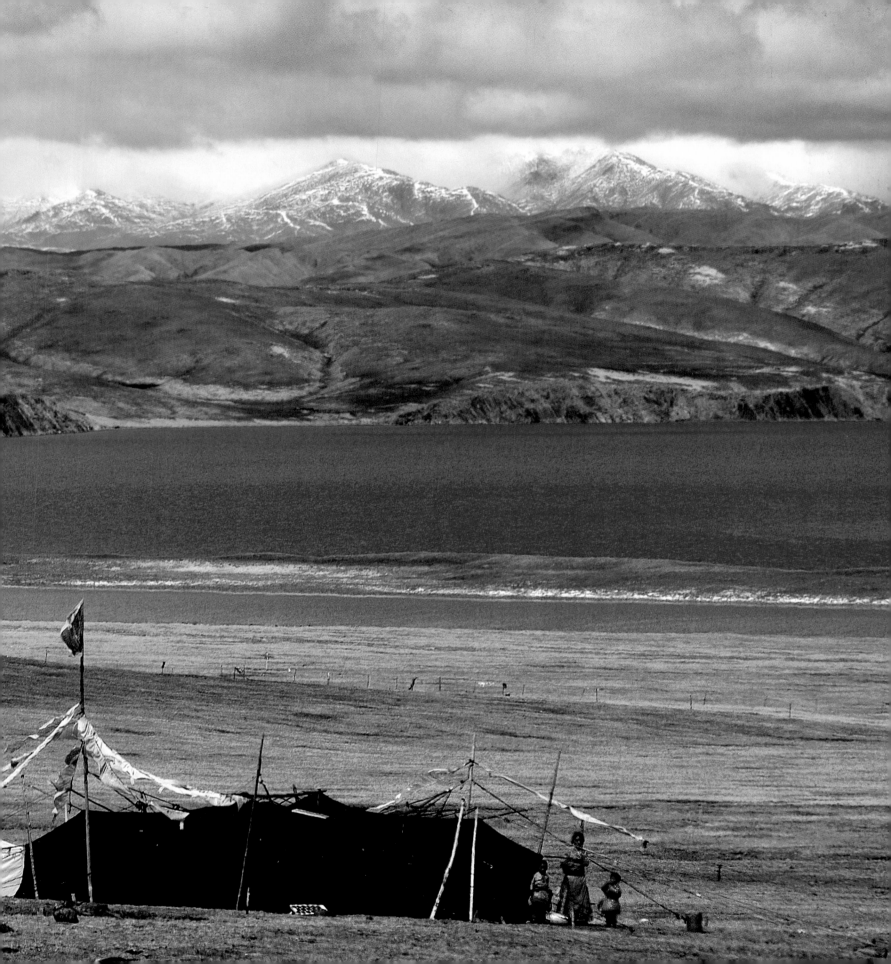

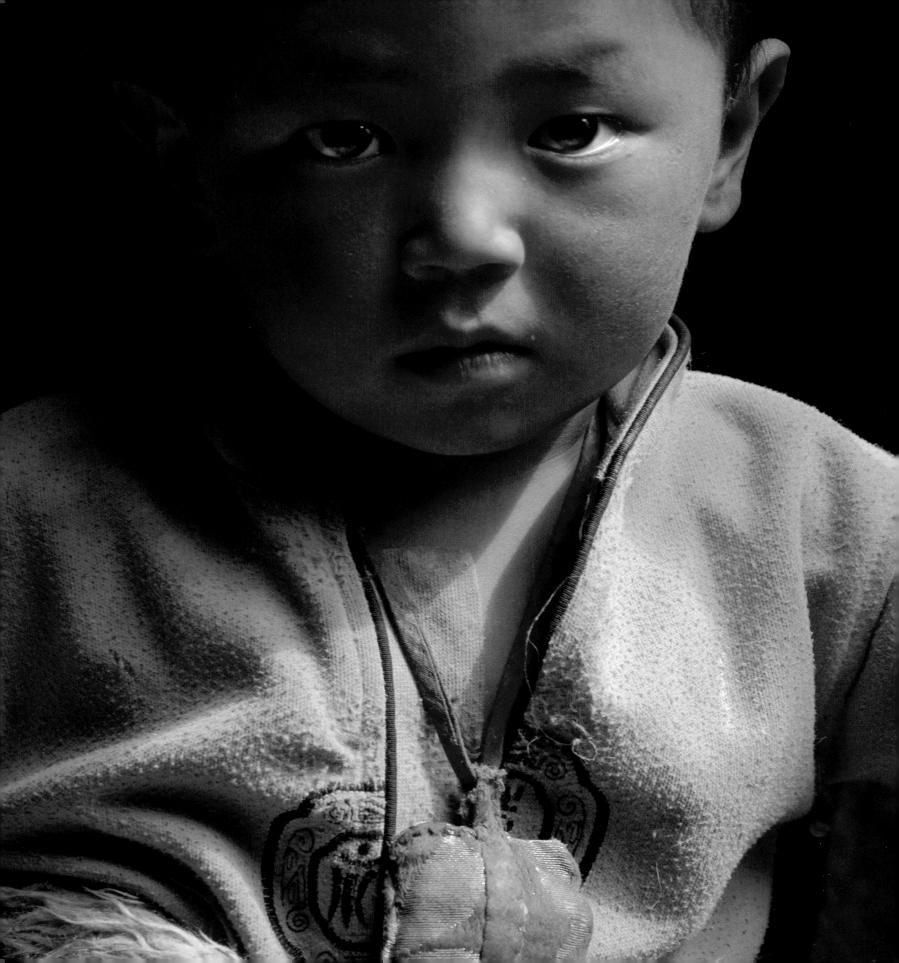

PRECEDING PAGES: A tent belonging to the Ngolok nomads on the shores of Lake Ngoring. The lake, an immense mirror reflecting the sky, contains over 10.8 billion cubic metres of water, from which the Yellow River emerges. This is the province of Qinghai, where at an altitude of 4,285 metres life is decidedly hard. According to Taoist cosmology, the eternal source of the Yellow River is to be found underground, and this place is the source of all life, and the place to which everything will return at the end of the world. Paradise is to be found beyond the Kunlun Mountains, which are the home of Hsi Wang Mu, the Mother Spirit of the West, or the Queen Mother of the West, an important deity in the Chinese pantheon.

OPPOSITE: A young Tibetan nomad photographed in the tent belonging to his family. Around his neck he wears a good-luck charm made for him by a Buddhist monk.

ABOVE: Many Tibetan nomads wear medallions bearing the portrait of the Dalai Lama underneath their clothing.

NOW I AM OUT OF BREATH. The climb is becoming increasingly steep, making it difficult to breathe. The sky has turned a deep blue, with a few scattered clouds, and the air has become thin. A storm has just passed over, raining down a mixture of sleet and ice-crystals. At this altitude there is very little oxygen, and my head is spinning slightly. The path zigzags ahead of me, like the sinuous profile of the dragon which I seem to see before me. Is it a phantasmagorical vision, or perhaps a physiological trick? The huge beast appears to stir, or so it seems to me. Its silhouette dominates the surrounding area, and defines the entire geological map of China that I have in my head. Its tail rests here on this hill, which divides two large lakes surrounded by infinite grasslands. Lake Gyaring and Lake Ngoring lie beneath us at an altitude of 4,285 metres (14,058 feet). Towards the south, the snow-capped peaks of the Bayankala Mountains rise up to the sky. This is the source of the Yellow River, the Huang He. The dragon draws its first breath here on the north-eastern side of the Tibetan Plateau. It sets out on its way having assimilated the waters of Lake Ngoring, a vast hydrographical impluvium. (For the record, as is usually the case, various geologists have discovered a tiny stream which constitutes the actual source of the river.) With every step, my heart beats faster and faster. Tenzin, my guide, runs ahead of me like an antelope: he is a 25-year-old Tibetan, and judging by his rosy cheeks he must have far more red-blood cells than I have.

Finally we reach the summit of the hill. It is the highest observation point for the Gyaring and Ngoring lakes. A monument looms before us: it is the stark silhouette of a yak, whose large horns are festooned with hundreds of Tibetan flags fluttering in the wind: prayers in honour of the dragon. Tenzin starts to murmur quietly 'Om mani padme hum'. When I look around me, my heart skips a beat and my throat tightens. Nothingness as far as the eye can see. There are no glaciers here, but an infinite sea of marshland and swamps which fades into the horizon, interspersed with grasslands which are either drenched with rain or covered with a blanket of snow. Tenzin points out a few solitary wild yak plodding slowly along the shores of Lake Gyaring, and says: 'This is my country, and I want it to remain as it is, wild and free, with its spirit firmly rooted in tradition.' We have reached the end of the world. This is a remote, isolated corner of Tibet, traditionally known as Amdo, which the Chinese administrative authorities allocated to the province of Qinghai, with Xining as its capital. This is the land of the Ngolok shepherds, a proud and fearless people. The city of Lhasa is far away from us here, over a thousand kilometres to the south. For a moment I think I have been abducted,

and have found myself transported to the vast prairies of America's Midwest. The yak have become buffalo, and Tenzin has become a Native American Chief, lamenting the loss of his homeland and his freedom. But we are not on Native American territory. This is China in the 21st century.

We descend into the valley. The lama of the Madoi Monastery welcomes me like a long-lost brother, and wraps a white sash around me as a gesture of welcome. We talk for a long time, and then he closes the door of the temple where we pray together. He prostrates himself in front of a framed photograph of the Dalai Lama, whose image is forbidden in Tibet, although it is tolerated up here. 'Qinghai is less controlled than down there,' he whispers to me. Madoi is the first village you encounter after coming down from the source of the Yellow River. This small settlement consists of two short streets running perpendicular to each other. Women are walking down the streets, their faces hidden by masks which protect them against the cruel wind. Bundled up in layers of clothing, they scurry through the flurries of snow. Beyond the village, there are millions of prayer-flags fluttering in the breeze, like wispy phantoms chasing each other through the evening shadows. But here the phantoms were once real and had a name: the Red Guard. It was the Red Guard that invaded the region, burning the monasteries and sending monks off to re-education camps. The scourge of the Cultural Revolution lashed the whole of China, resulting in millions of deaths. The forced annexation of Tibet was initiated here in the 1950s, and the revolutionaries in their madness attempted to eradicate the cult of the lama. Tibetan Buddhism was severely repressed, and it has only been in recent years that the intensity of repression has eased off. These days there is a curious phenomenon to be witnessed in Qinghai: the monasteries which were destroyed during the anti-religious mania are now being rebuilt or restored, with the blessing of the authorities. The aim is to turn them into tourist attractions, now that the Chinese can enjoy freedom of movement within their own country. It is well known that tourists bring money, and money is an important objective in bringing China closer to its goal of becoming a market economy.

OPPOSITE: Prayer-flags are to be found all over Tibet. These ones have been positioned around a ritual altar erected in honour of one of the spirits of Lake Ngoring. Tibetan Buddhism combines both Buddhist and animist elements, and remains inextricably linked with the ancient religion, which is still practised in the remote regions of the plateau.

OVERLEAF: A picture of Lake Gyaring, the sister lake of Ngoring, just before a violent storm of rain and snow sets in. The two lakes are considered to be the source of the Yellow River, and in Tibetan their names are Zhaling and Eling, meaning whitish-grey and greenish-blue respectively.

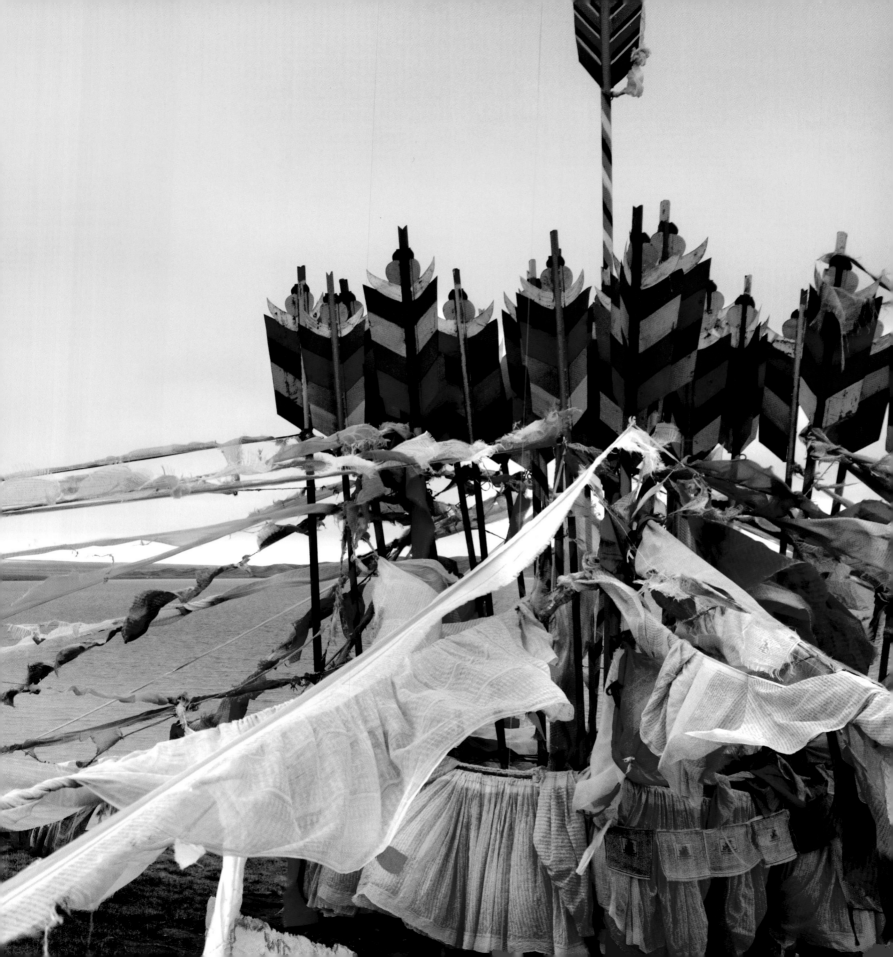

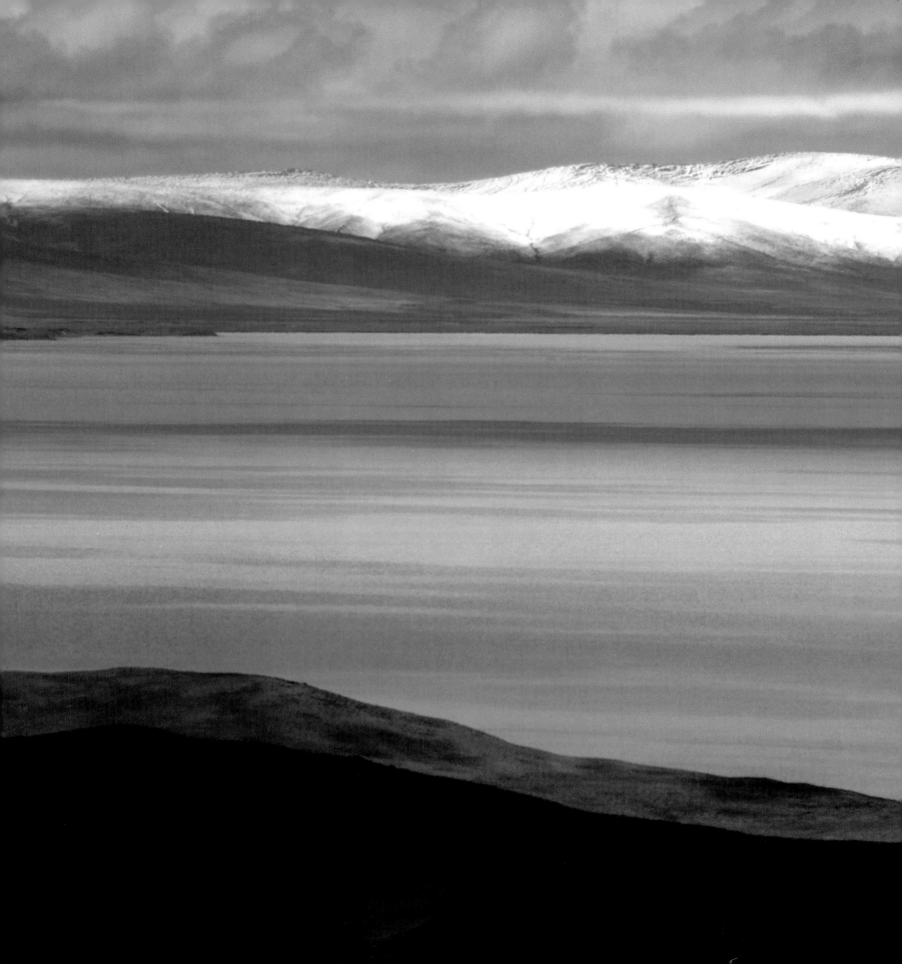

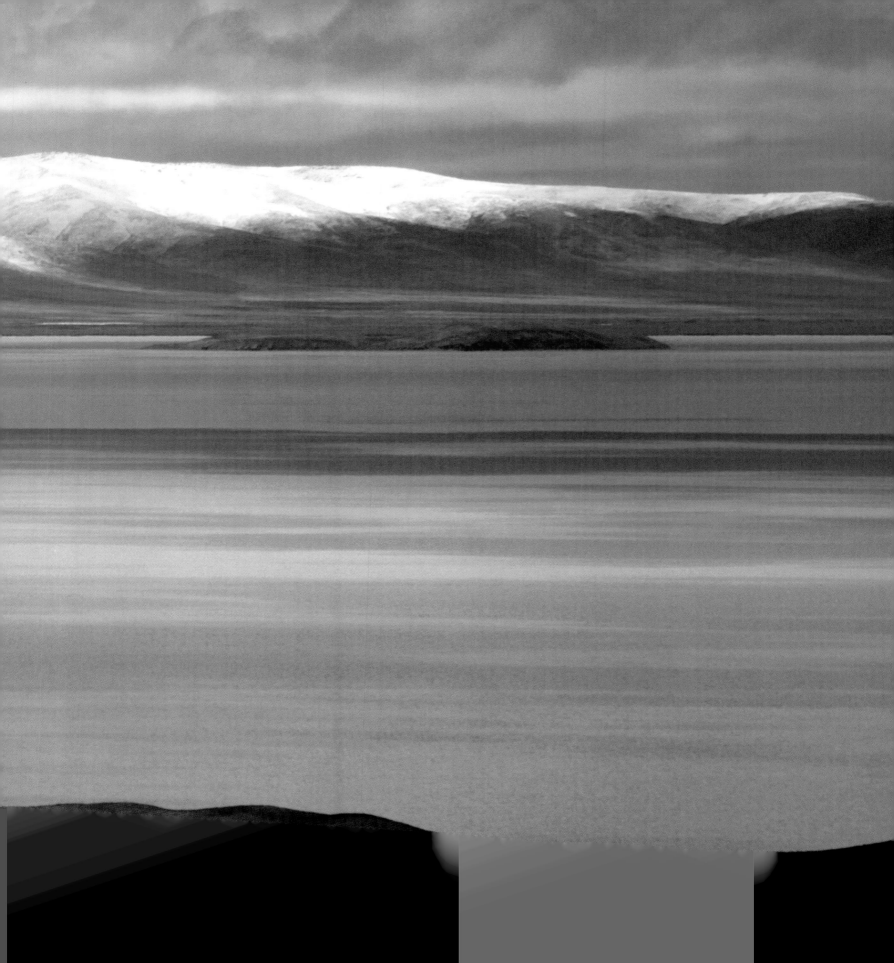

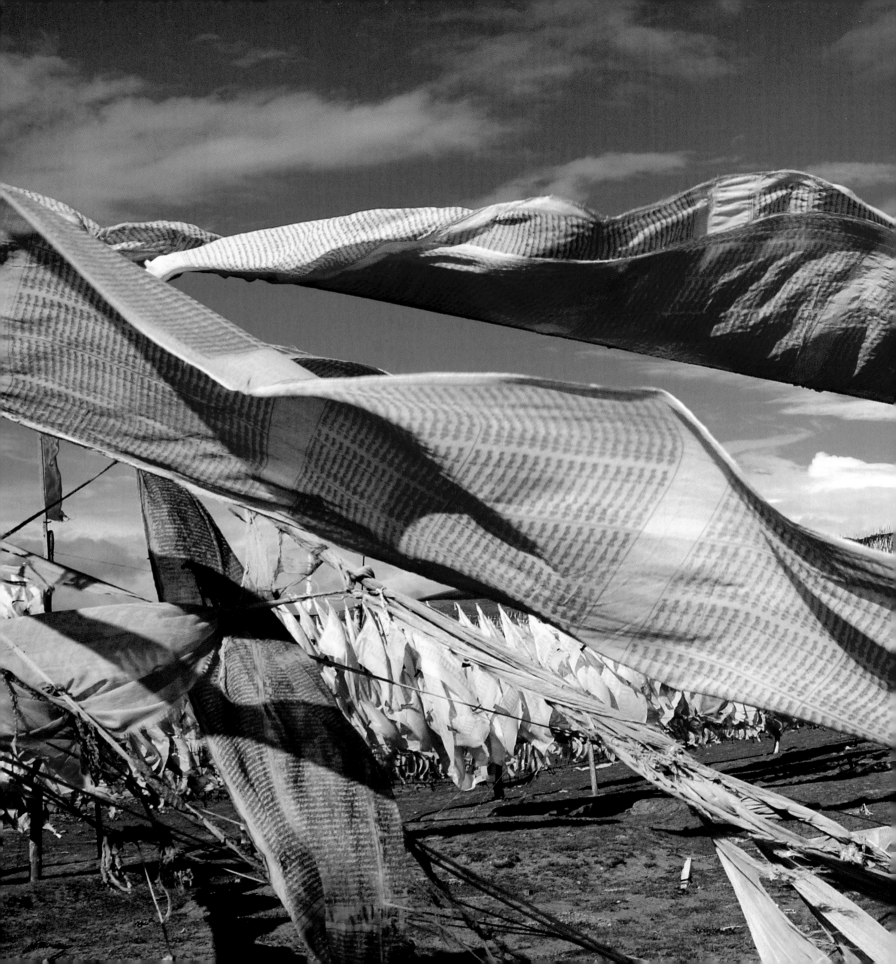

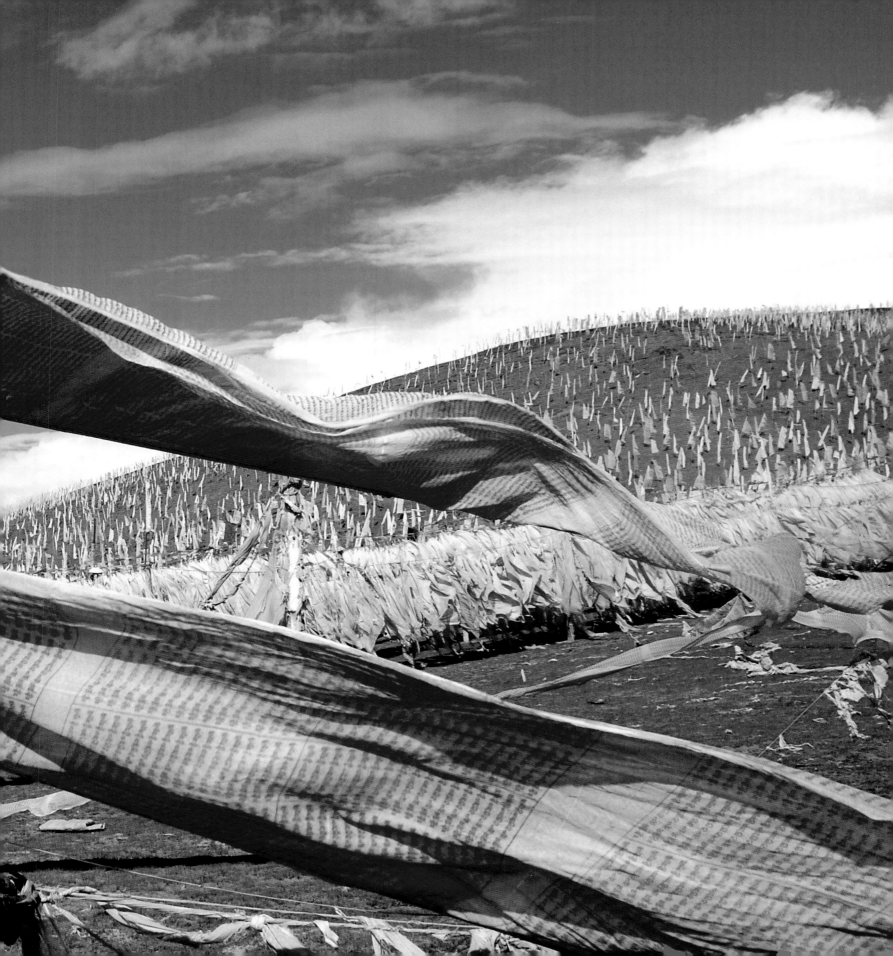

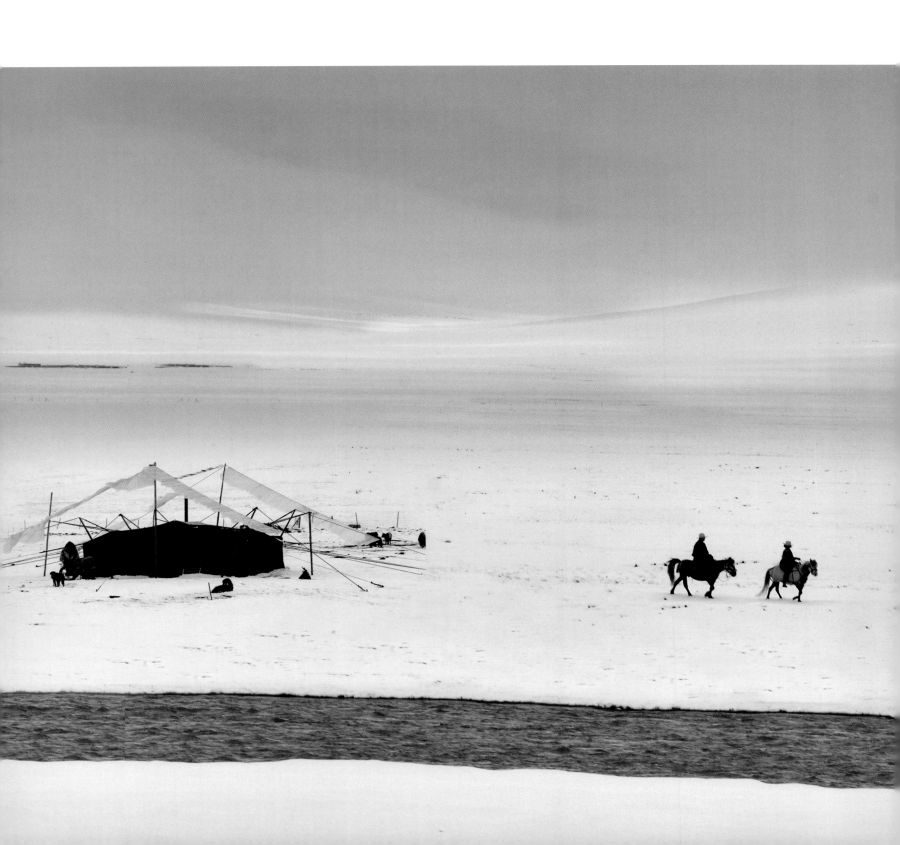

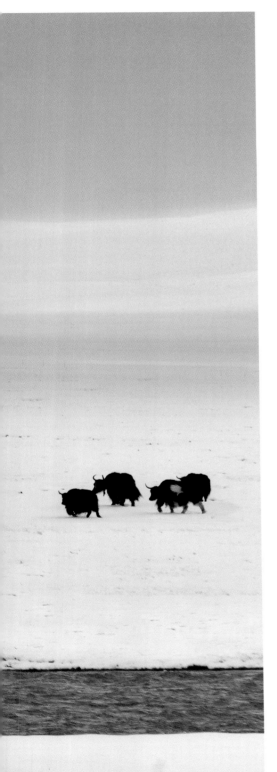

PRECEDING PAGES: A sea of prayer-flags stretches along the approach to the village of Madoi, the small settlement from which a rough dirt track leads to Lake Gyaring and Lake Ngoring. A small stream flows out of the lakes, gaining in width as it passes through swamps and pastures, and this is considered to be the first stretch of the Yellow River.

LEFT: A sudden snowstorm took us by surprise one morning in June in the village of Madoi. It took three or four hours of sunshine to melt the snow and enable the yak to return to their pastures.

RIGHT: The bitter wind forces the women who live at this high altitude to wear a mask to protect their cheeks from becoming rough and chapped. Notice the prayer-wheel which is kept in perpetual motion: it shows the diffusion of the Buddhist doctrine and the Eightfold Path, which according to the teachings of Buddha is the way that leads to the end of suffering.

OVERLEAF: A herd of yak passing the Tibetan village of Qingshuihe, while the first rays of sunshine melt away the snow and penetrate the thin layer of mist.

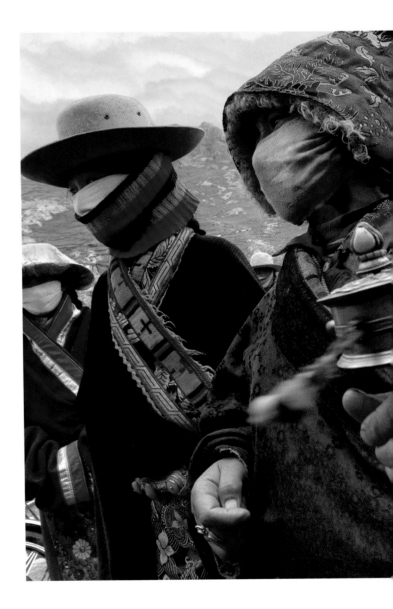

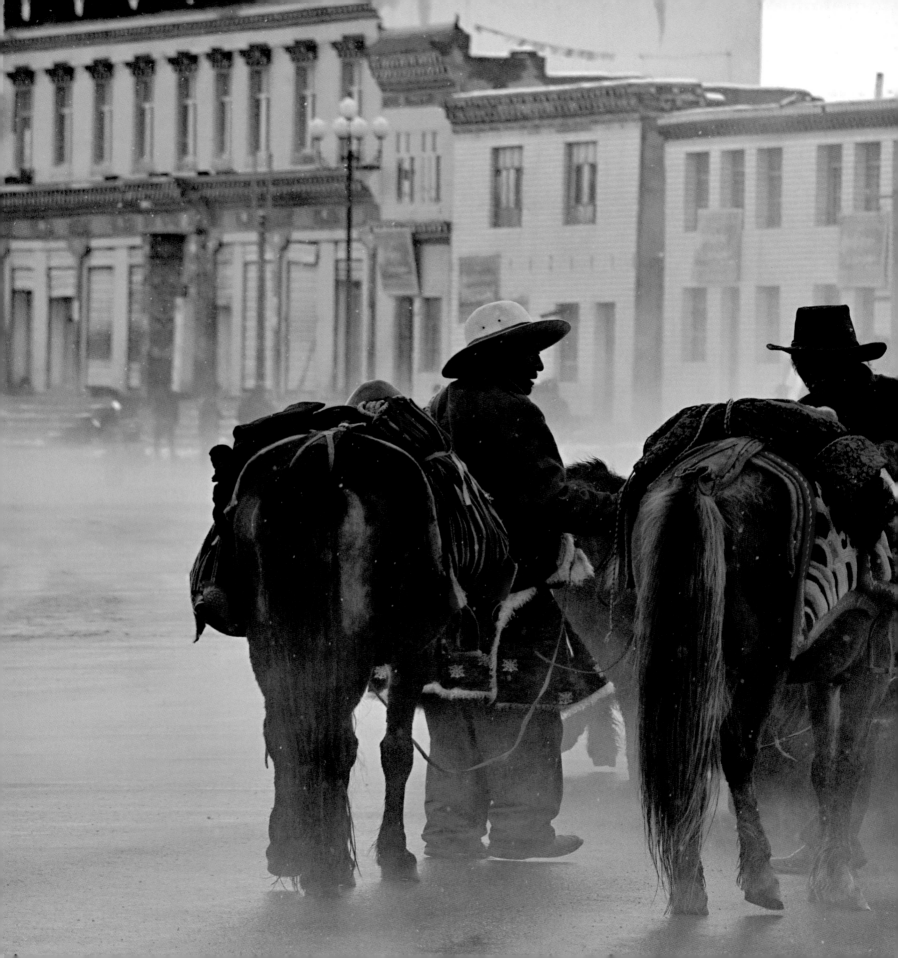

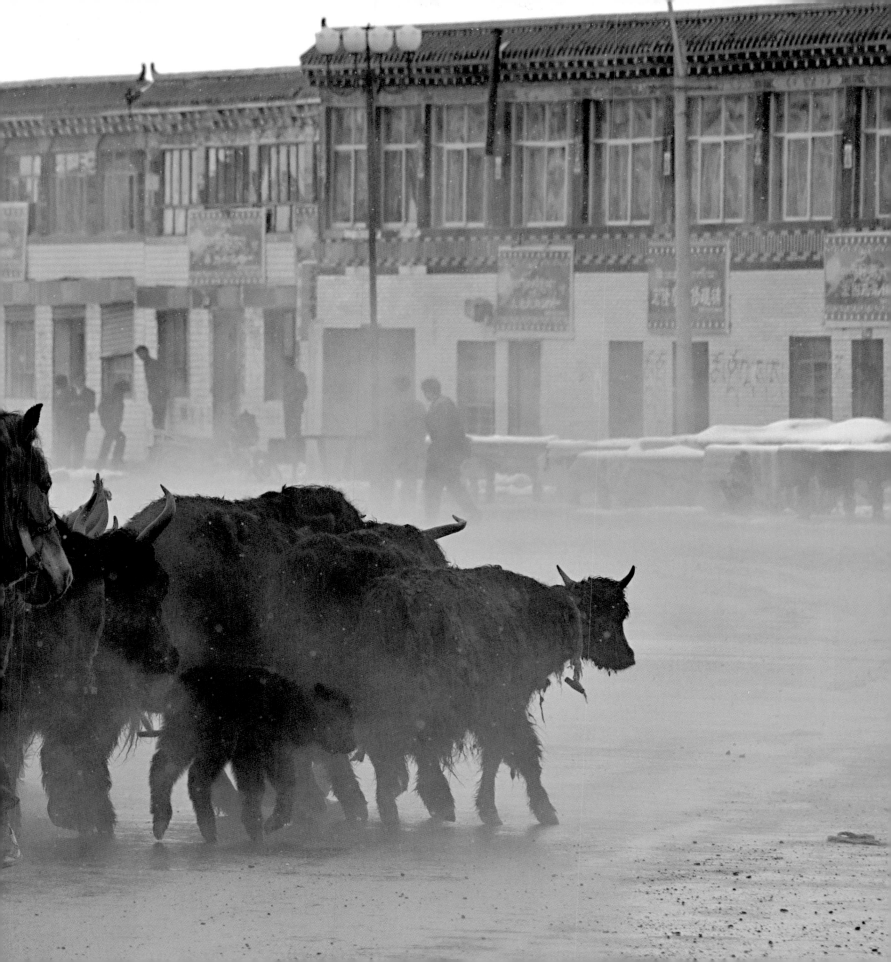

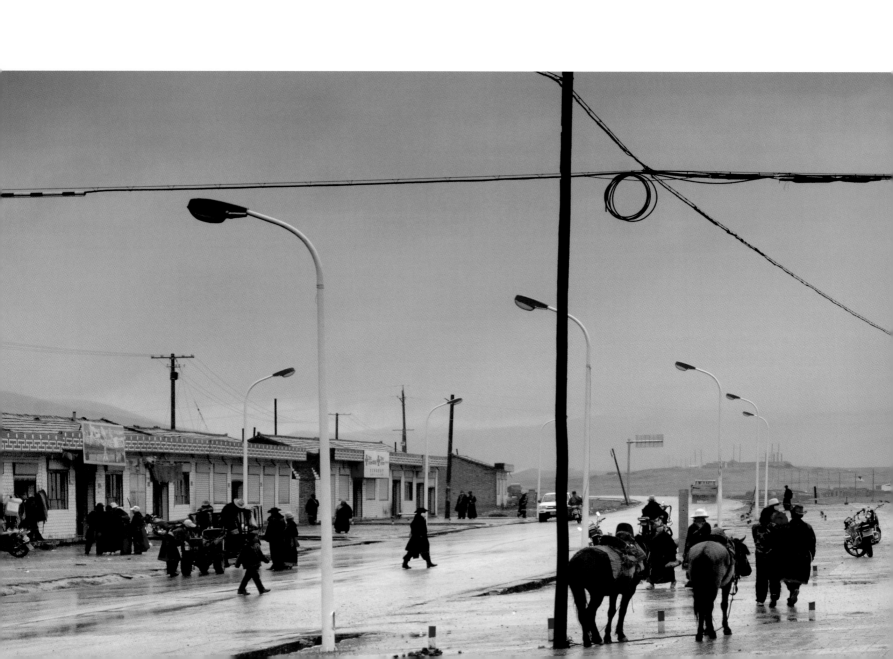

OPPOSITE: The village of Huashixia after a violent storm of summer rain. The streets are full of nomads who have arrived here on horseback or by motorbike from the surrounding grasslands.

BELOW: Qingshuihe under a blanket of snow. The billiard tables which have taken over the streets have been covered with nylon sheets to keep them dry. In good weather, Tibetan nomads, local Chinese and the Hui Muslims who run small commercial enterprises here all get together to play a game or two of billiards.

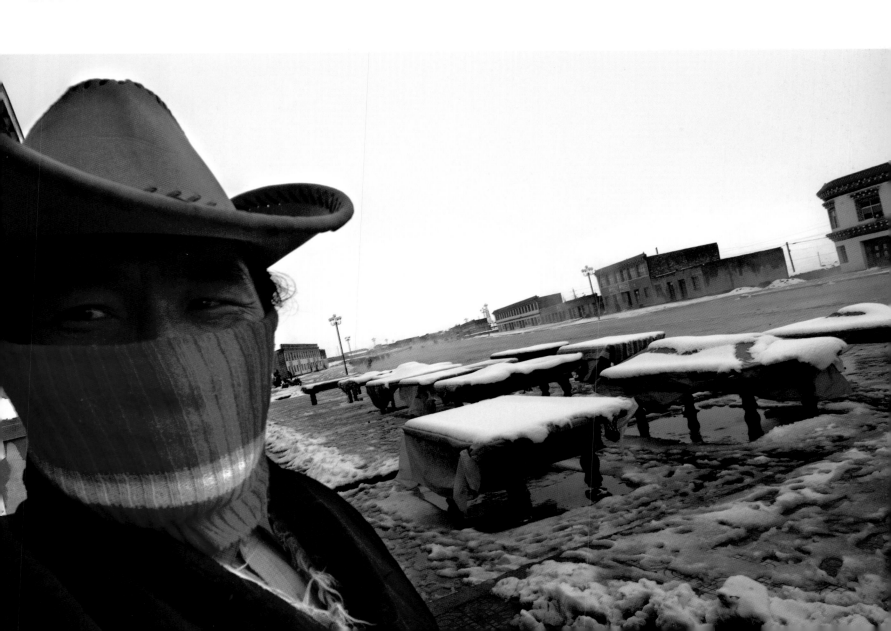

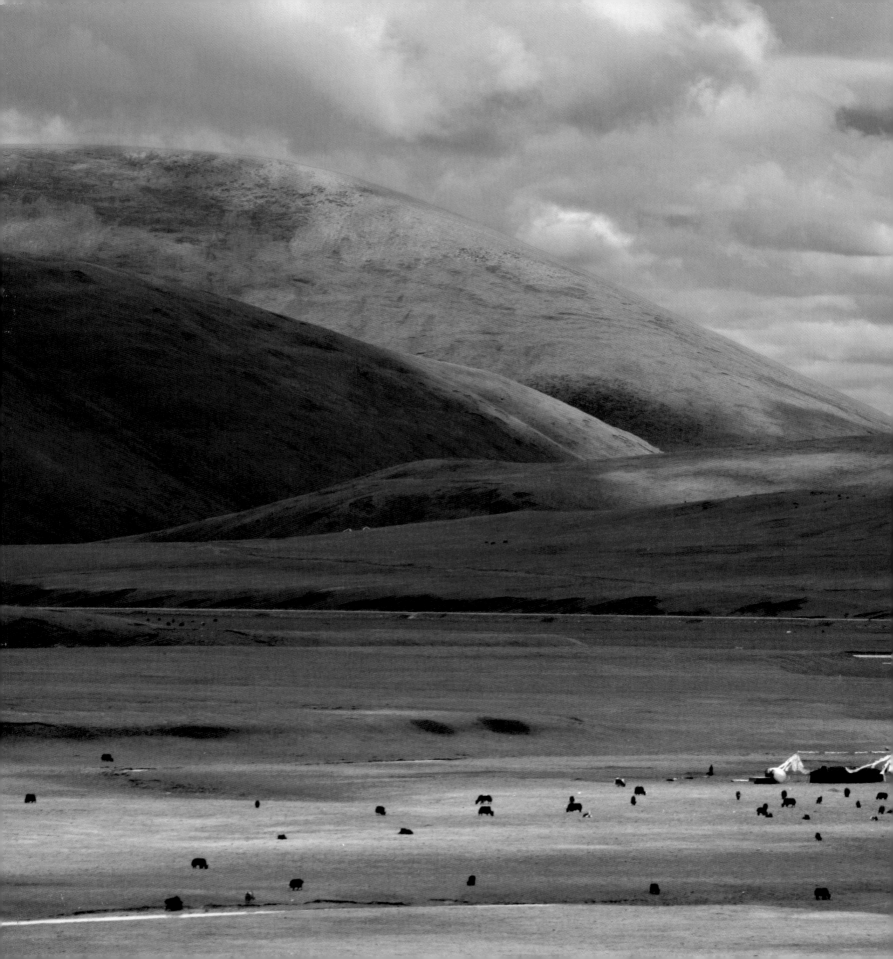

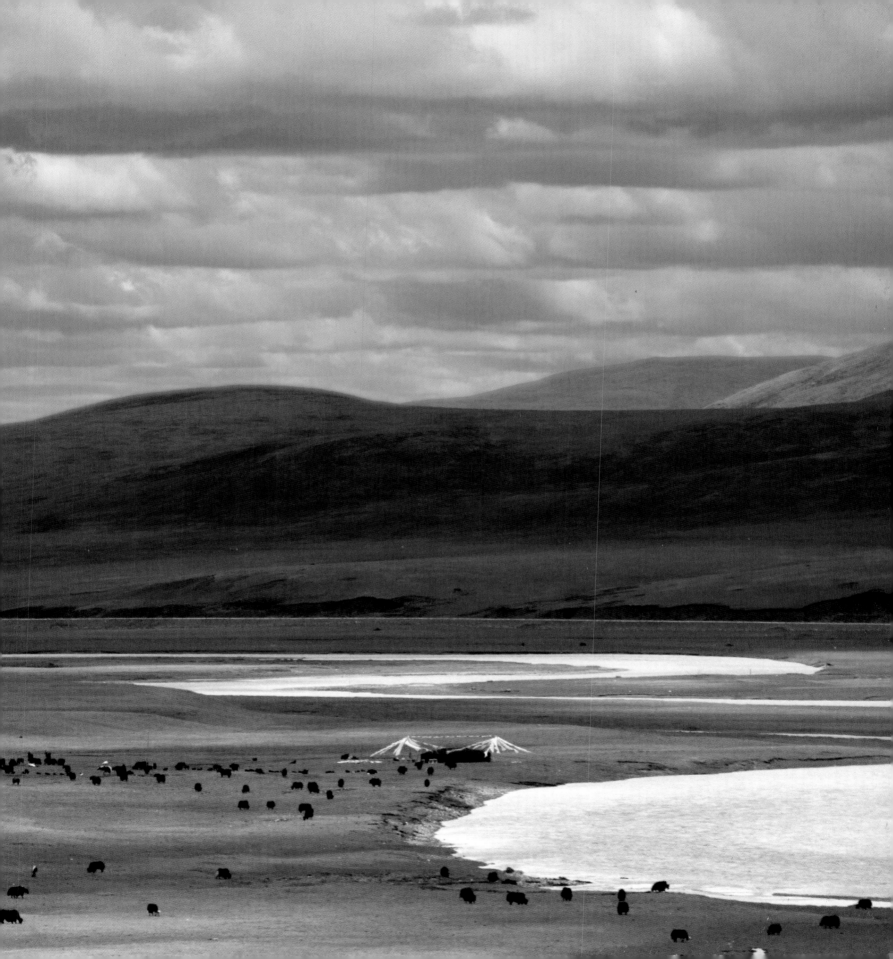

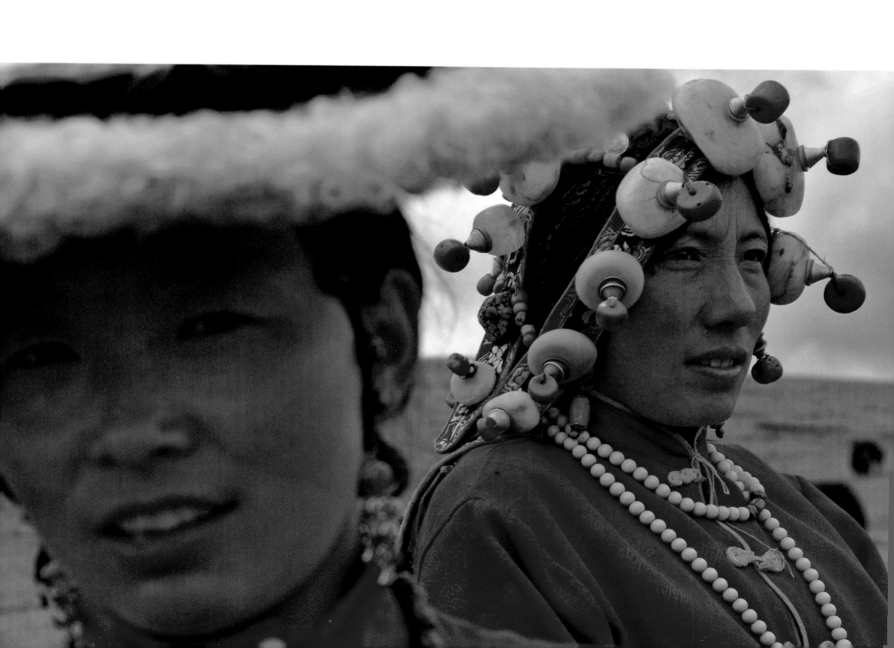

PRECEDING PAGES: A wide view of the plateau that is the birthplace of the Yellow River. The plain is dotted with tents and yak. The weather is constantly changing: one moment the sun is shining, and the next moment clouds darken the sky and there is a strong wind.

OPPOSITE: Two Ngolok women pictured outside their tent made from yak skins. In honour of the occasion, one of the women chose to wear her festival headdress, covered with large pieces of jade and Tibetan coral.

In these lands, hospitality is sacrosanct, and so after the photographs we were invited to drink the traditional Tibetan tea, which is salted and mixed with butter made from yak's milk. In return, we promised that we would find a way to let them have copies of the photographs we took.

BELOW: A herdsman on horseback accompanies his flock to pasture. In the summer months, the yak are scattered all over the grasslands in search of the best pasture.

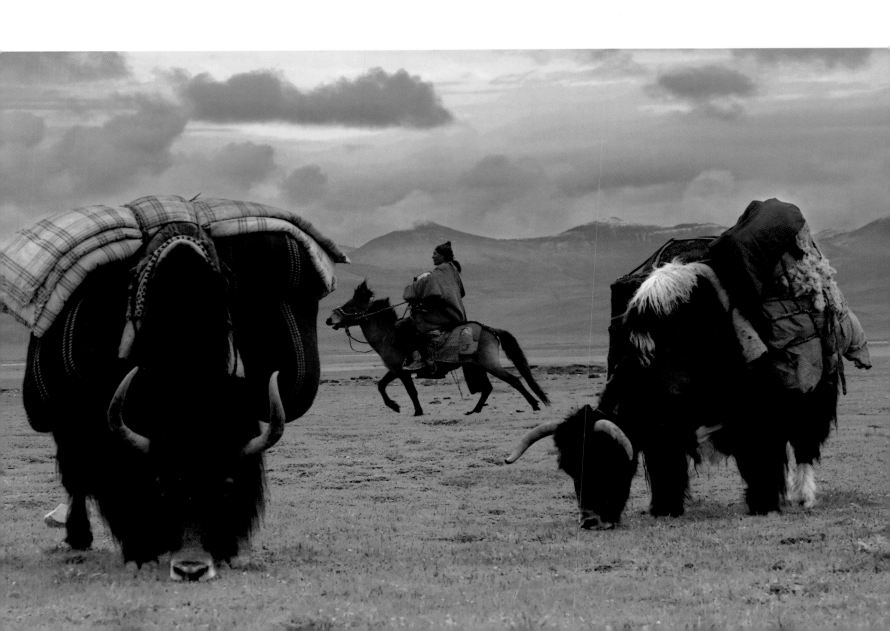

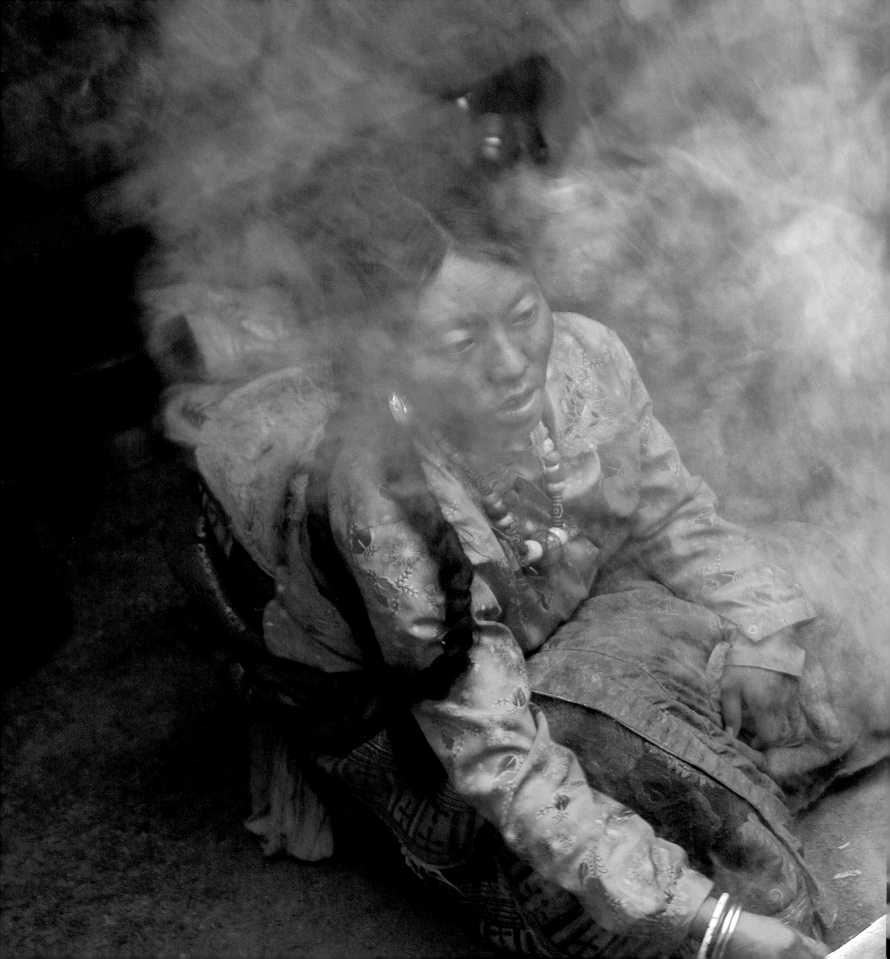

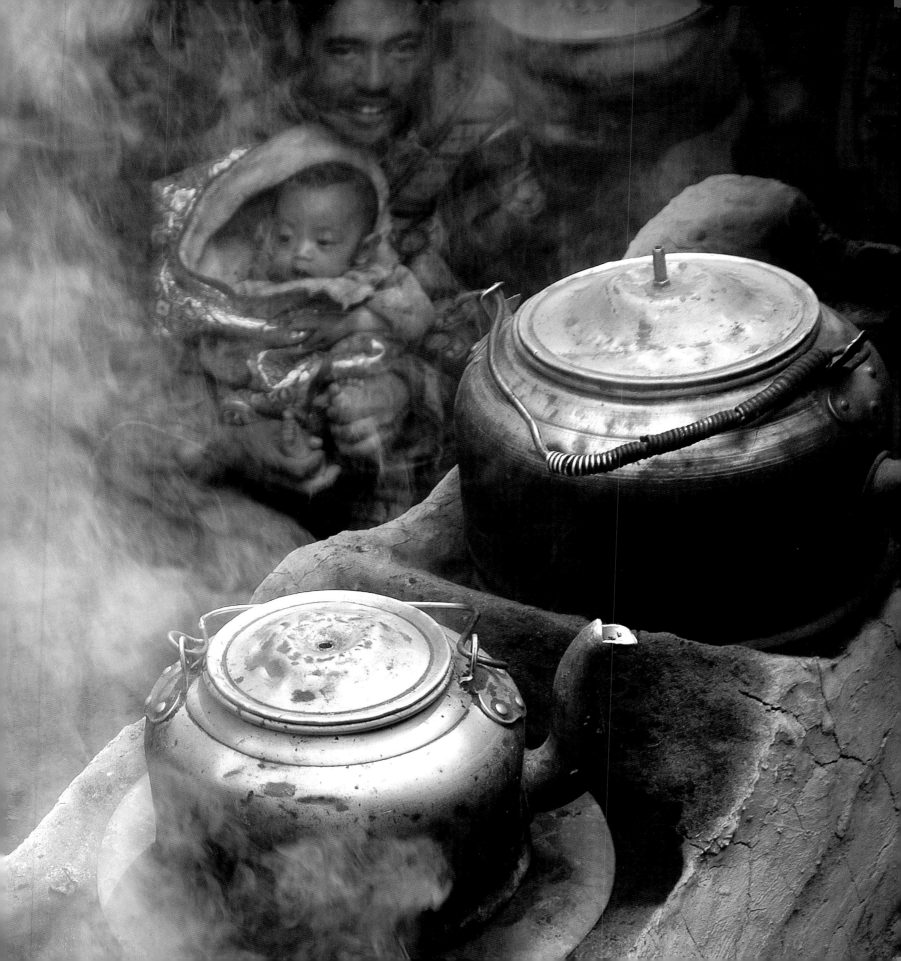

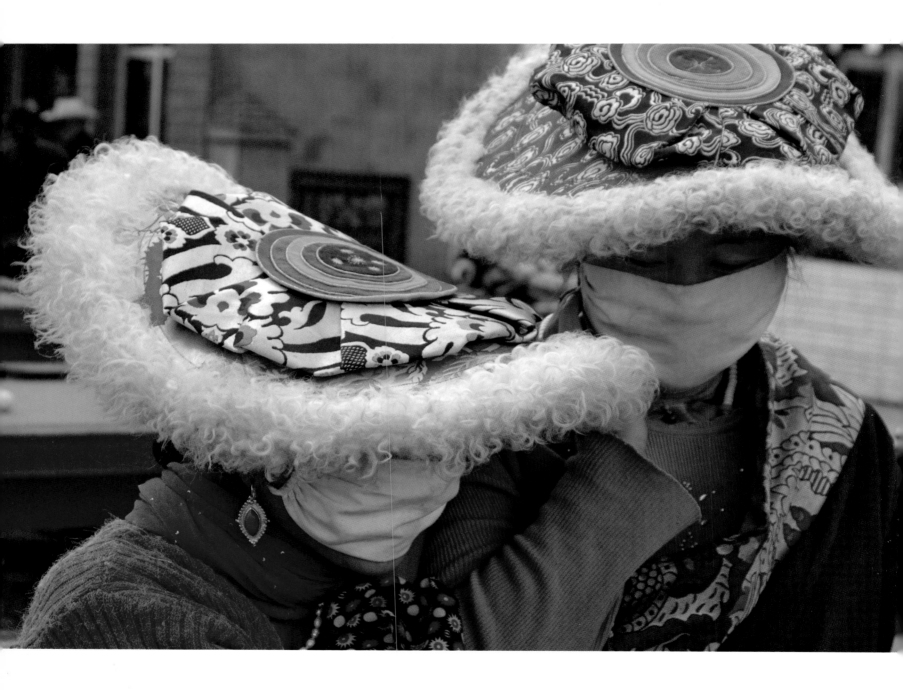

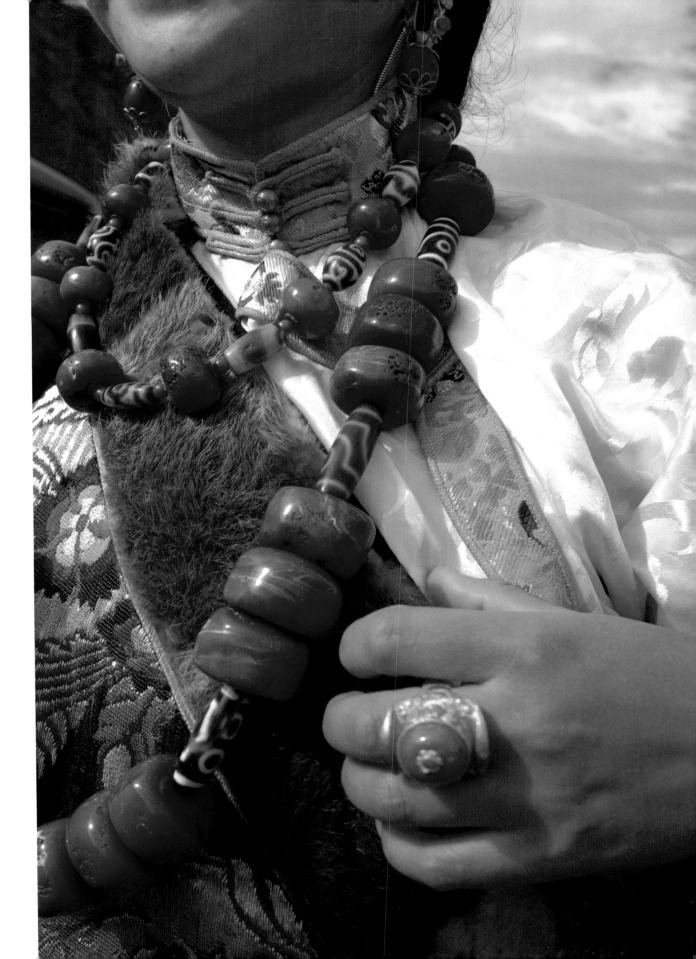

PRECEDING PAGES: The interior of a nomadic tent. Cooking is done in large pans on a mud stove: often it will be a large sausage made of yak's meat, or a dish using tsampa (roasted flour, usually barley flour).

OPPOSITE: Two peasants from Qingshuihe wearing the traditional hat belonging to the region.

RIGHT: A Tibetan woman proudly displays the festival costume and heavy jewelry which are valuable treasures to this family. Notice the fur sash. Recently, following the advice of the Dalai Lama, the use of real furs has been prohibited in order to protect species in danger of extinction. This has been a significant step in Tibet.

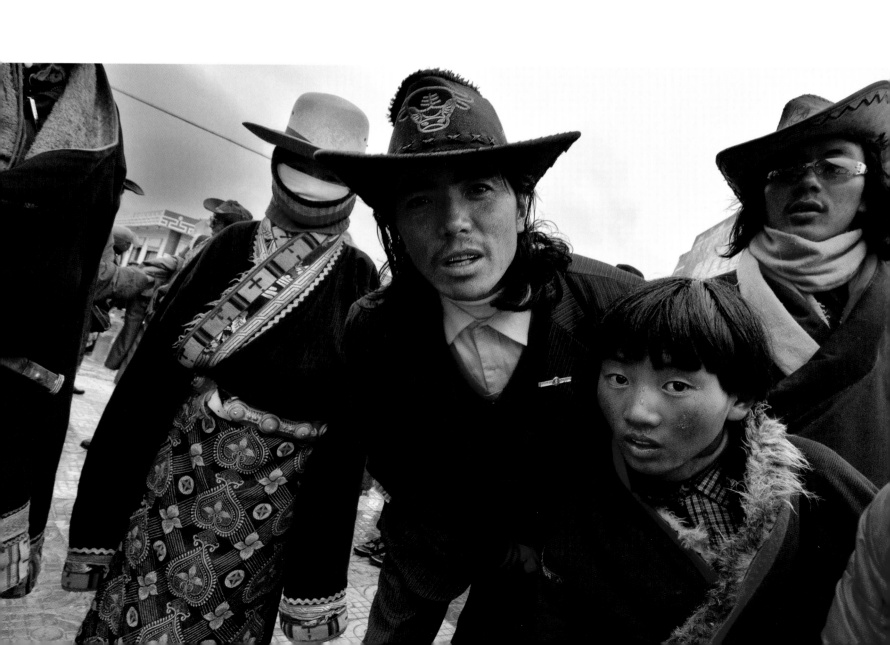

OPPOSITE: People on the street near Maqen. Western visitors are looked at with curiosity as they are something of an anomaly here in the heart of Qinghai. Everyone shows a great interest in the images generated on the screens of our digital cameras.

BELOW: One curious Ngolok boy has just come out of his tent to find out who we are and what we are doing. Often the severe and implacable countenance of many Tibetans living on the plateau along the Yellow River proves deceptive. It takes just a smile and a few words of Tibetan for us to engage in a simple form of communication based on friendly gestures.

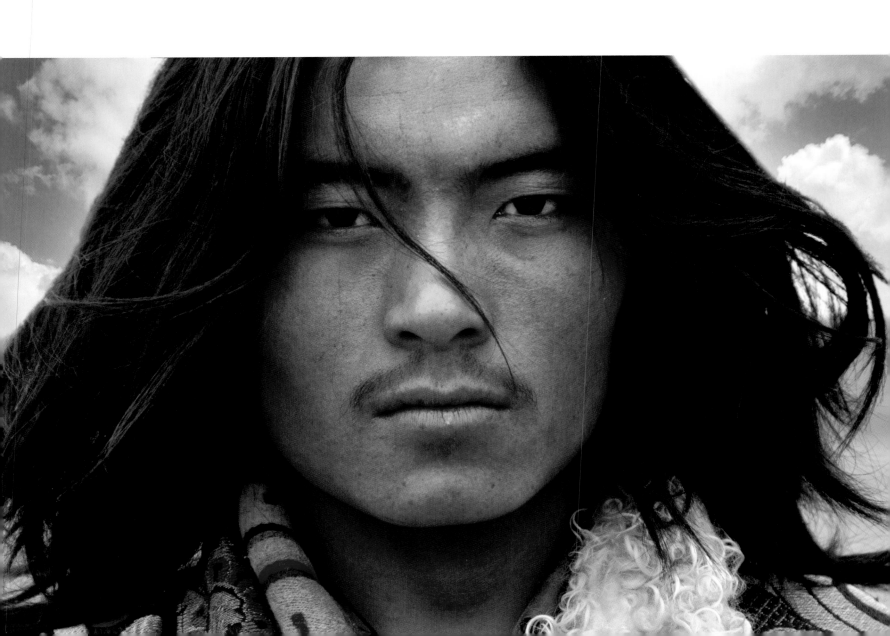

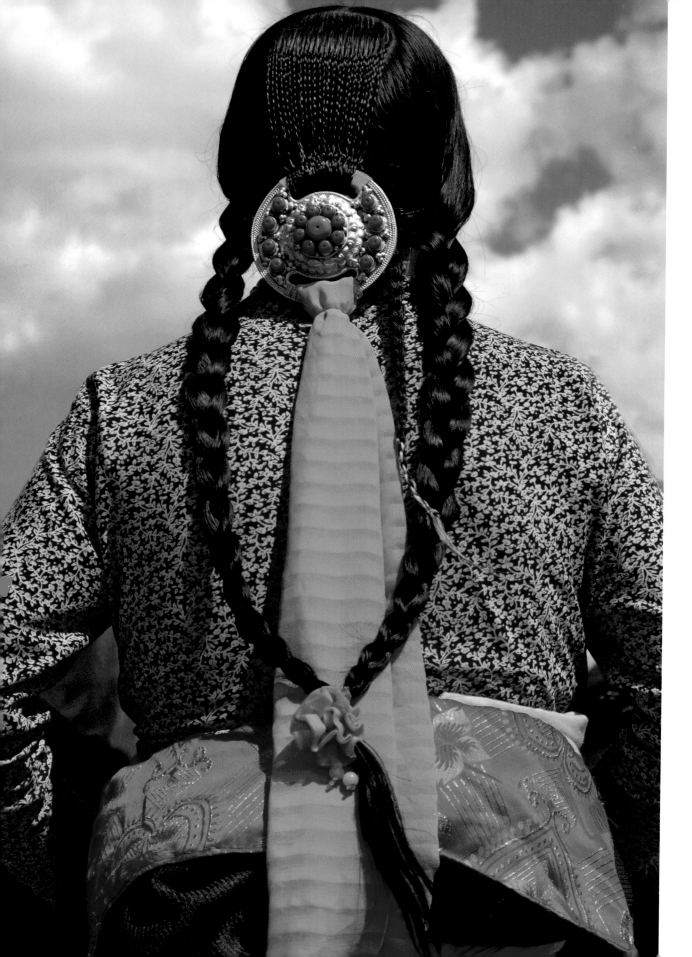

LEFT: A raven-haired Tibetan woman with long plaits whom we encountered close to Maqen.

OPPOSITE: The inhabitants of Maqen have distinctive hairstyles, similar to extensions, which enable them to decorate their hair with colourful bands.

OVERLEAF: A view of the Ragya Monastery, arrayed in splendour along the banks of the Yellow River.

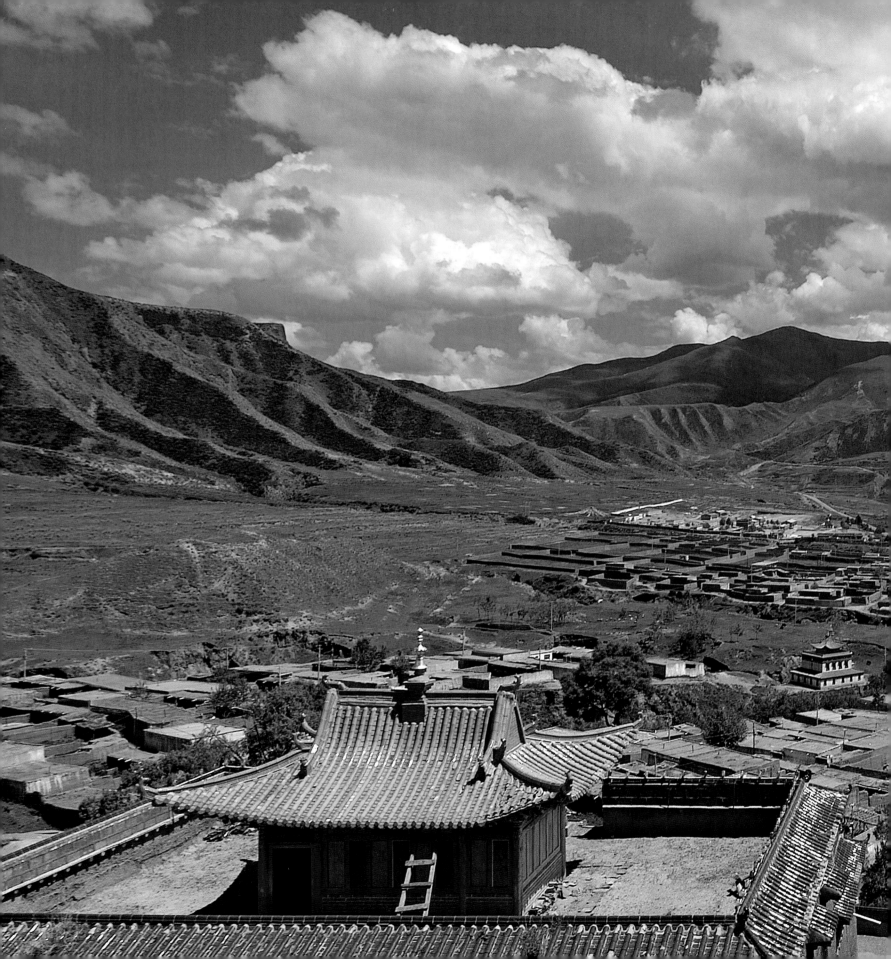

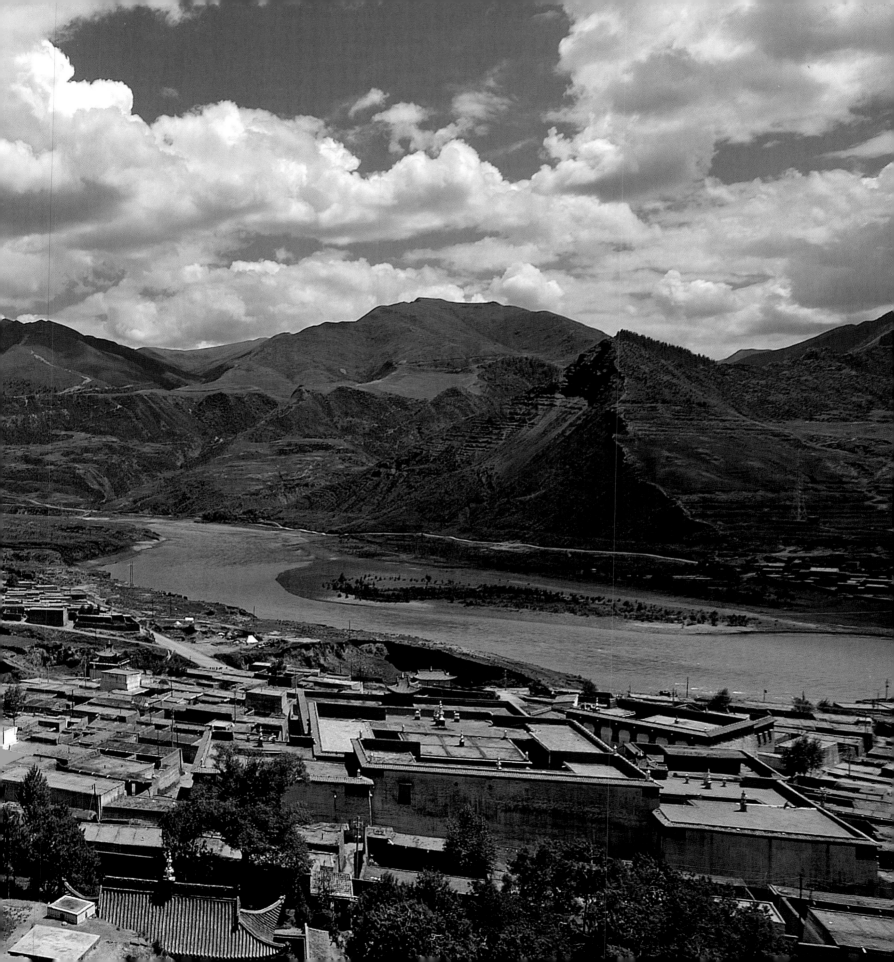

With every kilometre that we descend in altitude, the throbbing in my head diminishes, and now we seem to be entering a contented landscape. The dragon guides our path through undulating grasslands where the nomads congregate in their tents, which are heated by mud stoves. We find ourselves offered Tibetan tea, mixed with butter made from yak's milk, and tsampa, flour usually made from roasted barley. These isolated villages seem rather fragile: their walls have been erected hurriedly. But there is definitely something very solid about the people here – solid, beautiful and genuine. The men are raven-haired and proud-looking, with ruddy faces, and the women wear heavy necklaces of amber and turquoise. In accordance with Tibetan style, they wear heavy capes with sleeves that reach the ground. The old people rotate their prayer-wheels. This remote corner of Tibet looks like a scene on a postcard from a previous century. Very little has changed in the traditional nomadic lifestyle. Life is very tough, basic and spartan. Their principal food consists of meat from yak and sheep. Only the shops and inns are furnished with supplies of 'new arrivals', most of which are produced in China. The Tibetans are the customers, whilst the Han and the Hui Muslims are the shop-keepers: batteries, plastic buckets, soap, cans, toothpaste and small boxes. It is Beijing, not Lhasa, which directs the flow of goods, and exerts influence over the poor economy of the area. There has been a considerable amount of Asian immigration, but any thought of integration between the peoples is still a long way off, and seemingly impossible. Naturally they come into contact with each other, but these encounters can be hostile. They inhabit two different worlds, with two different visions of reality: there are hands chapped and roughened by hard work and cold weather, and there are smooth hands holding mobile phones; horses, or powerful new motorbikes racing through the fields; real fur coats, or synthetic outdoor jackets like clones from North Face or Nike; the Tibetan language, or the Chinese language taught in schools. Then there is of course the traditional religion which seems so out of keeping with the modernization of these towns in the plains. The ideals and the mythology connected with religion are not compatible with the pursuit of money, and especially of new Chinese money. I wonder which world will ultimately prevail.

OPPOSITE: A woman rotates a cylinder near Xinghai, the site of the largest 'mani' stone mound – made entirely from prayer-stones – in Qinghai and maybe in the whole of Tibet. In this small village, over the centuries they have accumulated a huge number of stone slabs inscribed with prayers or Buddhist mantras. It is a real shame for the Tibetans that the Chinese authorities decided to build a major construction site right in front of this sacred place, and the clean air has become polluted by the dense grey smoke from the industrial plants.

OVERLEAF: The laborious scrubbing of pots and pans in a tributary of the Yellow River.

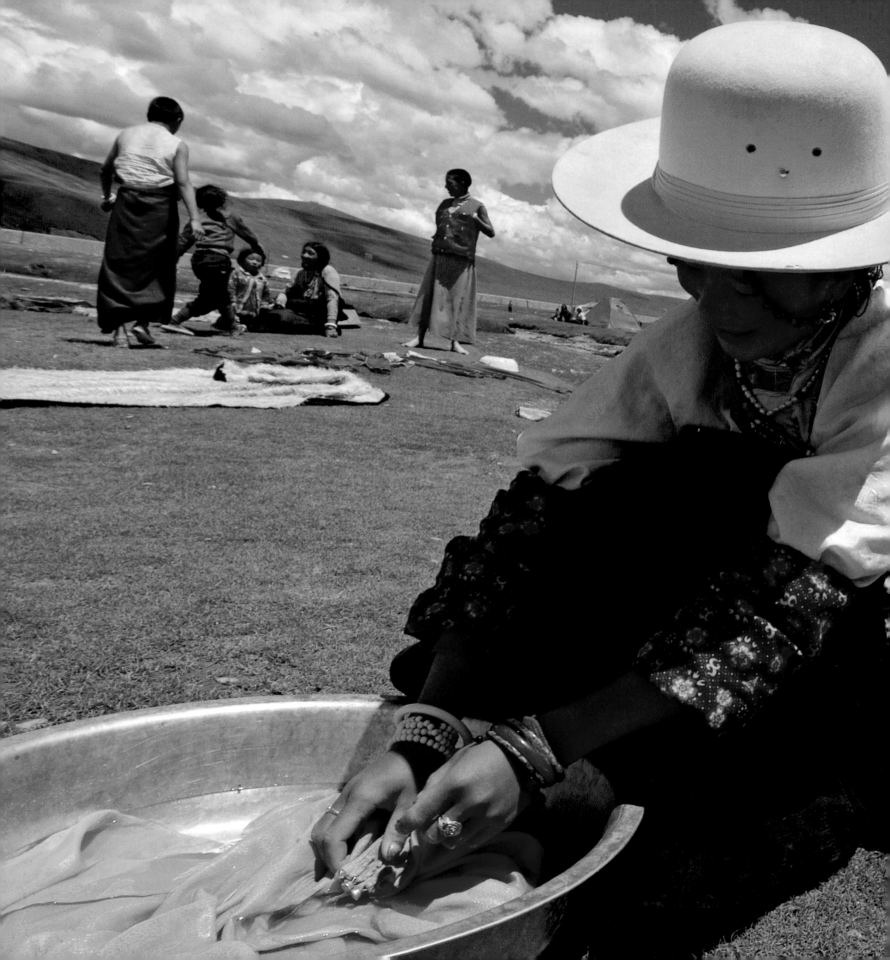

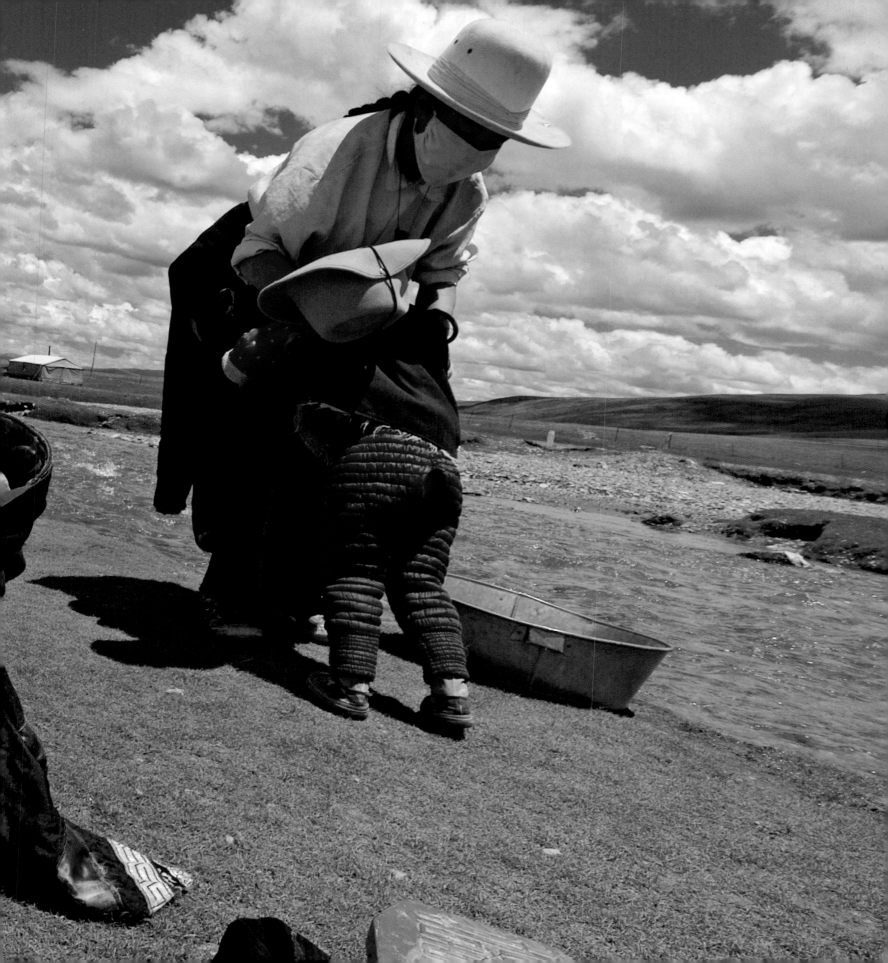

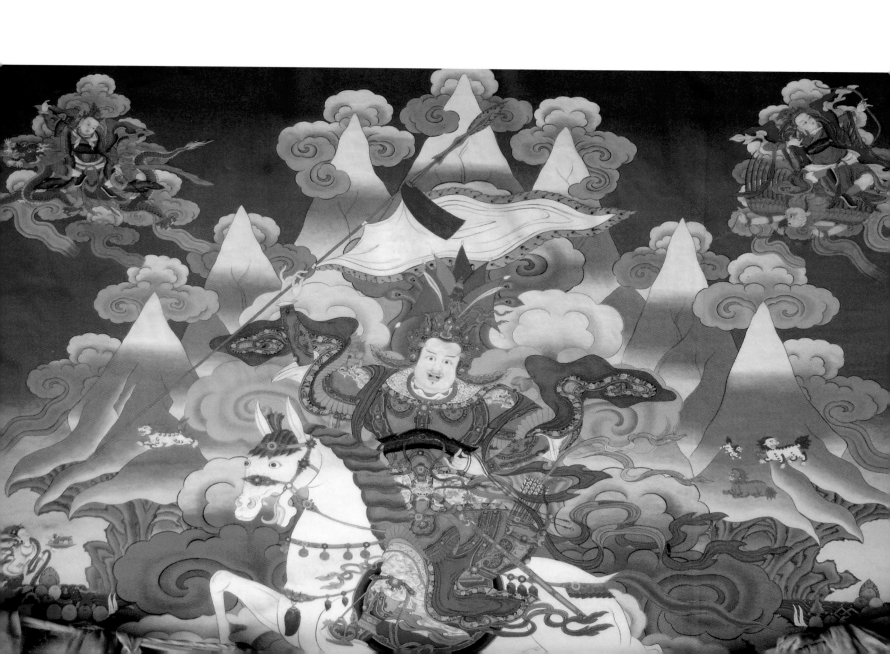

OPPOSITE: A painting of Mount Amne Machin, photographed in the small monastery at Tzatzatan. Mount Amne Machin is part of a range of mountains, skirted by the Yellow River as it forges north in a huge curve. The Tibetans in Qinghai consider this mountain to be sacred, and it is a destination for pilgrimage. Devout Tibetans will go for lengthy ritual walks around the mountains, whose adjacent valleys are covered with glaciers all year round, but which are now sadly receding. The torrents and rivers streaming down from Mount Amne Machin flow into the Yellow River, making a substantial contribution to its volume of water.

BELOW: An animist ritual taking place in the grasslands of Huangshatou. A dense crowd has gathered around an improvised altar covered with large, coloured prayer-flags. Popular deities and spirits are frequently venerated and worshipped, and these beliefs co-exist with the tolerant Buddhist doctrines. Religion and paganism are interwoven with the legends that form part of the secular culture of Tibet. Amongst the different mythical personages encountered here, one of the most important is King Gesar, the subject of the famous oral epic poem which is still sung by nomad troubadours. The legends of King Gesar originated over the course of several centuries, and the epic is believed to be around 1,000 years old. According to the stories, many years ago Tibet was the victim of countless natural disasters and was overrun by demons. In order to save the people from their misery, King Gesar came down to earth in the guise of a creature that was half man and half dragon. After a series of battles he vanquished the demons that had been persecuting mankind, and returned to the sky. This immense epic poem is the longest one to have ever been written, consisting of over one hundred and twenty volumes.

OVERLEAF: A view of the endlessly undulating grasslands on the Tibetan Plateau of Qinghai.

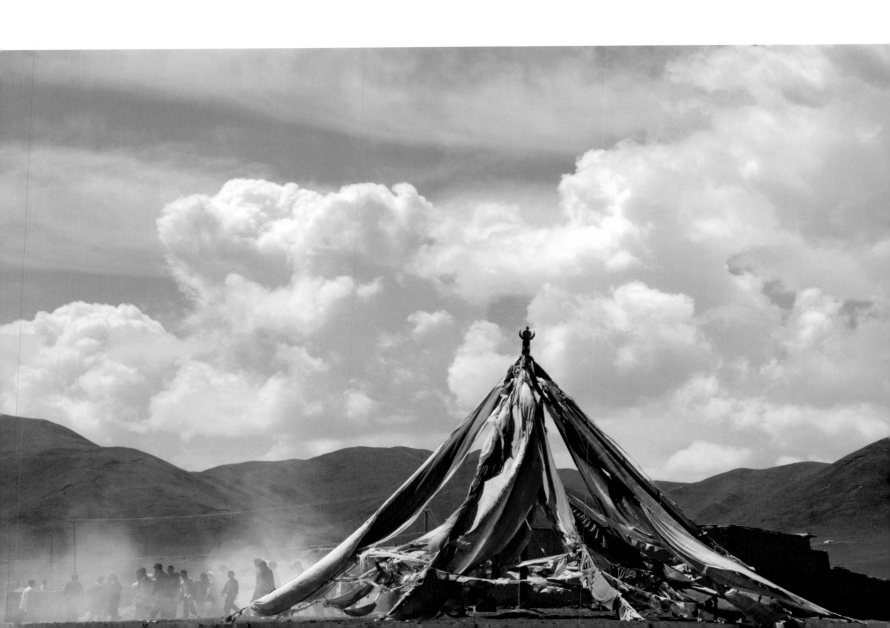

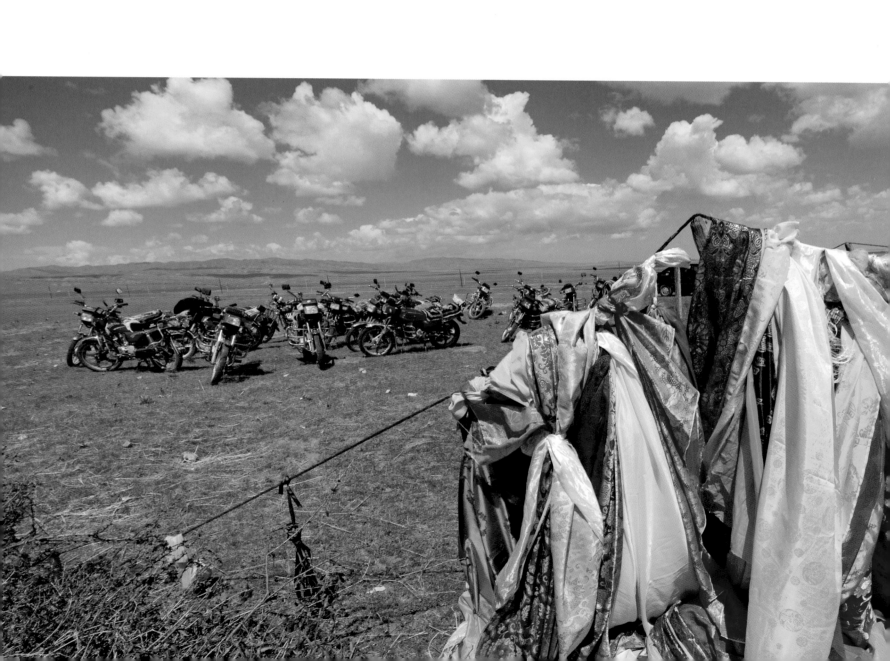

Traditionally, the Tibetan nomads went around on horseback, but nowadays the use of motorbikes is becoming more widespread. Modernity has even found its way into these remote areas of Tibet. These days the tales of the bloodthirsty nomadic people, who ravaged the land up until the middle of the last century, seem completely unthinkable and bear no semblance to today's reality. One such account was written by the American explorer Leonard Clark, who headed an expedition to Qinghai in 1949. The official aim of the mission was to discover the actual height of Mount Amne Machin, whose summit was then believed to rival that of Mount Everest. Until then Amne Machin had remained unconquered due to its reputation as a cursed mountain and particularly the presence of fierce tribes, the indomitable Ngolok. Clark was also under instructions to find an escape route for the troops of the Chinese national army, under the leadership of General Ma Pu Fang, who were trapped in the path of the encroaching Communist forces. The story of the expedition was chronicled by Clark in his diary, which he turned into a book entitled *The Marching Wind*. The book is considered to be one of the classics of travel writing. His words convey an unexpectedly violent image of a Tibet dominated by warlike peoples, which is a far cry from the mystical and ascetic country of our own experience.

OVERLEAF: A photograph taken in the remote village of Hebei, juxtaposing images of two very different worlds – a Honda motorbike and the elaborate ornaments worn by young Tibetan girls.

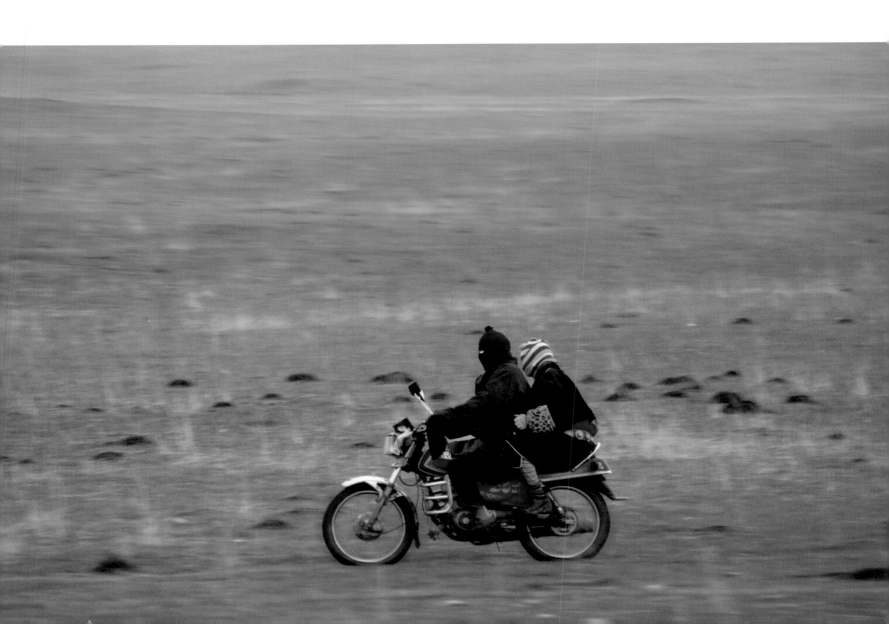

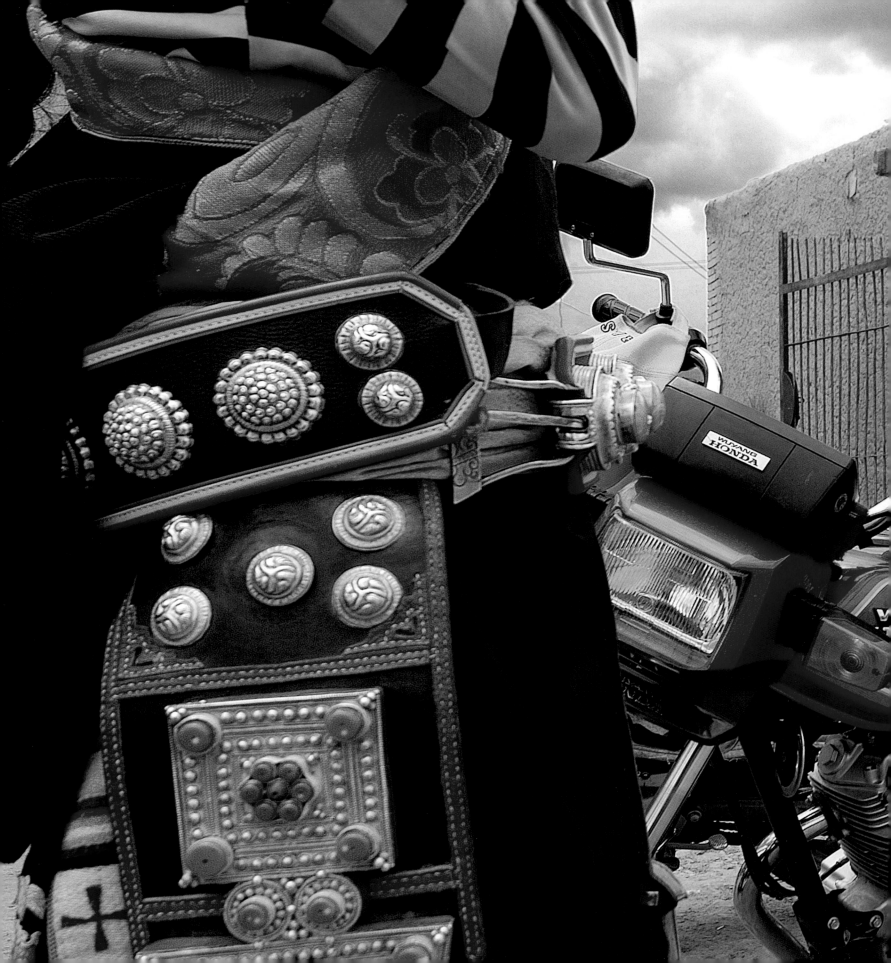

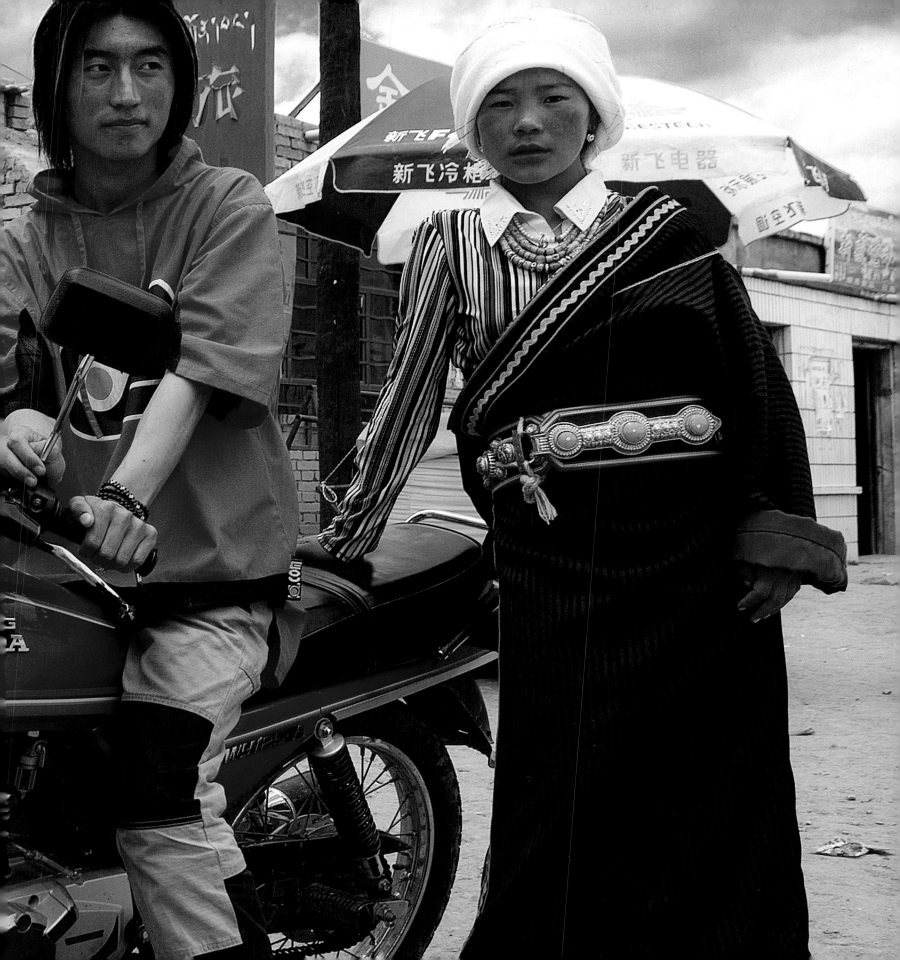

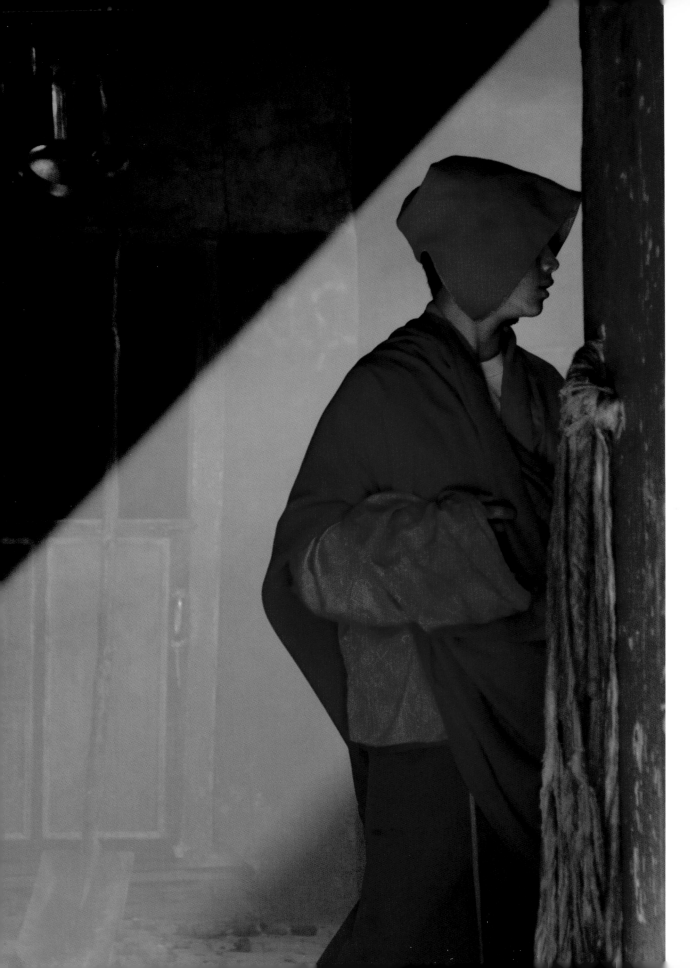

LEFT: A young monk comes out of the kitchen in the Xiwu Monastery, belonging to the Red Hat school. Tibetan Buddhism has four principal schools, but they all adhere to the two main schools of philosophy, the Mahayana and the Vajrayana. The most common school in Tibet is the Yellow Hat, or Gelugpa, meaning 'virtuous ones', which is based on the discipline of study and on the teachings of the Dalai Lama. The Red Hat school developed from the oral tradition passed down through the Indian Tantric yogis. On the high plateaus along the course of the Yellow River the most widespread school of Buddhism is the ancient school of Nyingmapa, which has incorporated the most animist and shamanistic elements of the Bön religion.

OPPOSITE: The Xiwu Monastery, glimpsed through a sea of fluttering prayer-flags.

OVERLEAF: Before prayer begins, a monk opens the door of the Jiegu Monastery in Yushu. This sacred edifice was built in 1398, and belongs to the Sakyapa school, which is chronologically speaking the second school of Tibetan Buddhism. It adheres to Tantric practices for the attainment of enlightenment.

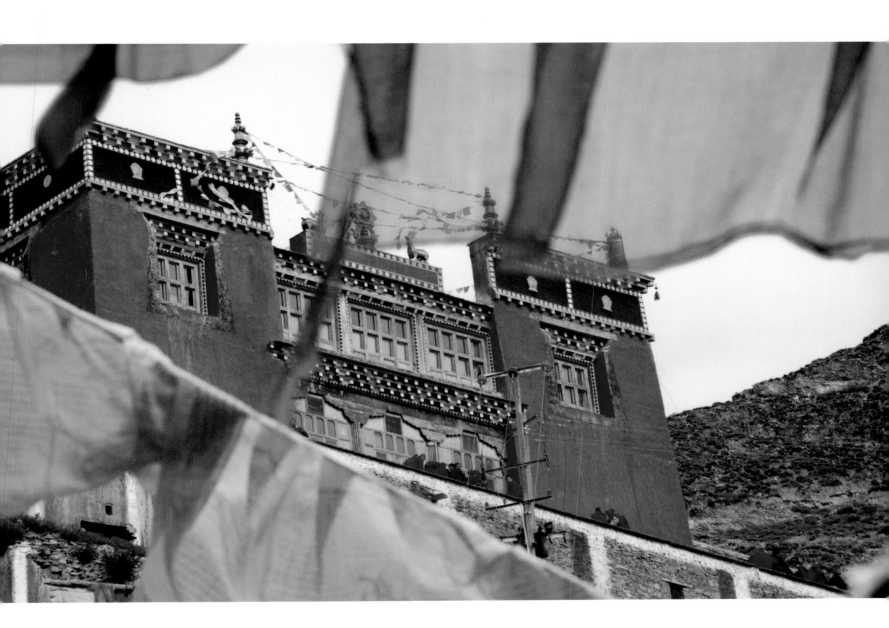

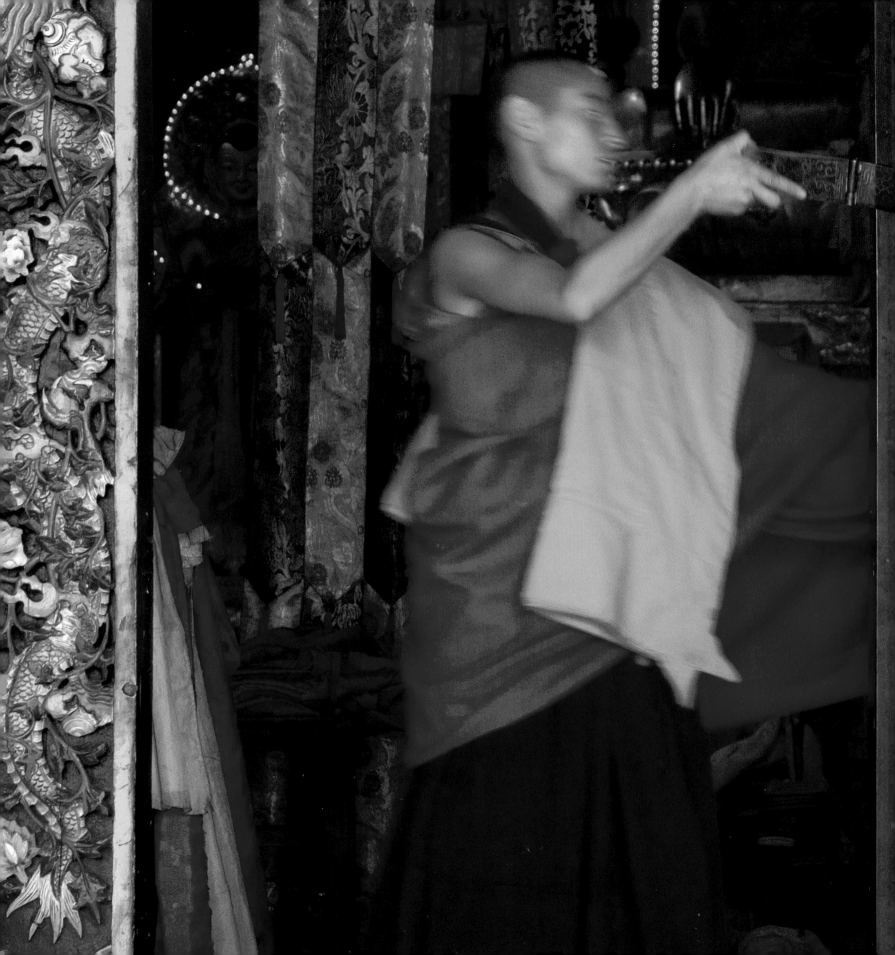

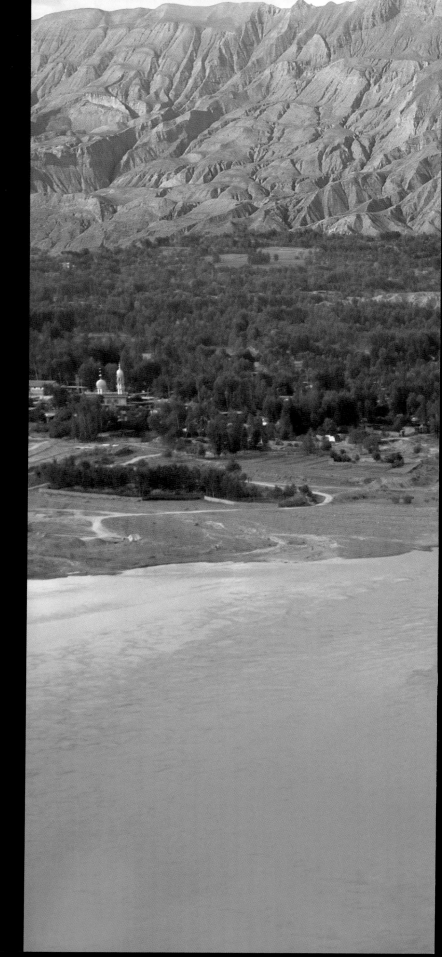

An Encounter with the Silk Route

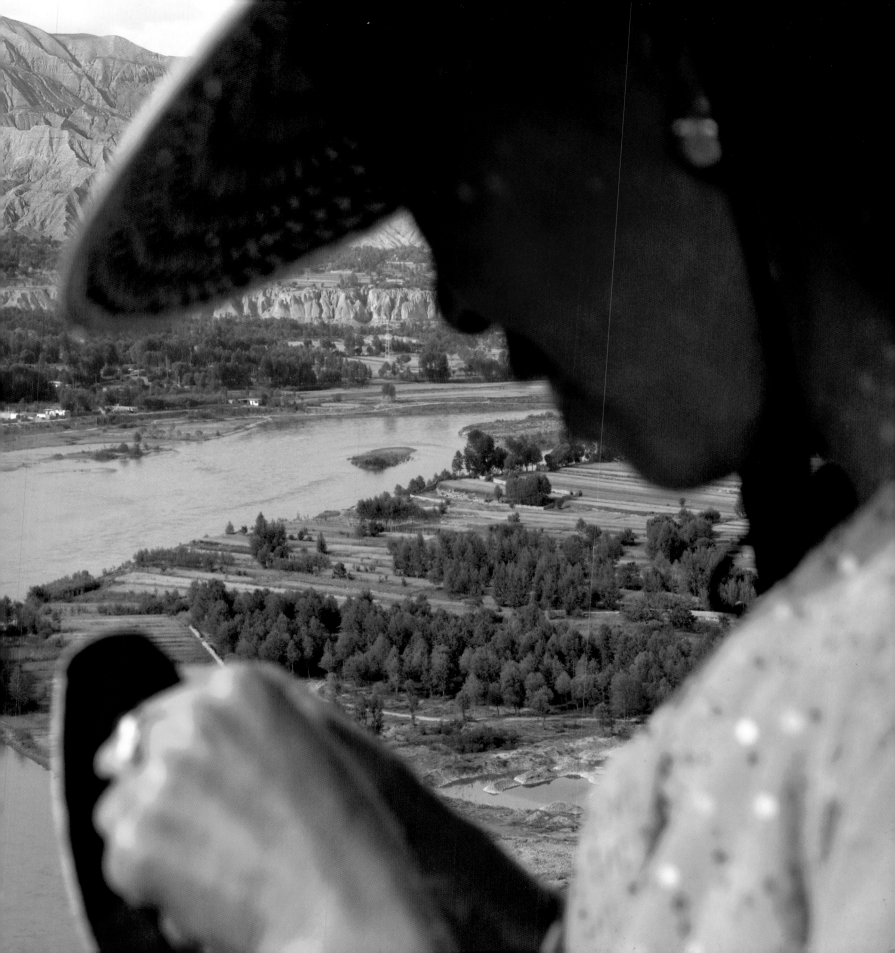

THE YELLOW RIVER forms an immense curve around the Amne Machin Mountains, which are sacred to the people of Tibet. Here the river flows with crystal-clear waters. Although I know it to be an illusion, out of the car window I can see verdant fields rushing past, and I am fast falling in love with the countryside. It seems to be so beautiful. We also pass through fleeting areas of desert, where the yak seem to wander around contentedly amongst the sand dunes. But this is only a mirage: life is extremely tough here. In the 1930s Mao Zedong led the core of his Red Army through the desolate swamps of Songpan's plains on the Long March. The cost in human life was appalling. Only when you descend further in altitude does the dragon seem to become tamer. At an altitude of 2,500 metres (8,200 feet) the first trees appear, and the banks of the river are transformed into cultivated fields of wheat and rape. Then suddenly the flow is interrupted, and the waters of the great river are held in check by the first of the powerful dams. They are harnessed to supply electricity to another dragon, the economic development in China, whose gross domestic product has been growing by 10% annually. This beast has stretched out its sinuous limbs even as far as here, sinking its claws into a land I had hitherto thought to be uncontaminated.

Now we have reached the remote city of Xiahe, which is completely Chinese in appearance, but as soon as you reach the last of the long line of palaces arrayed in psychedelic colours, it is like taking a step back in time, for we are confronted with the largest and most fascinating monastery in this part of Tibet, the Labrang Monastery. Just imagine an entire city, composed of 2,000 monks, living in low huts concentrated around a dozen or so temples. The perimeter of the monastery is marked by an endless line of prayer-wheels, stretching out across a valley surrounded by mountains which are covered in dense forests. In the summer, the scene is idyllic, but in the winter it is harsh: the roofs of the buildings are covered in a white blanket of snow, and the smoke of the stoves mingles with the perfume of incense. The monastery was closed during the Cultural Revolution, but reopened in the 1980s. Labrang Monastery is considered to be one of the most important places of spiritual learning in the Tibetan Buddhist tradition.

Today, the monastery has been invaded by a colourful crowd of pilgrims, who have flocked here from all over Tibet. They are mostly nomadic shepherds, with calloused hands. Images of the Dalai Lama lie concealed

beneath their thick coats. The expressions on their faces are a mixture of happiness and amazement. They look at me curiously, as if I embodied what was special about the place, rather than their own faith and devotion, which has already become a rarity in the western world. Suddenly the silence in the great courtyard is broken by a long, sombre tone. Raising my eyes to the sky, I can see two monks standing by the prayer-wheel which dominates the principal building of the monastery. They are sounding a large gong. Other monks come running. They are wearing robust boots made of fur, and on their heads they have the yellow hat belonging to the Gelugpa school, meaning 'virtuous ones', which is the most important religious order of Tibetan Buddhism. A few of them are wearing an enormous head-covering which resembles a flattened helmet. They enter the temple and immediately begin to recite their mantras. The preceptors are swathed in resplendent purple robes which make them seem enormous. The *puja*, or prayer, begins like this. Cymbals, gongs and trumpets provide the musical accompaniment. Young boys wander round with brass teapots brimming over with tea. Once the mantras are finished, a professor walks between the benches, questioning the young pupils. If somebody gives the wrong answer, they all laugh together.

If we take a brief detour from the Yellow River, we arrive at the gates of Xining. The current Dalai Lama, Tenzin Gyatso, was born in the small village of Taktser in 1935. Today, the spiritual leader of the Tibetan people lives in exile in Dharamsala, India, but his roots are here. My guide would only mention his name in a timid whisper whilst accompanying me to the nearby monastery of Ta'er, or Kumbum, as it is known in Tibetan, where the future Dalai Lama had knelt in prayer with his parents, before being hailed as the incarnation by the sages from Lhasa. Kumbum comprises four monastic schools, and is considered to be sacred by the Tibetans. It was here that the founder of the Gelugpa order, Tsongkhapa (1357–1419), was born and raised. Two of the master's disciples later became incarnations of Buddha: the first Dalai Lama and the first Panchen Lama, the two greatest spiritual authorities in Tibet. Sadly, these days the Chinese authorities have turned the monastery into a kind of living museum. Before 1958 there were 3,600 monks, but now only 400 remain. Visitors have to pay an entrance fee, and are accompanied by young women dressed in pseudo-Tibetan costumes. Nonetheless the monastery, which was founded in 1560, still retains its fascination. It is an incredible experience to step into the huge interior of the Great Temple of the Golden Roof, where each successive Dalai Lama has prayed as he has taken on the mantle of spiritual leader of Tibet.

OPPOSITE: According to popular belief, these footprints appeared miraculously in the floor of the Tongren Monastery after a monk spent endless hours in prayer walking around this spot.

OVERLEAF: The Yellow River near Lijiaxia.

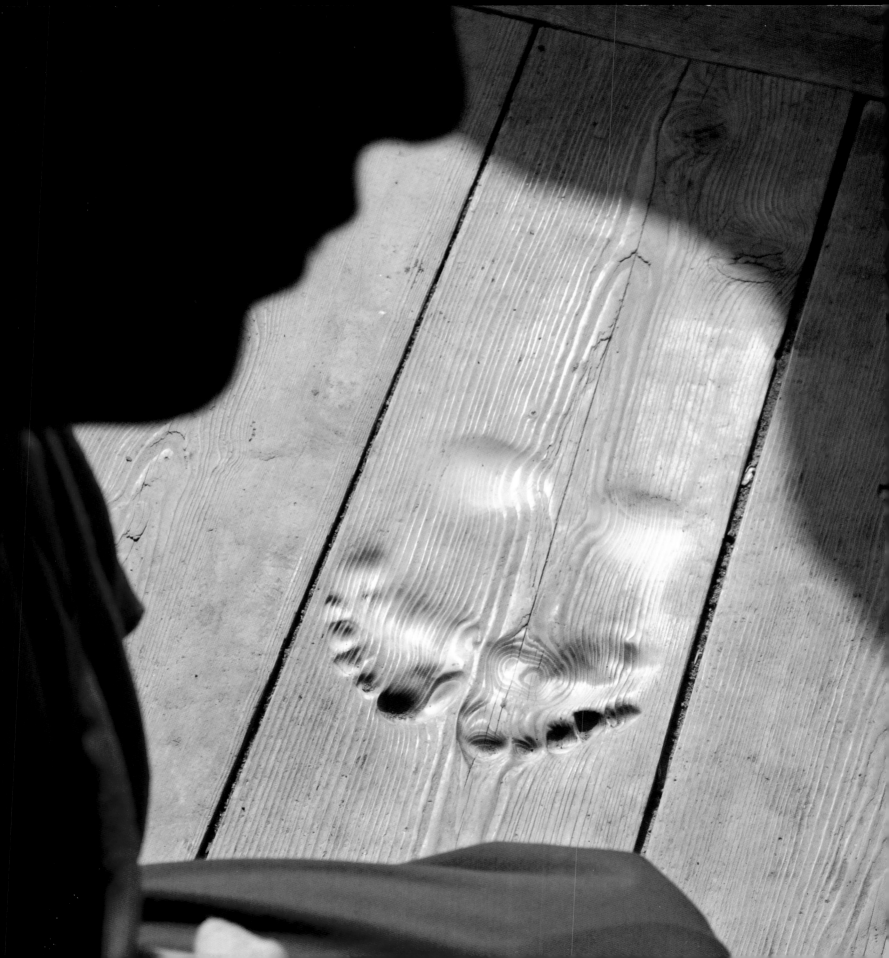

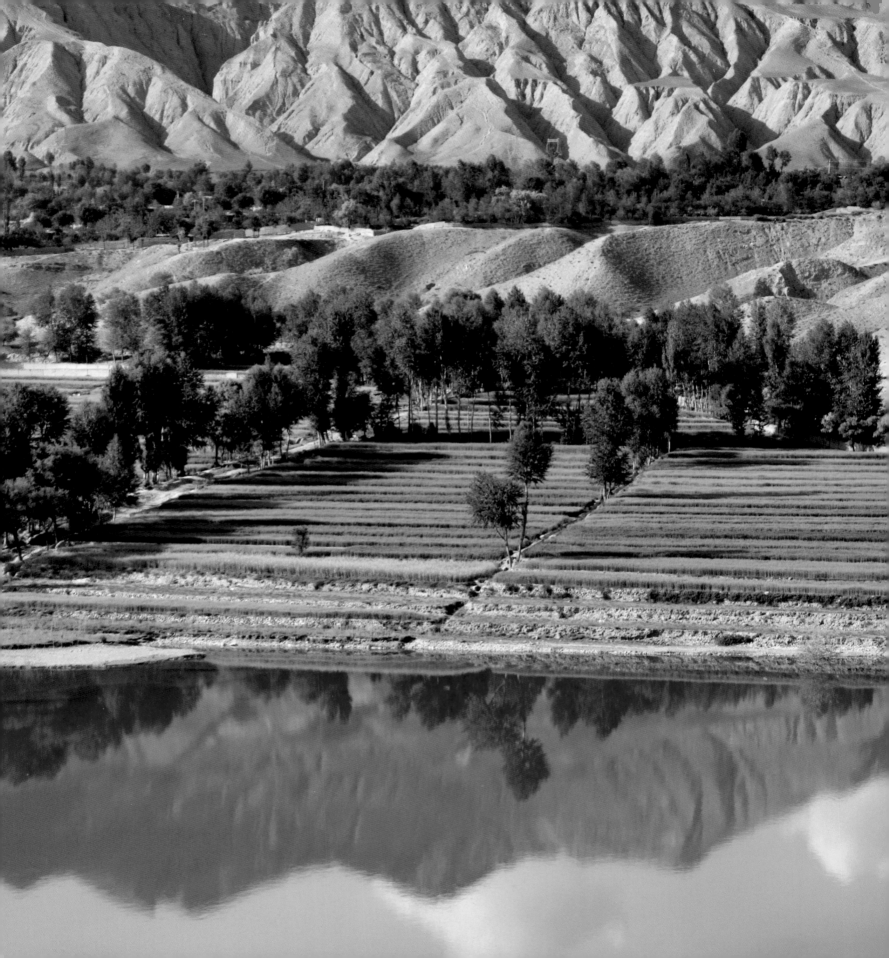

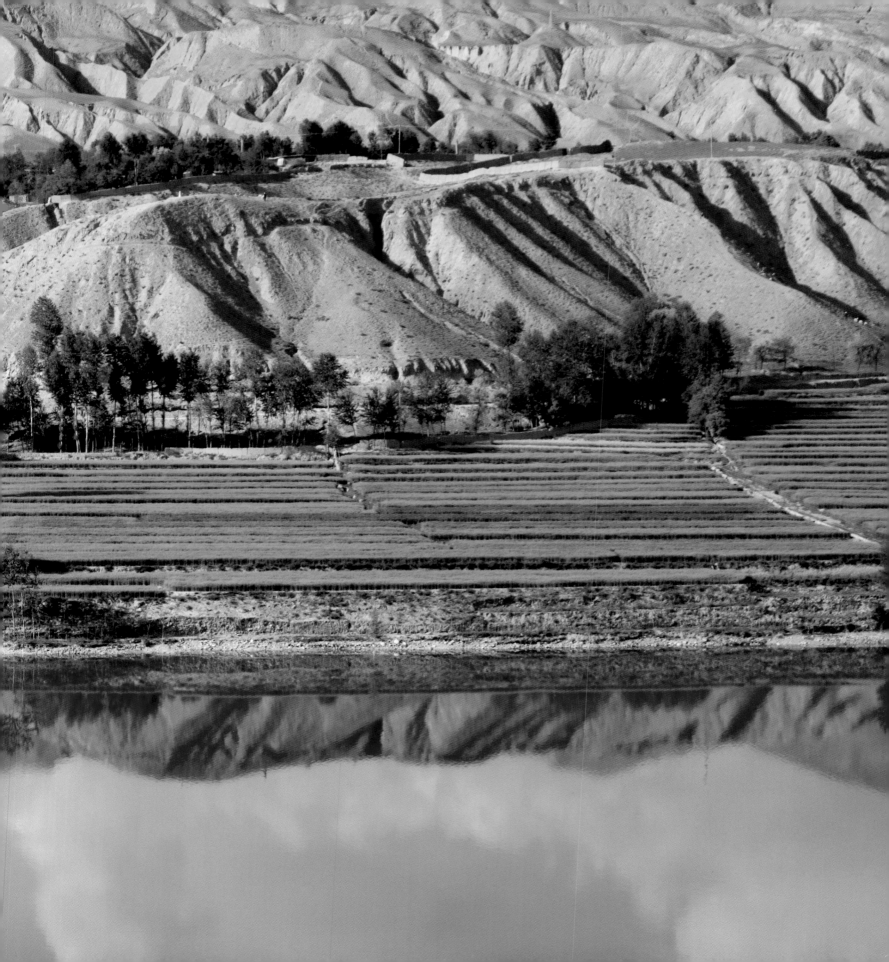

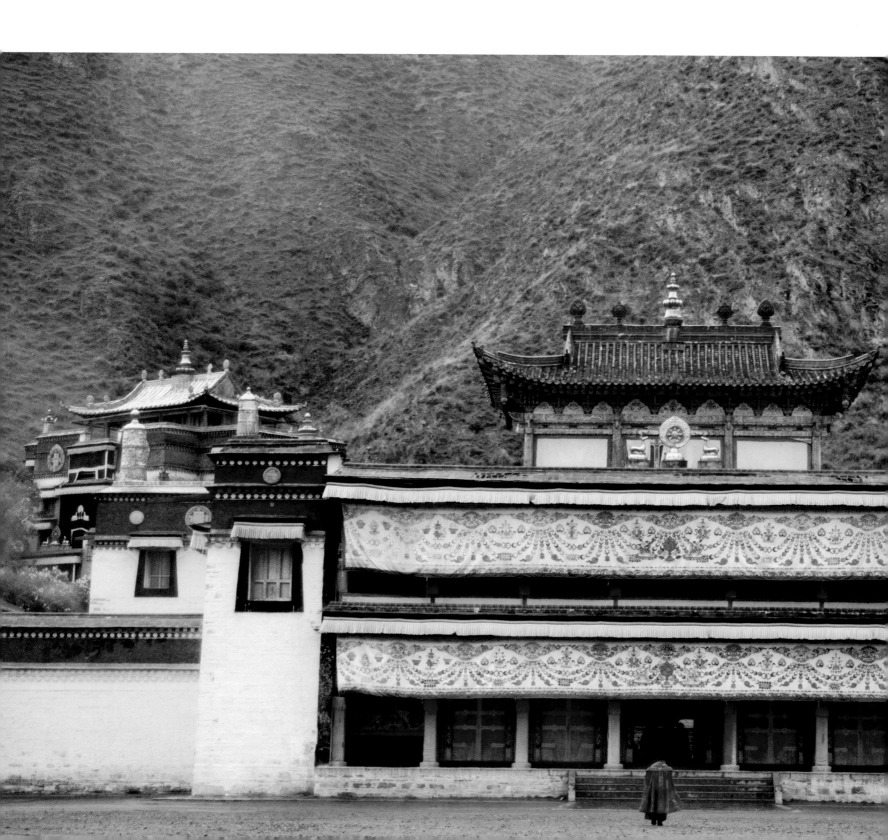

LEFT: The main temple of Labrang Monastery. This huge complex of religious buildings was founded in 1709 by a monk who later became the first living Buddha (Jiemuyang). He ranks third in the Tibetan hierarchy, after the Dalai Lama and the Panchen Lama. Unfortunately, in 1985 a significant part of this artistic heritage was destroyed by fire. Nonetheless, amongst the decorated temples, the tombs of saints and the statues, monks continue to study the traditional sciences associated with Tibetan culture: medicine, astrology and, of course, philosophy.

RIGHT: A group of monks studying together.

OVERLEAF: Labrang Monastery pictured in the early morning, before the veil of mist has lifted.

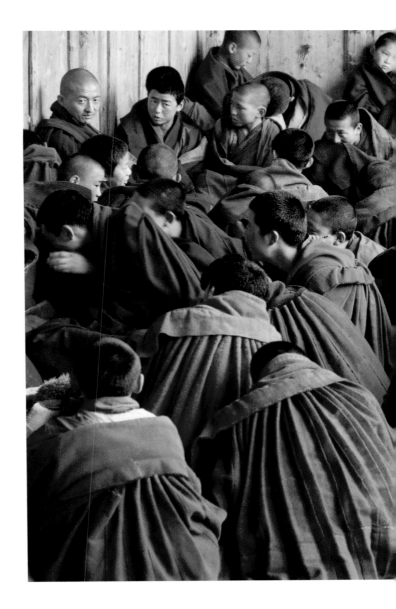

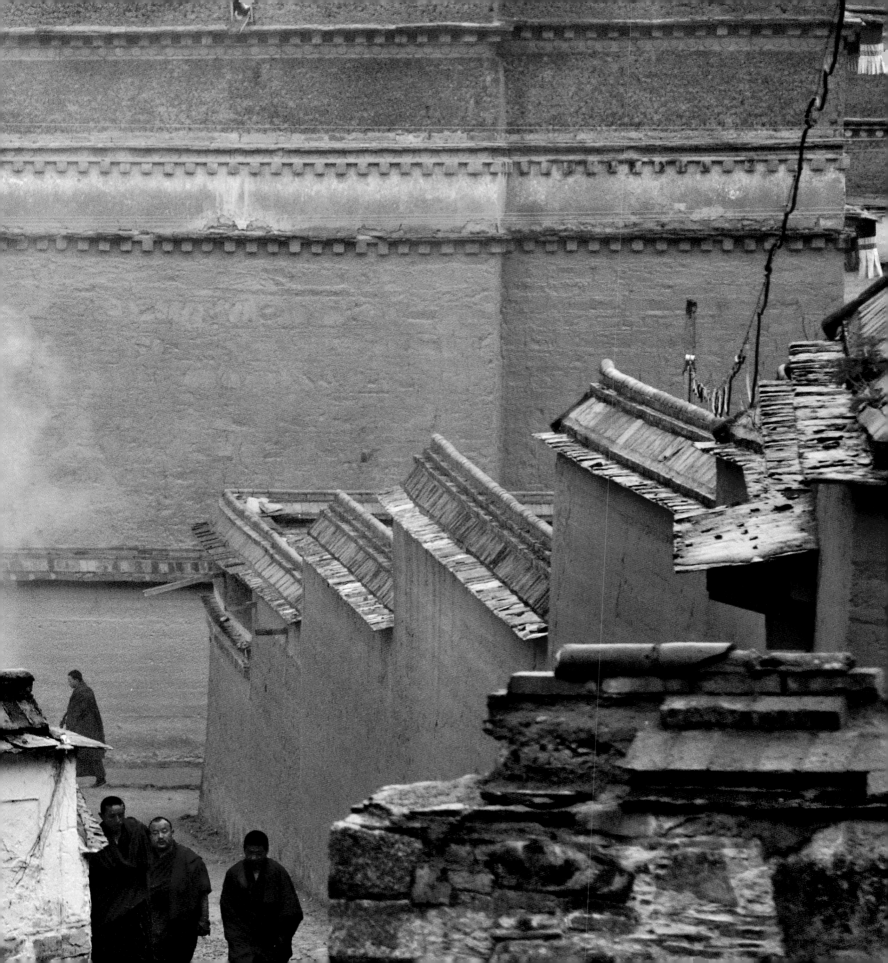

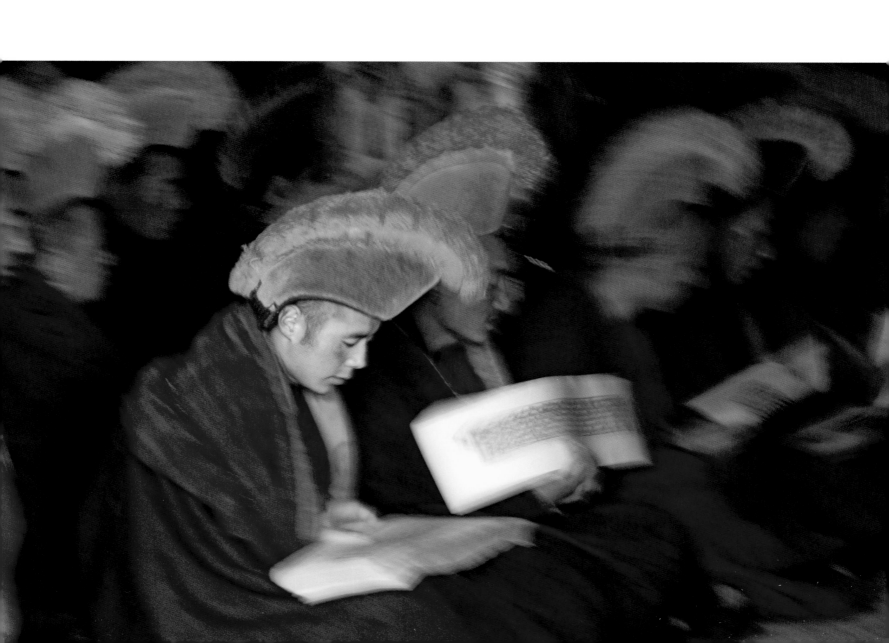

Monks at prayer at Labrang Monastery, carrying out the arduous prostrations demanded of them. The monastery itself occupies a surface area of 866,000 square metres, of which 400,000 are covered with buildings constructed in the traditional Tibetan style, which serve as accommodation for the monks. The complex comprises a series of temples, the Great Sutra Hall, the assembly room for the monks, and the rooms assigned to the various institutes of learning. On a particular mountain nearby, amidst the ruins of ancient temples, they celebrate the so-called sky burials, when the corpse is cut into pieces and fed to the vultures, symbolizing the cycle of life and death.

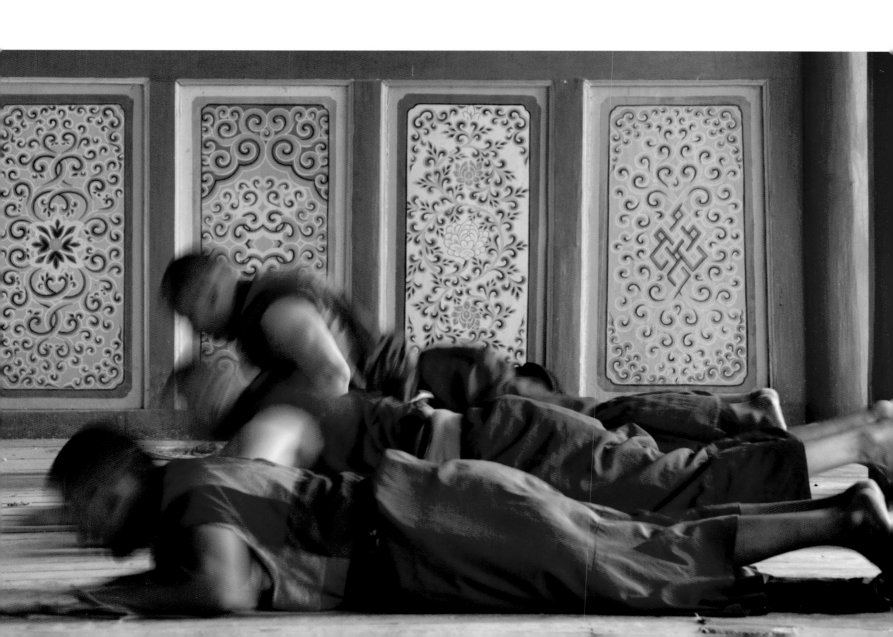

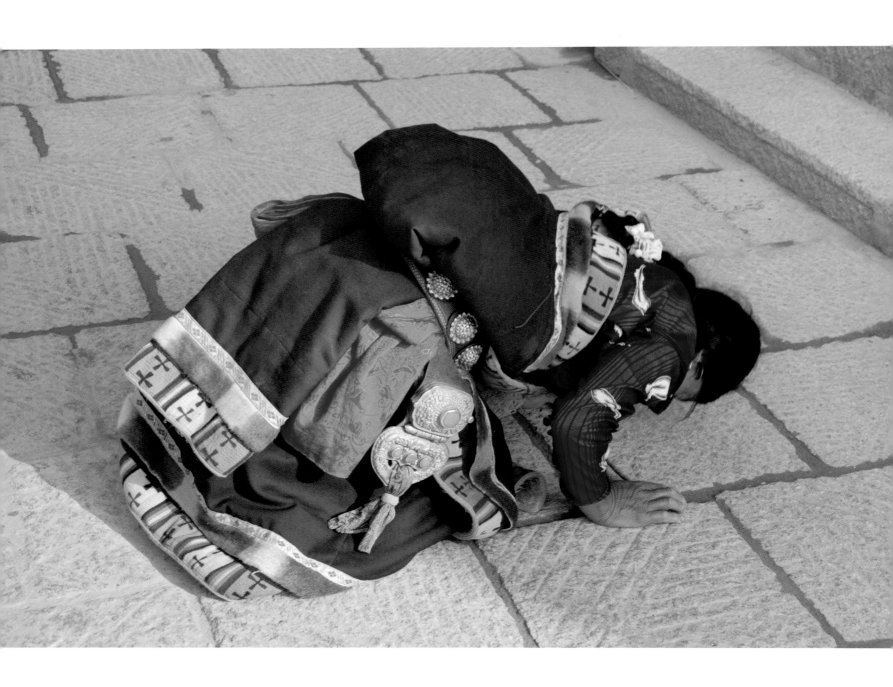

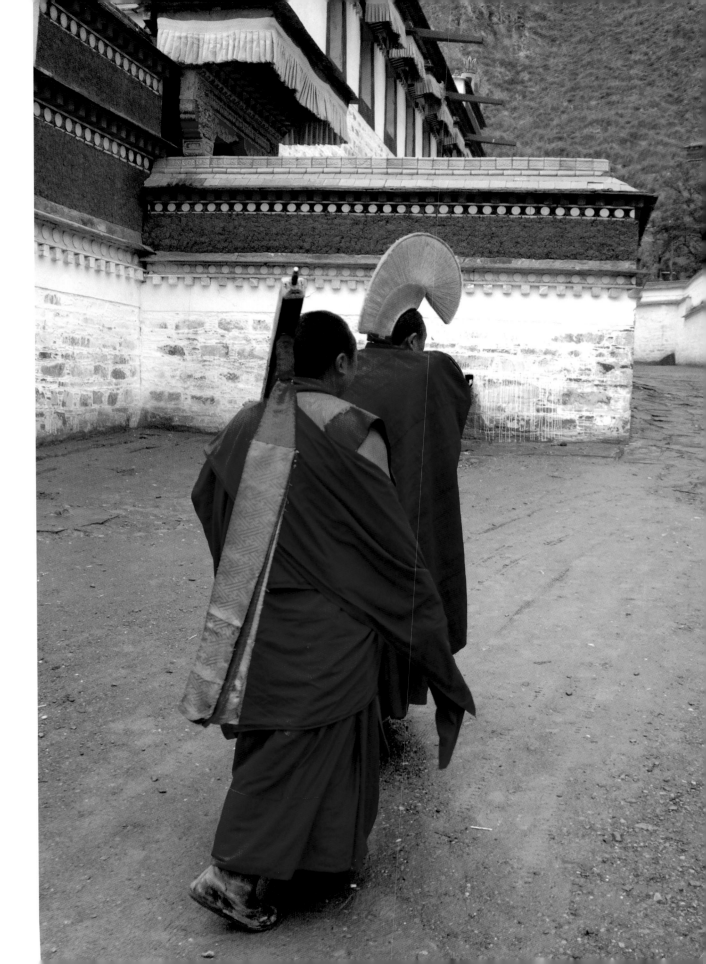

Two views of Labrang. A woman is praying, and two monks are about to enter the Great Sutra Hall for a theological debate. Several valuable libraries have survived within the monastery, containing precious volumes of classical, sacred and literary books, and encompassing a range of topics such as the calendar, music, philosophy and the fine arts. There are around 60,000 books in total.

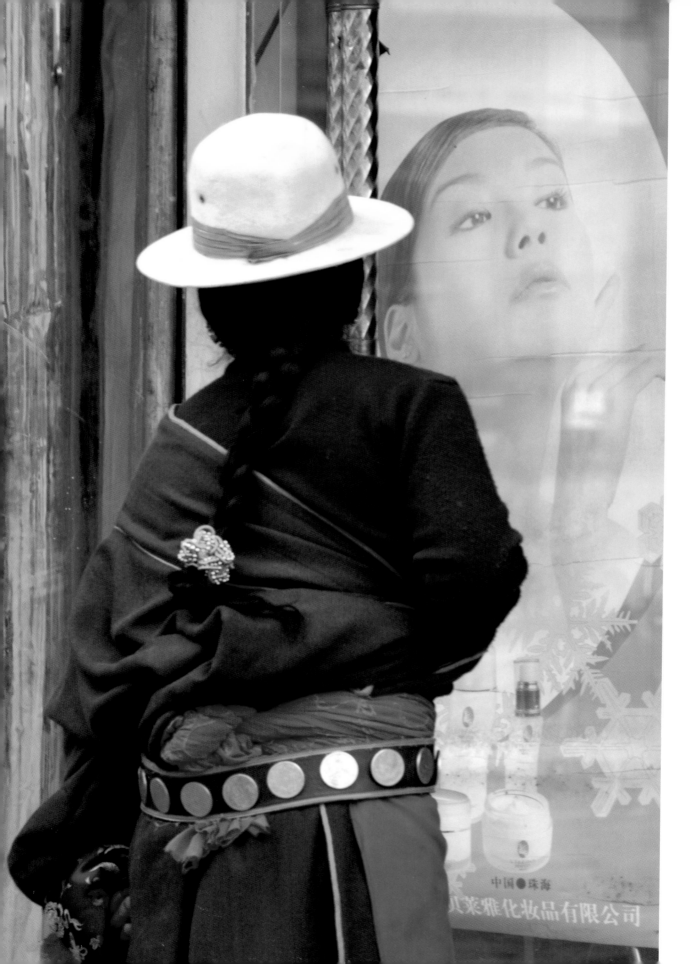

Two pictures taken in the centre of Xiahe, a town which is very much Chinese in character. Pilgrims are on their way to Labrang Monastery. To the left a Tibetan woman is looking curiously at an advert, while in the photograph opposite a mother leads a young child dressed in festival costume by the hand. The temple at Labrang has always been the most important centre of Buddhism in this part of Tibet. In its heyday it was said to have housed more than 2,000 monks. Each year important religious gatherings take place here, attracting not only Tibetan and Mongolian Buddhists, but also scores of pilgrims and Chinese tourists.

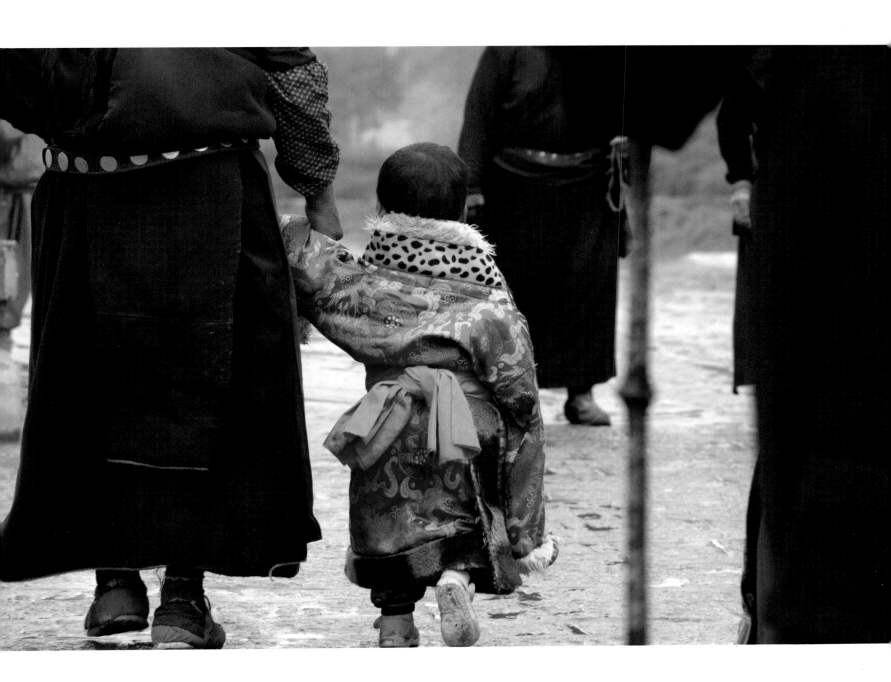

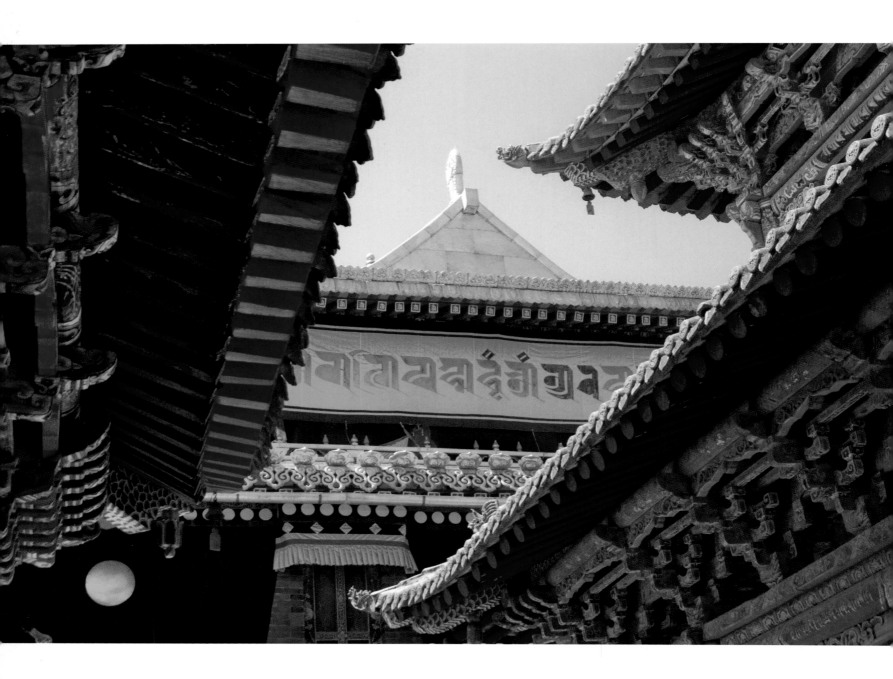

AN ENCOUNTER WITH THE SILK ROUTE

Kumbum (Ta'er) Monastery, an important complex of religious buildings not far from Xining. The Tibetans consider this place to be sacred, as it was here that Tsongkhapa was born, the founder of the Yellow Hat school, the Gelugpa, the most important religious order in Tibetan Buddhism. Two of his disciples became incarnations of Buddha: the first Dalai Lama and the first Panchen Lama, who are the two highest spiritual authorities.

OPPOSITE: The roofs of the Great Temple of the Golden Roof.

RIGHT: The sacred altar where all the successive Dalai Lamas of Tibet are said to have prayed.

OVERLEAF: Coming down from the Tibetan Plateau of Qinghai, the Yellow River broadens out between barren and inhospitable mountains, where there is no trace of humankind. In this picture the river is flowing between Guide and Lijiaxia.

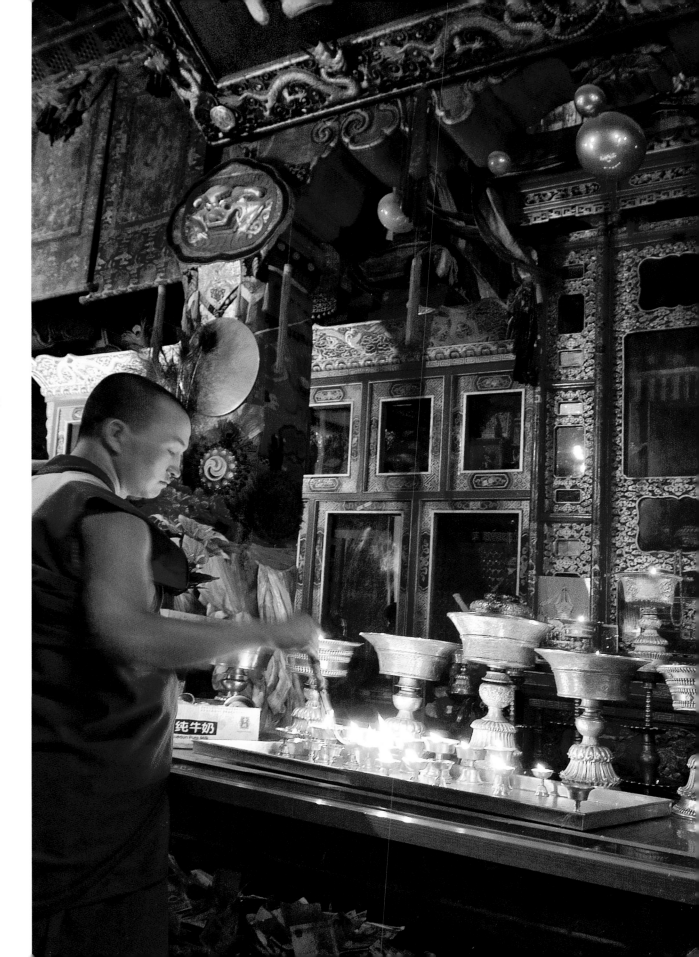

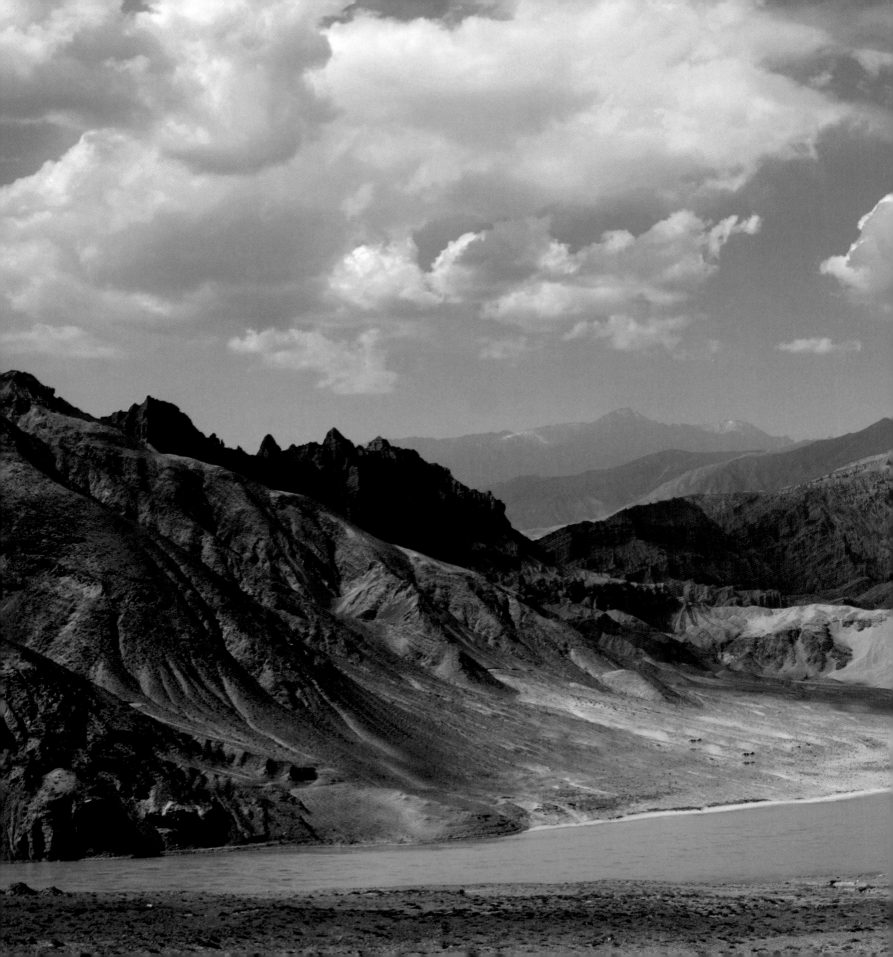

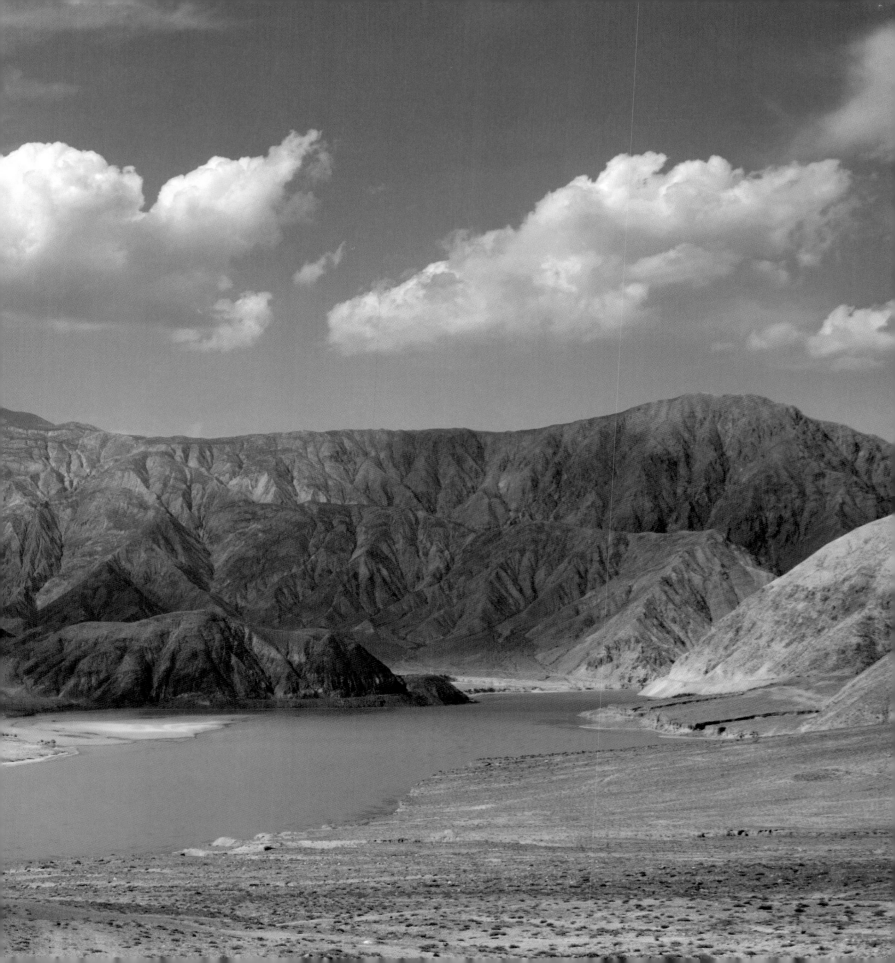

Coming down in altitude is like turning the pages of a book. The coils of the dragon wind around the city of Xining, and then writhe their way into the province of Gansu, towards the immense city of Lanzhou, an ancient staging-post on the Silk Route. It is along this stretch of the river that age-old Buddhism meets Islam. Along the banks of the Yellow River, timid minarets reach for the sky, competing in height with the uppermost branches of the eucalyptus trees. The streets are filled with men wearing white skull caps, and women wearing a special veil which only covers their heads and not their faces. It is their way of demonstrating their pride in a religion which is not only about faith, but is also about nationality and lineage. It is a way of differentiating themselves from the Han Chinese. The Muslim population is divided into several different ethnic groups, such as the Hui (who speak Chinese) and the Salar (who speak a language of Turkish origin).

Islam was born in China in the 7th century and spread from the 10th century onwards as Muslim traders travelled from afar along the Silk Route. But for many people who live in the remotest parts of China, the world outside seems quite alien. I look into the almond eyes of Mr Li as he devours a plate of tagliatelle about a metre in length. Like the Han Chinese in general, he is polite and charming to strangers. He has worked for thirty-five years, and ours is a casual encounter in a restaurant in Xining. He looks at me with the curious scrutiny of someone who has never seen a westerner before. Then he mutters: 'Now I see what it is – your eyes are deep-set...much too deep-set.'

OPPOSITE: An old man belonging to the Salar ethnic group, one of the Chinese Muslim minorities, photographed at Gaizi, a town on the banks of the Yellow River.

OVERLEAF: A view of the spectacular terraced landscape surrounding the Yellow River as it climbs from Lanzhou towards Linxia. The splashes of green are crops of onions.

PAGES 90–91: A pool of water created by the dam at Lijiaxia.

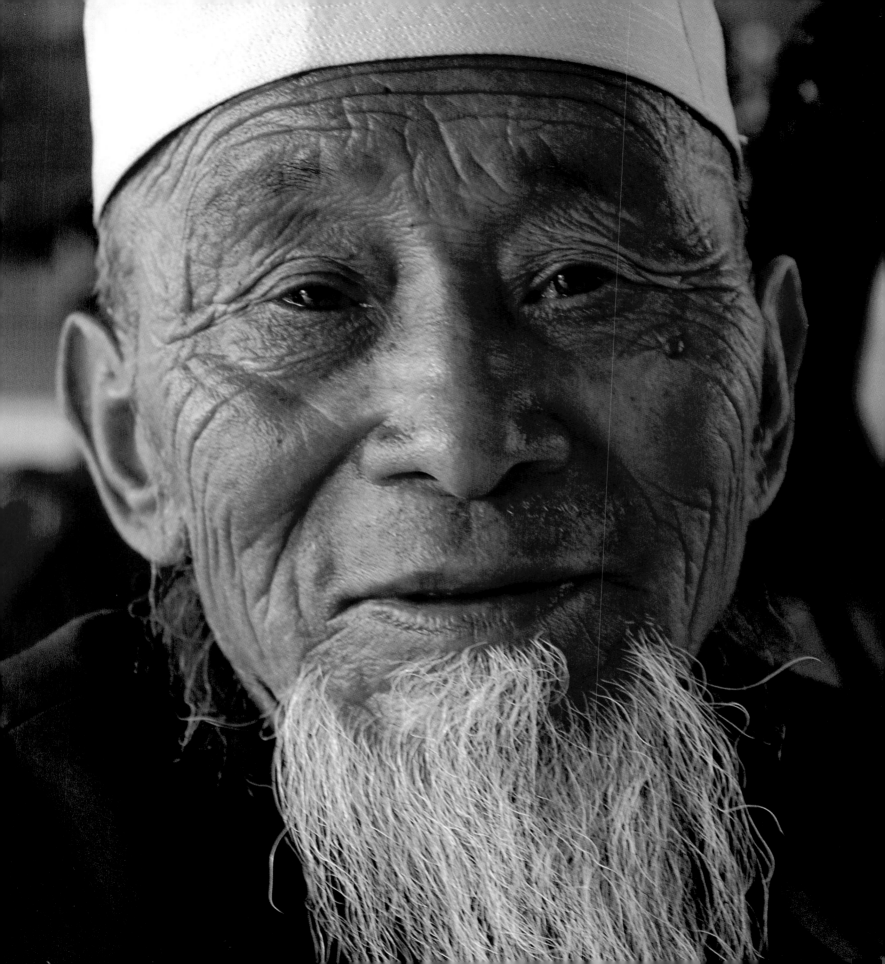

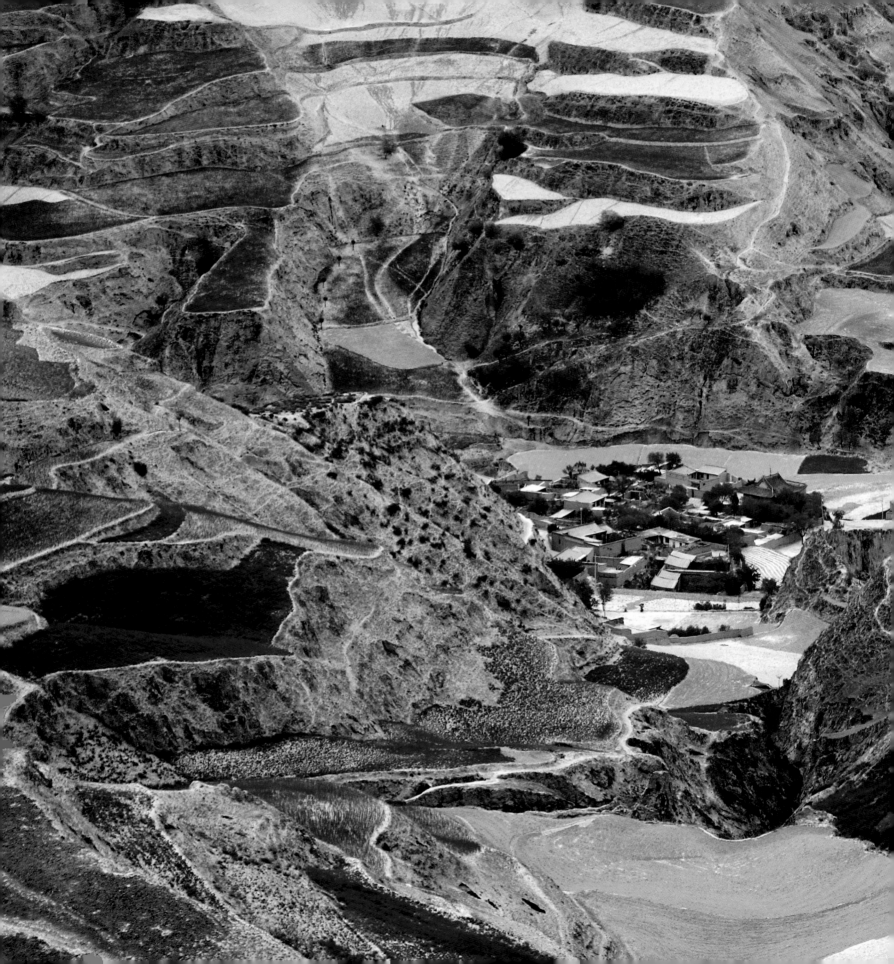

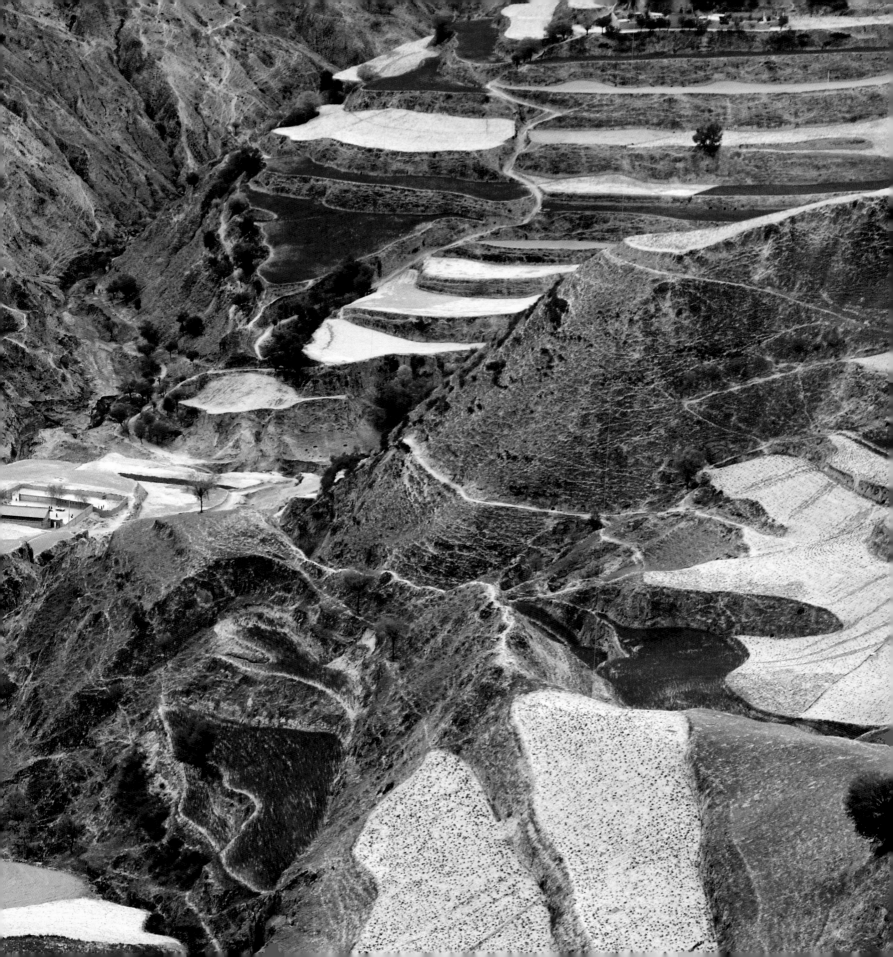

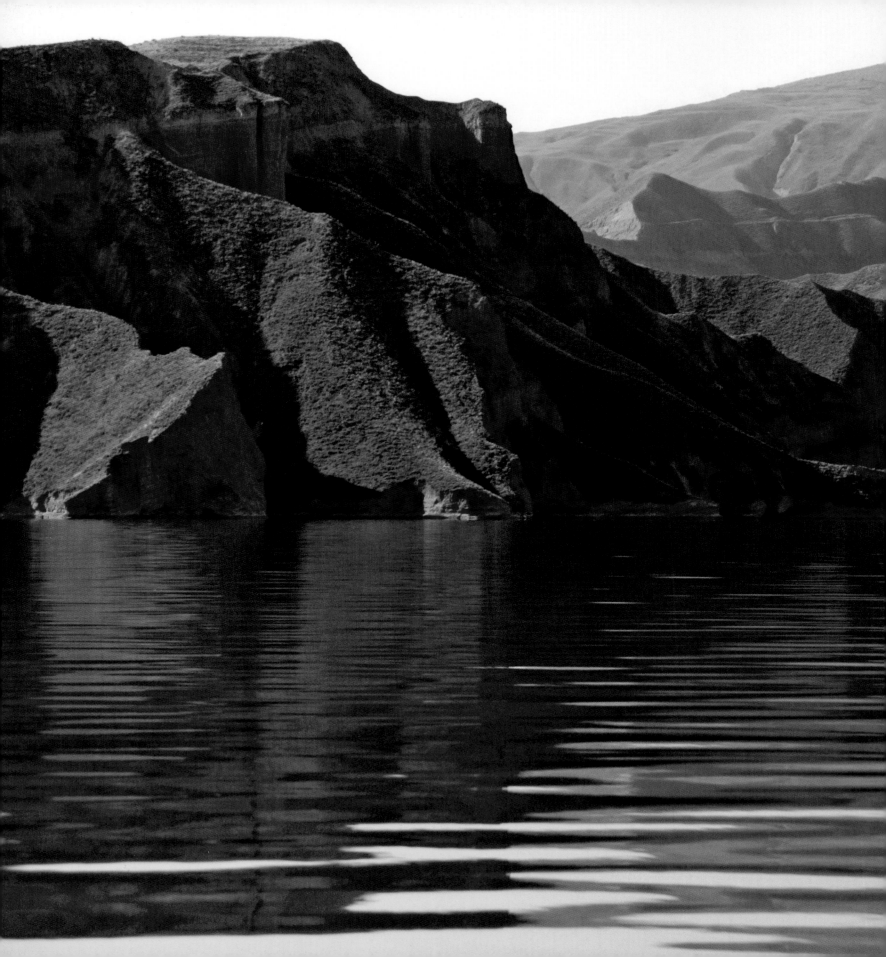

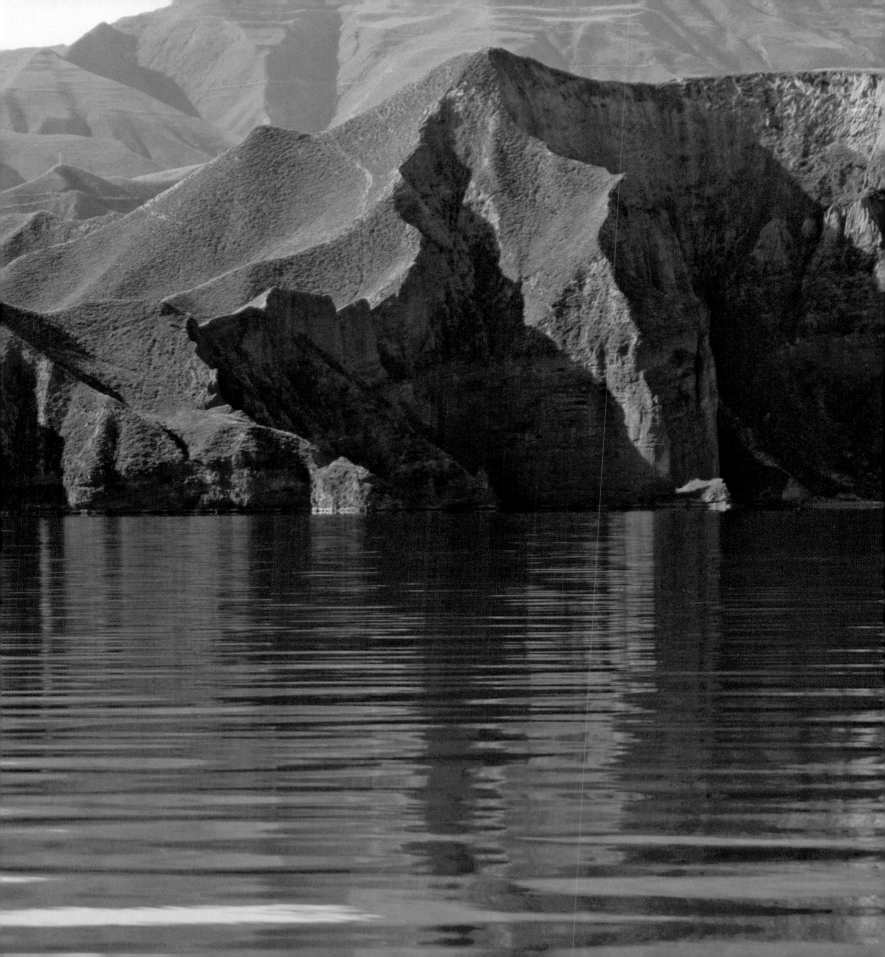

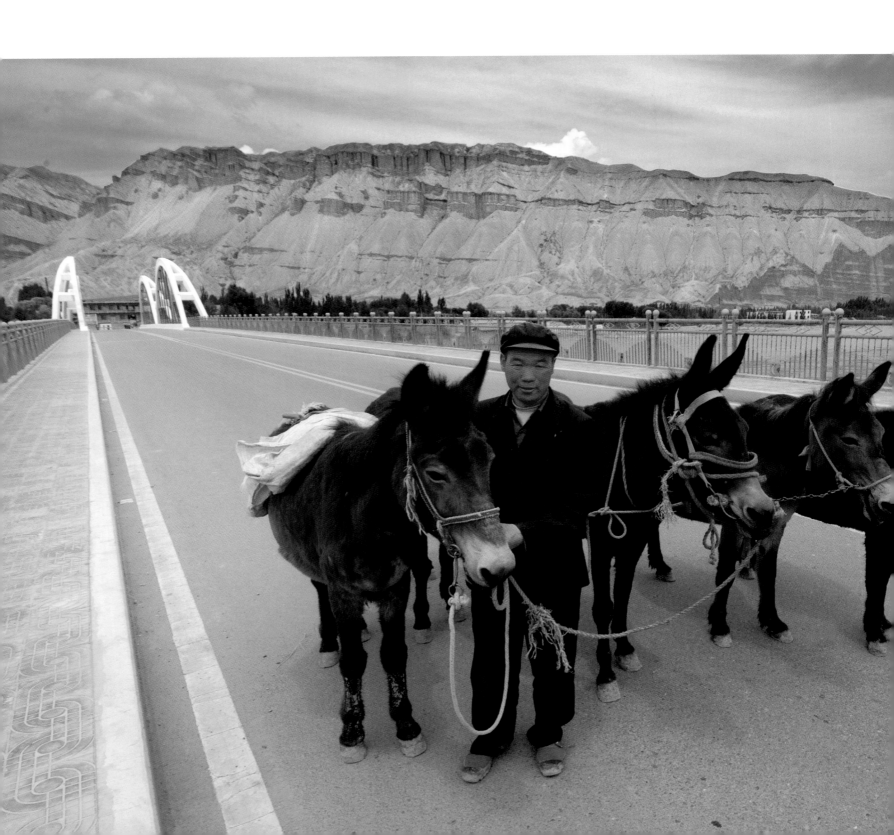

LEFT: A peasant and his four donkeys crossing the new bridge across the Yellow River at Gaizi. When he realized that he was being photographed, he struck a pose, proud to be the object of a picture taken by a stranger.

RIGHT: Two Salar girls wearing the traditional head-covering of Muslim women. They are walking along a street in Gaizi having done their shopping in the new, although modest, shopping centre in town.

OVERLEAF: The Great Mosque in Xining, one of the largest Islamic buildings in China. Built in 1380, it is almost completely devoid of any architectural elements of the Arabic style, but is constructed in the Chinese style, with pagoda roofs.

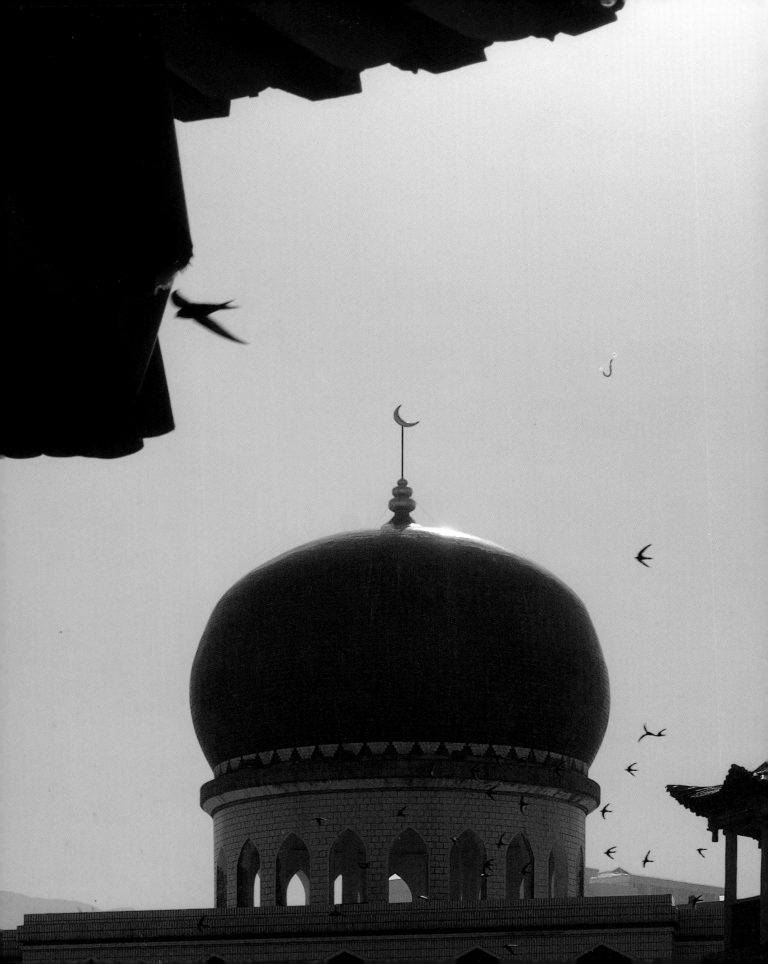

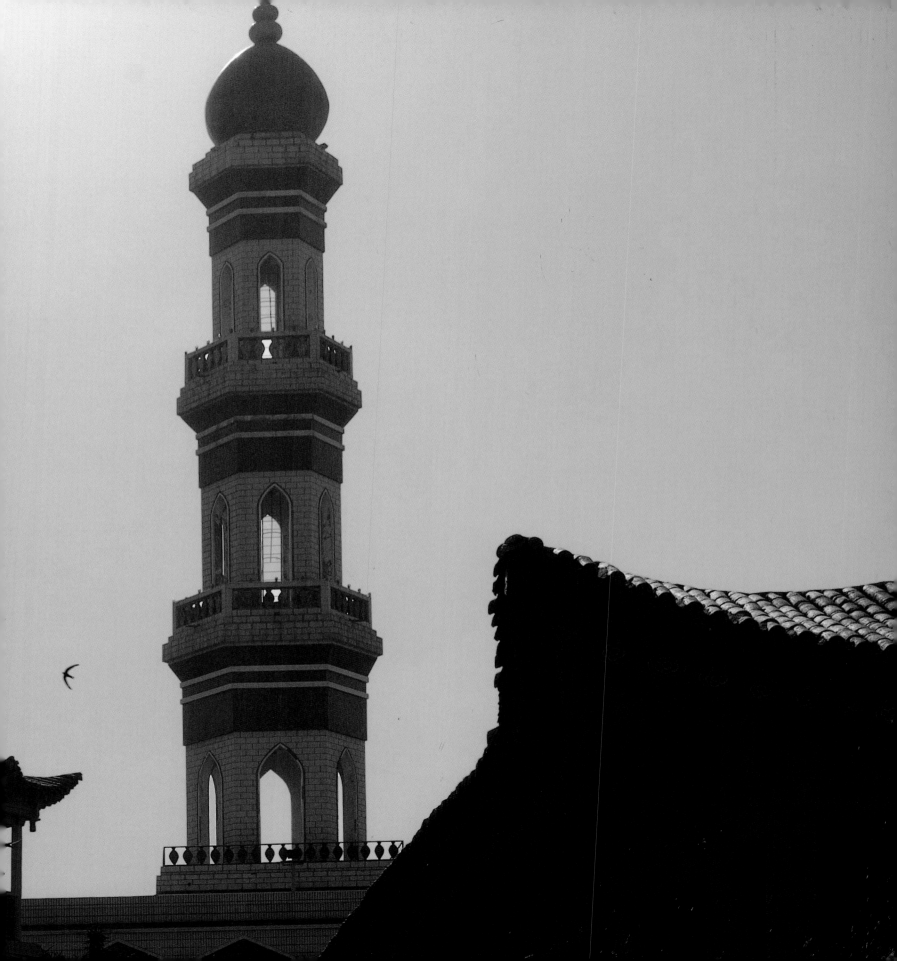

LEFT: Adverts promoting Chinese products are a sign of the policy of cultural and commercial penetration into remote areas that is being pursued by Beijing. This photograph was taken at an inn not far from the complex of monastic buildings in Tongren. Tongren is famous for its tankas, Tibetan religious paintings, and the town is currently undergoing major restoration work on a dozen of its temples which had been forcibly closed.

RIGHT: The steep banks of the Yellow River near Tongren form a backdrop to this local market which is selling meat.

OVERLEAF: Chinese bread, which has been freshly cooked by steaming, is on sale at the market in the Muslim quarter of Xining.

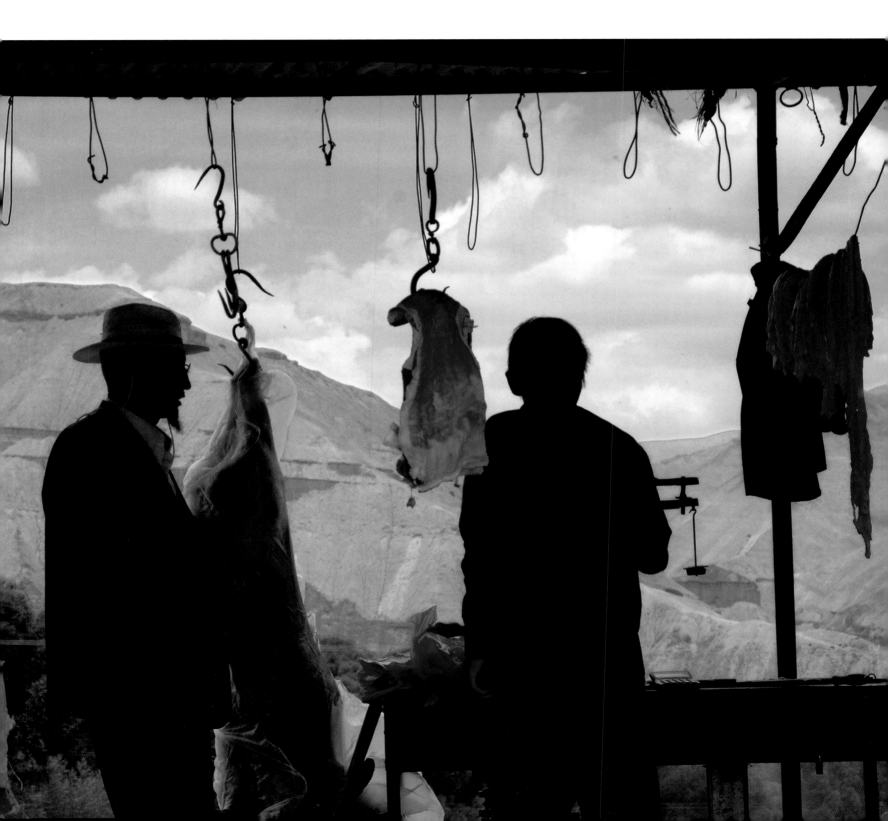

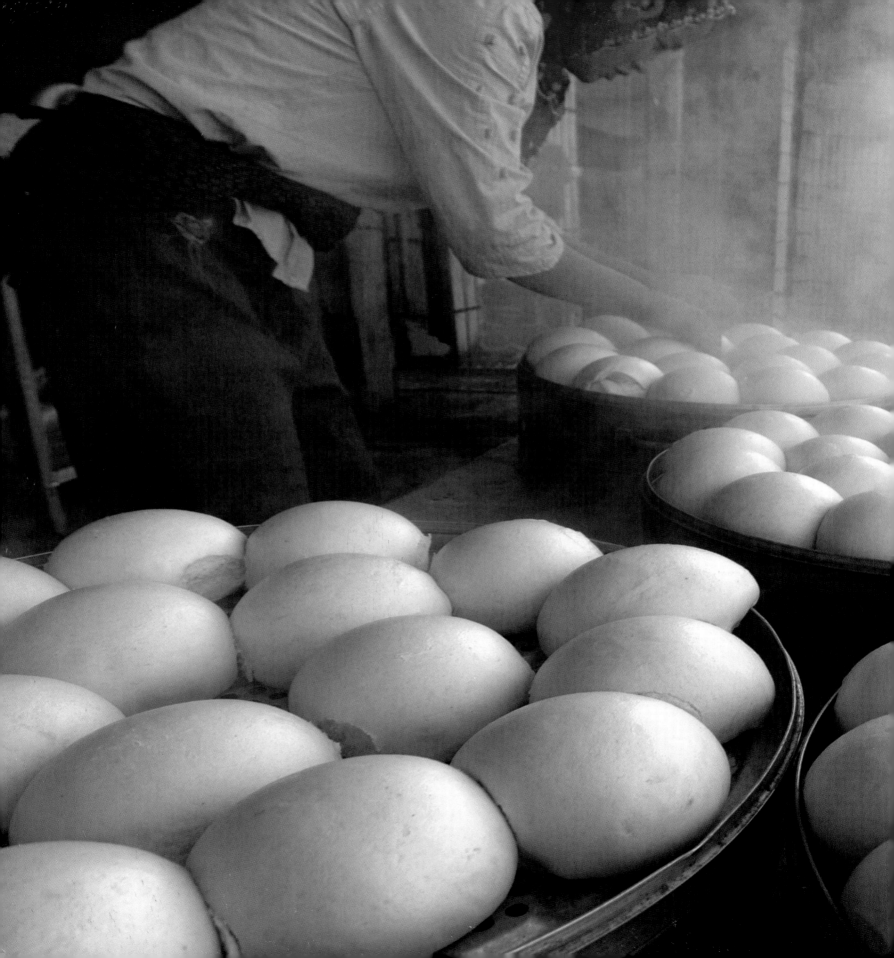

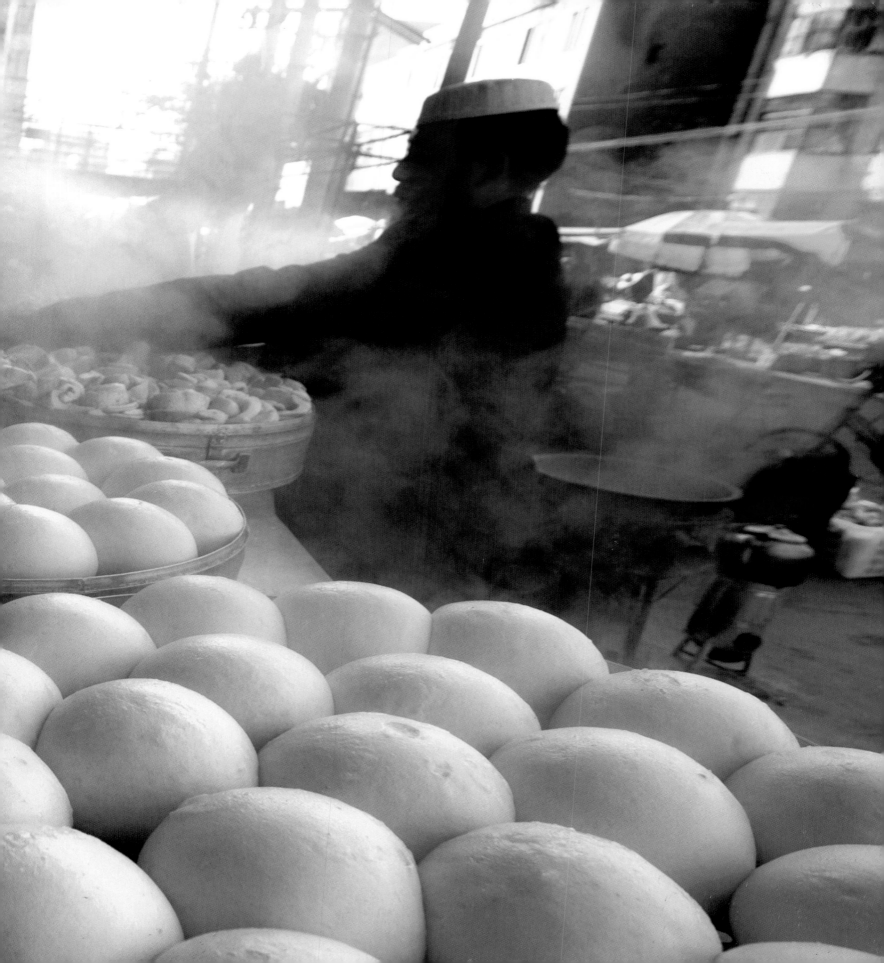

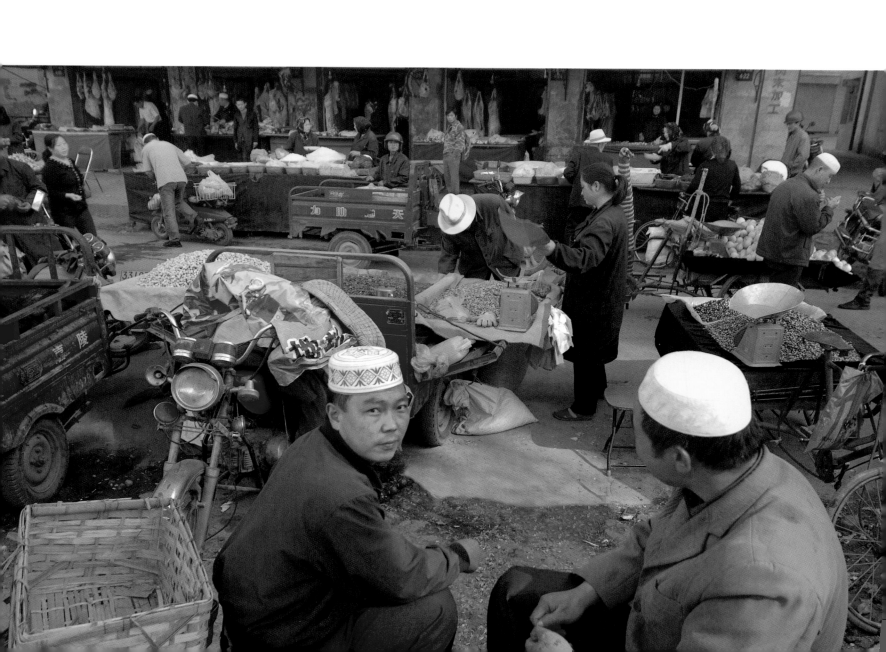

Two photographs of the colourful local market which takes place daily behind the Great Mosque in Xining. The men in the white caps are Hui Muslims, as are the women wearing a dark veil. Xining is the capital of Qinghai, and is situated at an altitude of 2,200 metres (7,200 feet), on the southernmost side of the Tibetan Plateau. The majority of its inhabitants are Han Chinese, with a minority of Hui and Tibetans.

OVERLEAF: The Yellow River flows through the Lijiaxia gorges before reaching the Buddhist grottoes in Bingling, in the province of Gansu. The grottoes contain a magnificent array of Buddhist art which arrived here via the Silk Route.

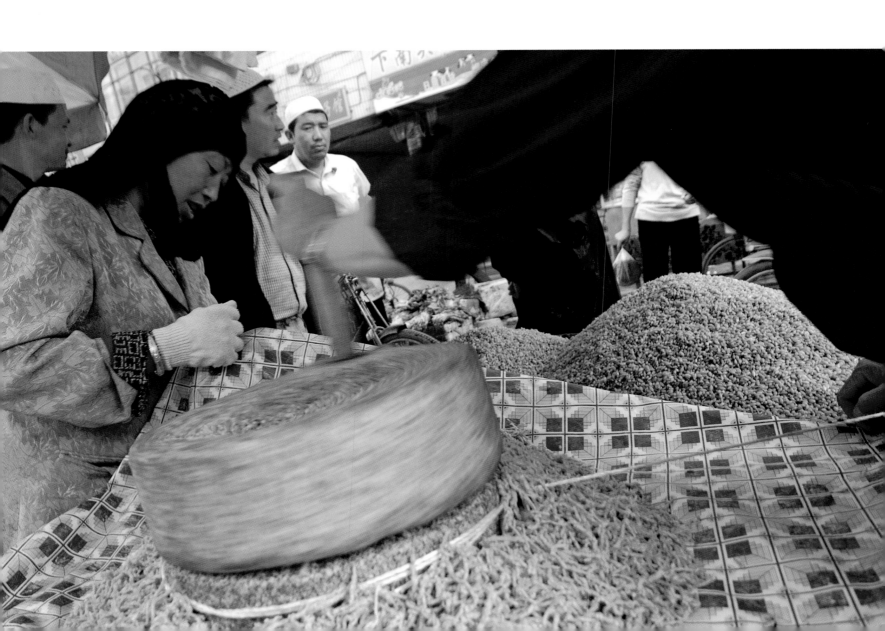

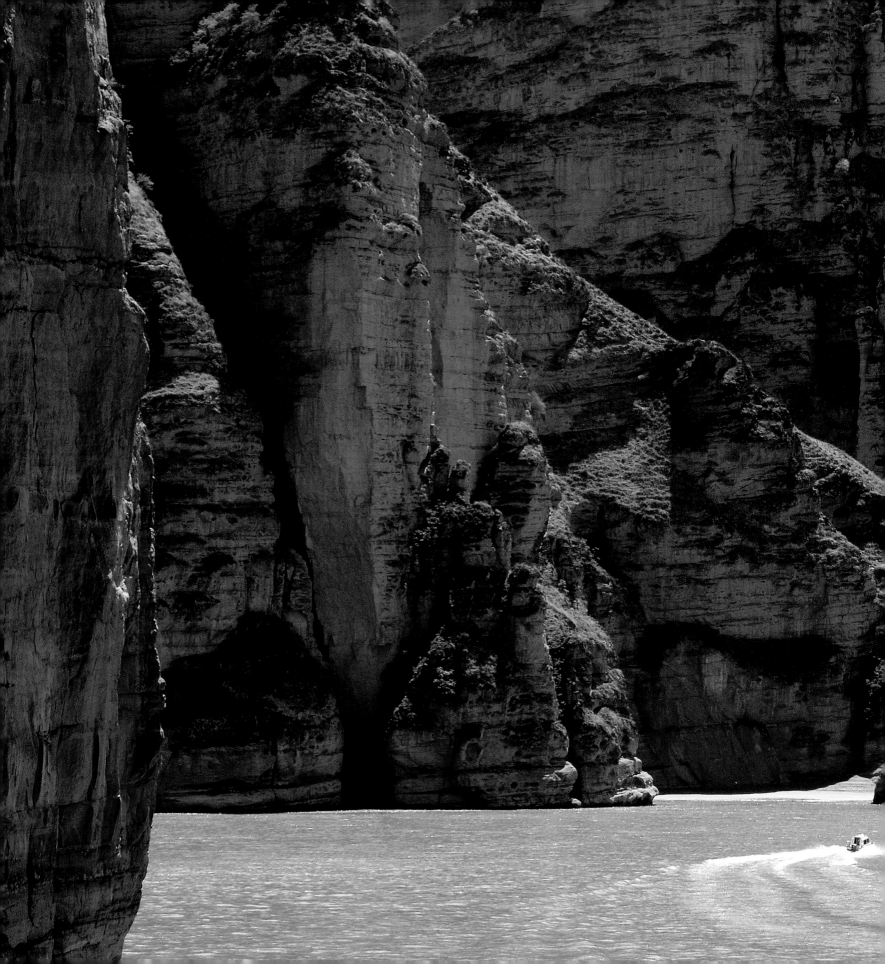

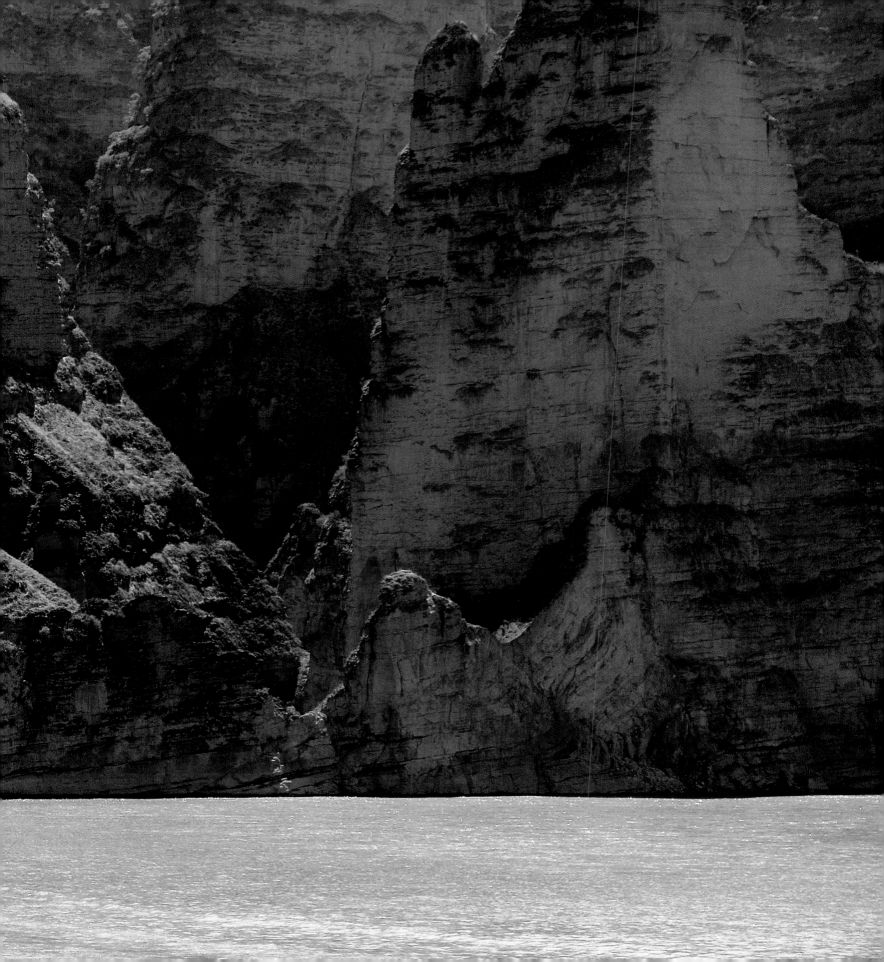

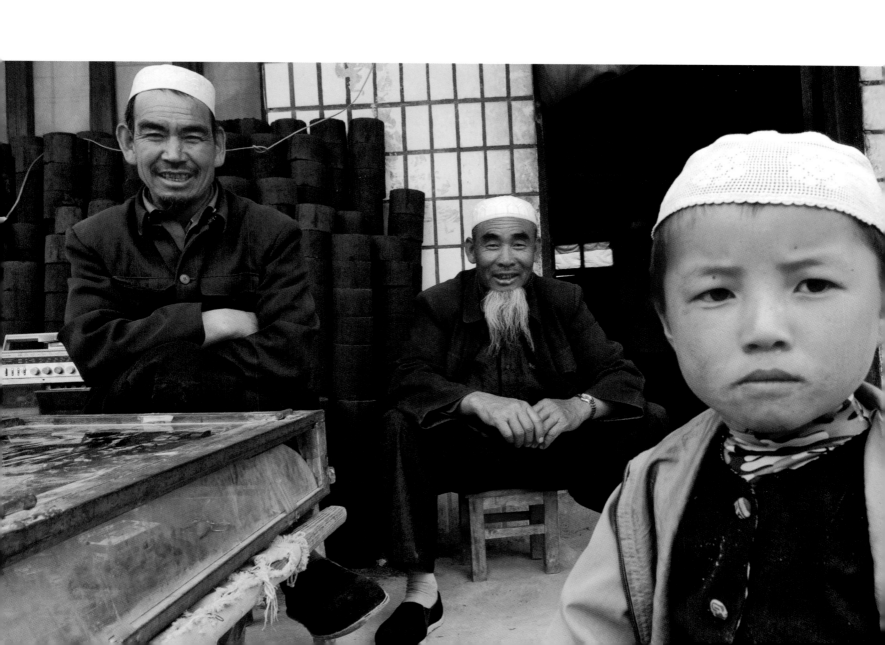

In Lanzhou, the capital of the province of Gansu, three generations of Hui Muslims have gathered along with a small crowd of people seated on the banks of the Yellow River. They are listening to amateur singers rehearsing some melodies from Chinese opera. The south bank of the river, Binhe Lu, has been paved over, and is the traditional meeting place for the townspeople. A statue has been given the name 'Journey to the West', in commemoration of the Chinese epic which tells the story of the monk Xuanzang, who travelled to India and brought numerous Sanskrit texts back to China.

OVERLEAF: The Yellow River at Lanzhou. Once an ancient trading post on the Silk Route, in recent times the city has been expanding at an unbelievable rate, stretching along the banks of the river for 30 kilometres (19 miles). Here, the waters of the Yellow River have lost their blue colour and have become laden with the mud and sediments which turn them their distinctive yellow colour.

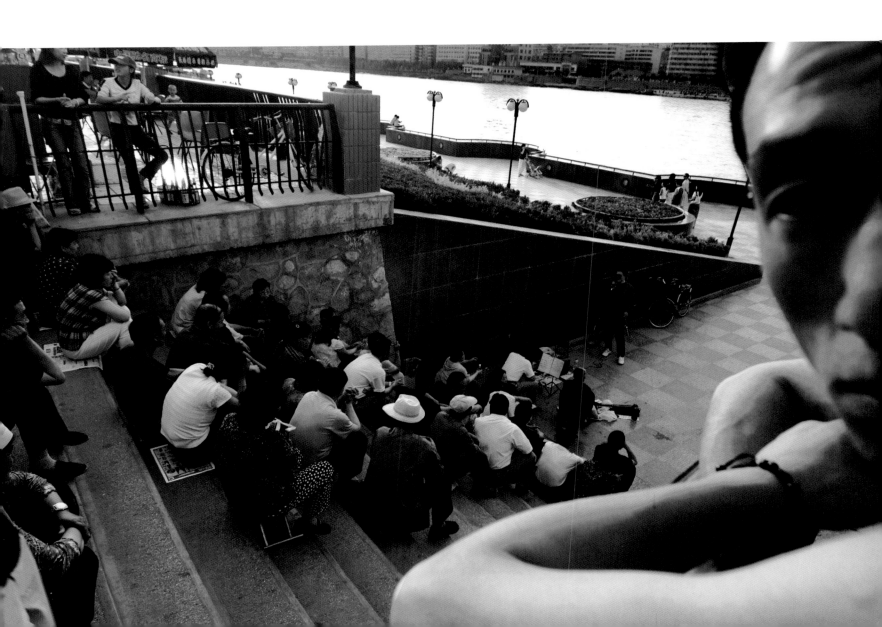

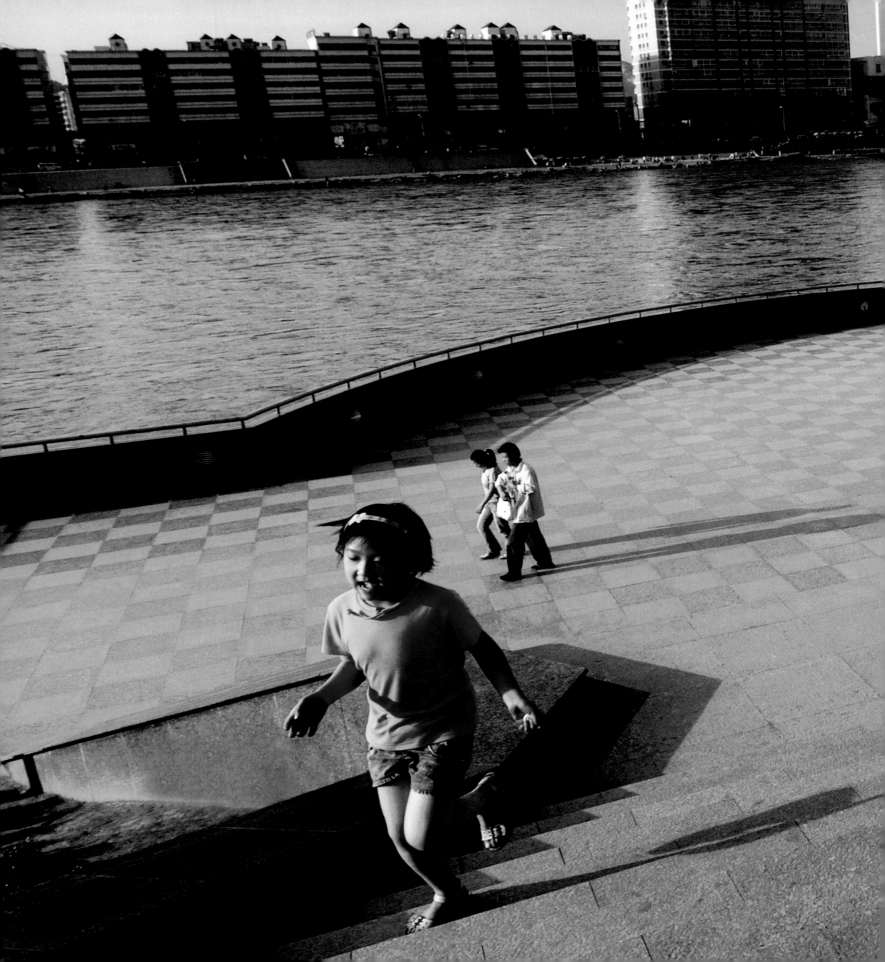

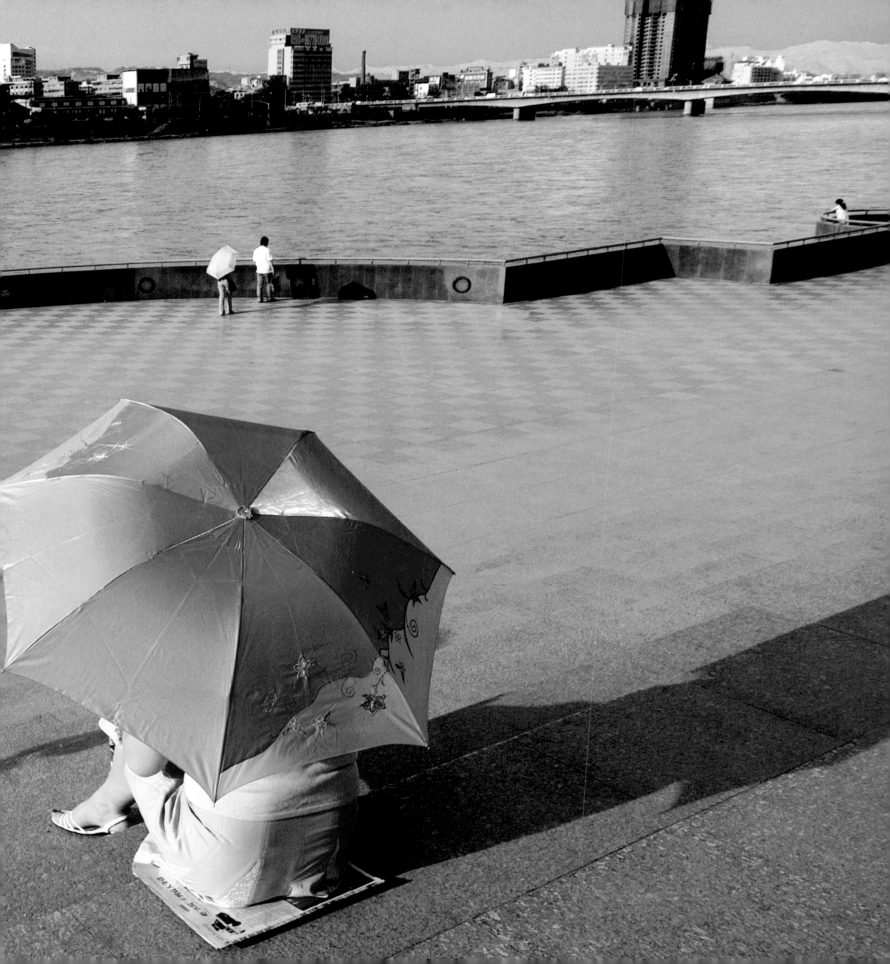

The Waters Traverse the Dunes and the Steppes

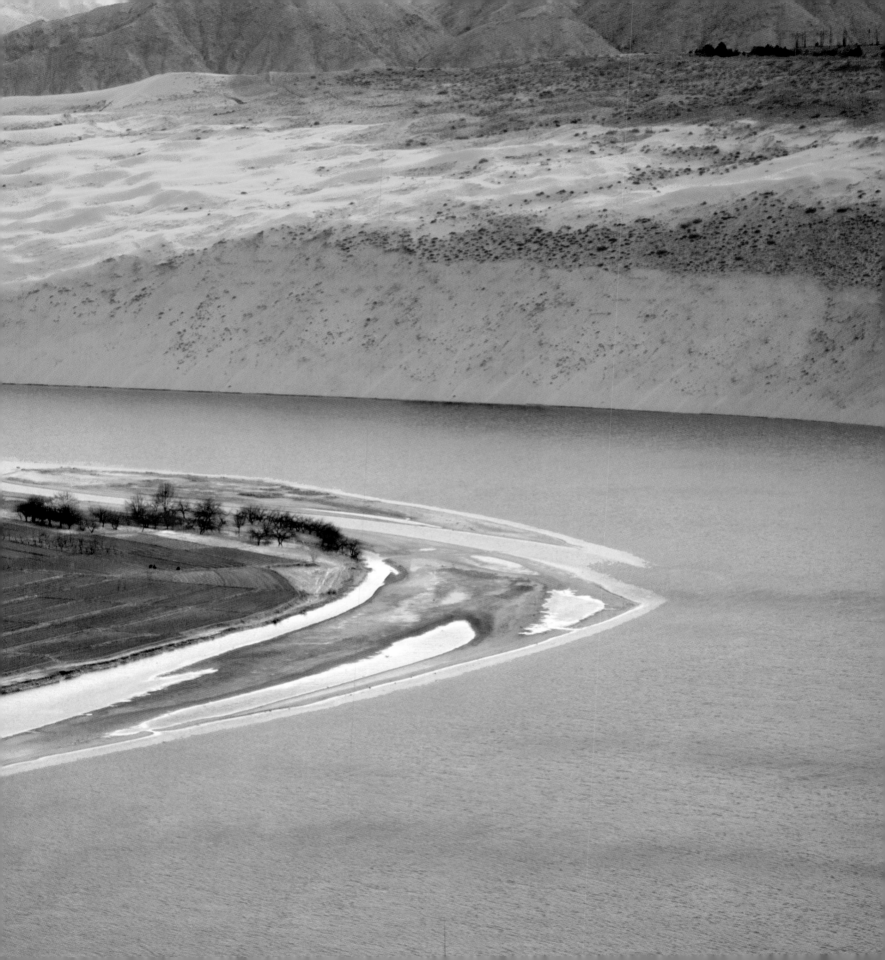

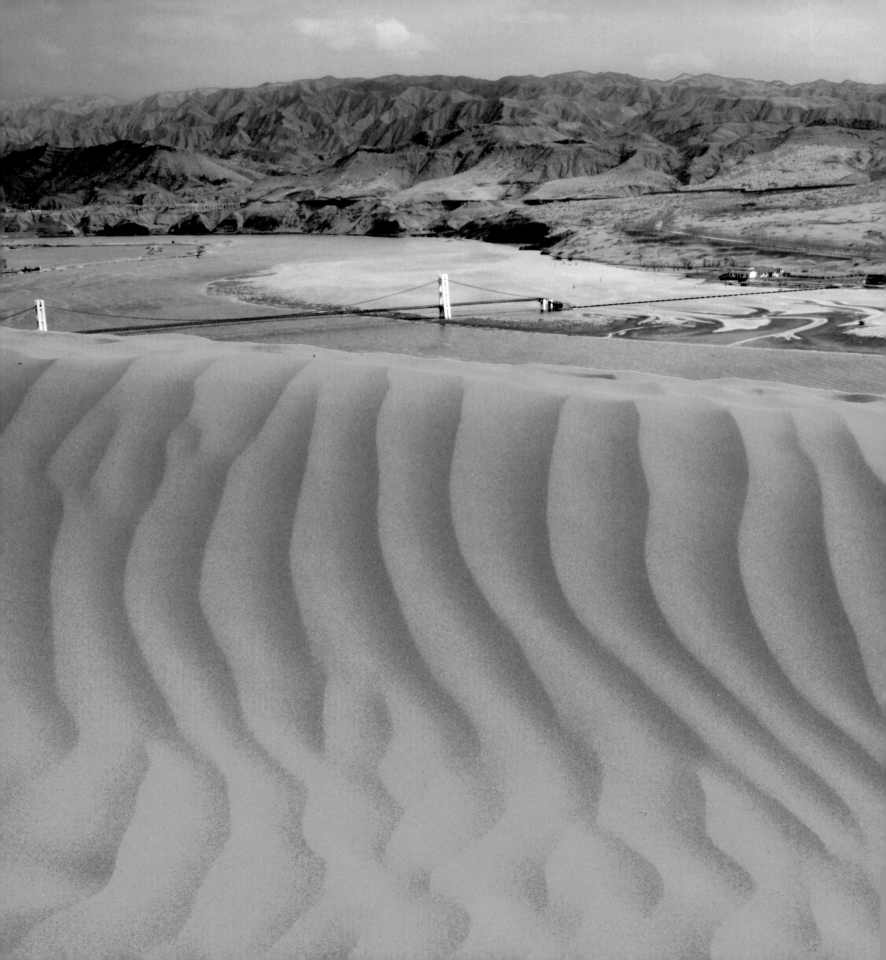

THE LUSH GREEN FIELDS accompany the dragon across an almost impossibly idyllic landscape. It seems like a beautiful dream, far away from the crowded cities of China. Which of the many faces of China is this one? Here, there are none of the glass and cement constructions which are to be found along the prosperous and developed coast. It is a harsh contrast. The ribbon of river, already laden with muddy sediments, snakes its way between isolated villages, between enclosed mud huts seemingly designed to keep out intruders. The peasants whose homes lie along the banks of the river live a life of unchanging rhythms. The dragon gives life, and so down the centuries they have learnt to use it to irrigate their fields of corn and maize and to avoid drought. The earth is hard and arid here, and looks like dried yellow mud, prefiguring the loess of the river's further reaches. The vast grasslands have disappeared, and the sand is starting to appear insidiously here and there. As you leave the province of Gansu and enter Ningxia, you begin to breathe in the thin desert air. The winters are freezing and the summers are sweltering. At this point the dragon curves, adapting to the orography, before turning decisively to the north.

The obstacles it will encounter are not just the mountains, but the results of the religious consciences of the Hui, of the vast Muslim world. This place has always marked the furthest boundary of the Yellow Empire. It is no coincidence that a section of the river runs along the Great Wall. In 1860 the Muslims revolted in Beijing, and the troops put down the uprising with a huge loss of life. It is said that the waters of the river flowed red with blood. These days the Muslims are demanding more than autonomy or freedom of religion, for the areas in which they live are badly underdeveloped, cut off from the rapid economic progress occurring elsewhere. This is a concern for the government, which fears that the economic divide will lead to a situation of political instability. For some years now there has been freedom of worship, and the call to prayer from the mosques has been tolerated, so they have already come a long way from the dark years of the Cultural Revolution. The Hui are a fairly liberal branch of Islam and even have female imams. In order to nip any vague pretensions to religious autonomy in the bud, in 1958 Ningxia was formally recognized as an autonomous Muslim province. As in Tibet, the government is even actively encouraging the immigration of the Han in order to modify the ethnic map. Today the Hui only constitute 30% of the total

population in Ningxia, which is clearly evident in the capital of the province, Yinchuan. The white skull caps have almost disappeared from view, only to be found concentrated around the mosques. 'Do we have more freedom than before? Well, yes, but now Beijing controls the appointment of our religious leaders. Everything is subject to the central authorities,' an old man tells me, who wishes to remain anonymous. He smiles sadly: 'Politics has even penetrated into religious hierarchies. Islam and Buddhism are in its clutches. Didn't they do that with Christianity as well?'

Beijing has pursued the same policy in Inner Mongolia. The same cliché, with the same result: today the Mongols are a minority. The only difference is that in this case it has been going on for centuries. As well as colonization, there is the issue of heavy industry, which becomes apparent when the Yellow River reaches the city of Baotou. After an infinite stretch of vast desert lands, there are no shady grasslands where horses roam, but only the chimneys of industrial plants manufacturing steel. Gone are my dreams of immense open spaces dotted with yurts, the traditional nomadic tents, and in their place I am faced with a landscape resembling a masterpiece of hydraulic engineering, which closes in on the dragon. A network of irrigation channels supplies the cultivated fields. Thanks to the Yellow River, the Mongols have become a sedentary people; they have dismounted their horses and taken spades into their hands. Yet, whether beneath the chimneys or out in the fields, it is clear that the infamous leader Genghis Khan (*c.* 1162–1227) is more alive than ever. Brimming with pride, these are the descendants of the tribe which, in the 13th century, put half of Asia to fire and sword. The Great Wall was built in order to keep them out, but thanks to their skilled cavalry, they still succeeded in taking the imperial throne. The Mongols founded the Yuan dynasty (1271–1368), and it was the first time that the Chinese had been subjected to a foreign yoke. They reached the apex of their power under Kublai Khan (1215–94), the Yellow Emperor whom Marco Polo (1254–1324) encountered during one of his epic journeys along the Silk Route. However, in one of history's many quirks of fate, the only way the nomads could retain their power was to settle, which is why for many centuries now the Mongols have had to adapt to the Chinese way of life, abandoning their own traditional path.

OPPOSITE: There is a significant population of Hui Muslims in Ningxia. In the photograph, two young men are strolling through the vast courtyard of the new mosque at Yongning, south of Yinchuan. It was constructed in 2006, on the site of a building which had been sacred to Muslims but was destroyed during the tragic years of the Cultural Revolution.

OVERLEAF: A sea of sand dunes in the Tengger Desert, which stretches away to the west of the Yellow River.

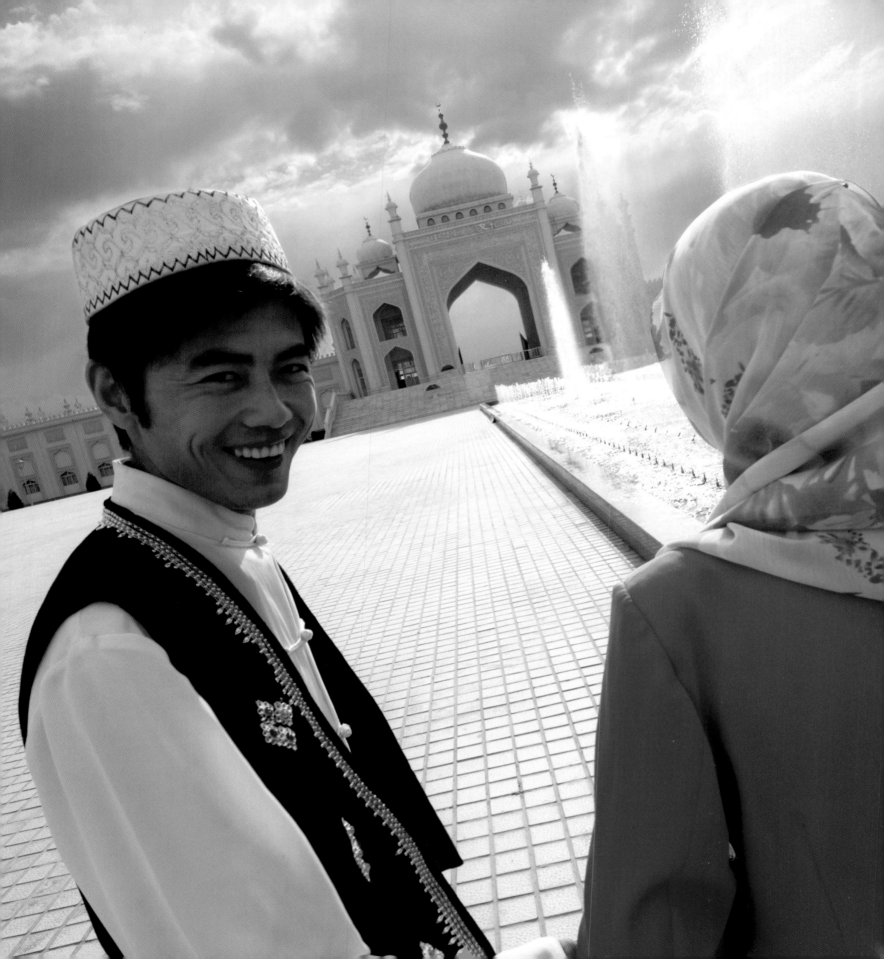

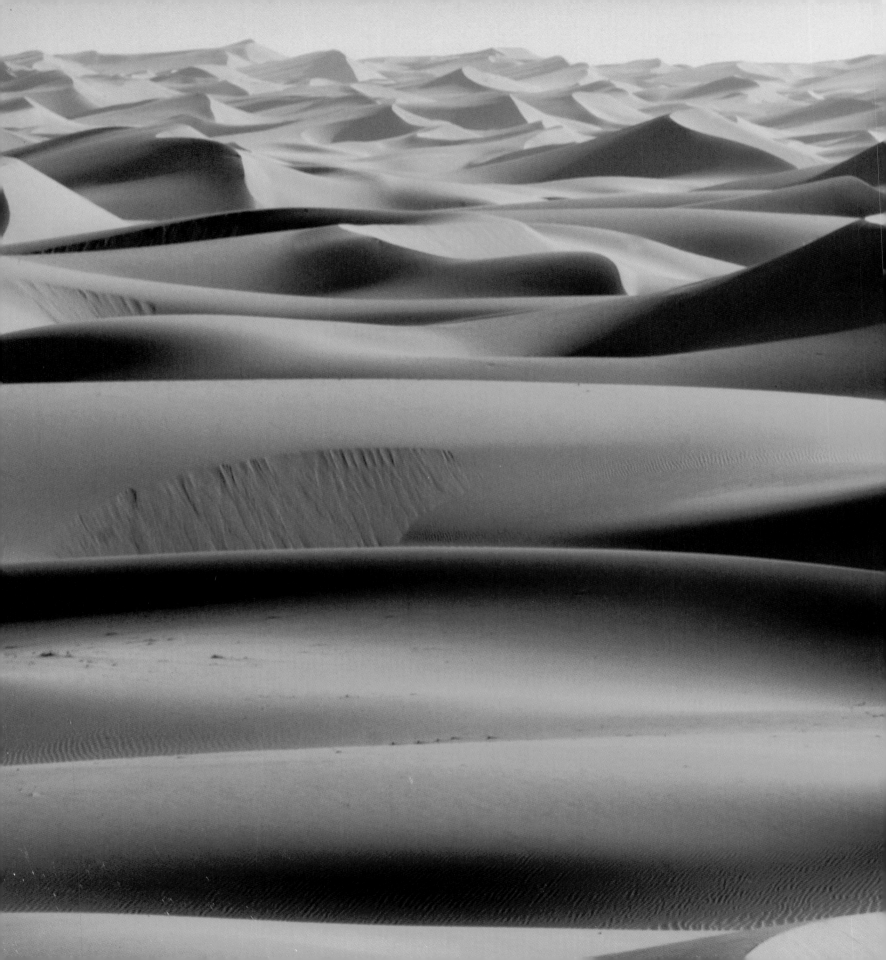

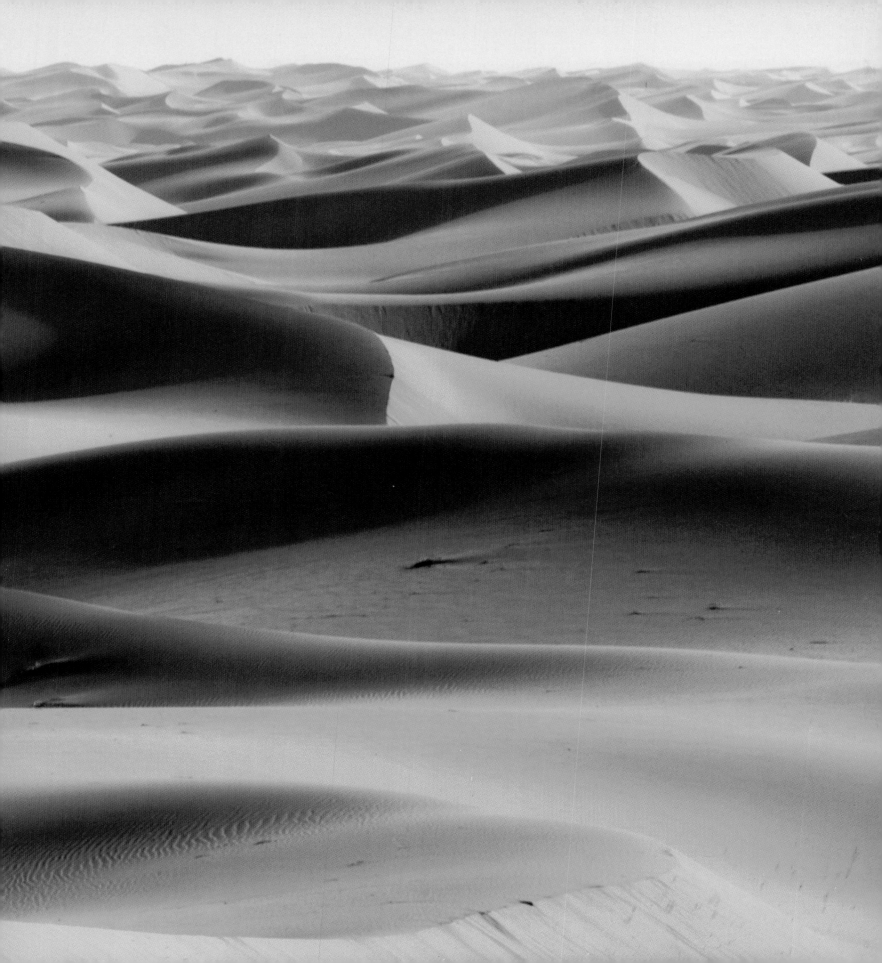

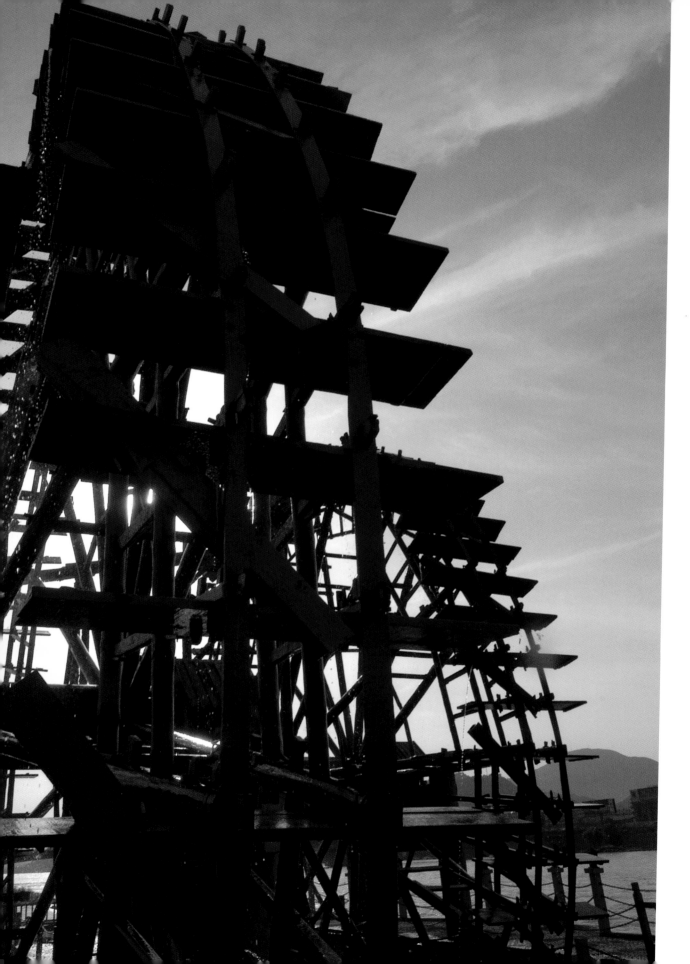

LEFT: One of the huge wheels installed along the Yellow River to draw water from the river and irrigate the crops of rice and wheat in the surrounding countryside. Agriculture depends entirely on the dense network of irrigation channels feeding off the great dragon.

OPPOSITE: A picture of the interior of the Temple of the 108 Dagobas, which are conical structures similar to the Buddhist stupas of the Tibetan monasteries, situated on the sloping east banks of the Yellow River.

OVERLEAF: Two people chat together whilst suspended from a telegraph wire close to the great dam at Zhongwei.

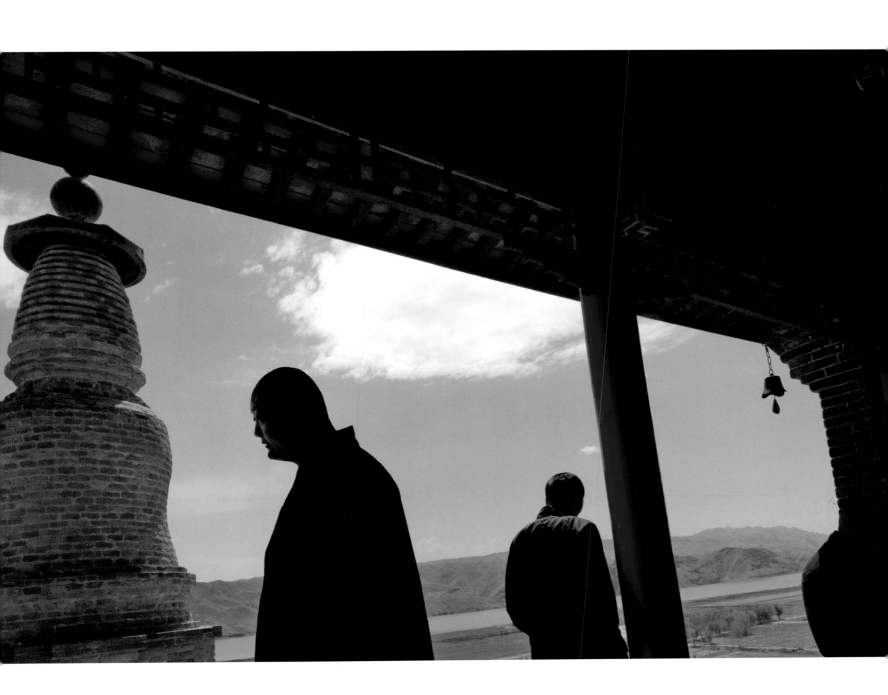

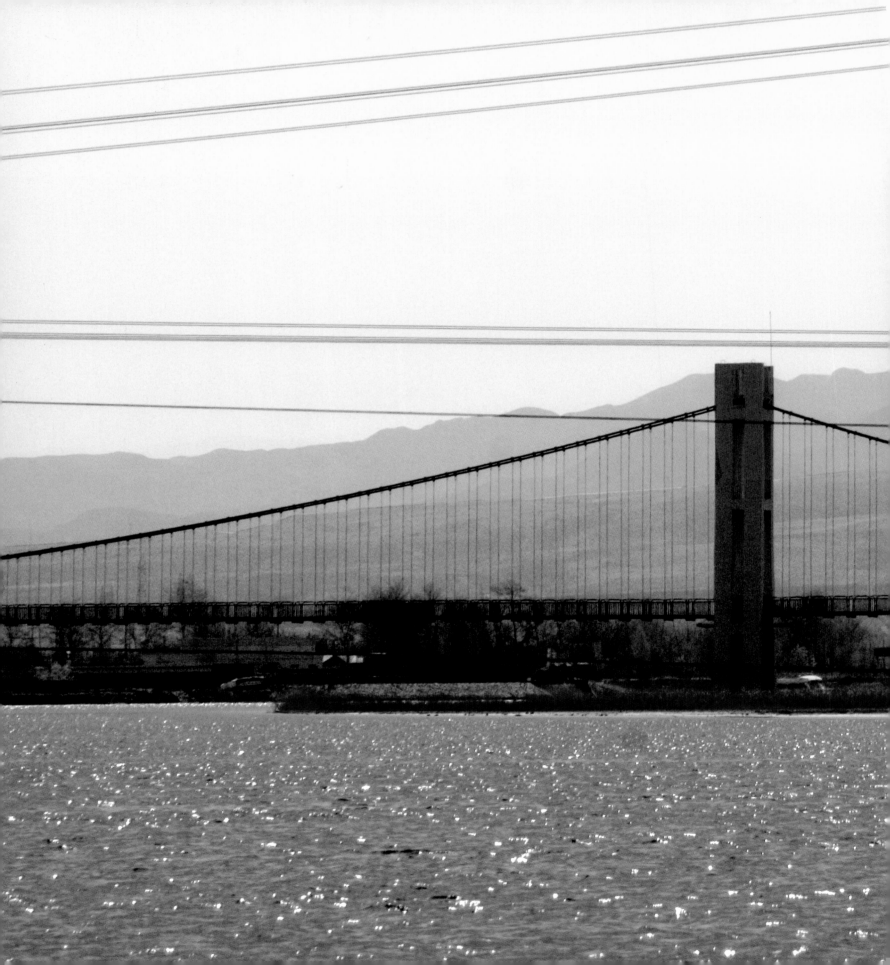

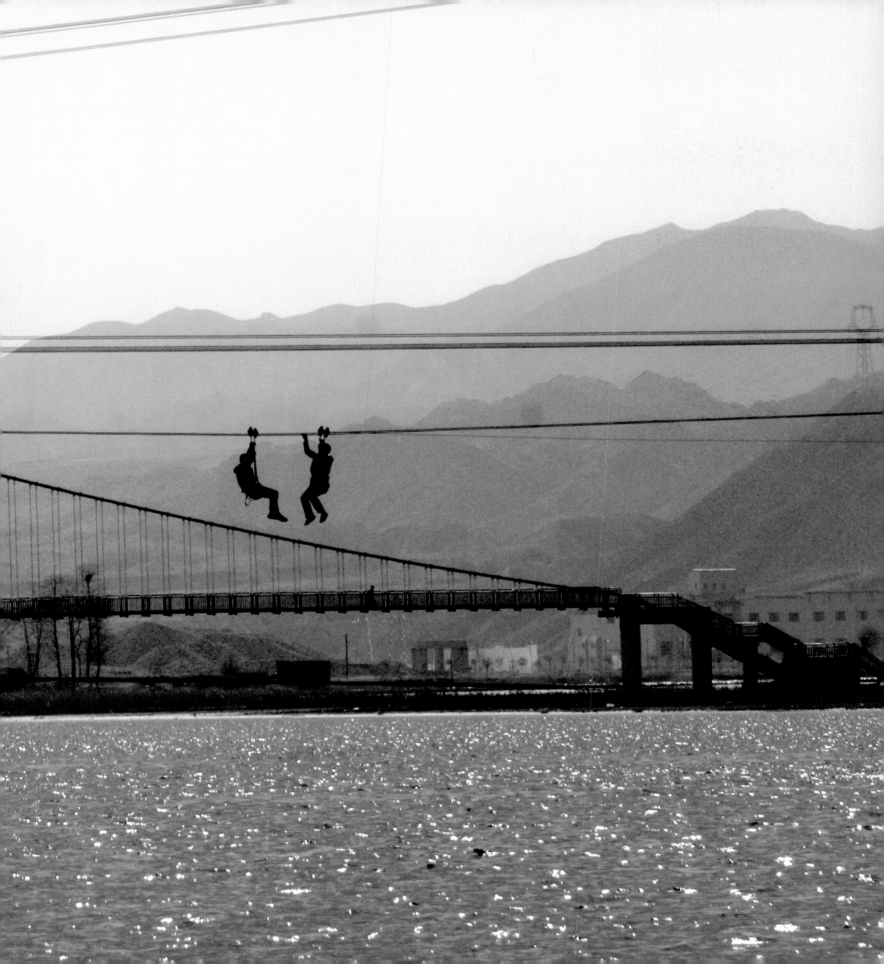

To find the true steppes, you have to travel north a long way from the Yellow River, almost to the border with Russia. 'People no longer live in tents in Inner Mongolia,' Zhao, a young translator, assures me with pride. Progress has made it this far. In China's interior, the escape out of misery and poverty often means an apartment or a new brick house – even better if its walls are covered with gleaming tiles. In fluent English, Miss Zhao proudly tells me that she is Mongolian. She points out her high cheekbones and golden skin, attributes of which she is proud. 'But the truth of the matter is that although we are emancipated, we have lost our roots. I no longer speak Mongolian as my parents did. But what can you do? From now on it will be an inevitable process.' She says goodbye – her Bactrian camel is waiting for her, and soon she disappears from view amidst the desert sands, albeit a strange kind of desert.

This desert is traversed by a chair lift, which goes to the top of a high sand dune. A few Chinese are skiing down its slopes, whilst others are trying to drive up in large off-road vehicles shaped like boats. They are as excited as children. This is a sort of Disneyland called Resonant Sand Bay, situated to the south of the city of Ordos, about 50 kilometres (30 miles) or so away from the Yellow River. Here, dozens of buses unload chattering parties of Chinese intent on experiencing the so-called spirit of the desert.

Not far from Ordos, which toponymy confirms comes from the Mongolian word *orda*, there is a famous yurt, where the body of Genghis Khan was said to have been kept for centuries. Today, instead of the simple tent made of animal skins, an impressive mausoleum has been built, which has become a place of prayer for Mongols. It is as if the great and ruthless leader has become a saint.

OPPOSITE: The bronze statue of Genghis Khan which stands in front of his imposing mausoleum in Ordos, where the great leader was said to have died. The mausoleum boasts a yurt-like vaulted roof. Genghis Khan succeeded in uniting all the Mongolian tribes for the first time, thereby creating the largest empire in history. Defeating the Jin dynasty (1115–1234), he conquered China. Marco Polo received a lavish reception from his grandson Kublai Khan, an occasion that displayed the wealth of the Mongol Empire.

OVERLEAF: A Mongolian driving a herd of horses. The long stick has a lasso on the end which he uses to grab the animals by the neck.

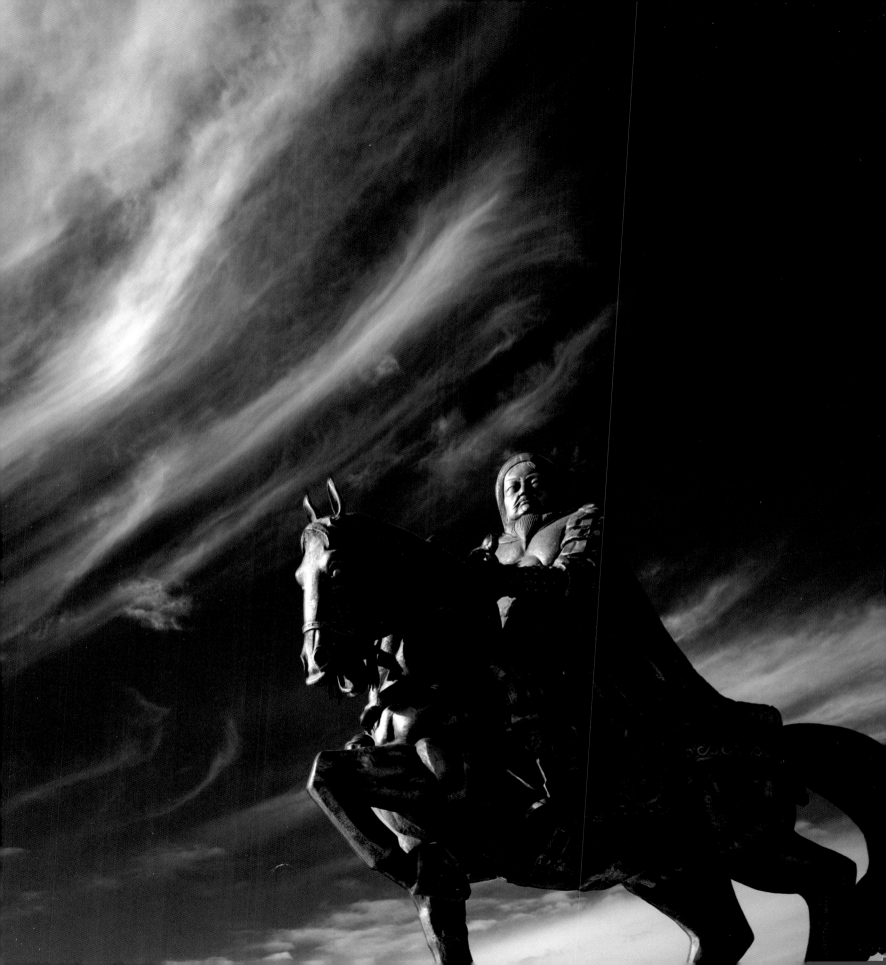

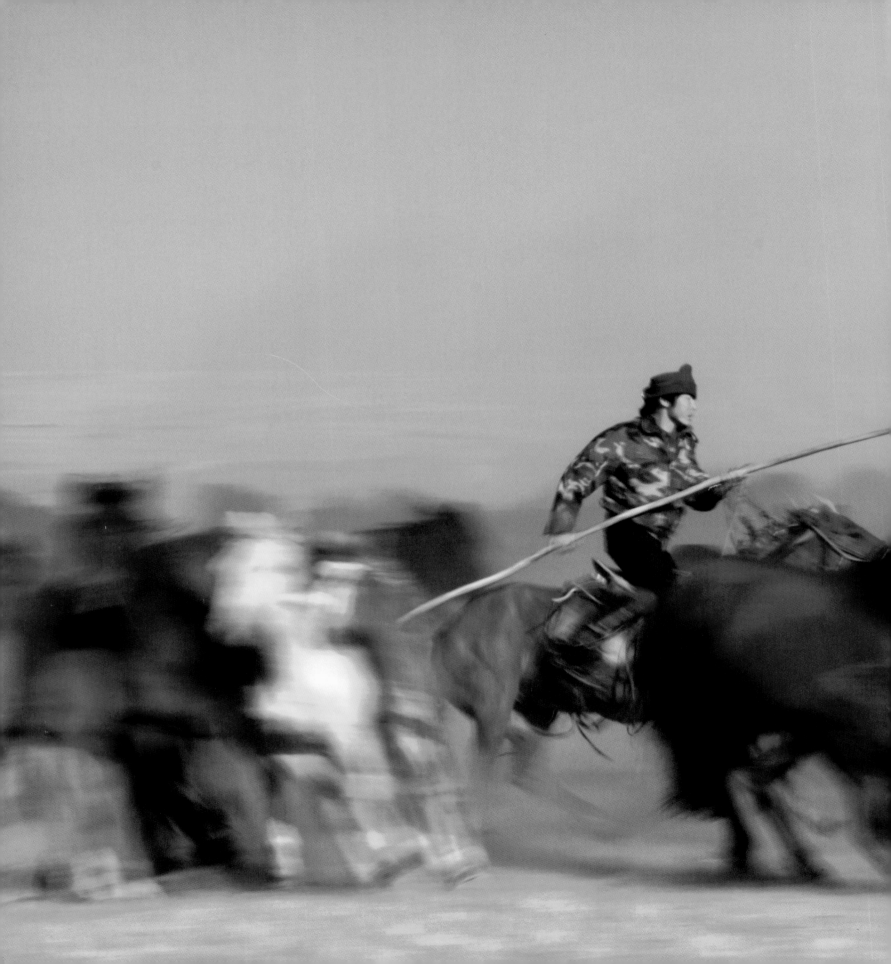

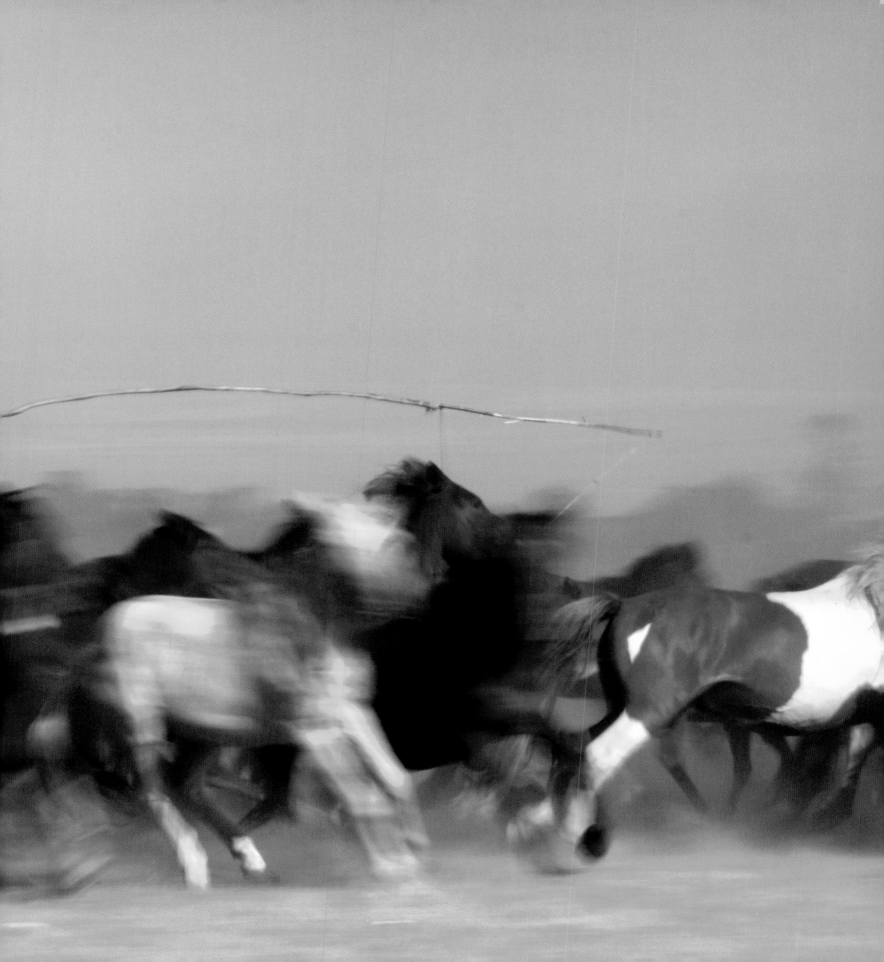

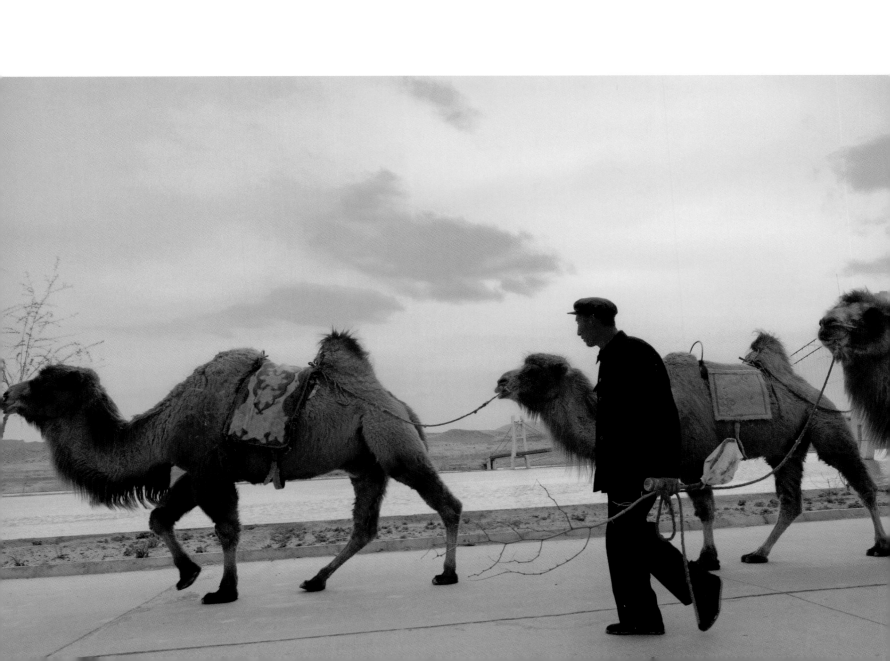

OPPOSITE: A herdsman leads his camels back to their stalls. The nomadic lifestyle has all but disappeared, but the practice of grazing animals is still widespread, along with the rearing of Bactrian camels. All across the desert lands to the west and the north of the Yellow River there are numerous semi-wild herds grazing.

BELOW: A satellite dish is positioned next to a simple Mongolian yurt known as a *ger*. Life in the grasslands follows ancient rhythms and practices, but is not immune to modernity.

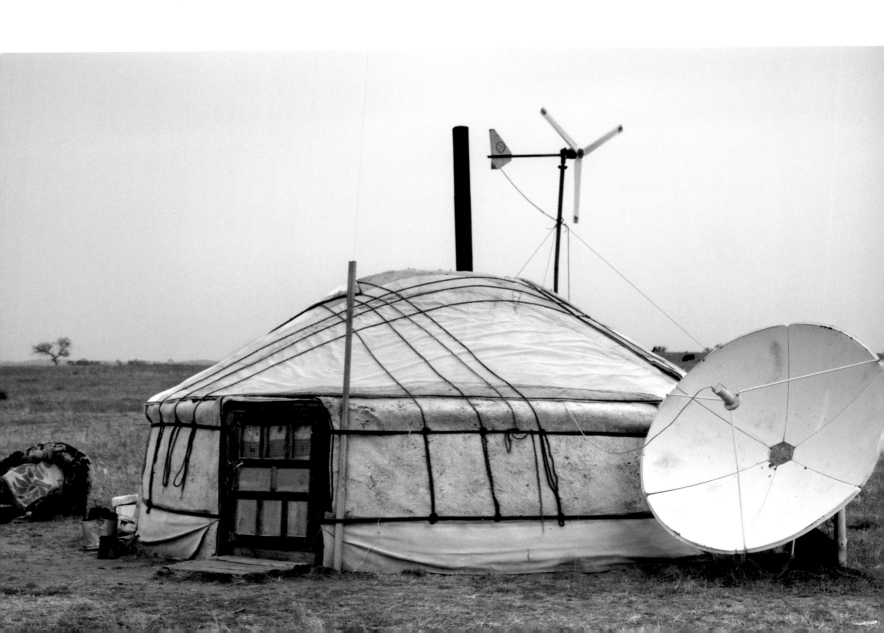

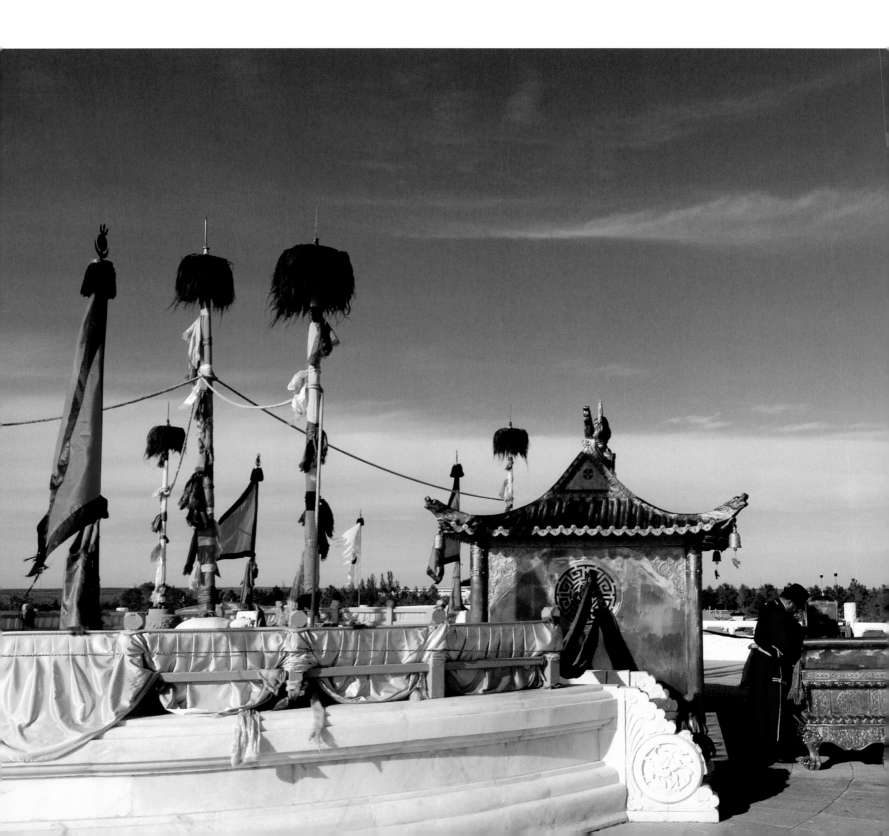

These two photographs show the mausoleum of Genghis Khan in Ordos. The mausoleum has become a place of pilgrimage, almost like a religious shrine. Inside, an enormous lamp burns with an eternal flame fuelled by yak's butter, which has never gone out since 1227 when the great leader died. A group of young men are kneeling before the sacrificial altar, which is reserved only for men. On the left, the *suled*, the Mongolian banners, are clearly visible. On the right, a young woman has put on the traditional Mongolian costume to pray at the mausoleum. She has arrived with a group of friends from Hohhot. In the picture she is hanging a sash on an altar. Their pride in their ethnic origin is evident from their dress, so different from the usual jacket and jeans. Nowadays the precious silk clothes and the jewels are only worn for special occasions.

OVERLEAF: A group of young people at Naadam, the summer festival that takes place in various parts of Inner Mongolia, following age-old traditions.

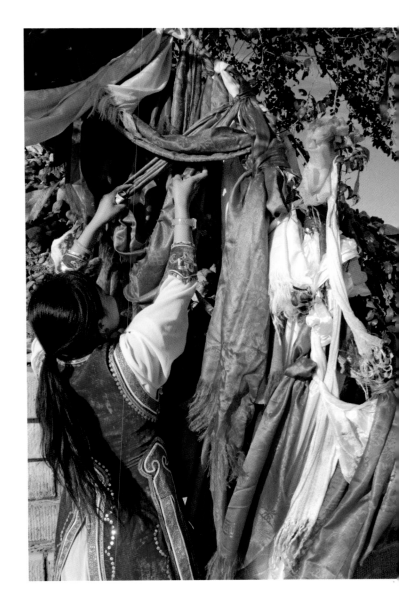

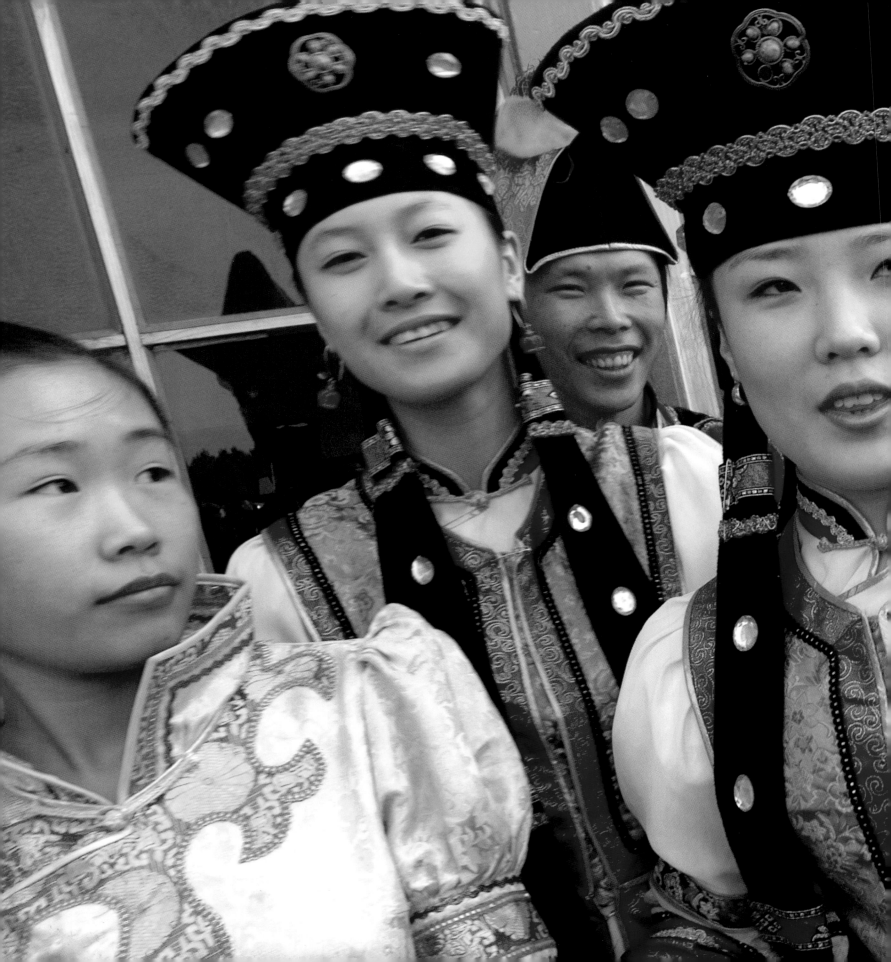

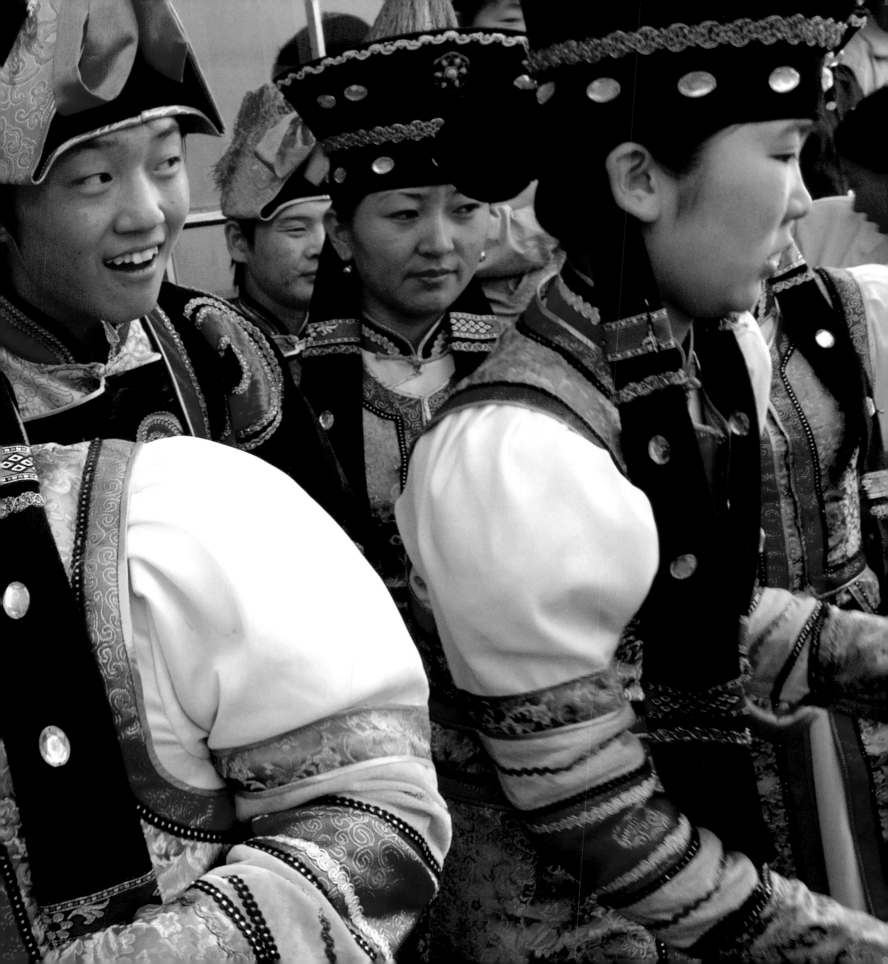

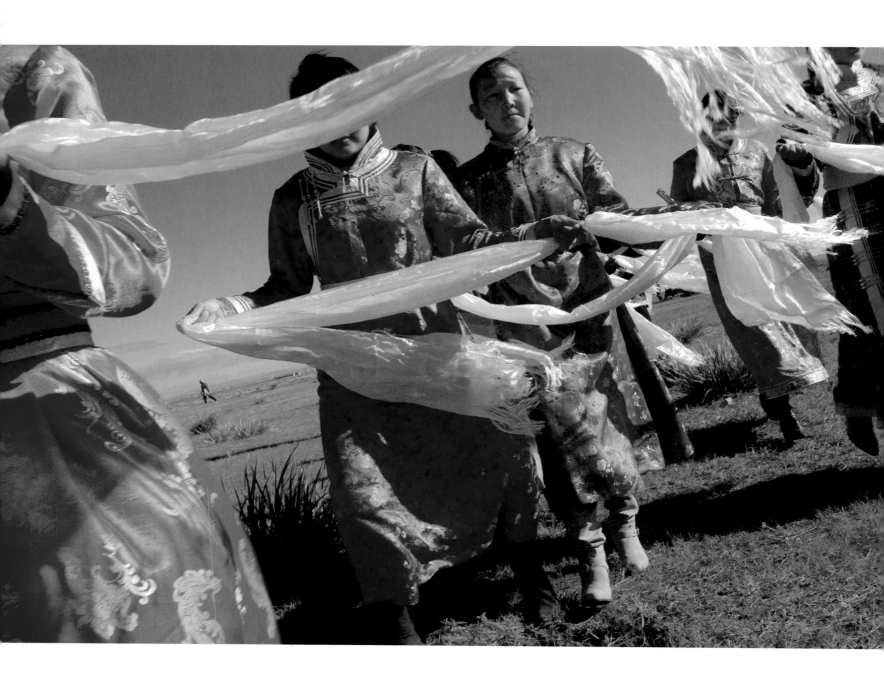

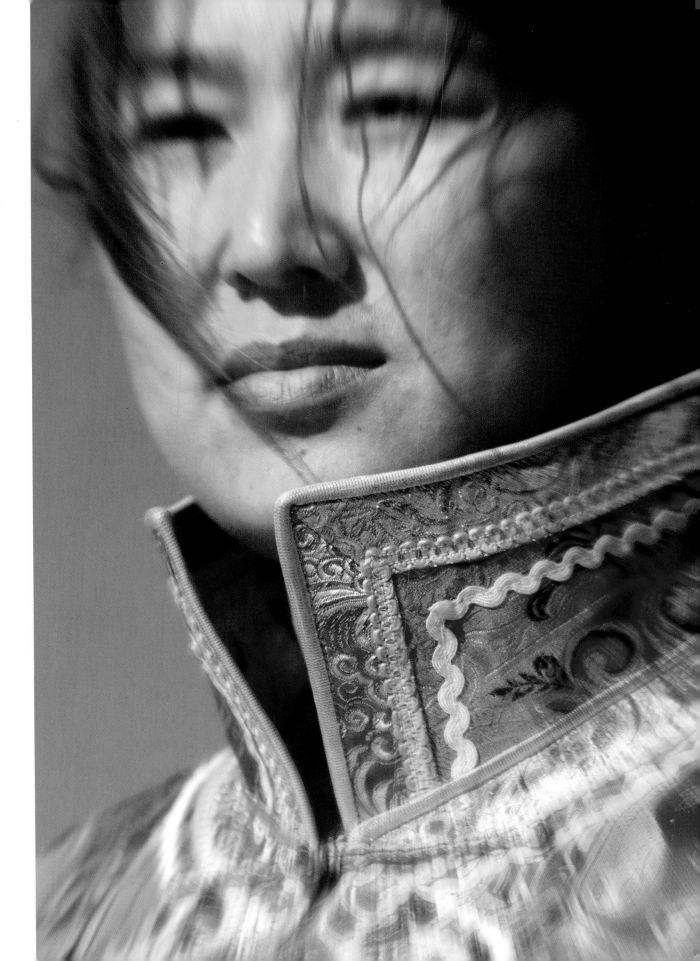

A few girls dressed in traditional Mongolian costume are preparing to welcome a group of visitors to a party in the steppes. The white sash is a sign of welcome, and is tied around the neck of the visitors. The Tibetans and the Mongolians share this custom; in fact, the two peoples have many traditional rites and customs in common, in addition to Buddhism.

OVERLEAF AND PAGES 134–35: Two shots of the desert dunes that extend south of the Yellow River, not far from the large industrial city of Baotou. The place, known as Resonant Sand Bay, is a type of Disneyland for Chinese tourists, who enjoy riding on the Bactrian camels or having their photographs taken amongst the dunes, like the young couple on pages 134–35 who have just got married.

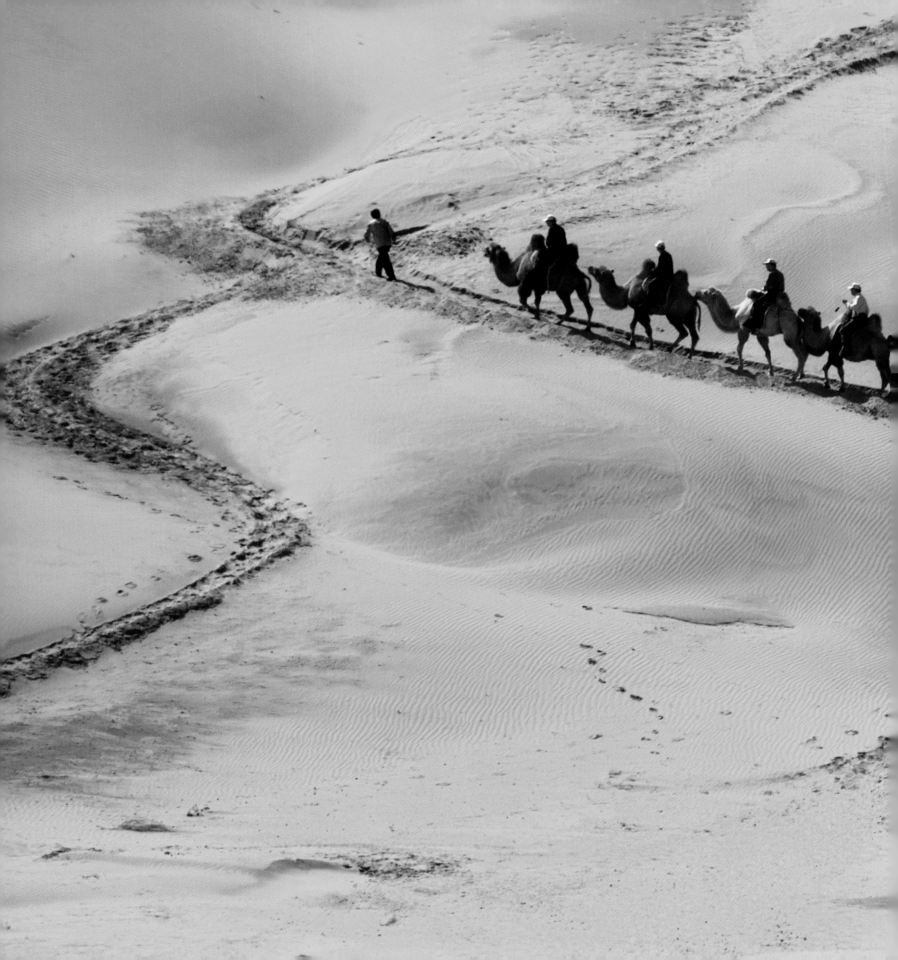

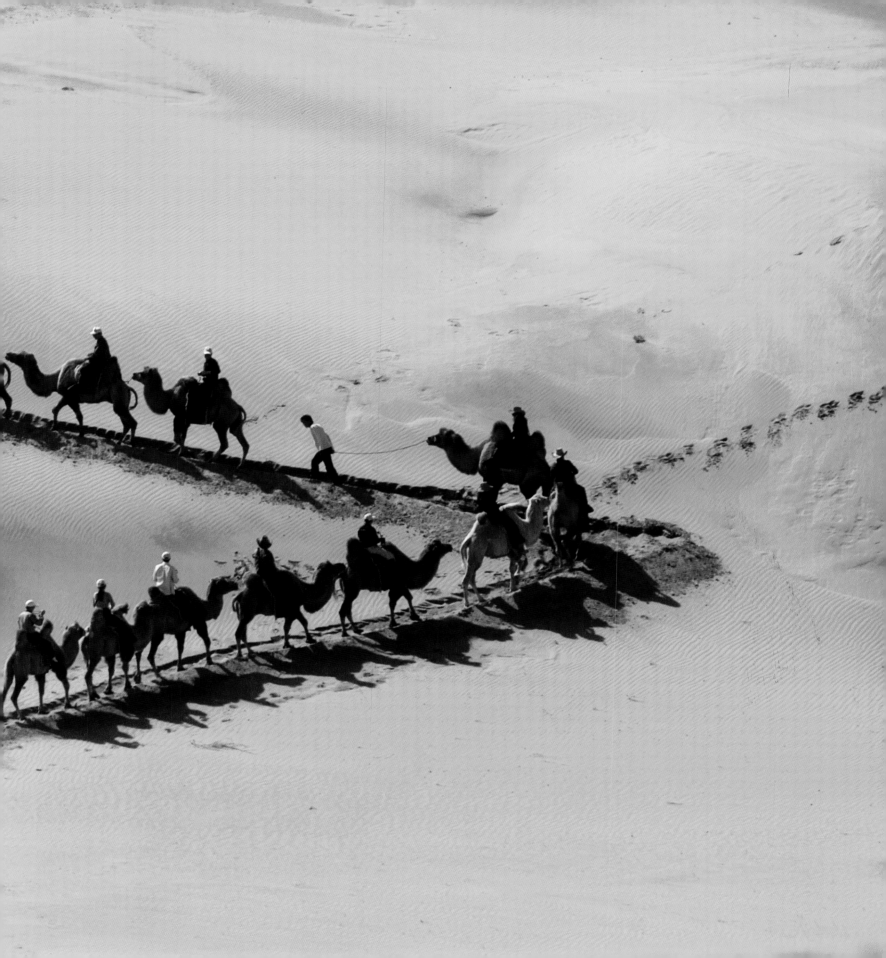

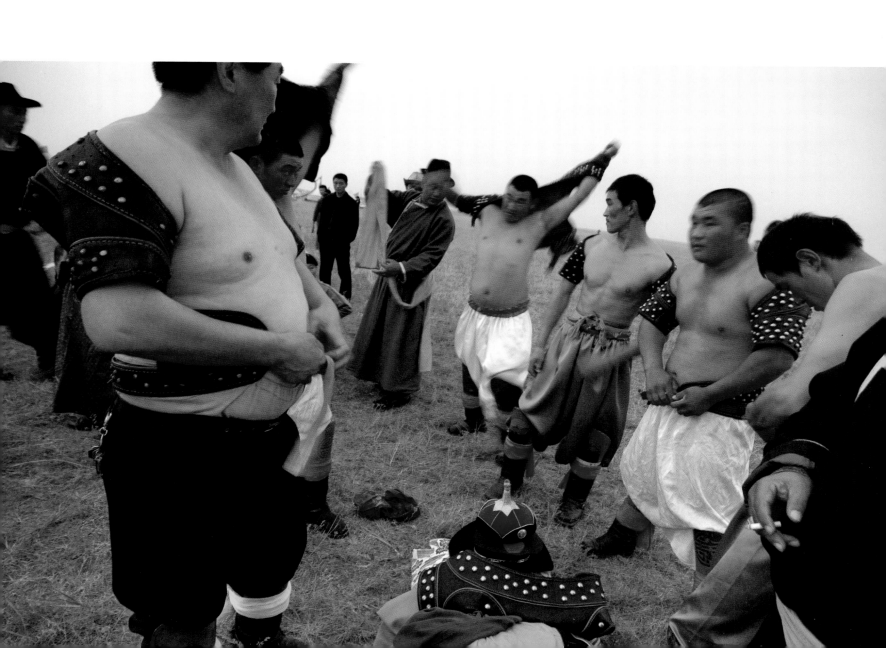

Wrestling is a traditional sport for Mongolians, together with horse-racing and archery. In the summer, large competitions are held during the festival of Naadam. This type of combat, known as *böke*, was already popular in the time of Genghis Khan, and used to keep the troops in training. There are principally two versions of wrestling – Mongolian and Inner Mongolian – but they both follow the same basic rule: if an opponent touches the ground with his back, knee or elbow, this signals his defeat.

OVERLEAF: A pedestrian bridge and a railway bridge cross the Yellow River at Baotou.

PAGES 140–41: At Hohhot, a traditional Chinese *paifang* archway contrasts sharply with the housing block behind it. The signs are written both in Mongolian and Chinese.

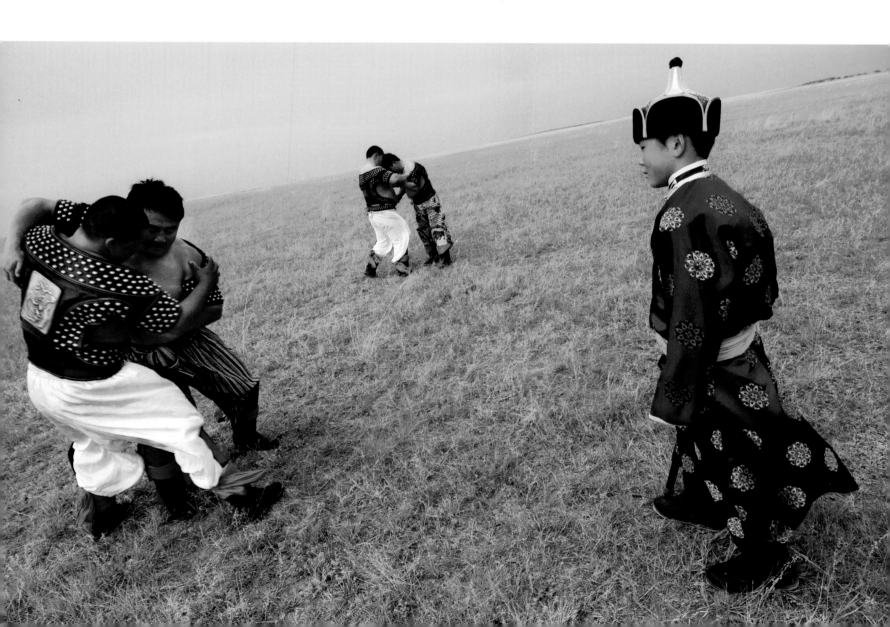

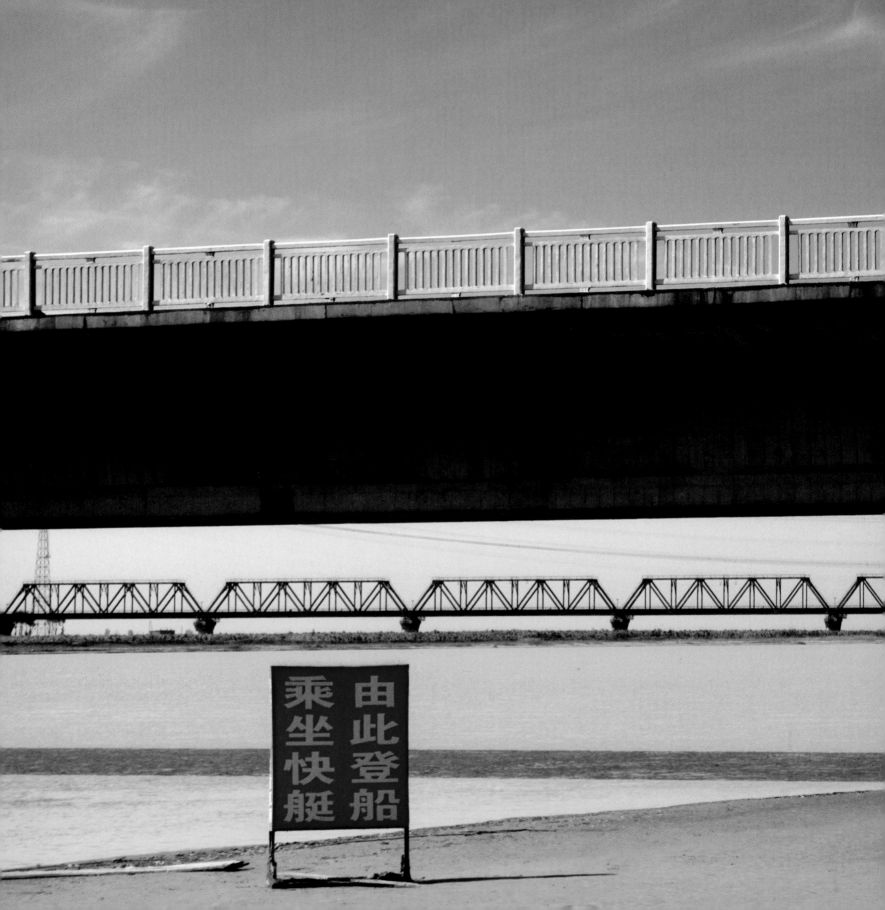

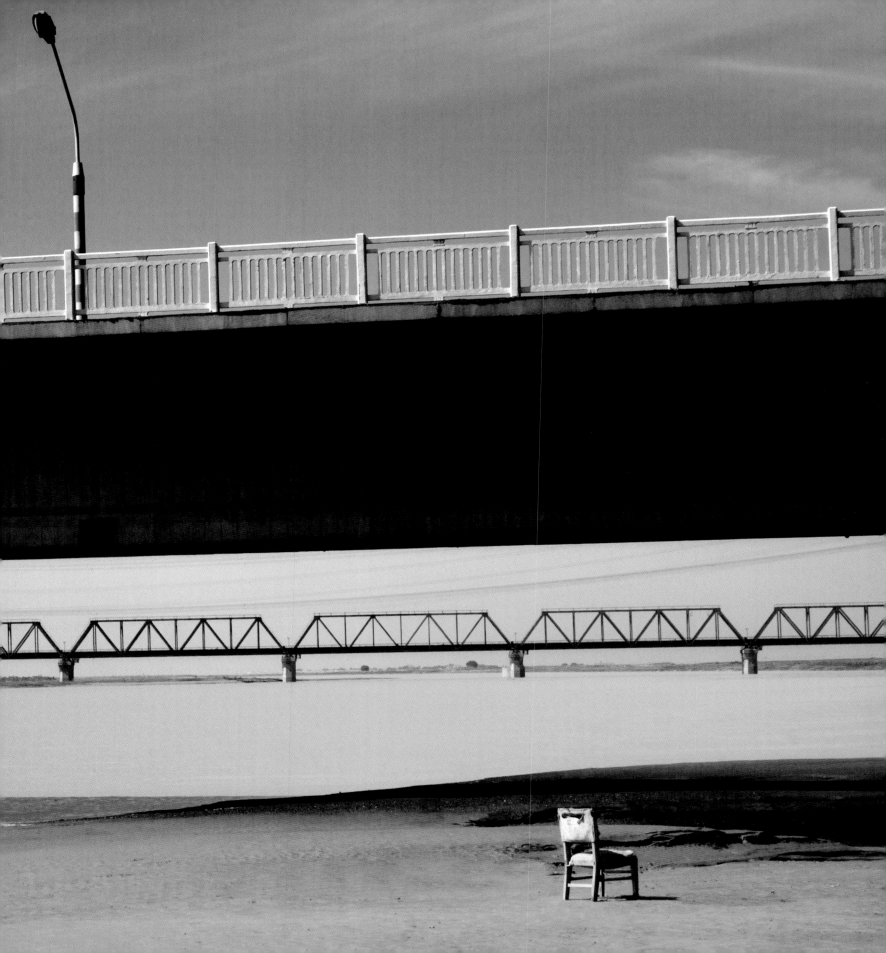

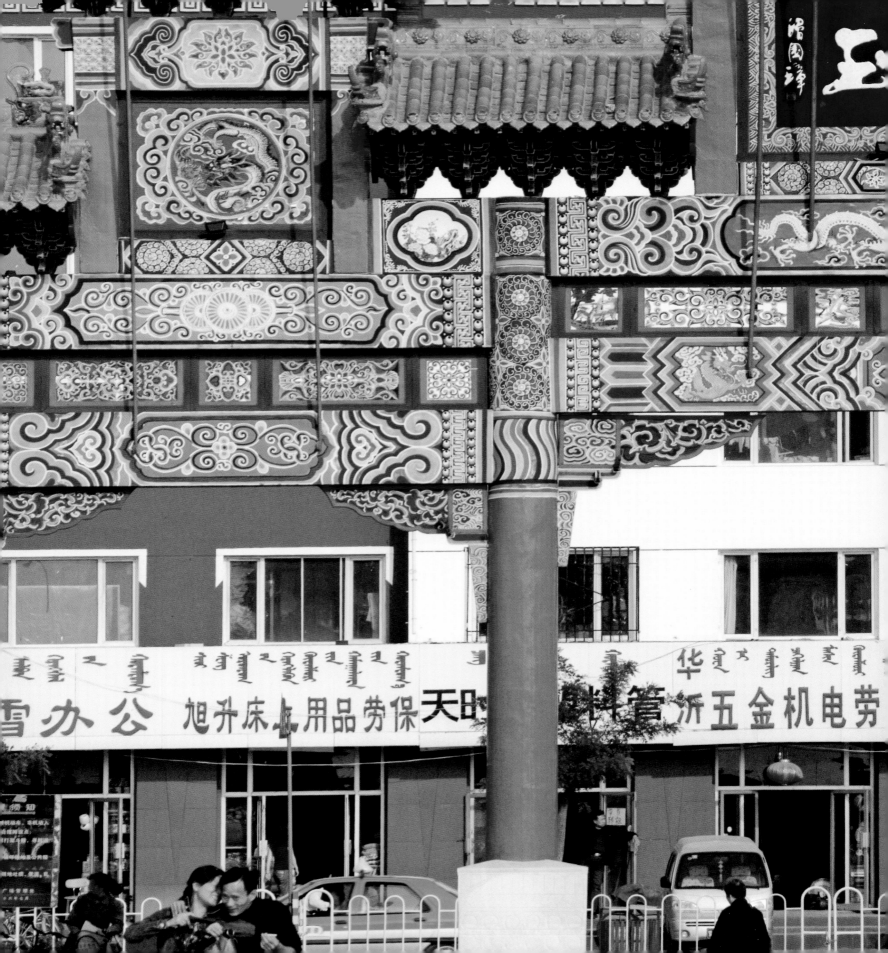

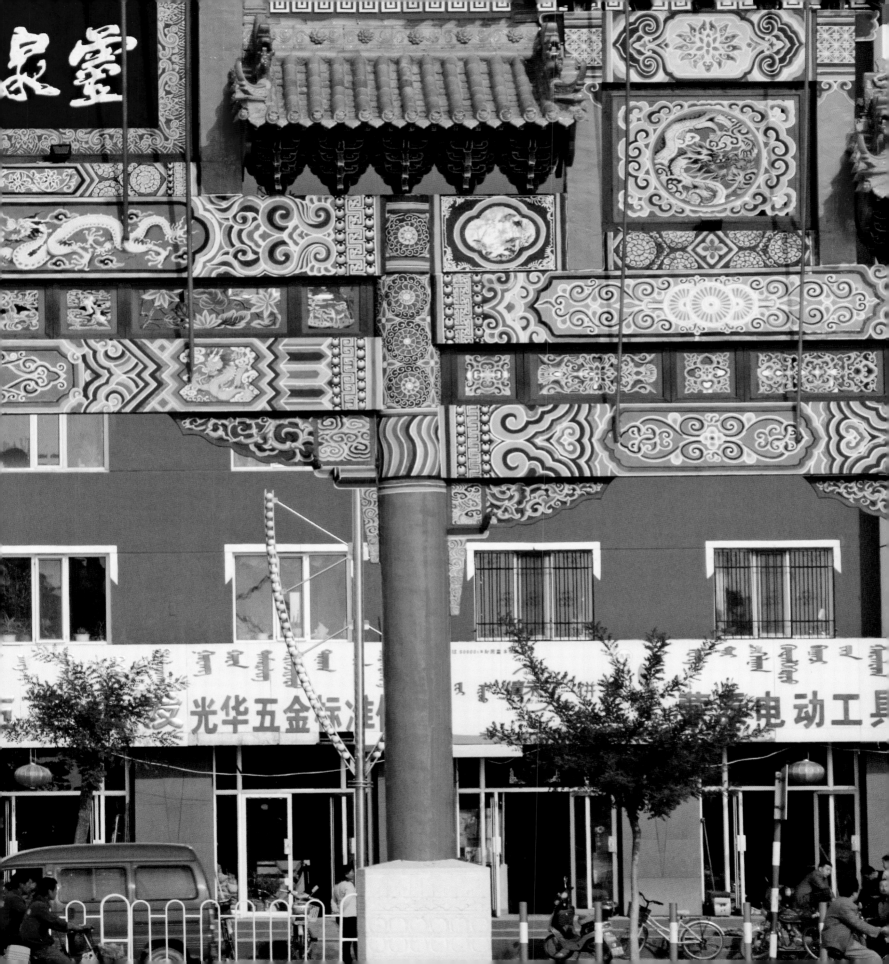

At the Foot of the Great Wall

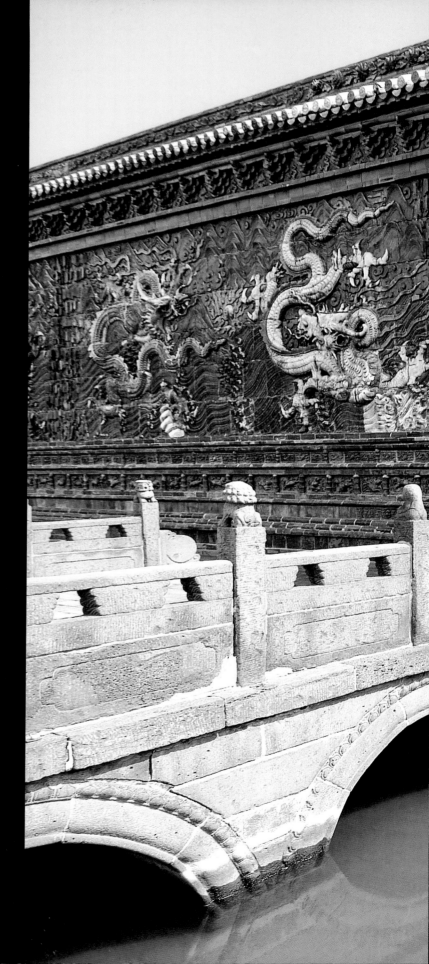

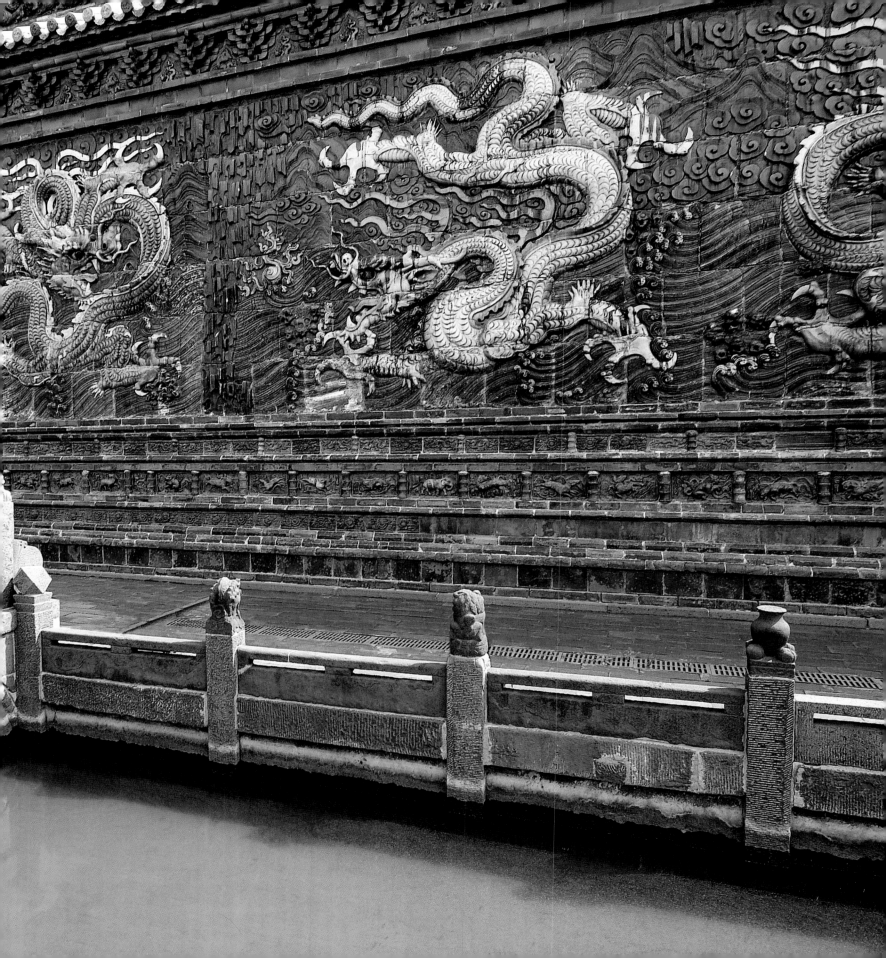

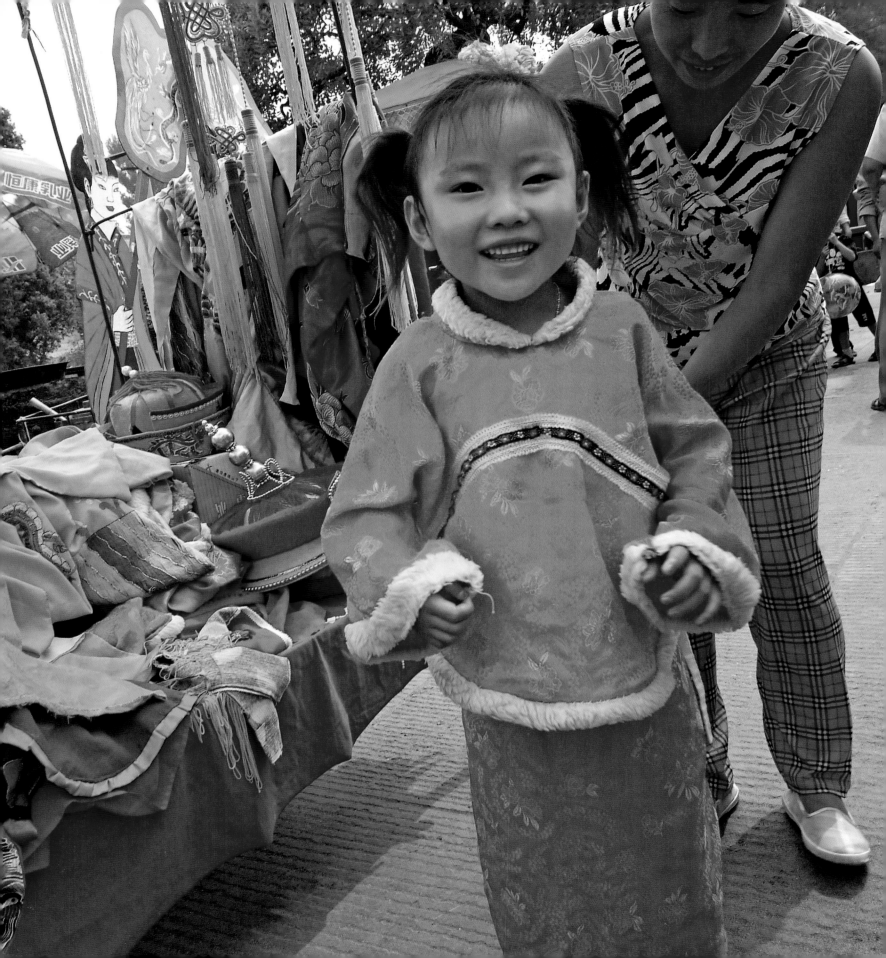

PRECEDING PAGES: The Nine Dragon Screen, a relic of ancient China in Datong. The screen, which is 8 metres (26 feet) high and stands alone between two concrete buildings, once formed part of an old palace which was destroyed by fire. According to Chinese tradition, the wall was intended to keep out evil spirits, who were said to move only in a straight line. The screen consists of nine flying dragons coming out of the water, painted in bright colours on glazed ceramic tiles.

OPPOSITE: A young girl at a festival in Jinci. She has put on the traditional silk costume to be photographed. The traditional costumes which were prohibited during the Cultural Revolution are now in vogue once again.

ABOVE: A Chinese ideogram symbolizing Buddha is caressed by pilgrims visiting the monasteries of Wutai Shan.

HAVING TRACED AN ARC ACROSS INNER MONGOLIA, the Yellow River curves southwards, where its waters start to pick up greater quantities of sediments and the famous yellow mud. The dragon cuts across the mountains like the blade of a sword, carving out gorges and valleys, and creating rapids and waterfalls. It carries everything along with it, as uncontrollable as a young boy who does not know his own strength. The river traverses the plateau christened by geologists as the Loess Plateau, and known to the Chinese as the 'yellow lands'. The dragon pursues its turbulent and dangerous course along the Qinshen Valley; for 700 kilometres (435 miles) it defines the boundary between the provinces of Shanxi to the east and Shaanxi to the west. The province of Shanxi has a population of thirty-two million, which is small by Chinese standards. It is an impoverished land, abundant only in coal, and heavily polluted: the stench in the air hits you as you enter the great urban sprawl. It does, however, boast precious relics of the ancient Chinese civilization, many of which were destroyed throughout the rest of the country over the course of the centuries and in particular under Maoism.

'I pray to the gods as my grandmother taught me,' says Mr Liang. 'She used to show me how to do it in secret, as in those days it was forbidden.' Mr Liang speaks decent English; he has had to learn business English out of necessity, as he is the manager of a firm which produces gym shoes. They export abroad, and his salary of less than £700 is ten times that of a worker. In the lenses of his dark glasses I can see reflected the imposing silhouette of a Buddha carved into the cliffs. We are standing in front of the spectacular series of sacred grottoes at Yungang, on the outskirts of Datong. In his fists Mr Liang clutches bunches of coloured incense sticks, which he then lights. 'Why do I come here? It's simple: to give thanks for my good fortune, now that I am becoming richer, and I do not want to lose it,' he explains emphatically.

Once it was not allowed; people were not permitted to get rich, and praying was forbidden. But now everything has changed: religion and money go hand in hand. It is a sign that China has moved with the times. The temples that were closed under Maoist repression have now become museums, albeit rather strange ones; museums where at the entrance you must buy a ticket, but once inside you are free to pray to your choice of god. The monks who for decades have been in hiding are now returning. The religious ministers

have started to officiate once more, raking in the offerings of the devout. The offerings are lavish: the rich give prodigious donations, knowing that good fortune is not brought about by miserliness. Here there are banknotes to the value of 100 or 500 Chinese yuan, worth around £7 or £33 pounds respectively, which is an unimaginable amount to the average Chinese.

The sun breaks feebly through the mist. During the summer, blue sky is a rare sight. Shanxi bodes well for the anticipated boom in motor transport as China becomes increasingly prosperous. Gleaming Toyotas mingle with trucks carrying coal, spluttering their way along roads full of potholes. The new four-lane motorway is a flash of modernity between the hills; hills that are dotted with villages, whose houses are enclosed by high walls, with pagoda-shaped roofs covered with glazed tiles. The old China is resistant to the advance of cement. The spirit of the Chinese is alive and well in the countryside, embedded in the traditions, the clothes and the rhythms of life. Confucianism – the philosophical and ethical system based on the teachings of the Chinese philosopher Confucius (551–479 BC) – permeates the air that they breathe; it is in their sense of family, respect for authority, and submission. The regime is well aware of this, and exploits it to its own advantage. 'May our friends enter within, and our enemies remain distant' reads the inscription above the doorway of a peasant house. The wealthier homes often have a high wall erected in front of the entrance to keep evil spirits at bay. The shrines of their ancestors are behind the gateways. There is a revival of popular religion: sanctuaries dedicated to the divine protectors of the villages are now being restored, mostly by municipal funds. Such financing would have been unthinkable a few years ago. Pagodas are being rediscovered: those of the Twin Pagoda Temple of Shuangta in Taiyuan have been renovated, and a new park has been created around them in order to create at environment of respect. The 11th-century Yingxian (Mu Ta) Pagoda, said to be one of the oldest surviving timber buildings in China, has undergone a luxury makeover: the monstrous palaces which had been built around it have been demolished, and reconstructed at vast expense strictly in the Ming style, with all the decoration and ornamentation characteristic of ancient China. The Buddhist temple in Jinci has become a popular destination for family outings. Its park and pagodas are a heaving mass of people and cameras. At nearby Mount Tianlong, people are curious to see and eager to participate in the religious rites conducted by an old Taoist priest with a long beard, dressed entirely in black and white. For the umpteenth time, somebody poses for a photograph in front of the symbols of yin and yang.

OPPOSITE: The narrow streets of a peasant village in the mountains of Wutai Shan. These Chinese houses look impenetrable: high walls enclose a courtyard which is surrounded on all sides by small single-storey houses.

OVERLEAF: Navigating the Yellow River is only possible when the waters are high.

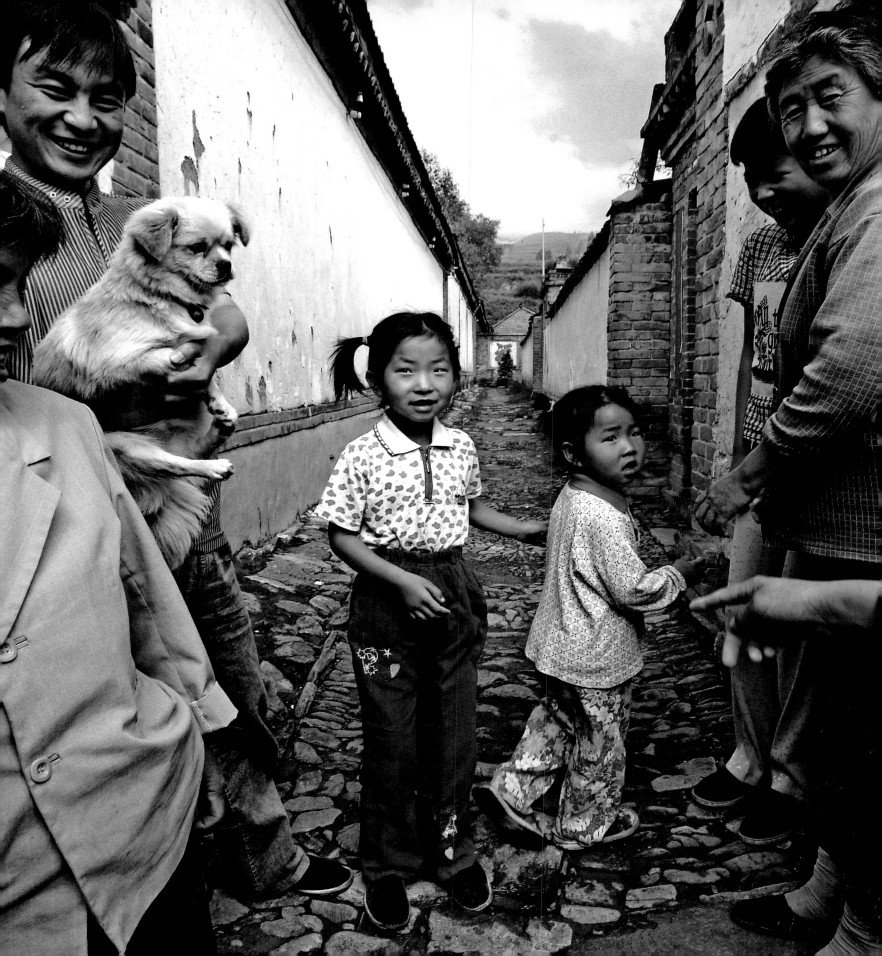

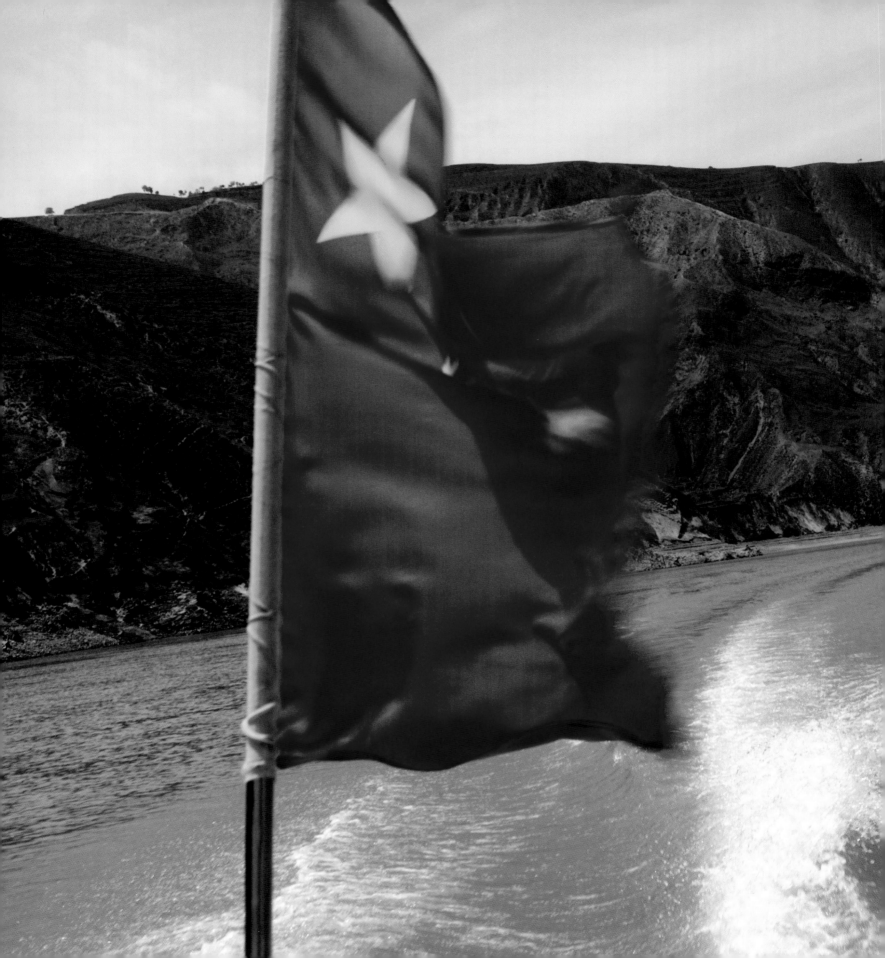

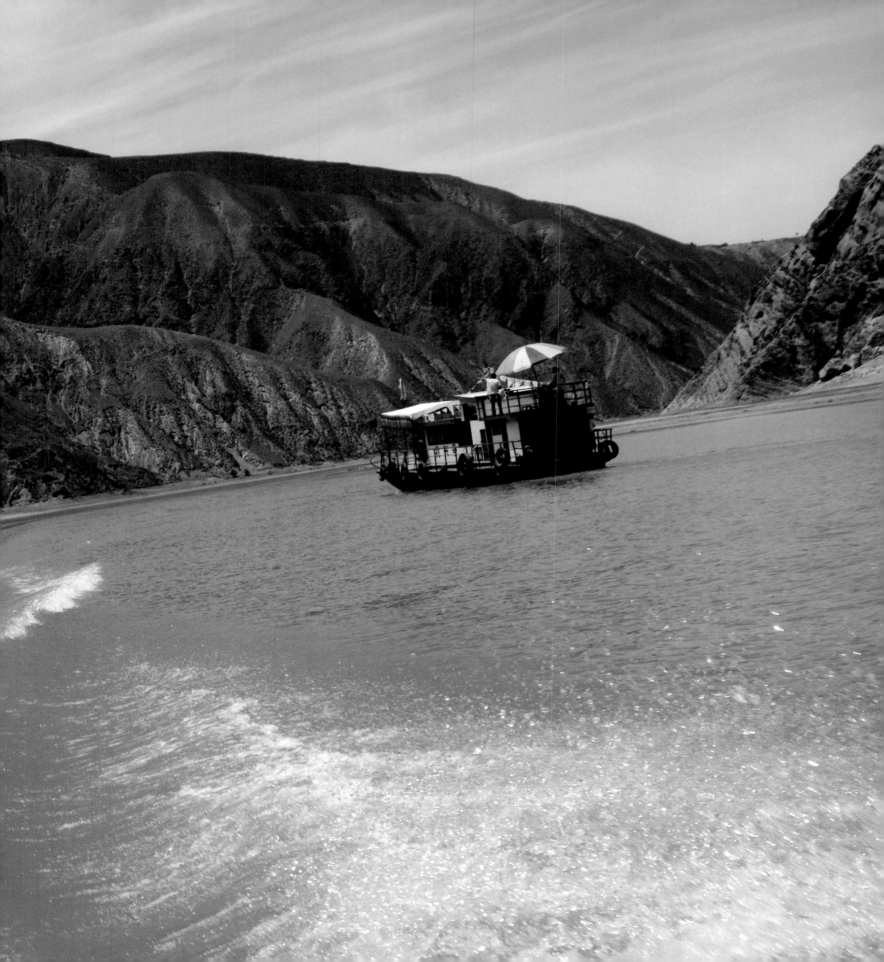

OPPOSITE: This village is near Taiyuan, the capital of the province of Shanxi. The tiled wall, representing a temple, and bearing calligraphic inscriptions, was originally constructed in front of an opulent mansion, in order to keep out evil spirits. Although China has determinedly embraced modernity, it is still firmly rooted in folklore.

RIGHT: Three boys playing in a mountain village in the Heng Shan region. Outside the big cities, the houses still retain architectural elements of the traditional Chinese style, with pagoda roofs, glazed tiles and impressive gateways along the imposing brick walls.

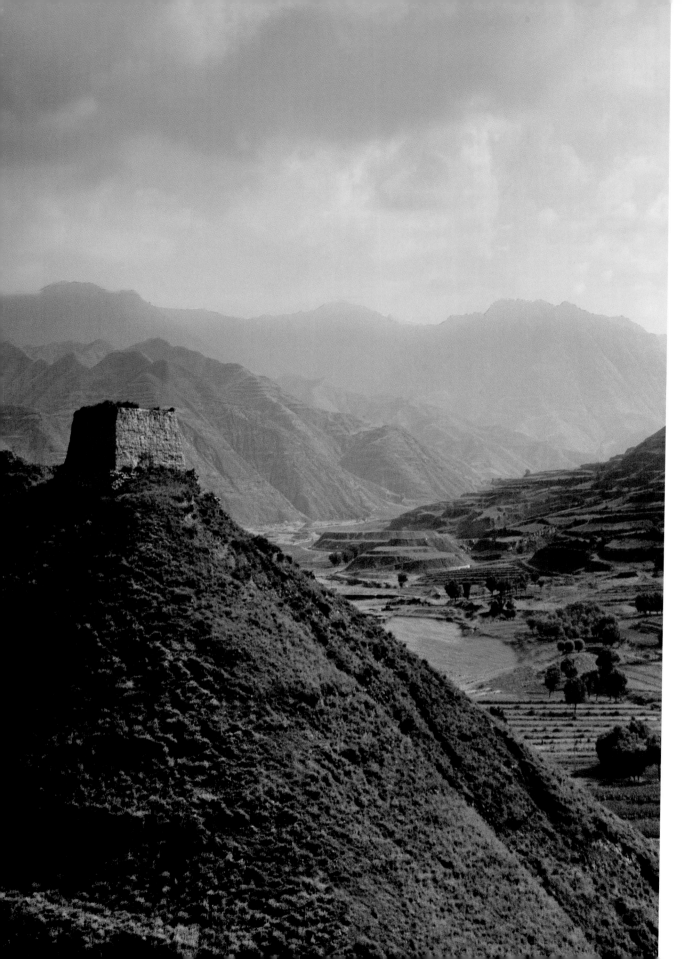

The Great Wall climbs up the mountains surrounding the Yellow River, along the stretch that marks the boundary between the provinces of Shaanxi and Shanxi. This extensive bastion, which was built using clay soil, resembles a serpent made of dried mud. A few solitary watch towers are visible on the summits of the hills. The scenery is typical of the landscape through which the Yellow River flows.

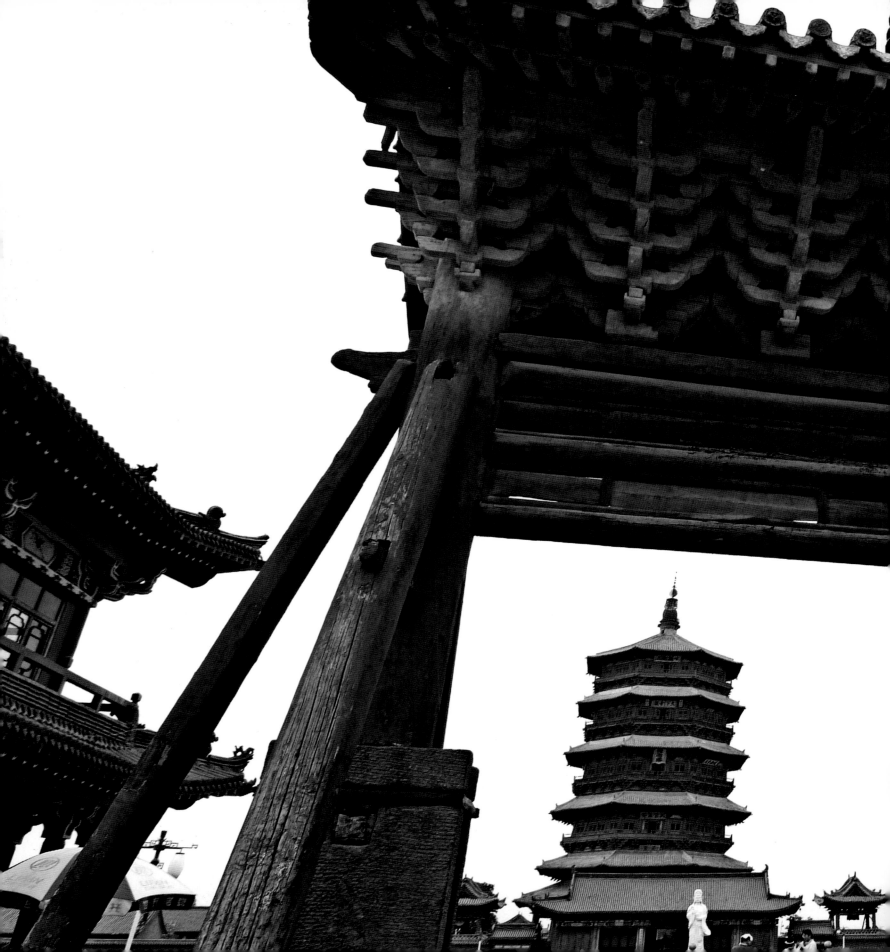

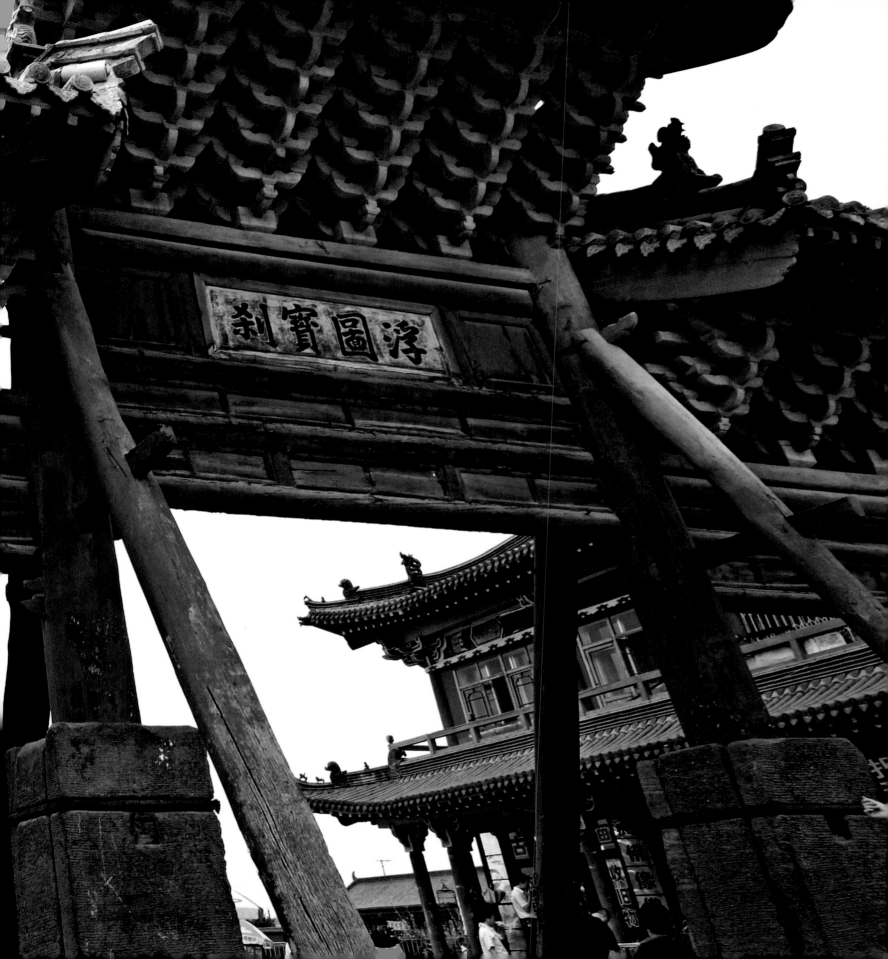

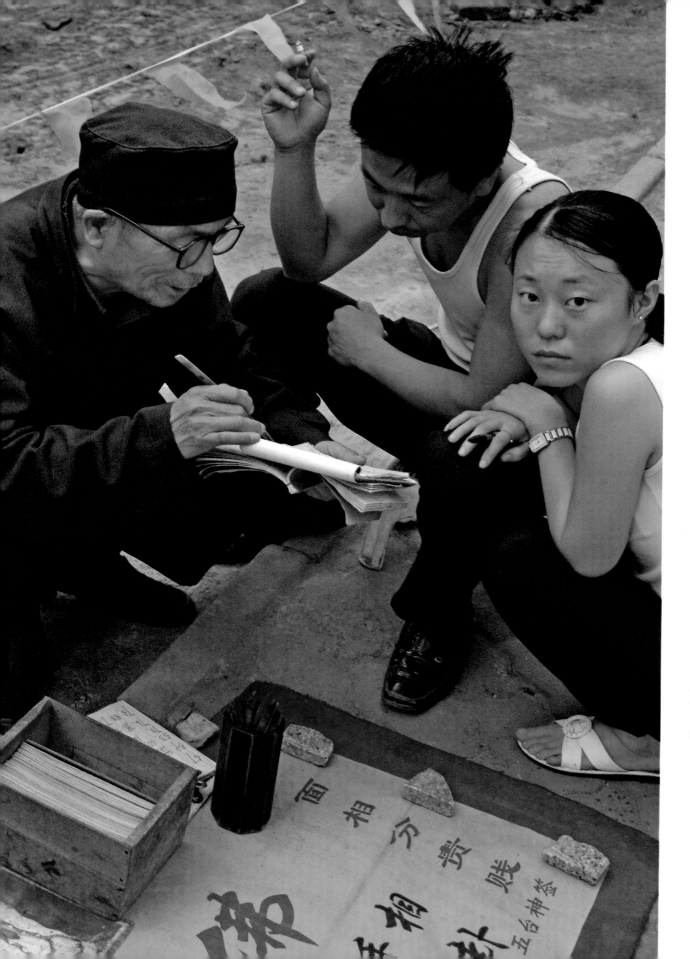

PRECEDING PAGES: The Yingxian Pagoda, one of the oldest timber constructions in China. The concrete buildings that had been erected around it have been demolished and rebuilt in the Ming style, following ancient methods of ornamentation and decoration. Taiyuan, the capital of Shanxi, is undergoing rapid expansion, although the province is still relatively underdeveloped compared with China as a whole. There are clear contrasts: in the city centre, old buildings have been demolished to make way for glittering new constructions housing offices and shopping centres, but down the side streets the urban style of the old China is still very much in evidence, and hutongs – the traditional quarters where dwellings are enclosed by high walls – are still being built.

LEFT: A young engaged couple visit a fortune-teller. The most common questions centre around money, health and children.

OPPOSITE: A few elderly men lounge around in front of a shopping centre. Where the hutongs are disappearing, the old lifestyles are forced to change, and the older inhabitants no longer have a place to meet.

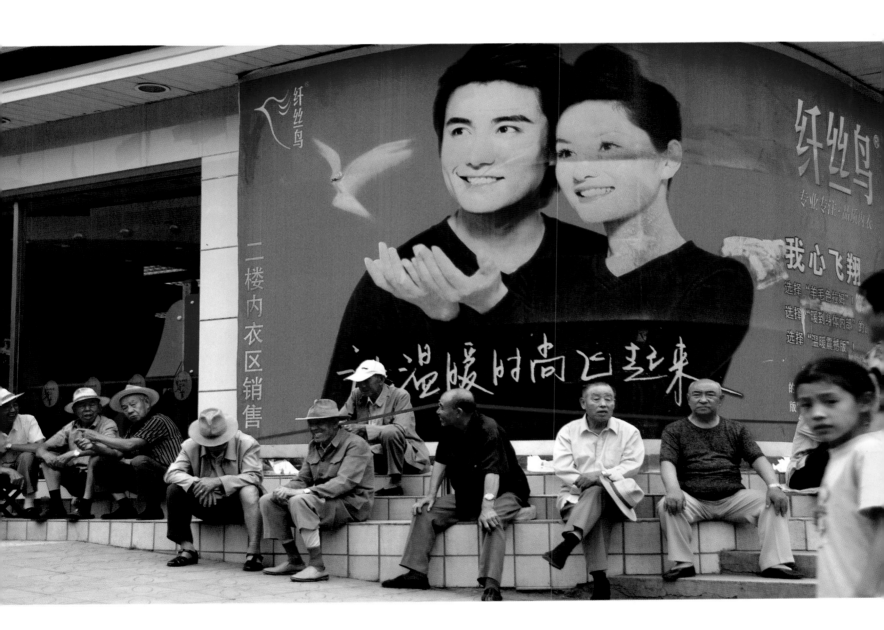

AT THE FOOT OF THE GREAT WALL

AT THE FOOT OF THE GREAT WALL **157**

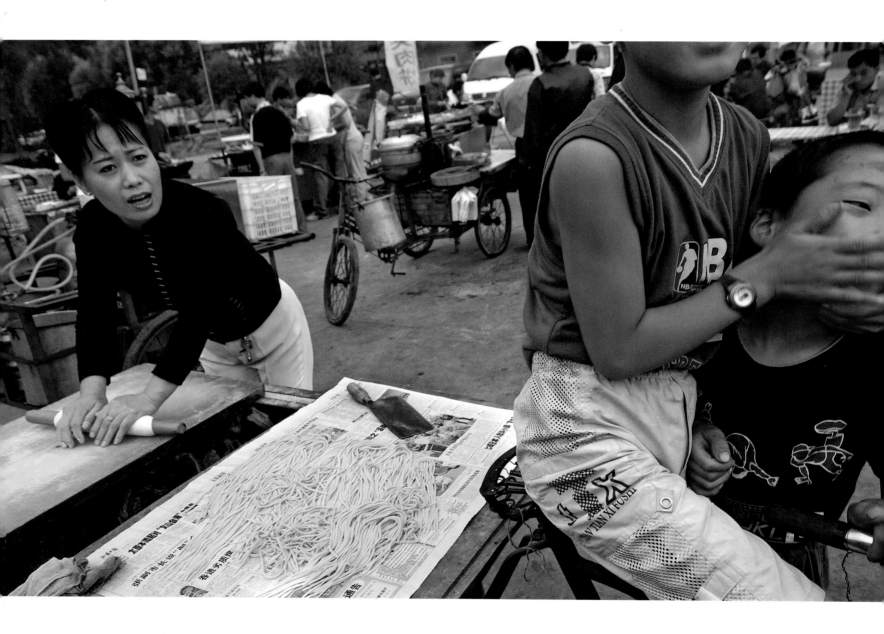

Two views of daily life in small urban centres in Shanxi, along the road from Datong to Taiyuan.

OPPOSITE: A noodle-seller works hard at her stall while her two children play around on their bicycles.

RIGHT: A colourful stall run by a man whose style of clothing was popular under Mao. This style was once widespread, but is now virtually non-existent in the cities and in the more developed provinces.

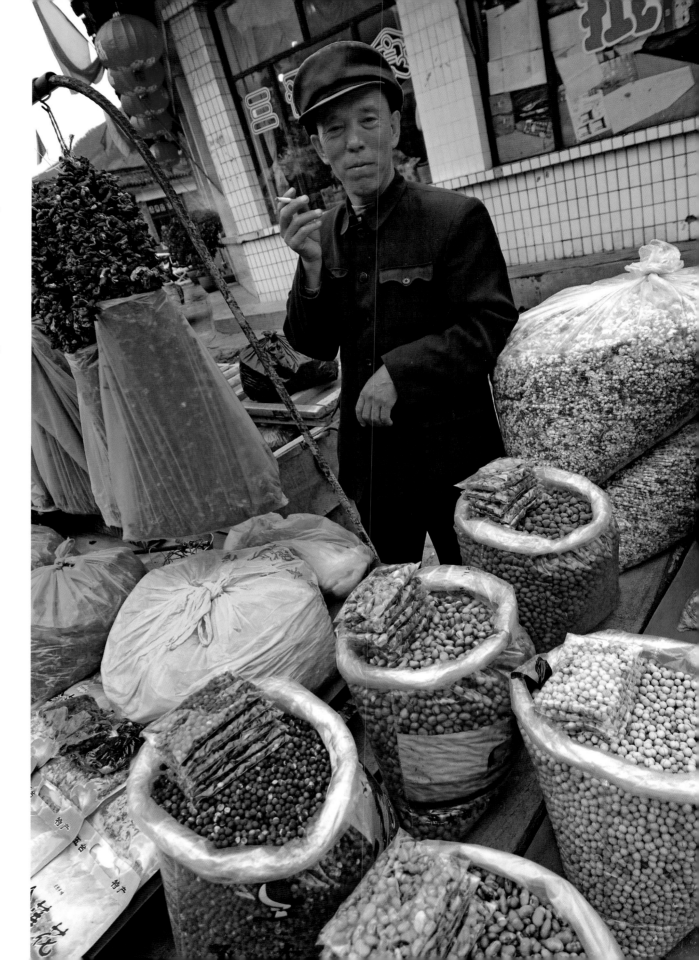

The air is thin. We have left the congested roads of Shanxi behind us, and are now at an altitude of 1,800 metres (5,900 feet), at a place that is the equivalent of the Vatican for Chinese Buddhists. Here there are several different monasteries belonging to the various schools of Mahayana Buddhism, including Chan, (which is most common in China), Vajrayana and Tibetan Buddhism. The place is called Wutai Shan. In order to get here we have climbed up through woodlands and gone past mountain villages. Life here is simple and basic: subsistence agriculture consisting of cultivated fields, vegetable plots and sheep-farming. Wutai Shan suffered when the fury of the Red Guard led to the destruction of forty monasteries, although it is said that a certain Chu En Lai intervened in an attempt to save this piece of heritage, whose oldest temples were built two thousand years ago. Nonetheless, Wutai Shan disappeared off the face of the map, like the forgotten son of the people. Then, when religion was no longer taboo, it reappeared, transforming itself into a religious destination, and clearly a tourist one also. Restaurants and hotels have sprung up like mushrooms. 'Good, very good,' a young monk named Wang assures me. He is wearing a grey tunic and yellow slippers, the traditional dress of Chinese Buddhists, and also has a straw hat on. 'Tourism has been the saving of the monasteries. It brings money, without which we couldn't live.' The sound of a gong echoes in the air, then the strident voice of a singer, and long, ringing tones. A Chinese opera is about to start in the courtyard of the temple of Wu Ye Miuo. It is only ten in the morning but already a great crowd of people has gathered. What a variety of apparel! Trainers, overalls, silk garments, Mao-style jackets, boots...it is a synthesis of all the aspects of modern China on its path to progress. A theatre in the house of God? Nothing amazing about that. The temple itself has staged the opera, using actors from the best theatres in China, who are proud to be performing up here.

OPPOSITE: The famous zigzag bridge at Jinci Temple, an important religious building with a long history which can be traced back to the 11th century BC.

OVERLEAF: A Buddhist chapel at the spectacular Hanging Monastery of Xuankong Si.

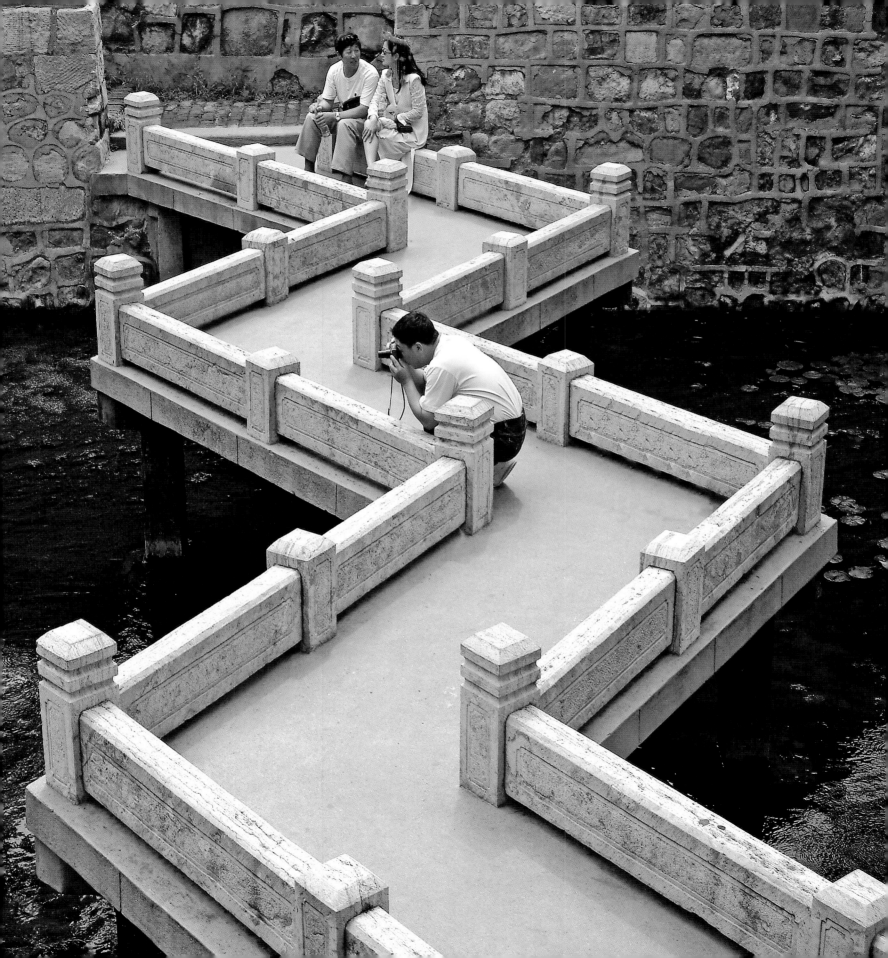

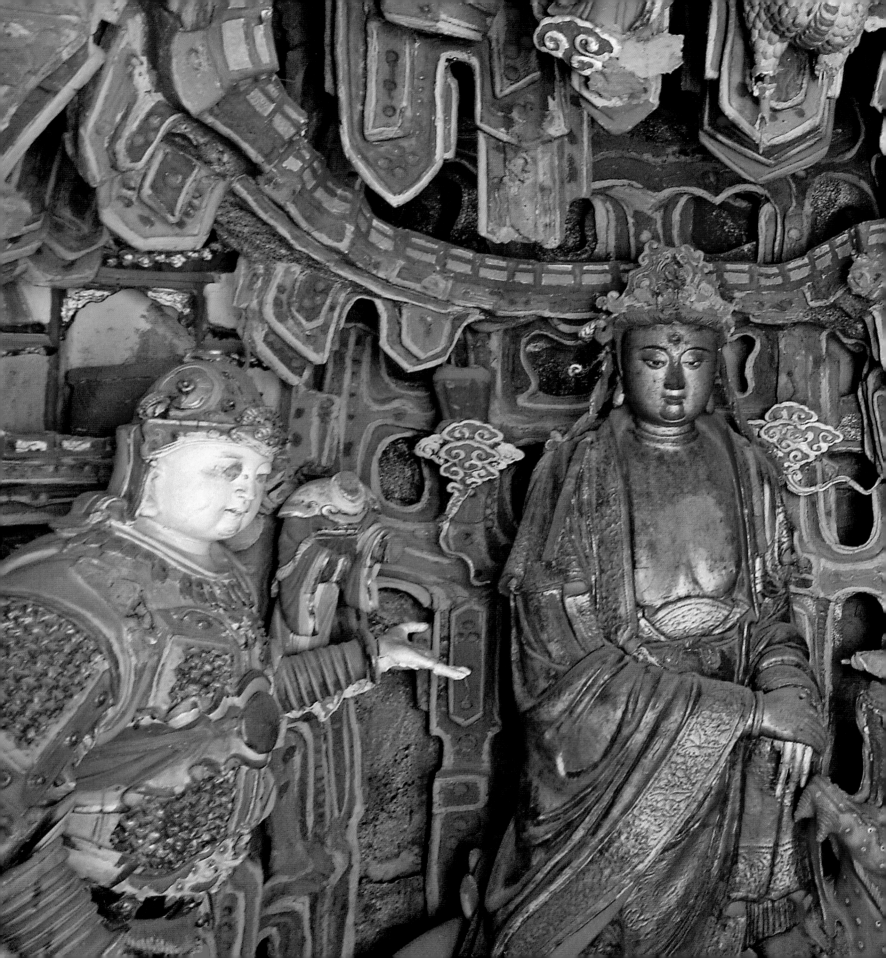

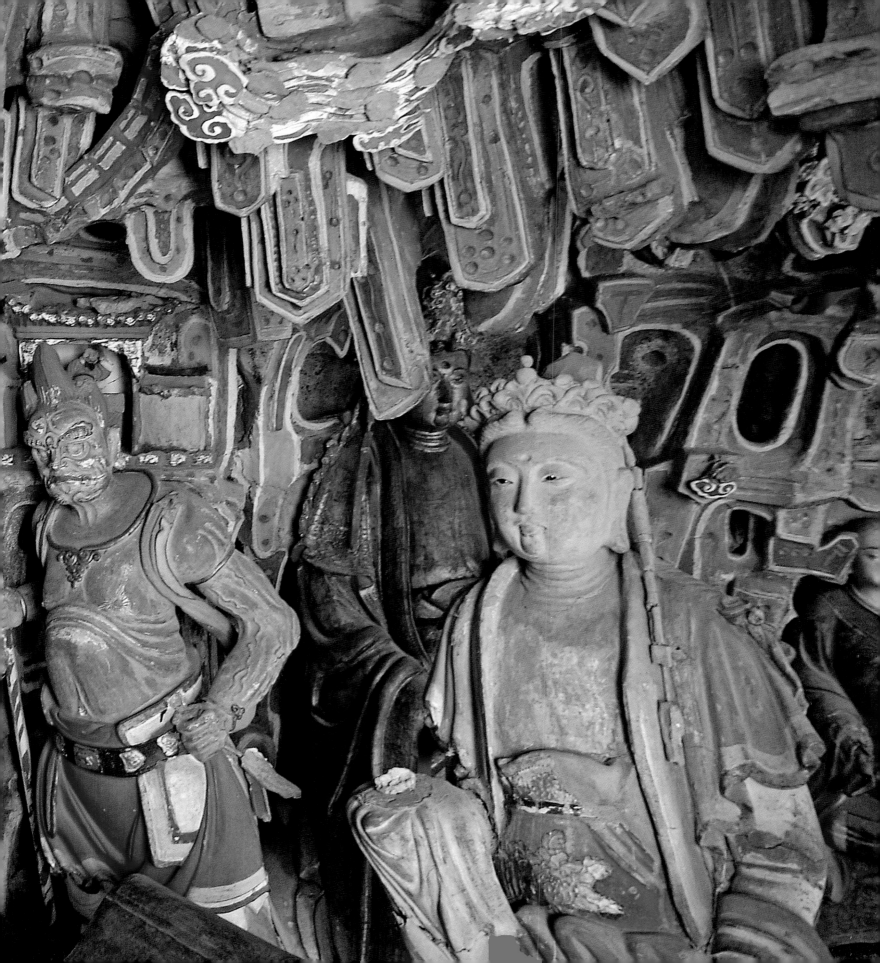

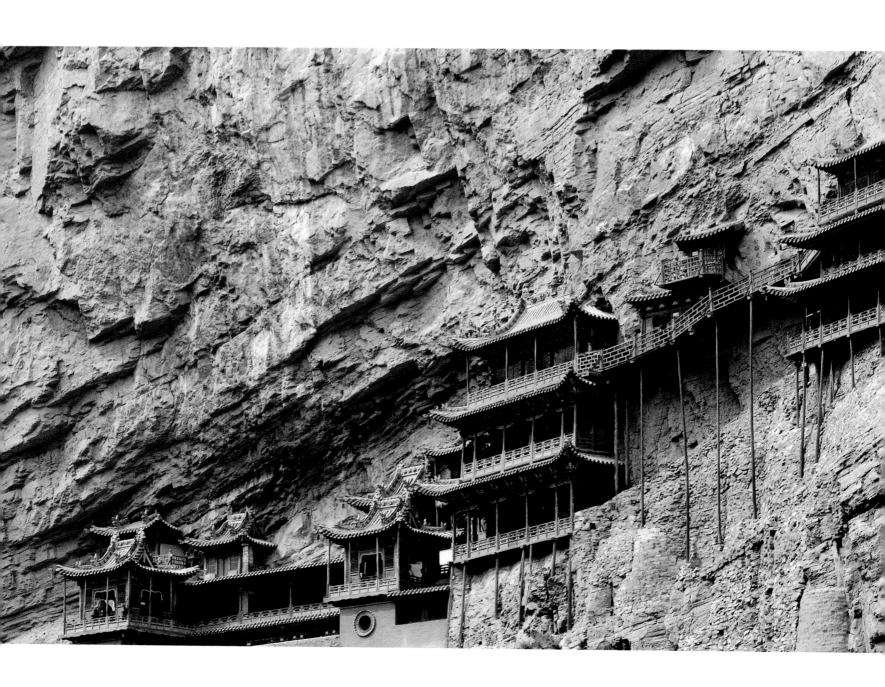

A monk prays inside the spectacular Hanging Monastery of Xuankong Si. Built more than 1,400 years ago, the complex is situated 75 kilometres (47 miles) from Datong in the Heng Shan Mountains. It is constructed from dozens of long, thin pieces of wood, and consists of forty small pavilions connected by precarious walkways suspended in the air. A protruding rock protects it from showers, like an umbrella, and the surrounding peaks shield it from the sun, although even in the summer the monastery receives only three hours of sunlight during the day. Perhaps it is for these reasons that the structure has remained intact for hundreds of years. The temple is dedicated to the three Chinese religions, integrating Buddhism, Taoism and Confucianism. This syncretism is characteristic of China, a country that absorbs different cultures, celebrating the similarities and smoothing over the differences. Contradictions are minimized and even eliminated, as with Christianity and Islam, which came to China from the west, and have somehow been adapted to the needs of the Chinese people.

The intense expression of an actress being made up for a performance of Chinese opera in the temple of Wu Ye Miuo in Taihuai, a village in the Wutai Shan Mountains at an altitude of 3,058 metres (10,033 feet). The central elements of this kind of theatre are music and dance, while the characters perform fixed roles. Actors come from all over China to perform on the stage of Wutai Shan. Opera and popular music are often performed, and it is not uncommon to find groups of people in city parks playing and dancing traditional scenes from the theatre.

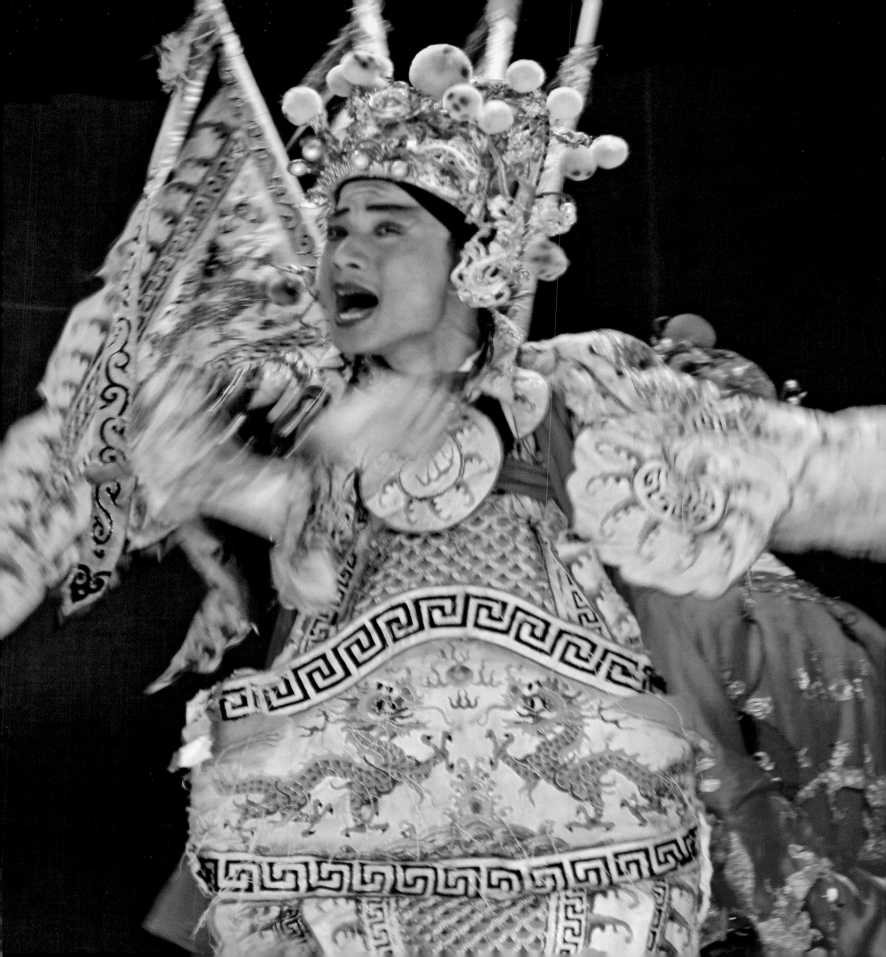

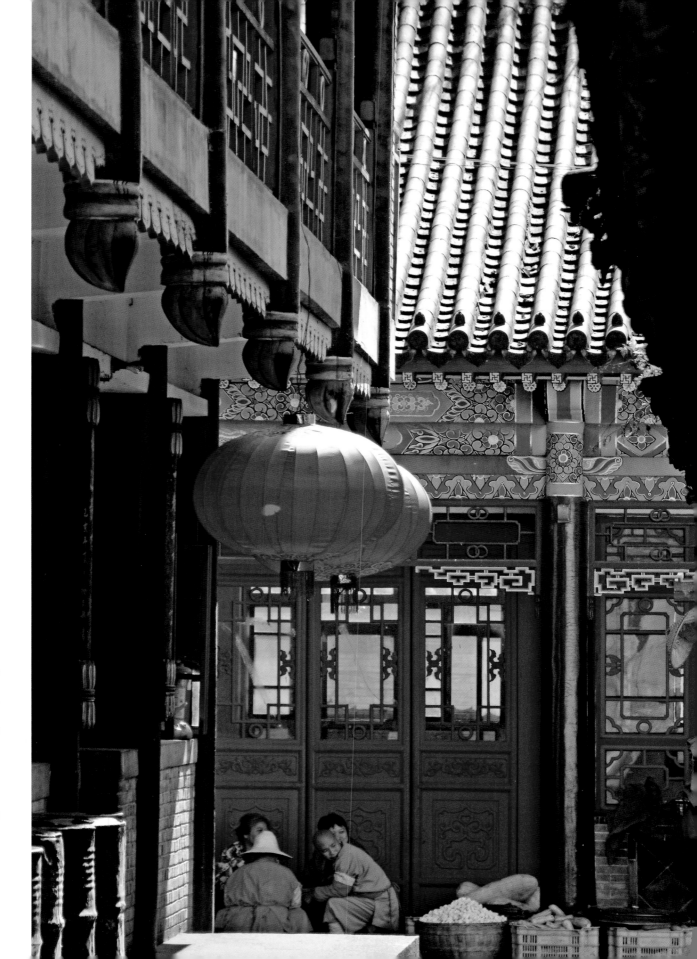

OPPOSITE: A tourist poses for the camera inside the temple of Pusa Din at Wutai Shan.

RIGHT: A glimpse of the Taiyuan Monastery at Wutai Shan, its principal religious complex. Over recent years, this Buddhist monastery has become a popular destination for 'religious tourism'. All of the main Chinese schools of Buddhism are to be found here, along with Tibetan Buddhism. The most popular school is called Qingtu, meaning 'Pure Land', which professes belief in Amitabha, who was one of the Buddhas recognized in the Mahayana philosophy. According to the legend, he was an ancient king who wanted to become a Buddha in order to save his fellow men, and establish a new reign of joy and wisdom. The bodhisattvas also venerate the female deity Guanyin, goddess of compassion. There is also the Chan School, which uses the Japanese term Zen to denote the belief that enlightenment occurs spontaneously, rather than as a result of theological thought and the cult of written texts. In reaction to this movement, a new school was developed which highlighted the importance of a combination of meditation, moral discipline, study and ritual. Another important strand of Chinese Buddhism is the Zhenyan School, otherwise known as Tantrism, which uses ceremony and magical formulas as a means of attaining enlightenment.

OVERLEAF: A view of the Fen River, a tributary of the Yellow River.

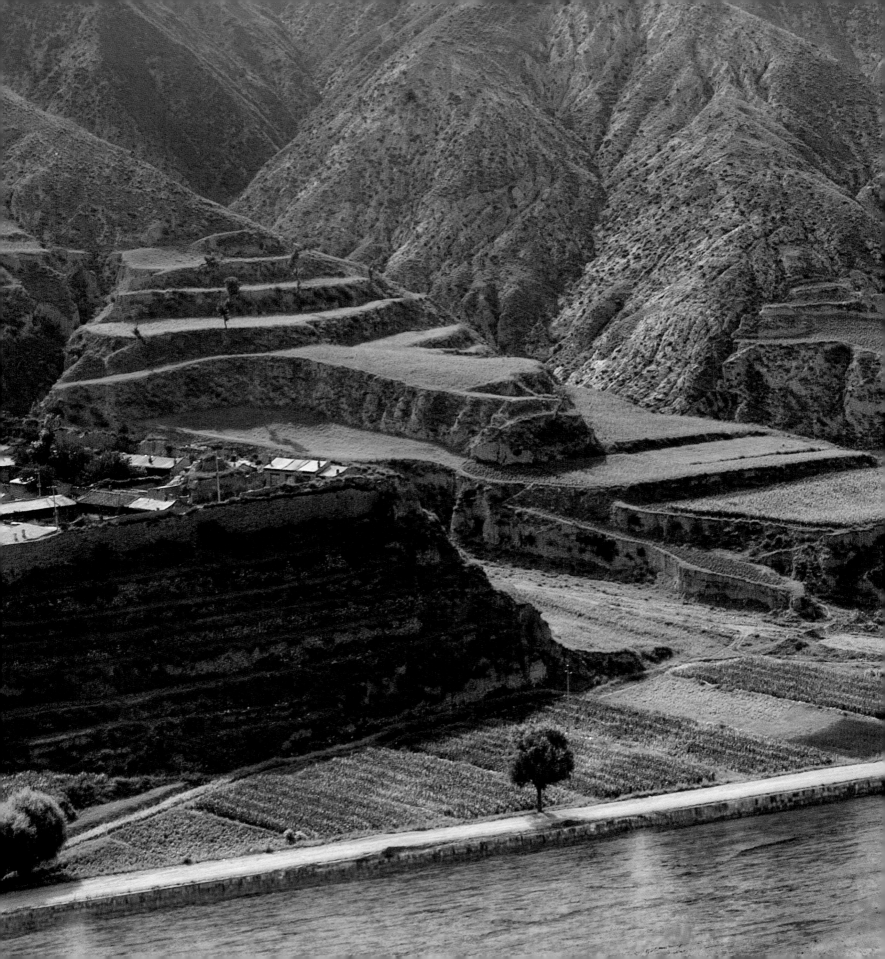

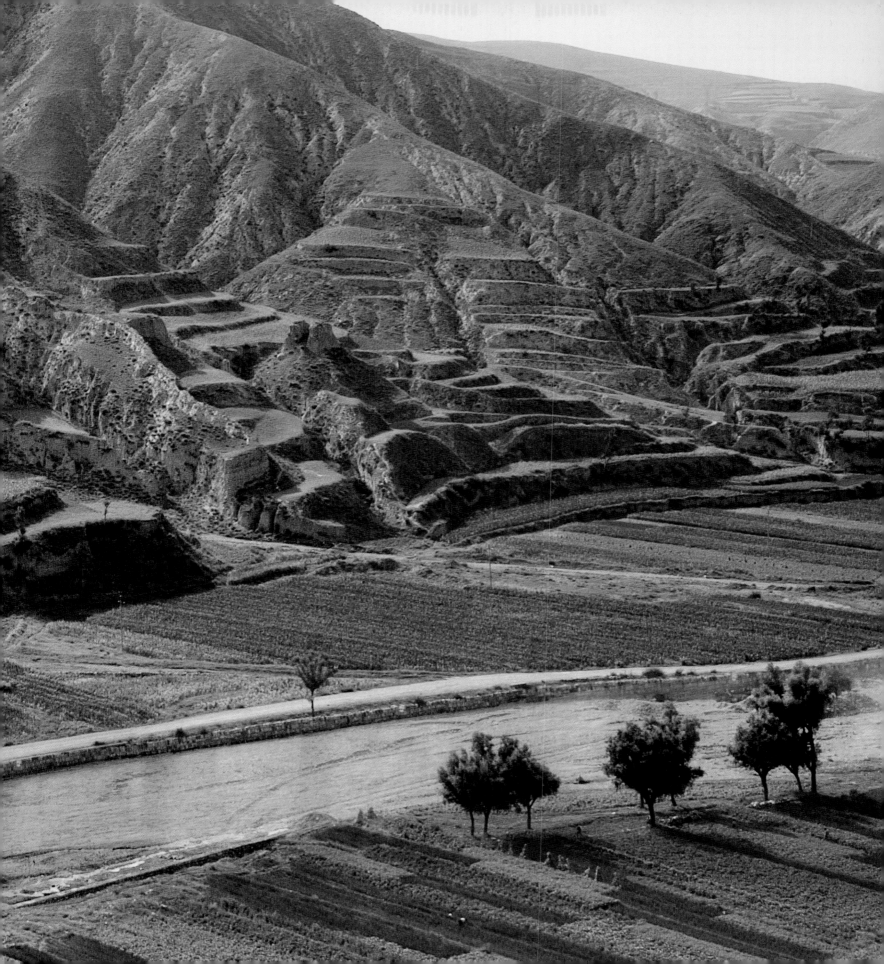

The Warm Glow of the Red Lanterns

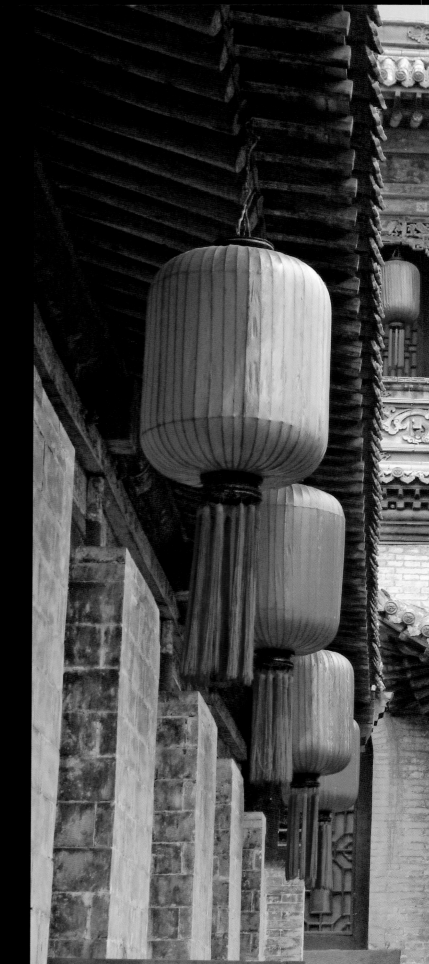

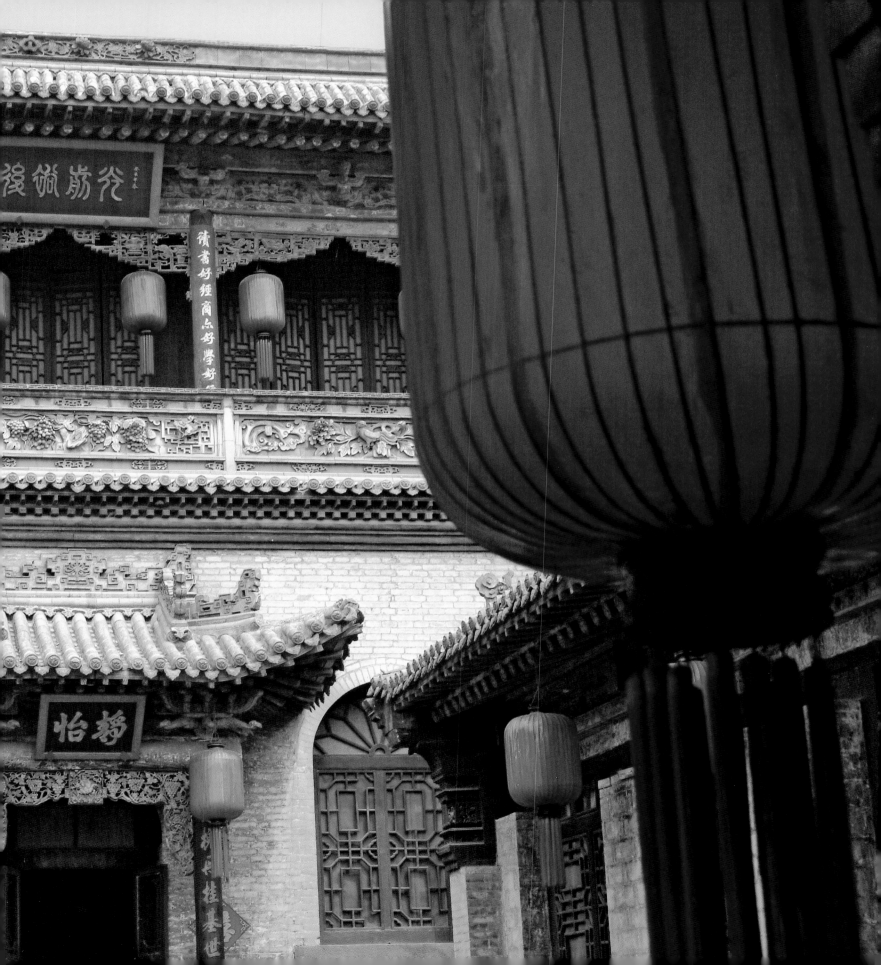

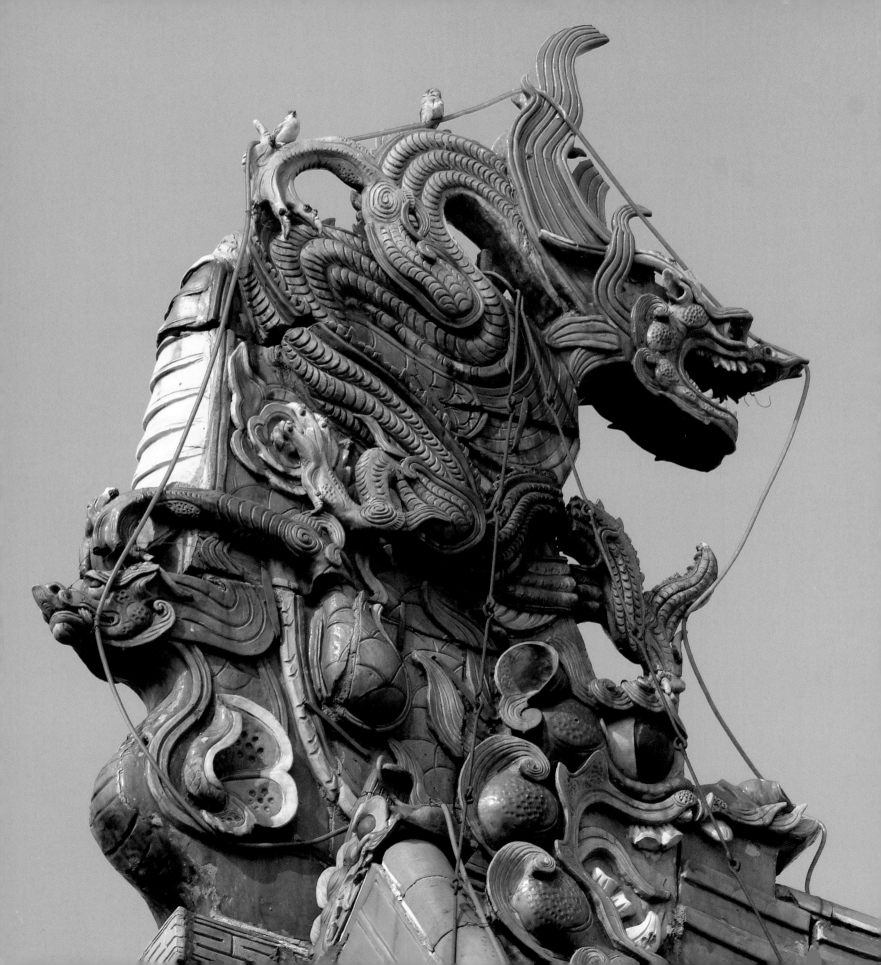

'NIHAO' – 'Hi.' A young woman comes up to me in the street. I am standing beneath a majestic central tower, completely constructed out of wood, which seems to be exercising a gravitational pull over the fluttering pagoda-style roofs around it. 'Are you looking for a hotel? Come with me please. Good price.' She is wearing the traditional Chinese *qipao*, a fitted silk dress with a long slit up the back. She is charming, with a gracious manner. She uses her charms to accost potential clients who have just arrived in the city. There are no cars or motorbikes to be seen, only rickshaws and bicycles. Pingyao is an anomaly in China, which is so crowded and chaotic, and well worth the detour from the Yellow River, for the dragon has left indelible traces here. Once inside the impressive circle of walls surrounding the city, the scene resembles a postcard from the Ming era, when Europe was already an avid consumer of Chinese merchandise: silk, porcelain, lacquered furniture, embroidered garments, jade and tea. These goods travelled along the Silk Route, as described in *The Most Noble and Famous Travels of Marco Polo*. Comfort, luxury, aesthetic taste – images of a rich and abundant country. Today, little remains of the great China of those days. Much of it has been ravaged by time; much of it became dust and ashes during the Cultural Revolution. Pingyao is an exception. Here, ancient China has suddenly been rediscovered. UNESCO has added it to its list of World Heritage Sites, and after decades of lethargy, it is being visited once again by tourists. Among the tourists to come here have been the Chinese themselves, who feel a spiritual affinity with this place. They have flocked here from Beijing, Shanghai, Hong Kong, and even from Taiwan and Singapore, in search of their roots, which have either been lost or destroyed. Upon arrival, they stand open-mouthed, for even they have never seen this face of China before. Narrow streets, high walls of grey bricks, pagoda roofs, and an infinite array of architectural frills, such as glazed roof tiles, panels decorated with miniatures, inlaid architraves, stone gateways, statues and red lanterns. In the evening, the lanterns bathe everything and everyone in a red glow, illuminating the rickshaws as they emerge from the darkness. There are shops with folding doors, temples with carved entrance archways known as *paifang*, gateways, and noble mansions with ornate interior courtyards. An abundance of riches from the days of the mandarins.

'This city would have been typical of the Han, the authentic Chinese. It is our origin. These are the roots of the Dragon Country,' Tang explains, with evident pride in his nation. At twenty-five, he has just graduated in architecture and is hoping to get a job here; perhaps a temporary contract in a civic museum. In recent years, the city has undergone a small revolution. Never have there been so many people on the streets, with amazing consequences: the revenue from entrance tickets now amounts to around $1.2 million per annum. That is a mind-blowing figure for China. The politicians who decided to protect the city at all costs have indeed spent considerable amounts of money on the restoration work. In the meantime they have also come up with a plan to evict a large proportion of the 47,000 inhabitants from the residential heart of the city. For the sake of conservation, they want a maximum of 20,000 to remain. They have already begun to carry out the plan, but not everyone agrees with it. Some fear that the city will turn into a silent museum, whereas others are delighted with the prospect of a brand new apartment outside the city walls, and are in favour of the municipal government's plan. The illusion of modernity is winning new converts, particularly among those living in old houses in the historic centre, which have never been renovated. Tang adds: 'There is no other way to save the city – everything will be lost otherwise. There are still many offices and businesses which would flourish extremely well outside the historic centre. Pingyao is a sacred relic which should be guarded and protected as if it were a species under threat of extinction. It is the panda of architecture.' It all boils down to money: once it was ideology that guided political decisions; now it is money. Tourism, the bourgeois pastime neglected by the regime until relatively recently, has now undergone a transformation. It now drives the Chinese economy, and for this reason in Pingyao and elsewhere many of the places of worship which had been closed and left to rot are now being reopened. Today, the temples compete with each other, having been touched up or even reconstructed according to some plan that may have little or nothing to do with the original. In addition to the worship of Confucius, Lao Tzu and Buddha, who have all been enjoying revivals, there is now the cult of the City God, a divinity whose temple is a magnificent display of roofs covered in glazed blue and green tiles, the most elegant in the whole of the city.

OPPOSITE: Cobblers at work in the streets of Pingyao. Chinese slippers, in particular those covered with intricate decorations, are in great demand among tourists visiting the city.

OVERLEAF: The city walls of Pingyao stretch for 6,400 metres (21,000 feet) and are 10 metres in height. The structure originally dates from pre-Christian times, perhaps the 9th century BC, but was entirely rebuilt in 1370 under the Ming dynasty, during the reign of the Hongwu Emperor, when the perimeter of the city was extended. There are 6 imposing gateways and 72 watch-towers: 71 for each of the disciples of Confucius, and one known as the Tower of the God of Literature. The city covers an area of 2.25 square kilometres (0.9 square miles), and was built according to precise instructions which required that the plan should resemble the shell of a turtle. There are 4 main streets, 8 side streets and 72 orthogonal corners.

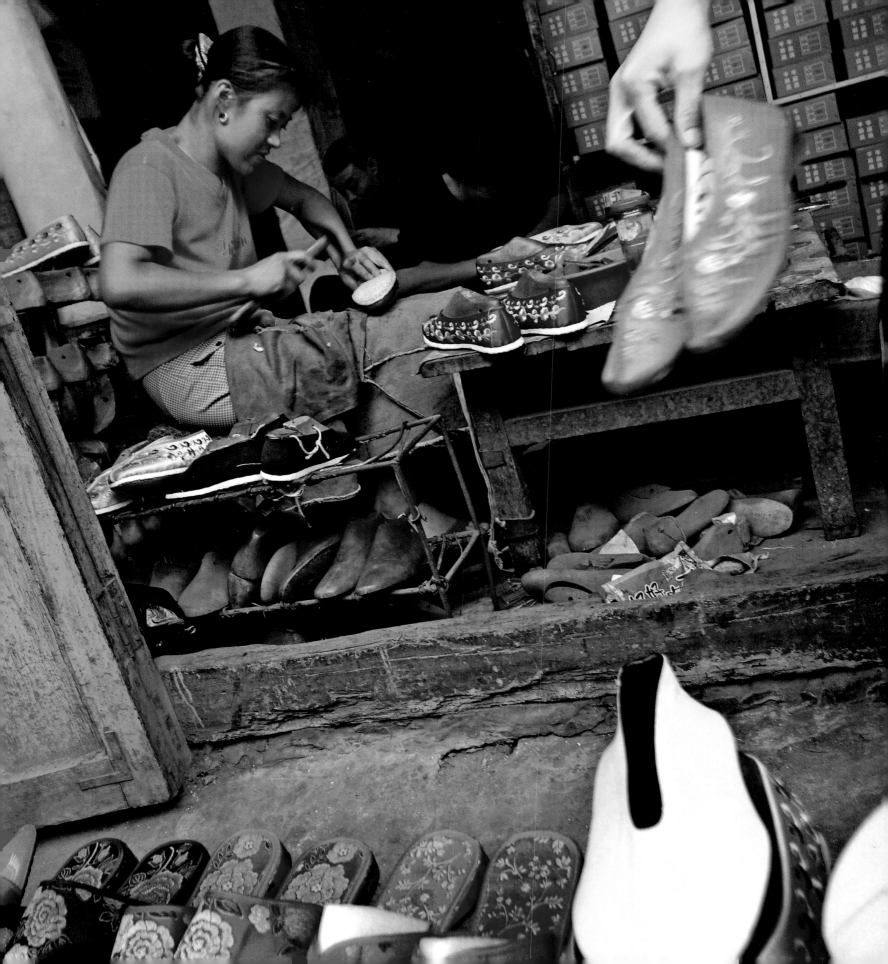

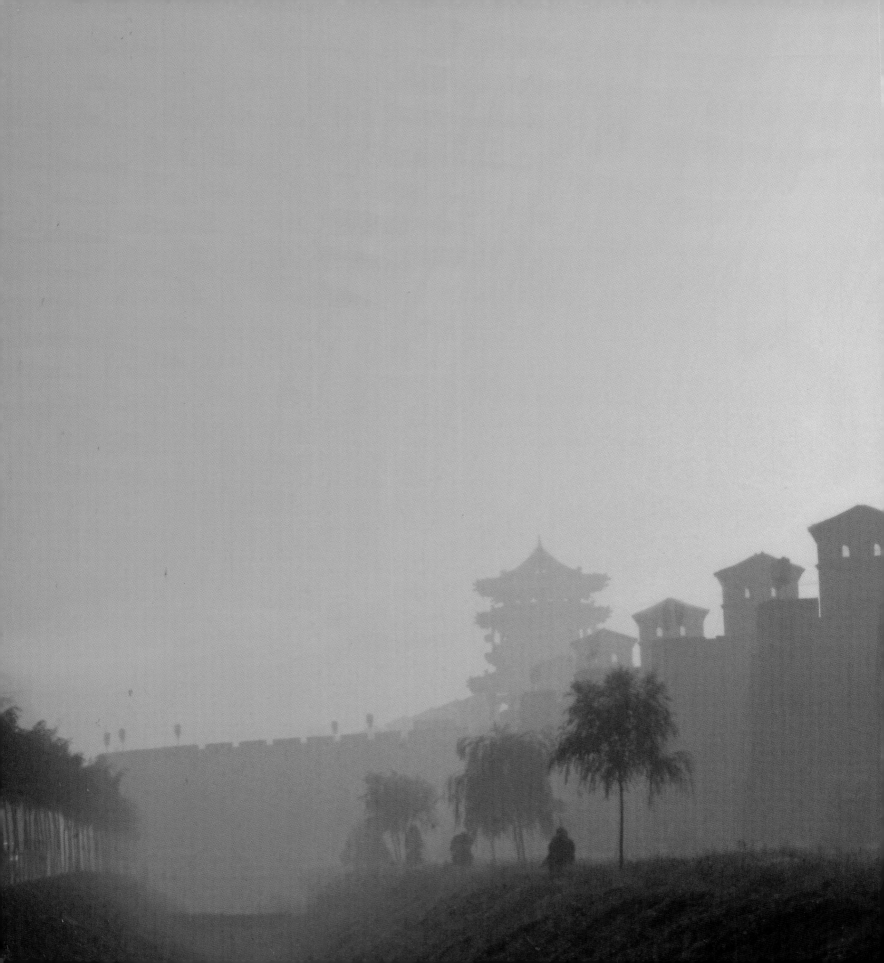

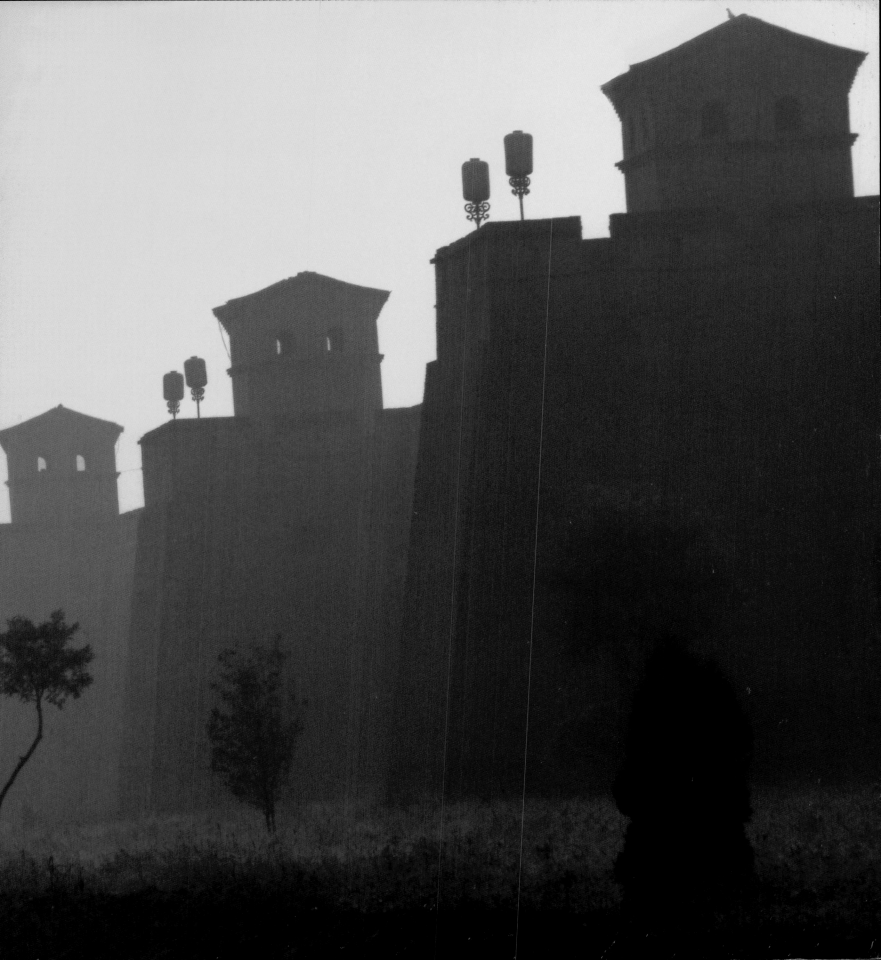

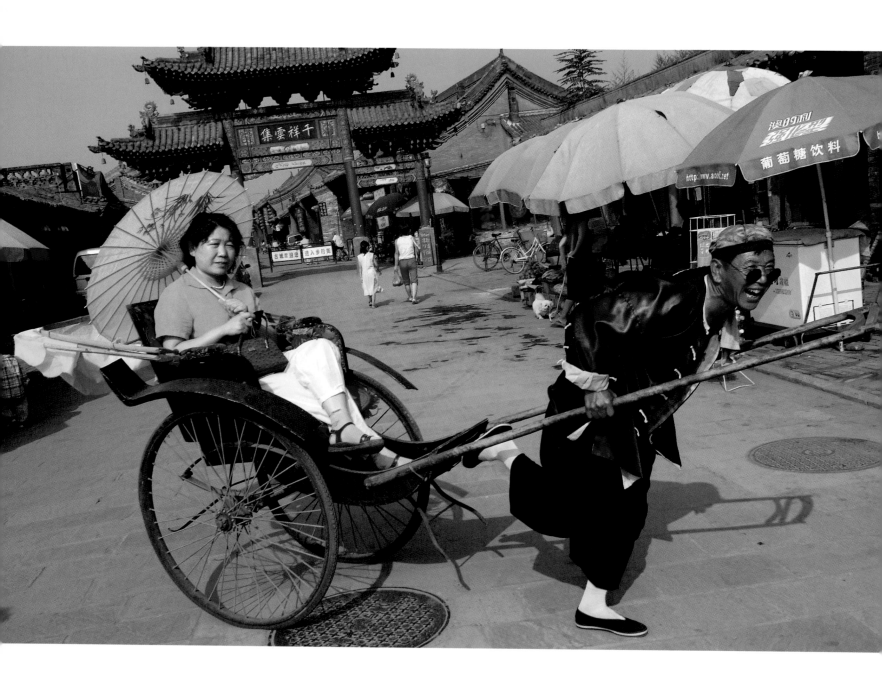

THE WARM GLOW OF THE RED LANTERNS

OPPOSITE: A Chinese tourist allows herself to be photographed on a traditional rickshaw.

RIGHT: The entrance to the temple of the City God, which is dedicated to Shui Yong, the god who has power over the river waters used for the irrigation of crops. The original temple was built in the 14th century, although the current style belongs to the Qing period. The roofs are decorated with acroteria in the form of mythical figures made from glazed tiles. The magnificent gateway, or *paifang*, is a work of art requiring great skill, covered with ornate designs, and making use of the typical coloured bracket joints known as *dougong*.

OVERLEAF: The City Tower, an entirely wooden construction of three storeys, reaches a height of 18 metres (59 feet). It used to be the seat of the authorities, who could oversee the commercial activities taking place below them. Most civic activity is concentrated in the two main axes of the city – East Street and South Street – and most of the historical buildings are found along them. There are around four hundred such buildings, many of which have now been turned into museums. The most famous one is what used to be the Ri Sheng Chang bank, the first bank to open in China. Others were the headquarters of institutions such as the civic government, the yamen, or the homes of wealthy merchants in the 19th century. Amongst the most opulent of these was the house belonging to Lei Lutai, a well-known businessman.

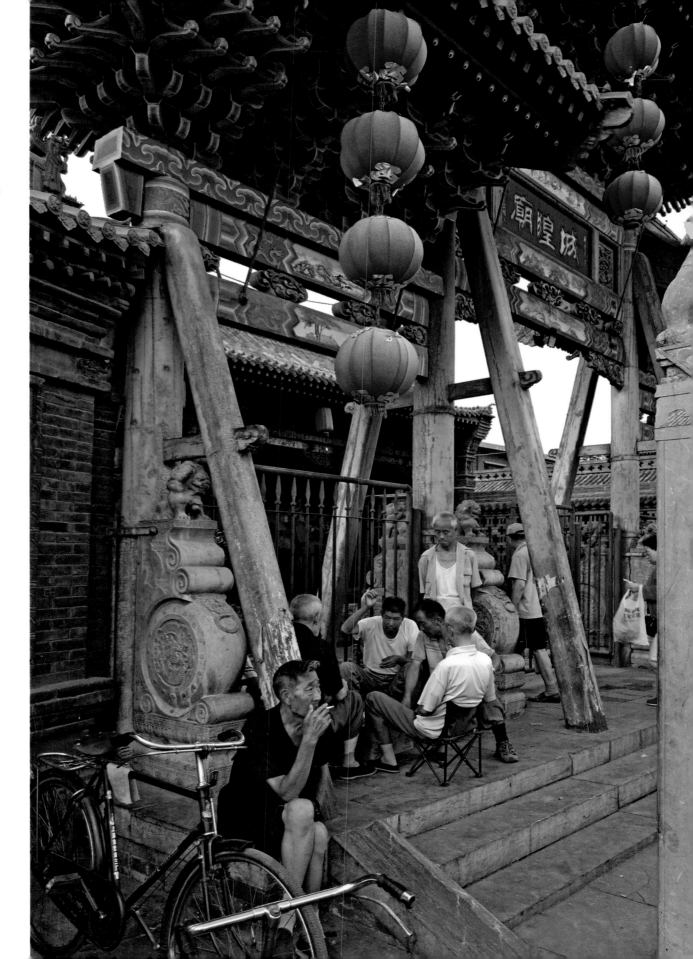

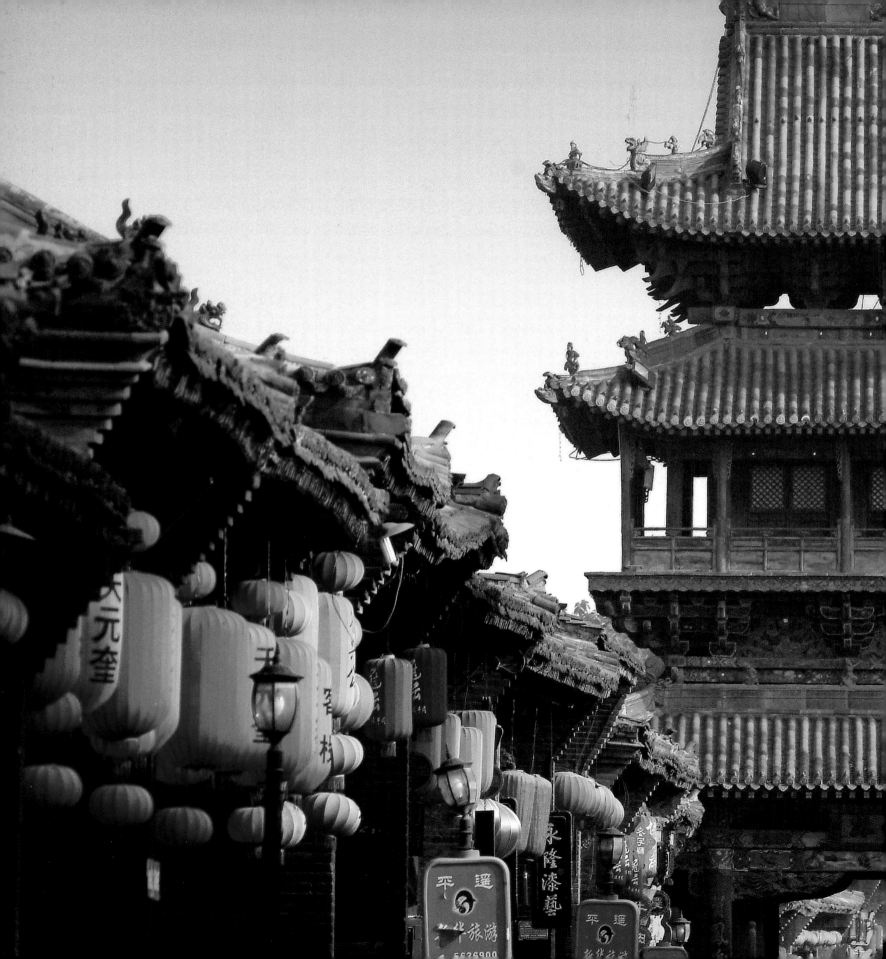

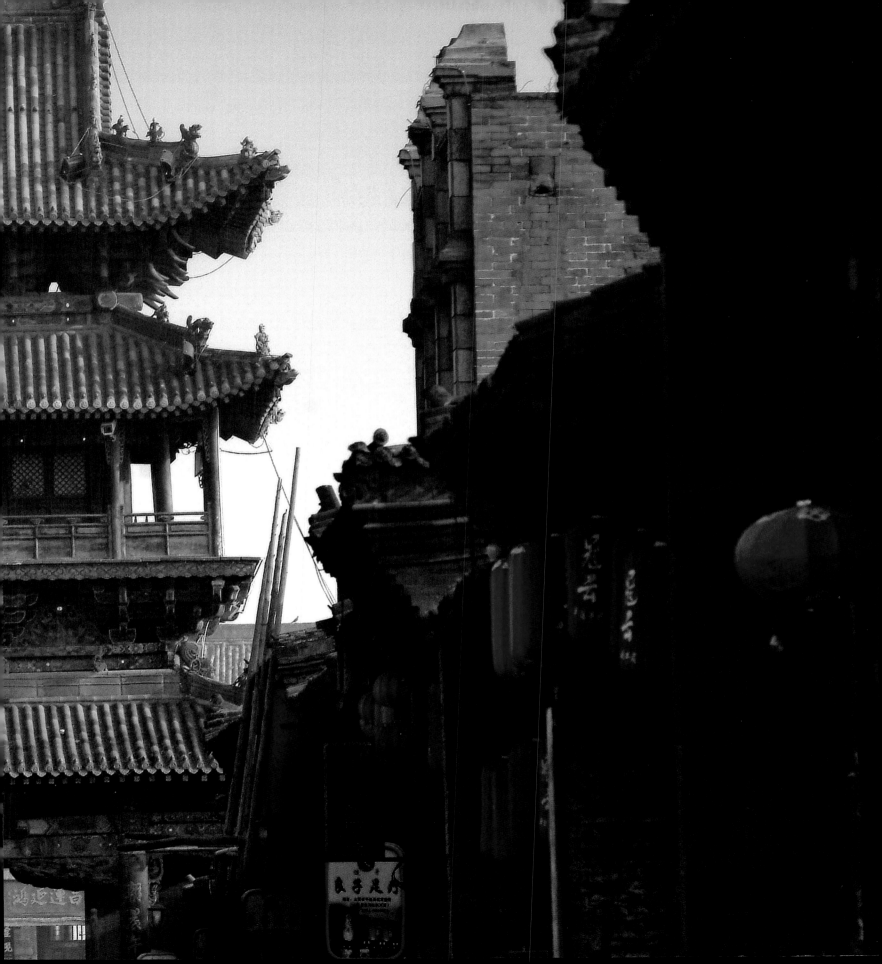

LEFT: A school of design and calligraphy, two arts that are still much prized in Chinese culture.

RIGHT: A view of the centre of Pingyao. The city was once one of the major financial centres in China, and was known as 'Little Peking'. In 1823 China's first bank opened here, the Ri Sheng Chang, which was capable of processing inordinate sums of money, all virtual, by means of cheques, which were a novelty in those days. In the golden years there were twenty-two credit institutes, boasting branches in more than seventy cities in China and abroad. Banking activities enabled the financing of profitable commercial exchanges, and this led to the emergence of a new entrepreneurial class which travelled throughout China. Power was concentrated in the hands of an elite known as the Shanxi Group. The golden years lasted for a century, and then Pingyao began to decline in importance, and luckily for the city, modernization passed it by.

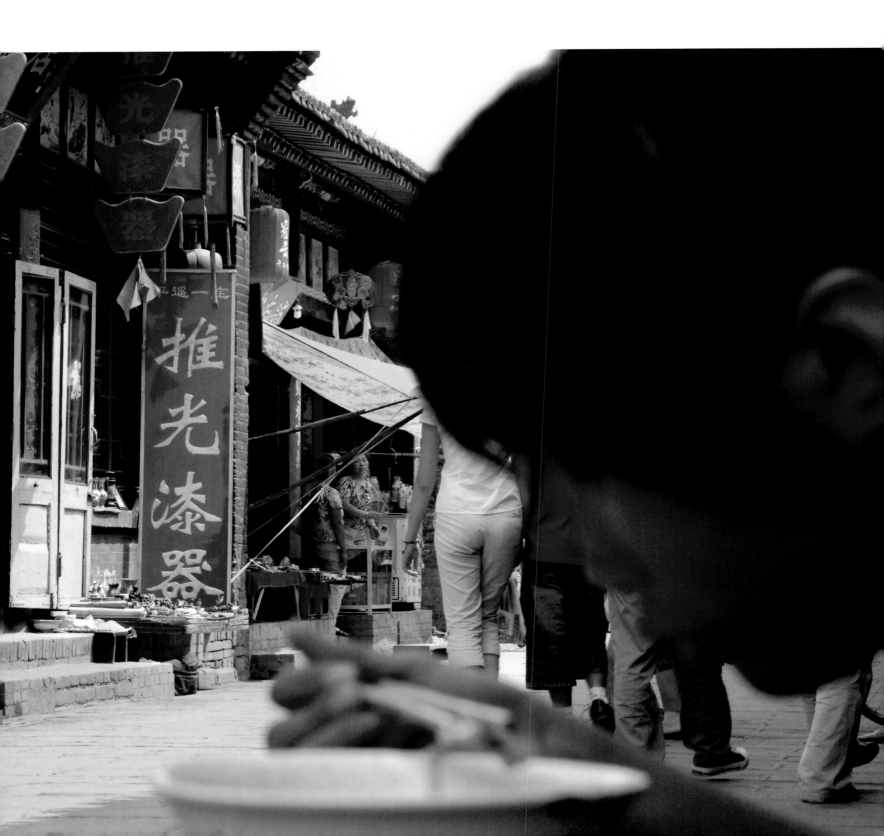

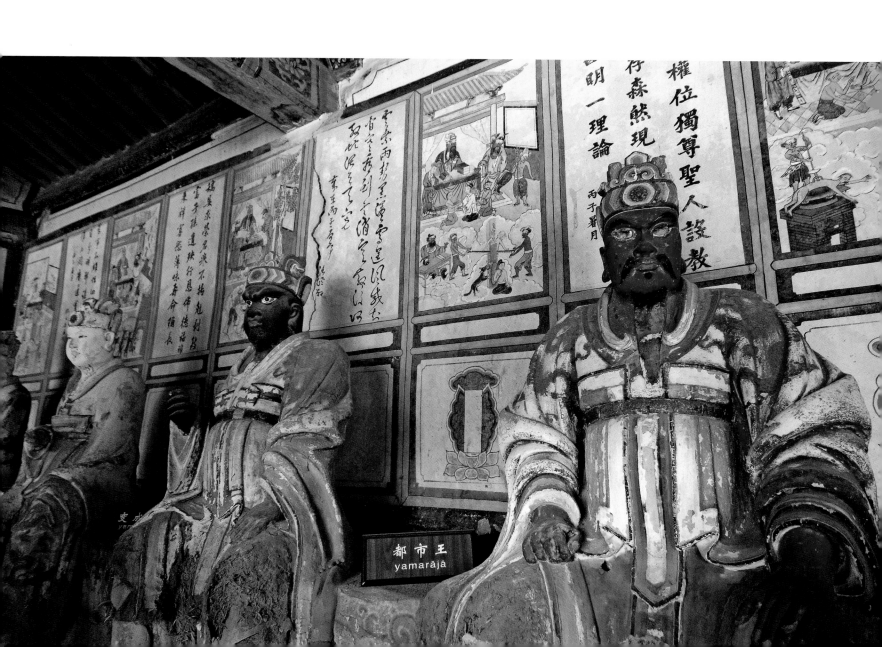

都市王
yamarājā

OPPOSITE: The interior of the temple at Shuanglin, which was begun over 1,500 years ago. Its principal treasure consists of more than 2,000 sculptures created during the Ming dynasty, which were miraculously saved from destruction by the Red Guard. They are displayed in eleven different buildings. The sculptures and reliefs are made out of wood and plaster and represent various deities, or bodhisattvas, illuminated beings, landscapes with flowers, birds, mountains, rivers, houses and temples.

BELOW: A young student at the art school makes a meticulous clay copy of one of the famous statues of Shuanglin Temple.

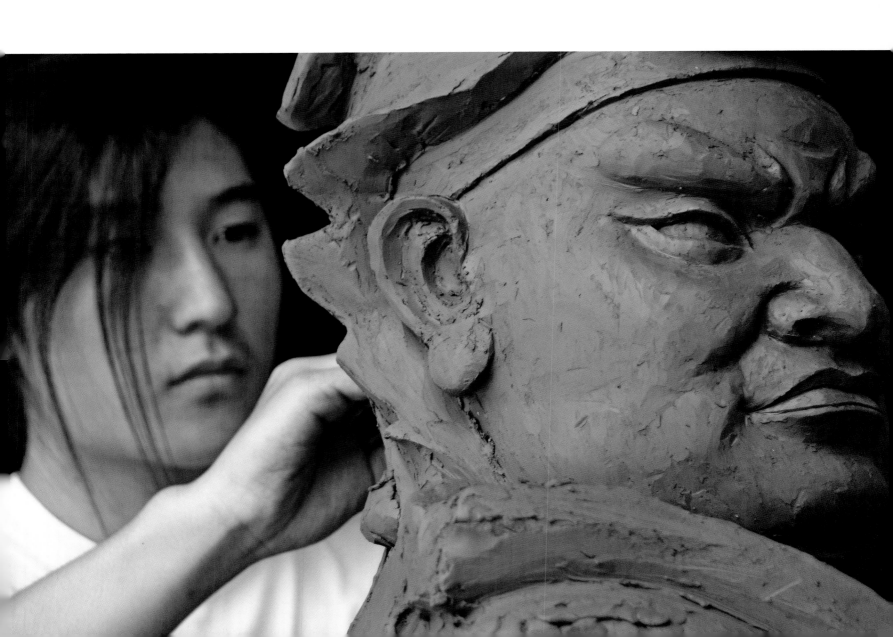

We may have left the Yellow River behind to the west, but not the yellow lands – these are never-ending. We are still in the glow of the red lanterns, searching for the last traces of ancient China. Shanxi boasts a vast treasury of such traces, although to find them you have to look beyond the features of a land that has suffered at the hands of demographic change. In the midst of villages overcrowded from the soaring birth rate, and tangles of intertwining roads, it takes a good deal of determination to trace the signs of the dragon through the ages. But gradually it becomes possible to discover half a dozen old noble mansions, which belonged to mandarins, merchants or businessmen. There are often pearls to be found among the jumble of buildings. The most famous of these is Qiao's Compound, used for the filming of Yimou Zhang's *Raise the Red Lantern*, in which the actress Li Gong plays the role of a concubine. The house once belonged to a merchant (a capitalist according to the local guides), and it is now overflowing with Chinese tourists. It is impossible to move through its courtyards and its 313 rooms. The furnishings used during the making of the film have been retained for visitors. Naturally there is a sea of video cameras and constant flashes next to the bed that belonged to the master of the house in the film. Despite its fame, Qiao's Compound is neither the largest nor the most significant of the residences in Shanxi Province. The most immense and spectacular construction of all is Wang's Compound near the city of Jinsheng, with 55 courtyards and 1,083 rooms. Close by, just beyond a small natural valley, there is a brand new construction, built in an alarmingly similar style. When I enquire about it, I am told that it is to be a new hotel.

A view of the roofs of Wang's Compound in Jinsheng. Covering an area of 15,000 square metres (161,500 square feet), the compound consists of two distinct complexes which together comprise fifty-five courtyards and more than a thousand rooms. The western complex was built on a mountainside and surrounded by a wall, whereas the eastern complex was built according to a plan representing the Chinese character of the Wang family: one main vertical axis crossed by three horizontal ones. The Wang family belonged to one of the noble lineages of Shanxi. There are superb sculptures and bas-reliefs depicting scenes of daily life in ancient China.

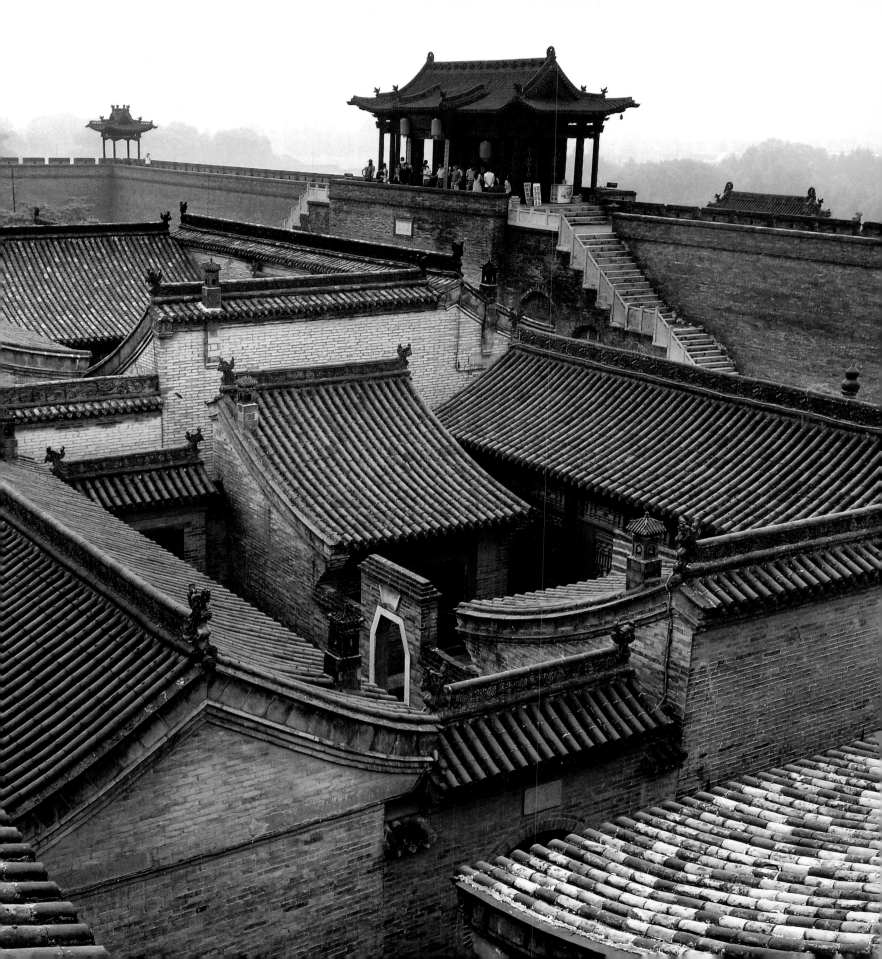

LEFT: The entrance to a house near Jinsheng. There is usually an ideogram above the doorway of Chinese houses, which is meant to bring prosperity, abundance and happiness.

RIGHT: The entrance to Cao's Compound, a magnificent noble residence not far from the city of Taigu.

OVERLEAF: This distinctive architectural feature, the *dougong*, is a complex bracket joint which supports the roof and is found in Chinese palaces. The purpose of the *dougong* is not only practical but also aesthetic; it is designed to reflect the artistic side of architecture.

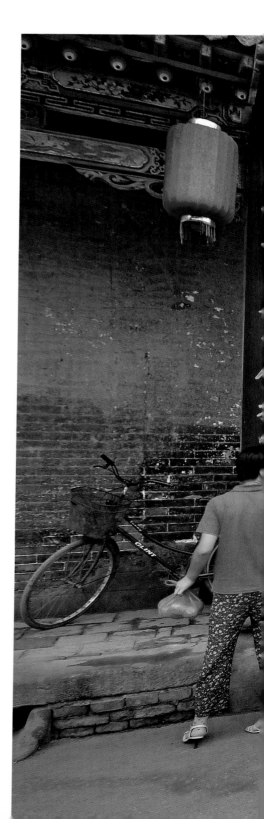

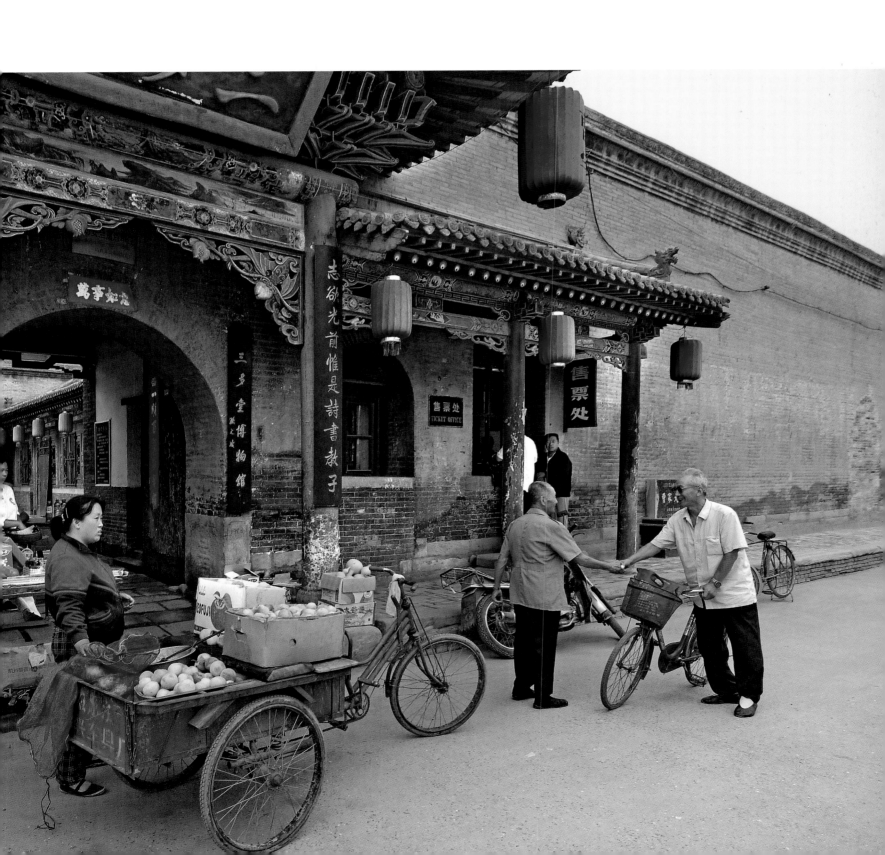

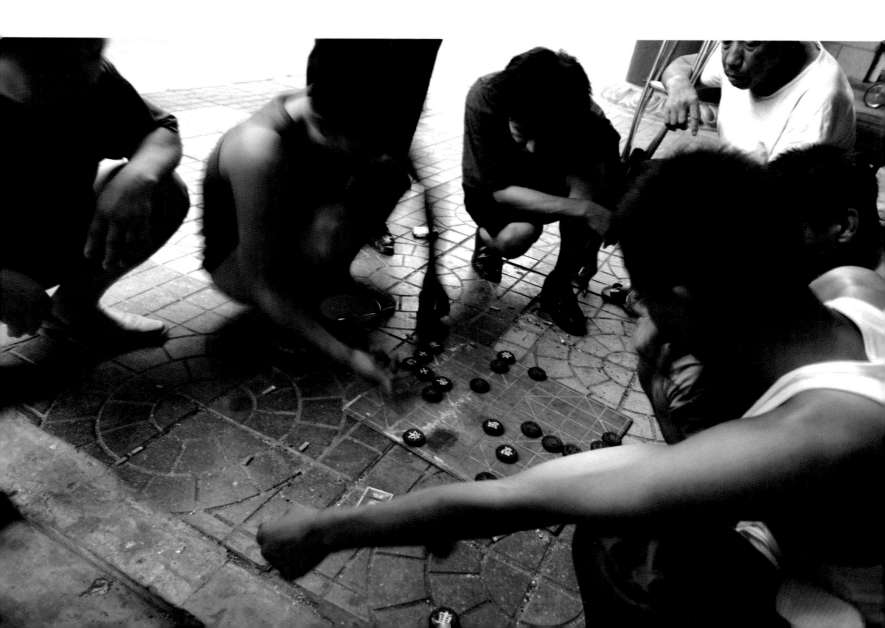

A group of men playing Chinese chequers on the street, while two elderly women gossip and observe the comings and goings. The Chinese habitually spend a large part of their free time relaxing and chatting outside their houses. The rules of traditional Chinese architecture are dictated by geomancy. The basic plan of a house has the form of the Chinese character that represents the sun, and in wealthier times people would position two sculpted lions outside their doorways to guard against bad luck.

OVERLEAF: A portrait of Mao among the bric-a-brac in a junk shop. It was in Yan'an, not far from the Yellow River, that Mao Zedong established his headquarters, and for this reason the city has become associated with the birth of the Cultural Revolution. These days the Museum of the Revolution, once much-visited, has become a tourist attraction.

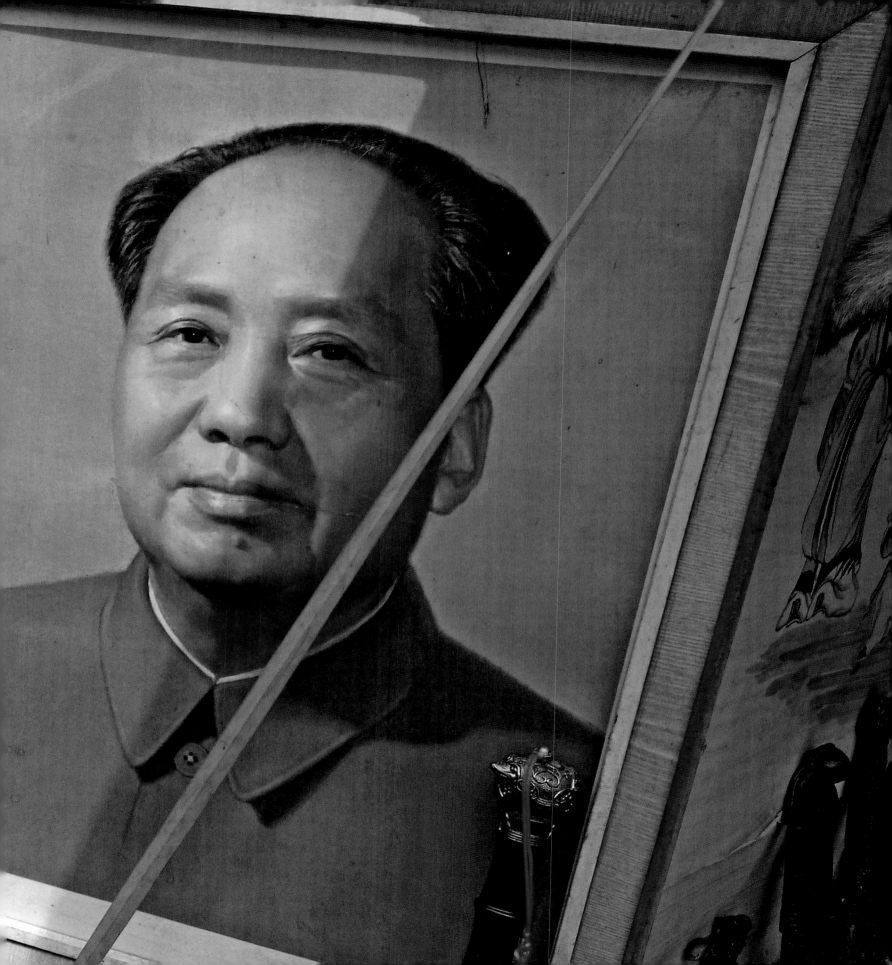

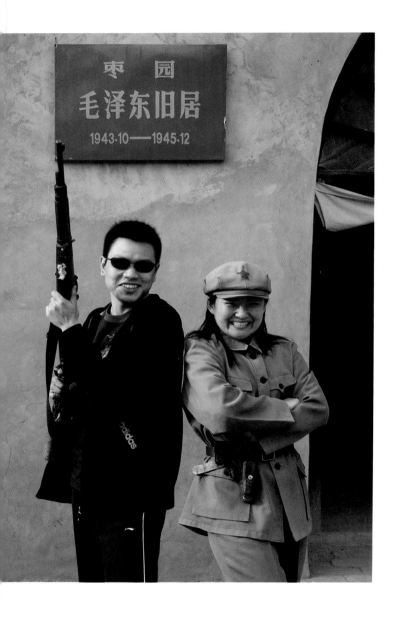

LEFT: Two university students visiting Yan'an pose for a photograph outside Mao's headquarters. The girl is wearing the uniform worn by the soldiers during the Long March.

RIGHT: Members of the Communist Party, on an outing from a country village, stand with their raised fists clenched in front of a poster of Mao as a young man. They sing Communist songs while three men take photographs of them all.

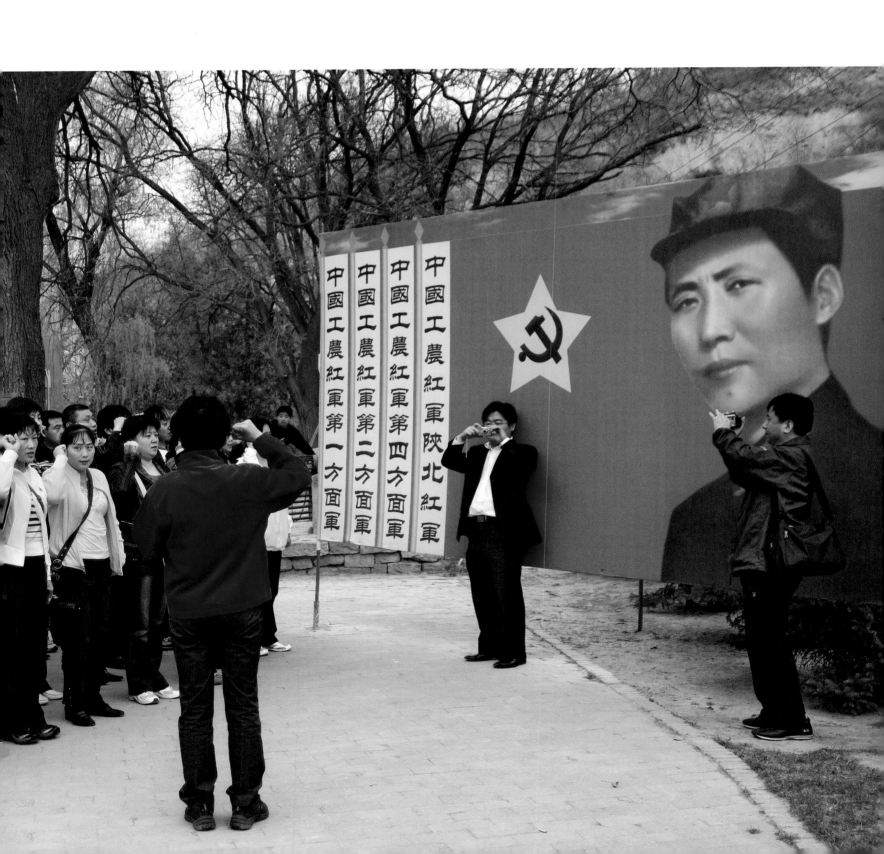

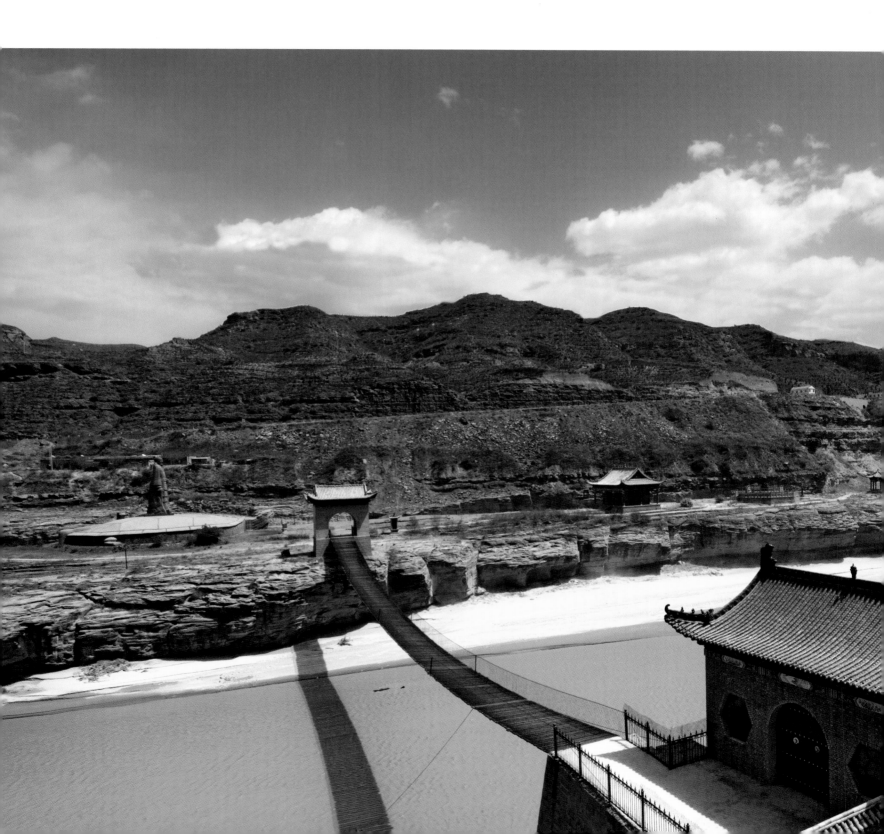

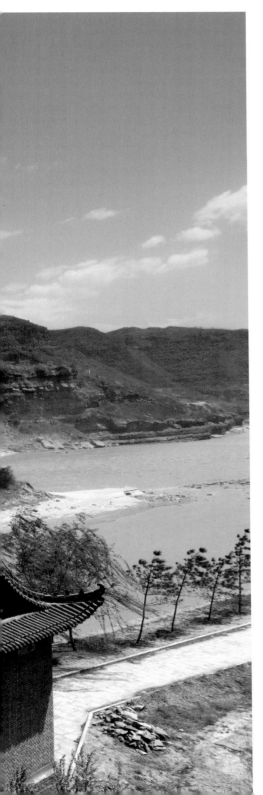

Leaving the grasslands of Mongolia behind, the Yellow River traces the boundary between the provinces of Shaanxi and Shanxi, flowing through a deep gully that has been carved through the mountainous plateau of loess over thousands of years, the waters swelling with muddy sediments. In this picture the river circles a small, rocky island, linked to the mainland at Meg Men by means of a hanging bridge. The large statue on the left was erected in honour of Emperor Yu the Great, who is famous in Chinese history for his extensive hydraulic engineering, which was able to control the dangerous flooding of the river for the first time.

OVERLEAF: The magnificent Hukou Waterfalls.

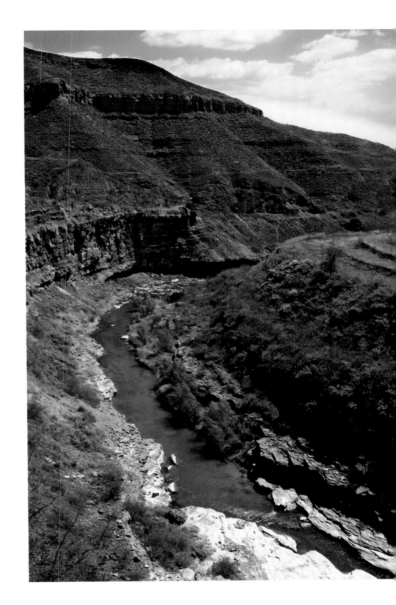

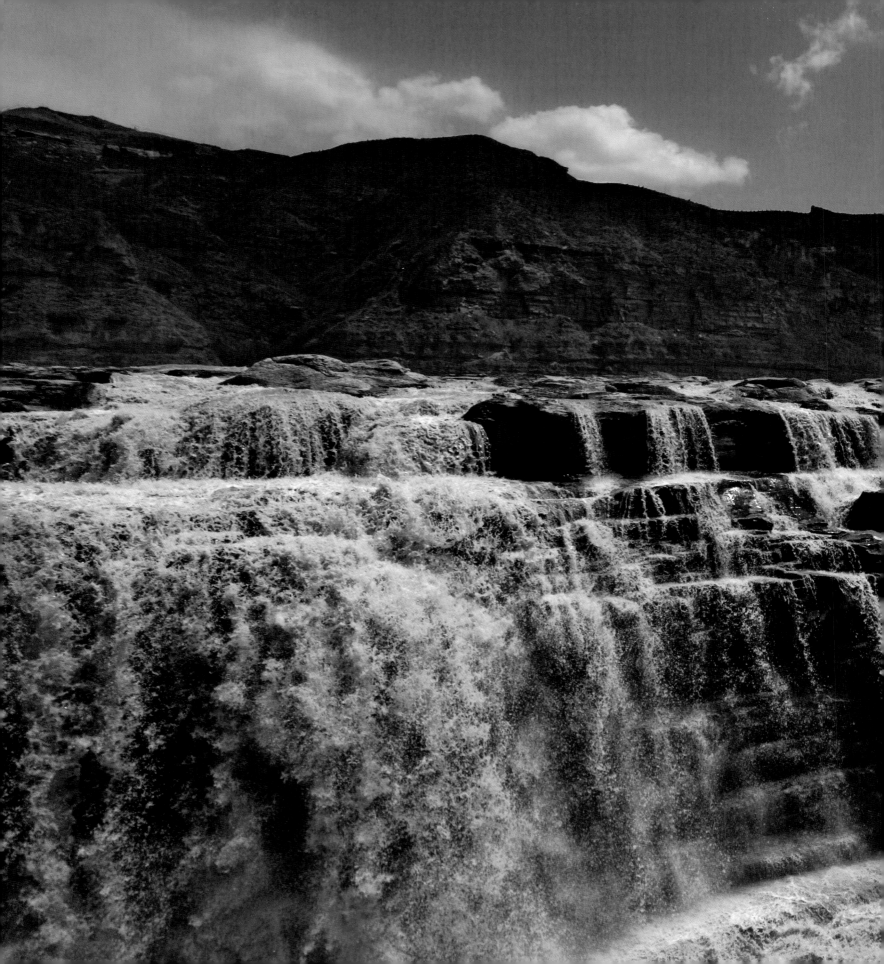

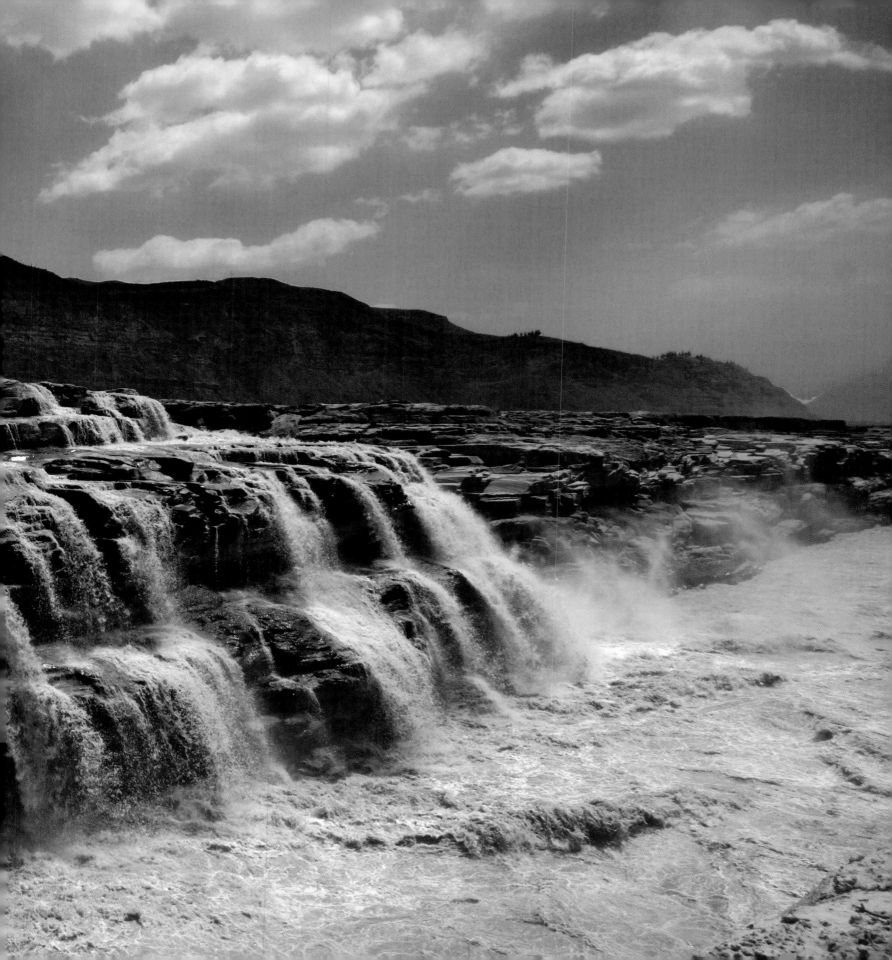

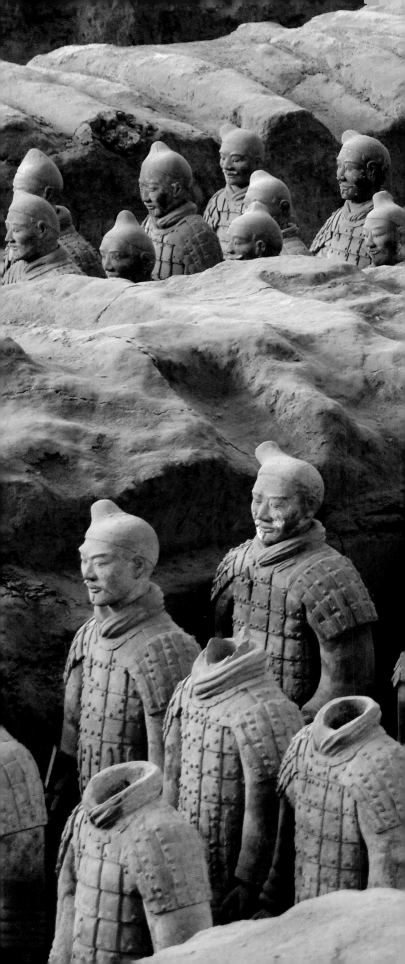

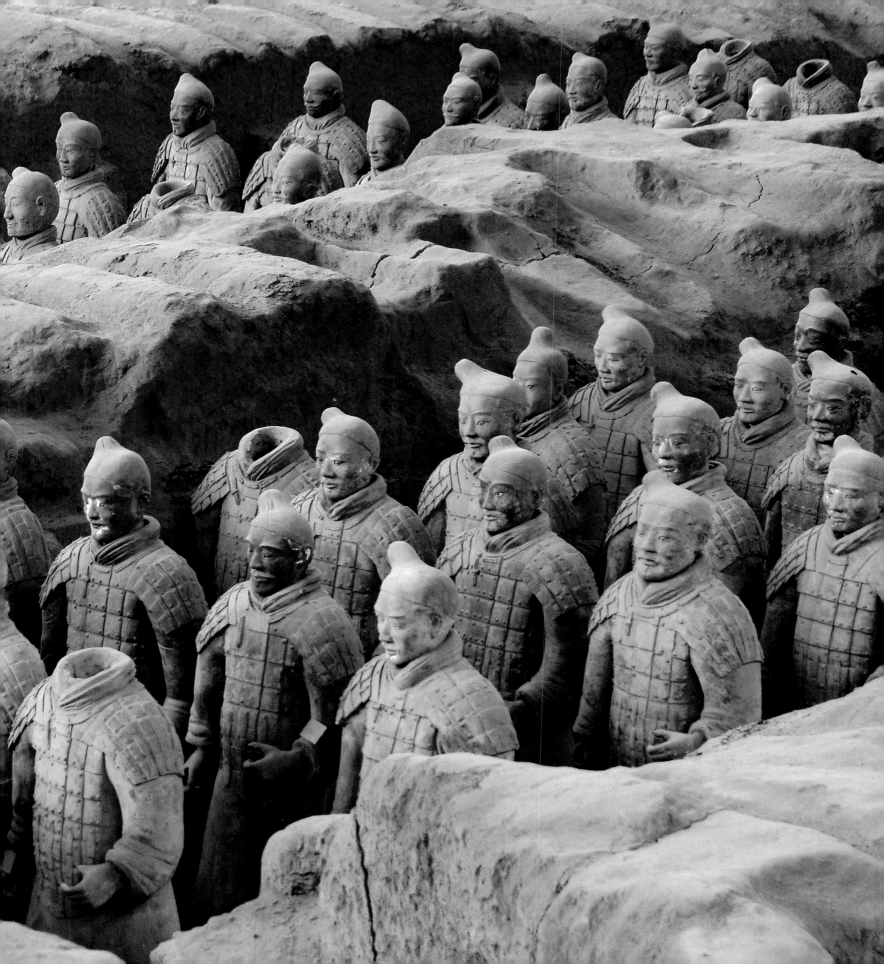

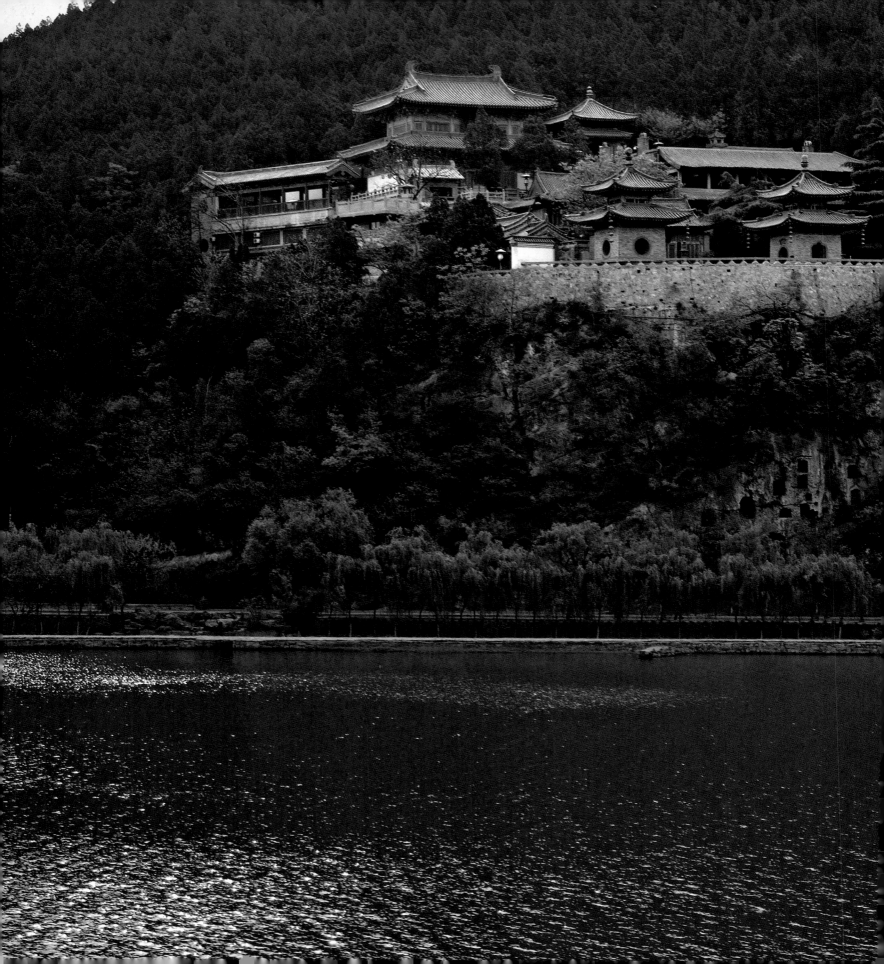

A YOUNG WOMAN SHOWS OFF as she strikes the huge bell of the ancient Tang dynasty (618–907) tower which looms above the centre of Xi'an, the capital of Shaanxi. She has paid a fistful of yuan for the privilege and laughs loudly as her boyfriend grins at her. She is completely dressed in designer labels, as is he; or rather, in the immaculate Chinese style of the nouveau riche, with a Rolex on the wrist and a Nike leisure suit (real or fake?). It is quite fashionable among the Chinese to wear fake designer goods: they cost ten times less and look almost identical. At the end of the day, they are all made here, even the originals, so why spend more in a boutique? Xi'an takes shopping seriously. Here you can find the best shopping in China – a quick glance in one of the many shopping centres will confirm it.

Xi'an has played an important role in the history of China for more than 4,000 years. With its population of seven million, it is an industrial and commercial mega-city; a sacred monster. Here, the dragon is rooted in ancient history. Xi'an was the arrival point on the Silk Route. The city was the capital of the empire during the various different dynasties between 1000 BC and AD 1000. The famous Terracotta Army was found here, belonging to the emperor Qin Shi Huang, who succeeded in unifying China into one empire, the size of which was comparable to that of ancient Rome.

It is a disconcerting experience for the traveller who has been following the course of the Yellow River. How different the way of life is here in Xi'an, compared with life up on the Tibetan Plateau, or in the deserts of Ningxia, or the back-breaking existence in the terraced fields of Shaanxi. This is like another world. This is the other pace of life which exists in China as it enters the third millennium. It is an experience that leaves you breathless. All along the main street, Dong Dajie, you can see yourself reflected in the glass sides of new buildings. Gone are the bicycles, and in their place are powerful cars. Traces of old China are only to be found off the beaten track, in the old Muslim quarter for example, which is concentrated around the mosque; a convoluted maze of twisting streets and the traditional two-storey homes of the Hui.

'People are rich here – they don't think twice about spending money,' observes a kite-seller contentedly, standing in the main square, which is dominated by the Drum Tower. The sky is a dancing mass of different

colours. People walk past, their heads held high, and buy. 'It no longer pays to be a farmer – it's better to come to the city because you'll always find something to do. Even selling kites can be a business for an immigrant like me.'

During the spring, Xi'an is full of yellowish sand which blows in from Mongolia. Many people wear masks to protect themselves: the dust mingles with the pollution which is one of the biggest problems facing China in the third millennium. Even the Yellow River has become a problem: more than 60% of its water is now so polluted that it cannot be made drinkable with treatment, a fact that is worrying the authorities, especially in the lower reaches of the river where the need for water is at its greatest owing to the sheer density of the population. China has a desperate need for water in the new millennium. The future will be full of challenges.

'If the Yellow River is at peace, the nation is at peace': So reads a large inscription in red capitals on the cement of the dam at Sanmenxia. At the foot of the dam the river flows impetuously, like a mountain torrent. Until a few years ago, this hydro-electric plant was the biggest one on the Yellow River, but now it has been superseded (with evident pride) by another mega-structure 100 kilometres (62 miles) or so further down the valley, north of the city of Luoyang, in a place called Xiaolangdi. Here, a colossal dam has been built, 154 metres (505 feet) high and 1,667 metres (5,469 feet) wide, creating a reservoir that extends over 272 square kilometres (105 square miles). As has been the case with the simultaneous project on the river Yangtze, entire villages have disappeared in the process, and the hydrogeological balance in the area has been drastically altered. The new lake has become a tourist destination, and the farmers have turned into boatmen. On payment of an entrance fee, you can visit the dam and the surrounding green areas, which have been turned into gardens for relaxation. On Sundays there are thousands of visitors.

'We like to escape from the chaos of the city, and enjoy some peace and quiet here,' says Chen, a tourist guide who is accompanying a group of Chinese from Shanghai who have come to admire the wonders of modern technology in Xiaolangdi. 'This way we can also enjoy the Yellow River.'

A young woman strikes the bell at the top of the Bell Tower, which was constructed in the centre of the city during the Tang dynasty. Even today the four main roads of Xi'an intersect at this point.

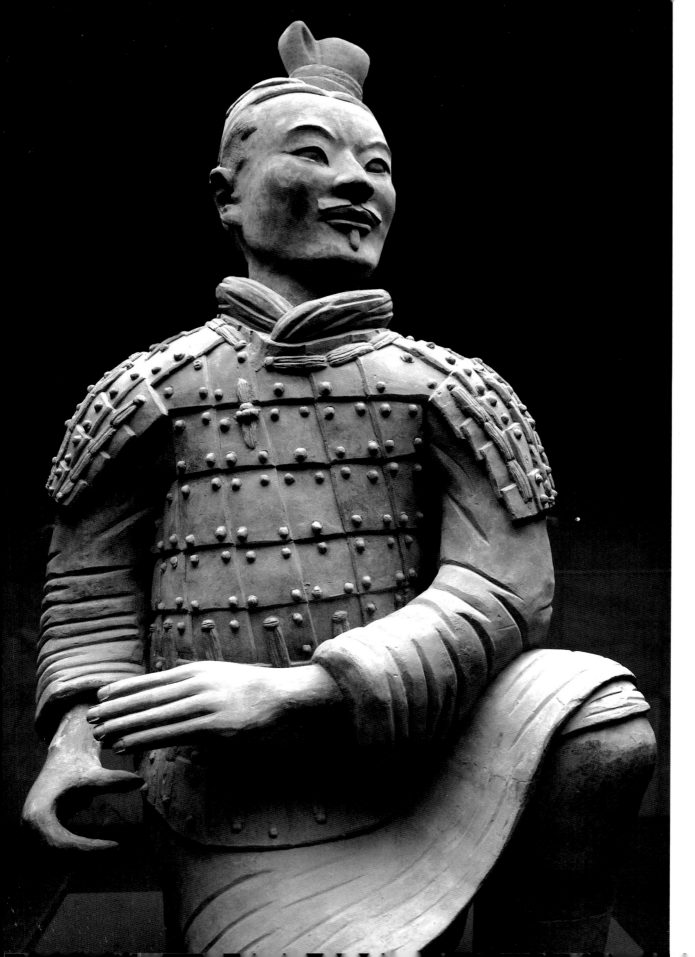

LEFT: One of the terracotta soldiers found on the outskirts of Xi'an. There are estimated to be 8,000 in total. In addition to the statues, over one hundred terracotta horses have been unearthed, and eighteen wooden chariots. Emperor Qin Shi Huang ascended the throne in 246 BC, and during his reign he succeeded in uniting the quarrelsome eastern states, thereby becoming the first emperor of unified China. In his attempts to maintain the stability of the empire, he instigated a series of policies of centralization, which earned him the reputation of a tyrannical ruler. He made many efforts to promote the development of society and the economy. Units of currency were unified, as were characters and units of weight, capacity and measurement. He also initiated the construction of the Great Wall.

OPPOSITE: The bronze carriage that was discovered in 1980. During recent years further excavations have produced 50,000 ancient relics, including numerous treasures.

OVERLEAF: The Stele Forest Museum, another important site in Xi'an, which is housed in an old temple dedicated to Confucius. It contains more than 1,000 ancient stelae carved with sacred Chinese texts. The most important ones date from the 9th century and are inscribed with the twelve classical texts of Confucianism. This photograph shows the room where copies can be made of the most famous ones.

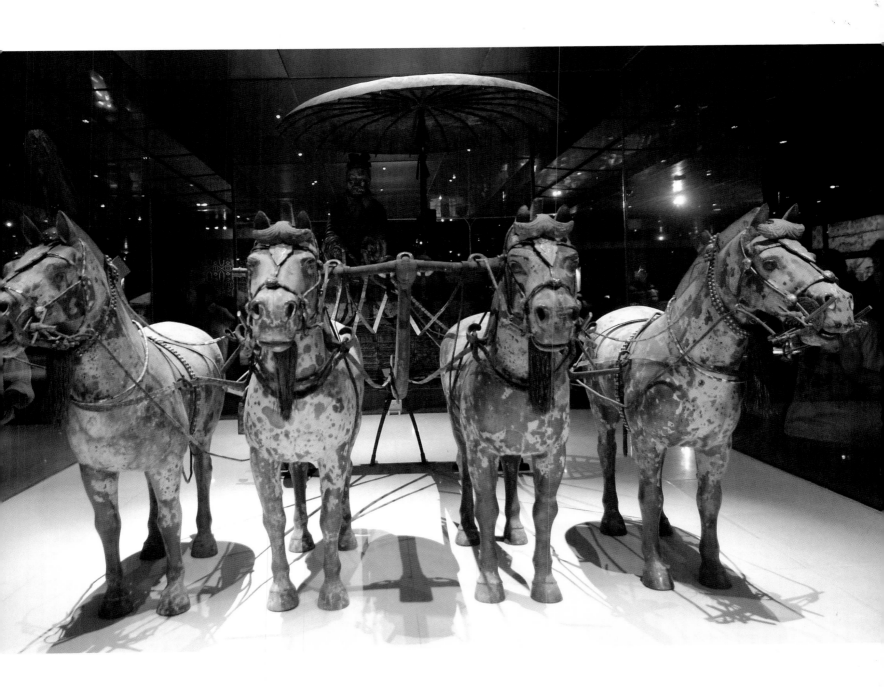

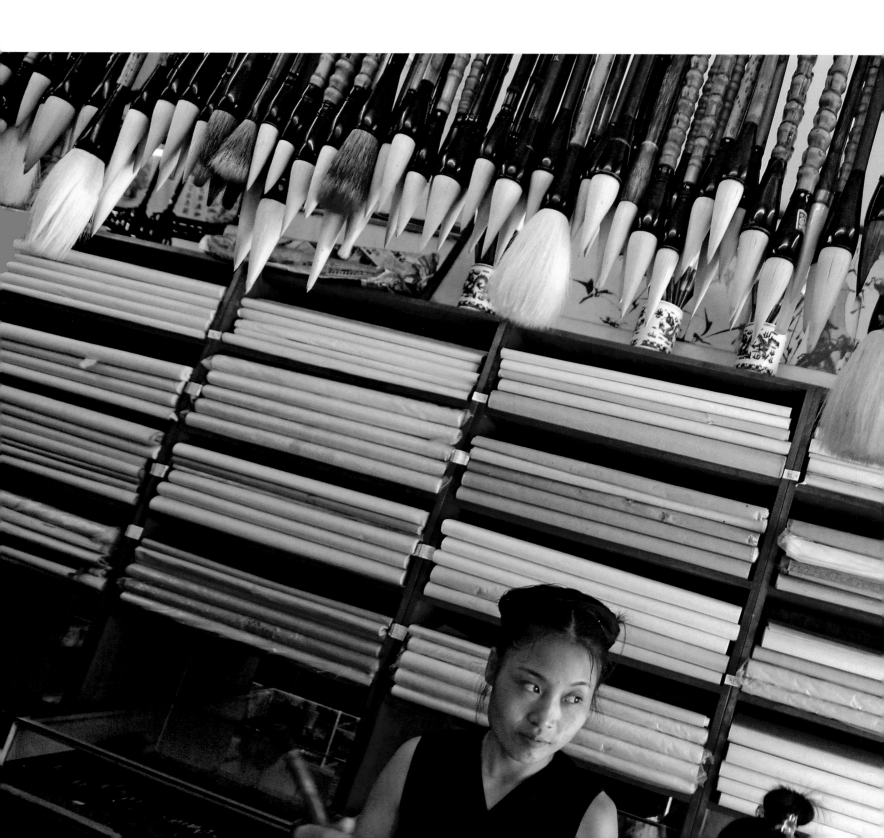

LEFT: A shop selling paintbrushes on Shu Yuan Men street, where Chinese paintings are also for sale. The paintings are all typical of the traditional themes: landscape, animals, flowers and plants. Chinese pictorial art favours nature and rarely depicts human beings. Certain images have symbolic meanings; for example, plum blossom for spring, chrysanthemums for autumn, and bamboo for eternal friendship because it remains green all year round.

RIGHT: A calligrapher is writing the character He, meaning river, one of the two characters that form the name Huang He, Yellow River. Both calligraphy and painting are highly prized skills in China. Characters began as representations of real objects, and have been successively modified and stylized. Good painters also need to be good calligraphers. Technical prowess in both these arts relies on mastery of the brush.

OVERLEAF: A craftsman makes stamps bearing people's names or sayings from the ancient sages, or snippets of poetry.

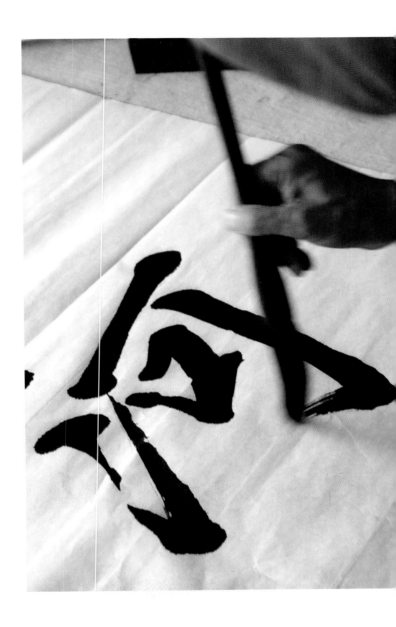

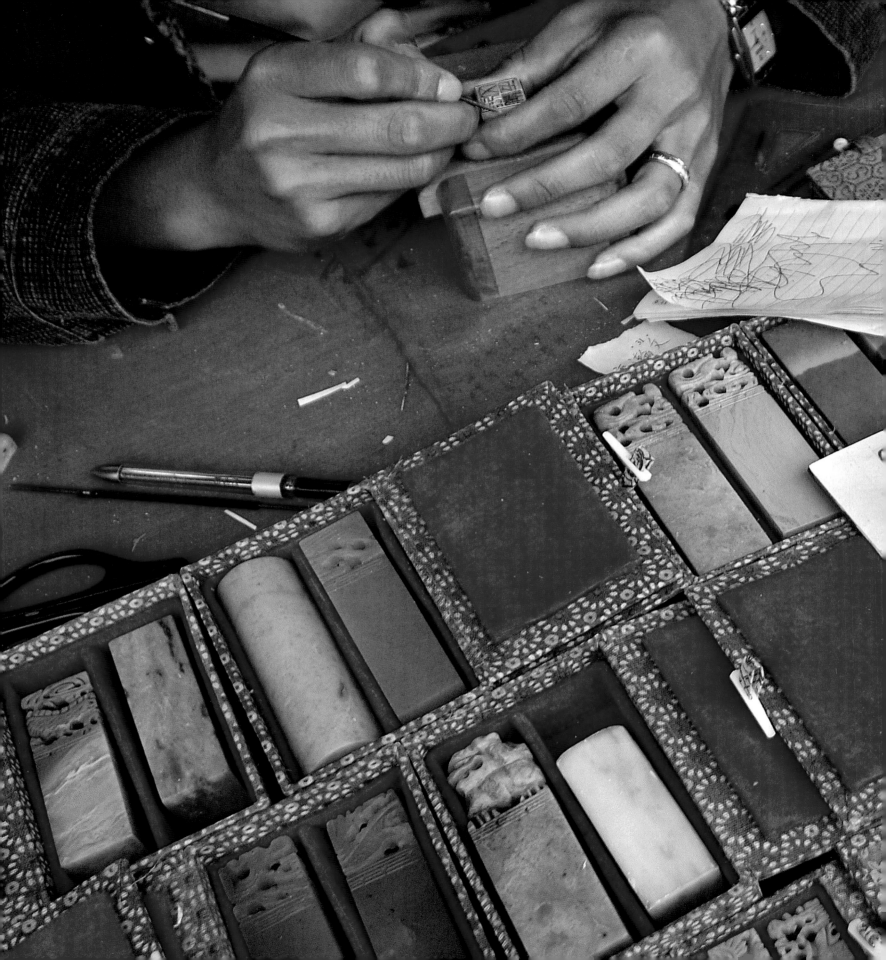

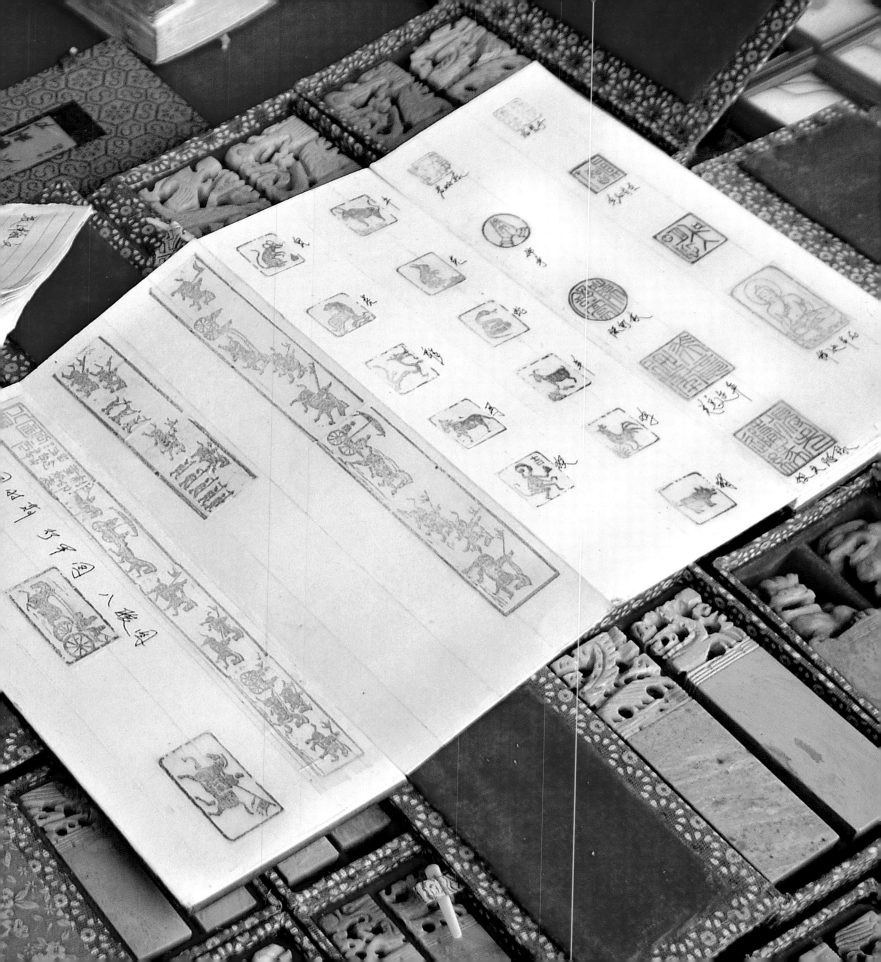

OPPOSITE: A row of bird cages along the shopping street Bowuguan, which runs along the southern section of Xi'an's impressive city wall. Keeping canaries and other small birds is part of Chinese tradition.

RIGHT: An itinerant hawker flies a stream of his kites in the skies above Xi'an in order to attract customers. The Drum Tower, the epicentre of the city, is in the background.

LEFT: A shot of local traffic in Xi'an. Chinese women prefer to avoid getting the sun on their skin, and protect themselves as much as possible. They use umbrellas when walking along, and when they are on a bicycle or moped they use visors and gloves. Pale skin is more highly prized than tanned skin.

OPPOSITE: A fashion show in front of a department store. The models are wearing clothes which imitate familiar western brands.

OPPOSITE: The preparation of spaghetti at a restaurant in the Muslim quarter of Xi'an, in the area north of Xi Dajie. It is mostly inhabited by Hui, and contrasts greatly with the modern streets elsewhere in the city. The cuisine here is strongly Arabic in flavour, an influence that dates from the days of the Silk Route, when Xi'an was the point of arrival. Typical dishes include ravioli filled with meat, lamb kebabs, and sheep's brains, which are extracted from the severed head and cooked immediately in large pans. At the heart of the Muslim quarter is the Great Mosque, dating from 742 and magnificently restored during the Qing dynasty. The structure is a synthesis of Chinese and Arabic styles.

BELOW: A tea shop.

On entering the plains of Henan Province, the great river is kept under strict observation, like a patient who needs special attention. By this stage it is completely yellow, laden with sediments. For centuries the Chinese have recognized that from this point on the river can potentially become a curse, a dangerous enemy who must be overcome. Therefore a commission has been set up to monitor water resources, employing tens of thousands of people. The huge quantity of silt which the dragon carries is equivalent to 1.6 billion tons a year. One cubic metre (35 cubic feet) of water contains 36 kilograms (79 pounds) of earth, compared to the 1.4 kilograms (3 pounds) that is present in the waters of the Nile. This mud clogs up the river and results in deviations and flooding.

This particular stretch of river has nurtured the Chinese civilization for 3,000 years. This is the home of the Han, the largest ethnic group in China. In addition to Xi'an, the Yellow Empire had many other bases, which changed frequently as invaders were repelled, or as people fled the unpredictable behaviour of the Yellow River. Among these were the cities of Luoyang, Anyang and Kaifeng. In recent years the silt of the Yellow River has revealed to archaeologists precious tombs and walls of palaces which had remained hidden for thousands of years. For the Chinese people of today, watching excavations in progress is like turning the pages of an old family photo album. On one of the cliff-faces along the river Yi, a tributary of the Yellow River, in Longmen, more than 100,000 statues have been discovered over the centuries, mostly representing Buddha. Not far from the Yellow River, on Song Mountain, is Shaolin Monastery, which has become a major tourist attraction. It was here that the ancient martial art of kung-fu was developed, an art that was affiliated to Chan Buddhism, better known as Zen Buddhism.

OPPOSITE: The Iron Pagoda in Kaifeng. The sacred building, which has thirteen storeys and reaches a height of 56 metres (184 feet), was constructed in the 11th century and acquired its name because of the rust-like reddish-brown colour of its glazed tiles. Kaifeng, which is situated on the alluvial plain of the Yellow River, was one of the ancient Chinese capitals. It reached the zenith of its splendour during the Northern Song period (960–1127) of the Song dynasty.

OVERLEAF: The dam at Sanmenxia. A slogan is written in large letters on one of the walls: 'When the Yellow River is at peace, the nation is at peace.' Built in 1960, it was the largest dam on the Yellow River until 2004, when construction work finished on Xiaolangdi dam, near Luoyang, the third largest dam in China.

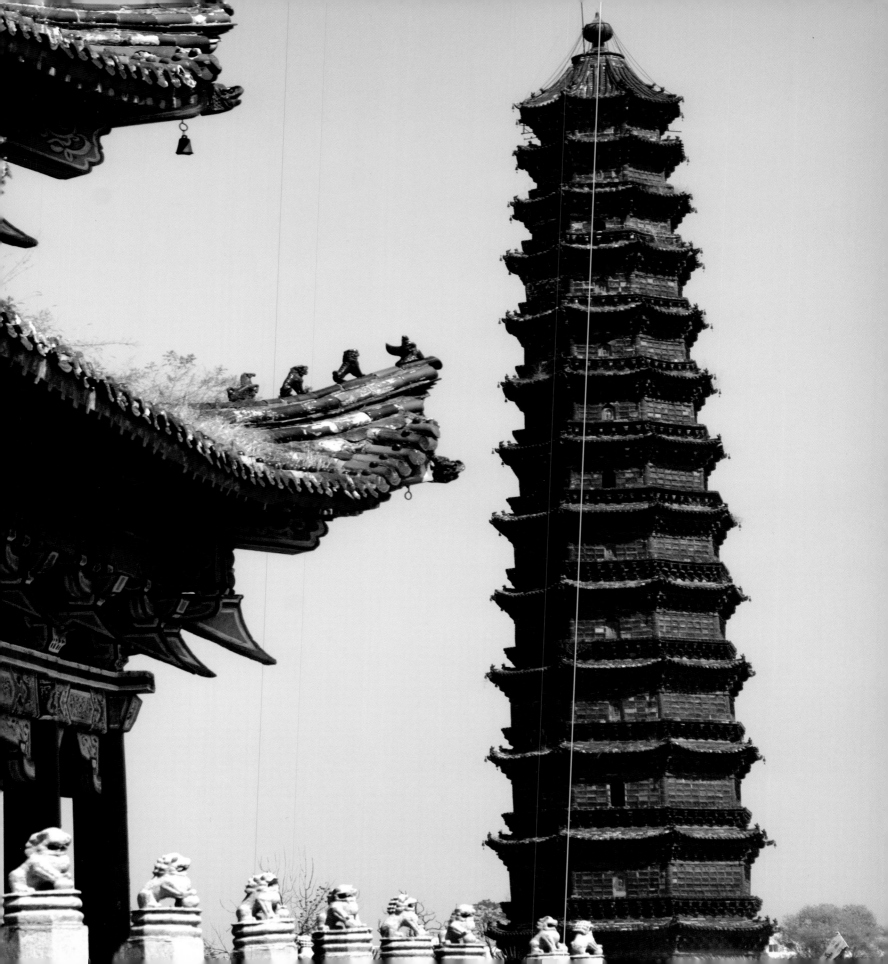

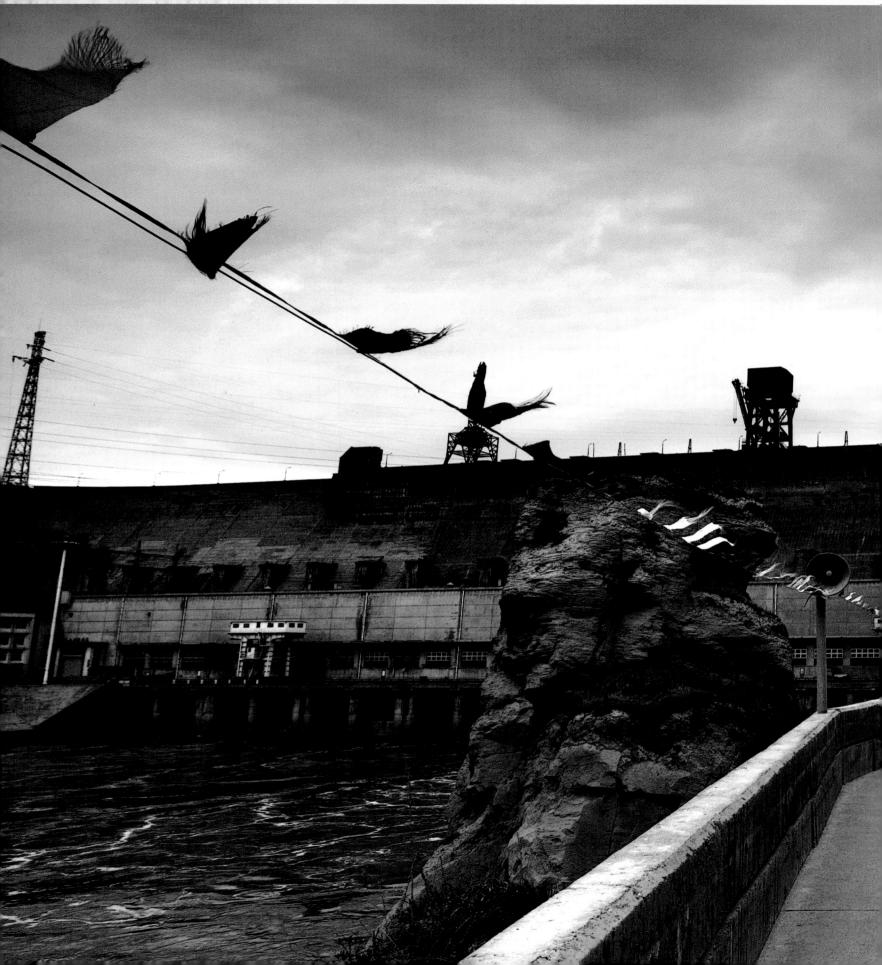

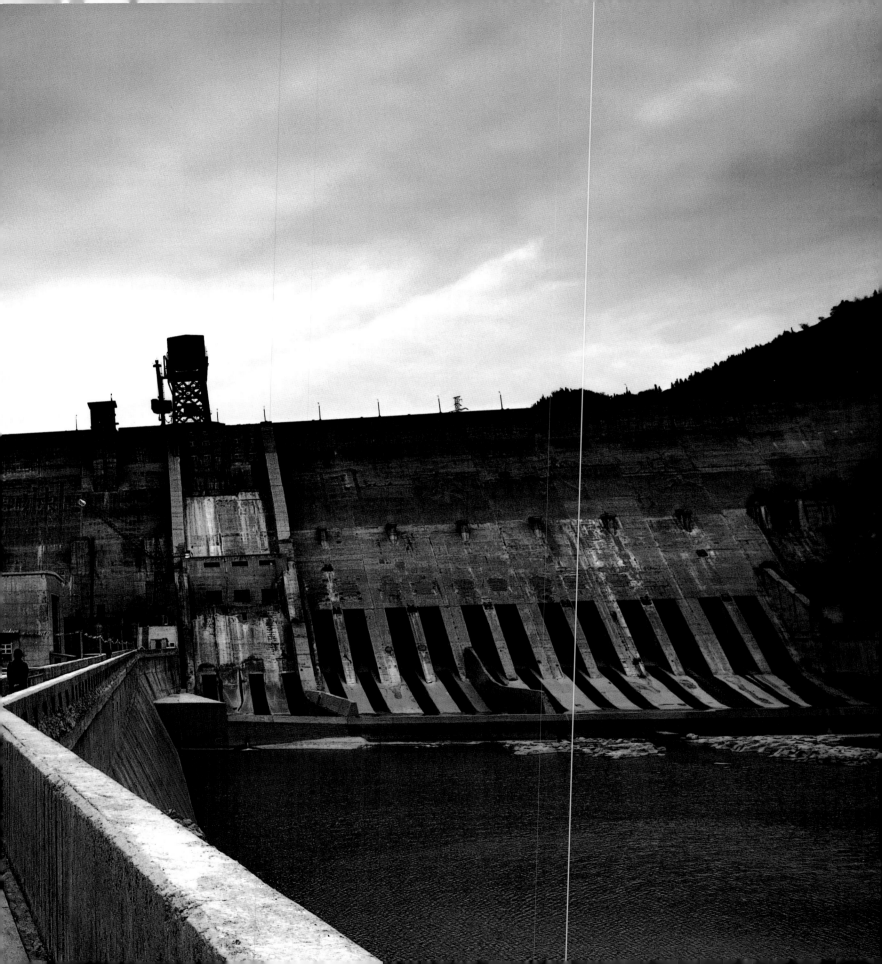

LEFT: A fish pond at Xiangshan Temple in Longmen. Visitors throw in small change and banknotes to bring themselves good luck. The one-yuan note still has a picture of Mao on it.

RIGHT: The towering cliff-face on the river Yi, a tributary of the Yellow River. At Longmen, the waters flow between steep mountainous slopes, where over 100,000 statues have been carved over the centuries, most of them representations of Buddha. The sacred images were commissioned by the emperors who ruled over China for five centuries. The earliest statues date from the end of the 5th century. The huge display reached the peak of magnificence during the Tang dynasty. In the centre of the rock-face is the entrance to the vast grottoes dedicated to the worship of ancestors. They contain a statue of Buddha which is 17 metres (56 feet) high, and is flanked by two bodhisattvas, or disciples, the king of paradise, and some guardians with menacing faces. Longmen has become famous throughout China, especially since UNESCO added it to the list of World Heritage Sites.

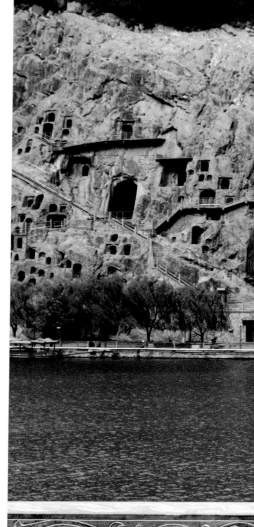

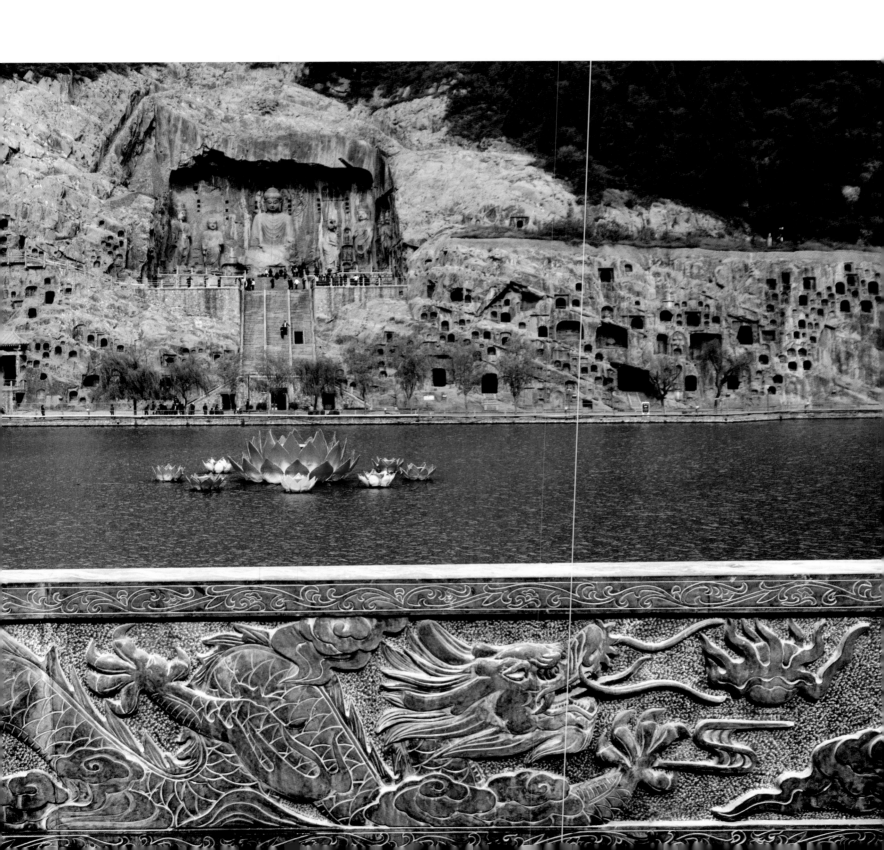

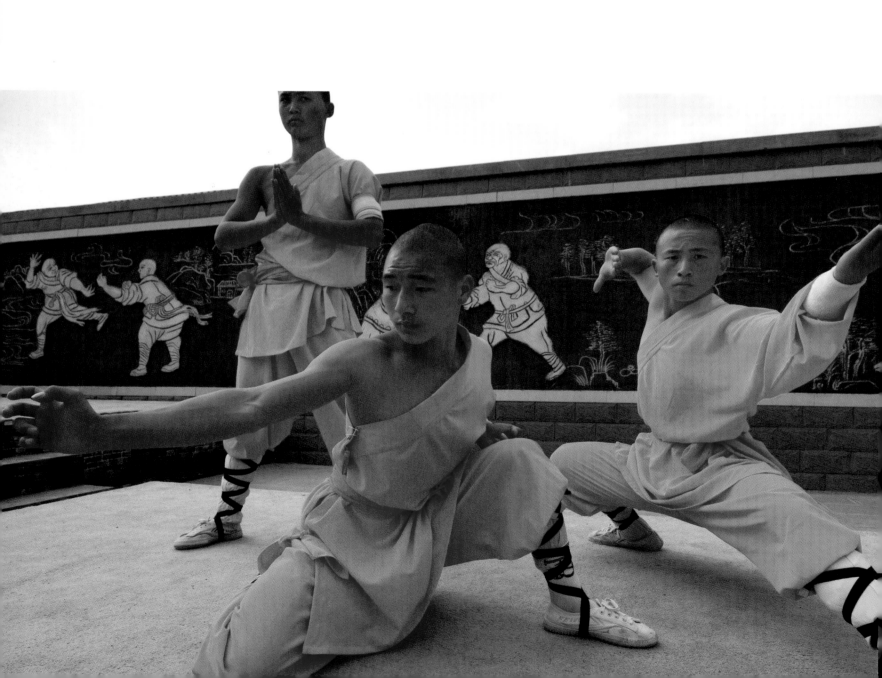

Not far from the Yellow River, tucked away on Song Mountain, is Shaolin Monastery, one of China's greatest tourist attractions thanks to its connection with the popular art of kung-fu.

OPPOSITE: A few kung-fu fighters at Shaolin pose for photographs. These days the athletes no longer have anything to do with the religious life or with Chan (Zen) Buddhism, which was founded by an Indian monk called Bodhidharma who lived in the 6th century.

BELOW: A moment of prayer inside the temple. These days very few of the monks practise the ancient martial art, which has become big business for the numerous private schools that have been set up, exploiting the fame of the monastery. There are thousands of pupils who pay considerable sums of money to learn the noble art which became famous again in China and throughout the world after the release of the 1979 film *The Shaolin Temple*. The film starred the Chinese actor and former kung-fu champion Jet Li.

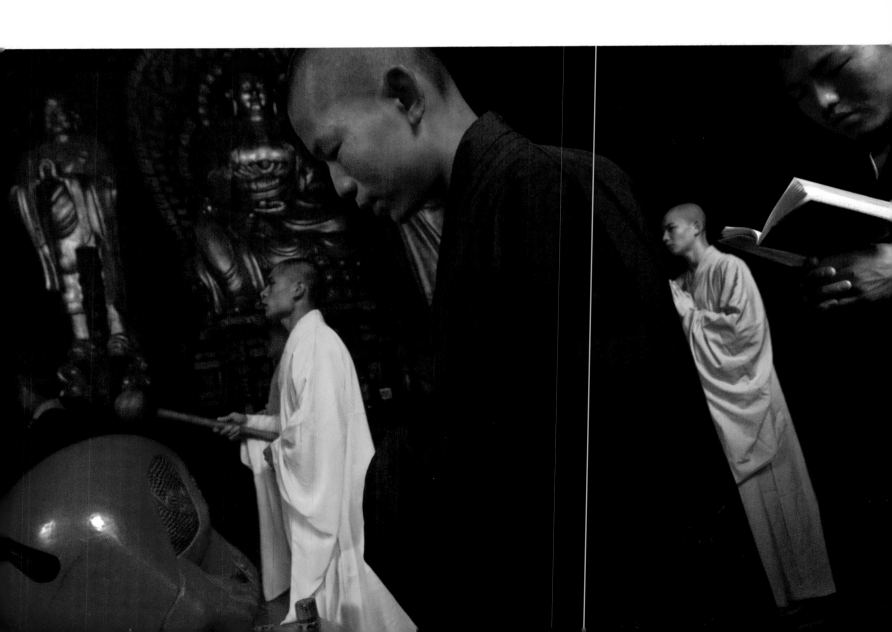

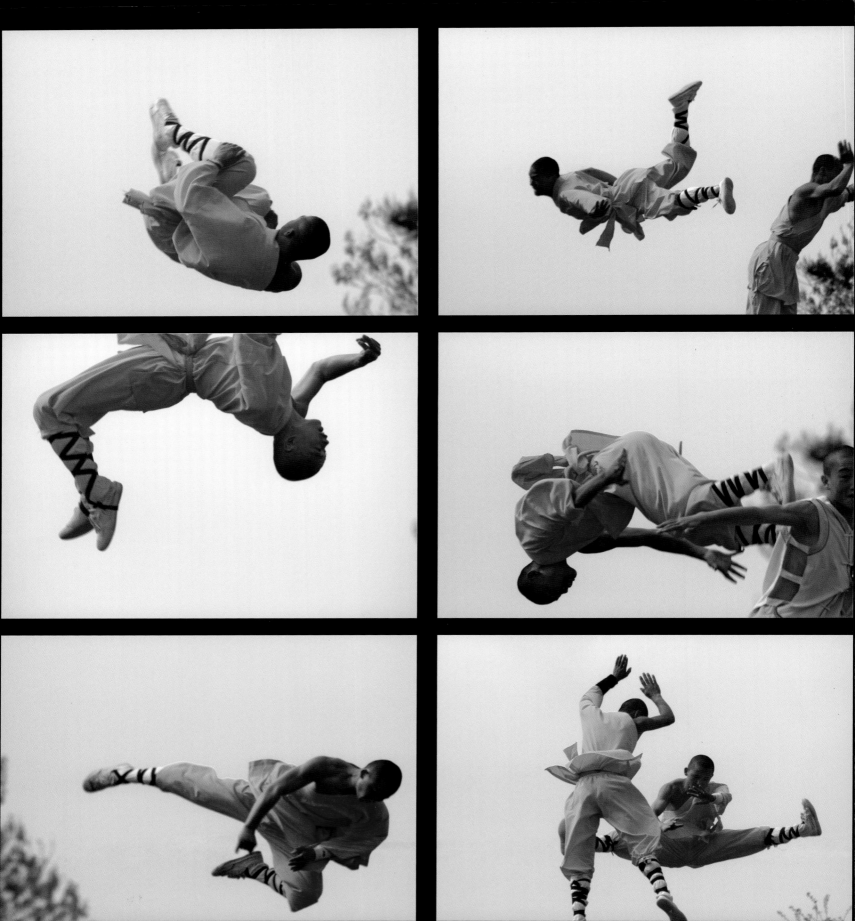

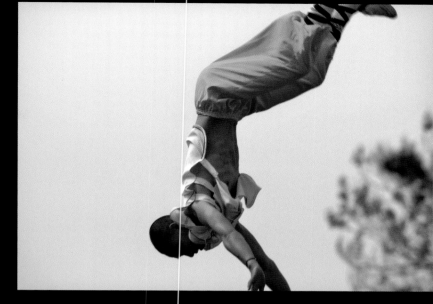

OPPOSITE AND RIGHT: A series of images of the kung-fu displays put on for the many visitors to Shaolin Monastery.

BELOW: The ancient martial art features in an old fresco in the White Drapery Hall, which shows the emperor Taizong (599–649) being rescued by thirteen monks.

OVERLEAF: The Yellow River at Huayuankou, north of the city of Zhengzhou.

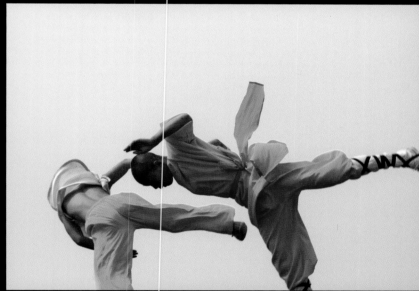

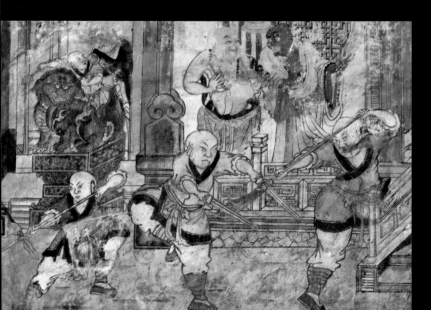

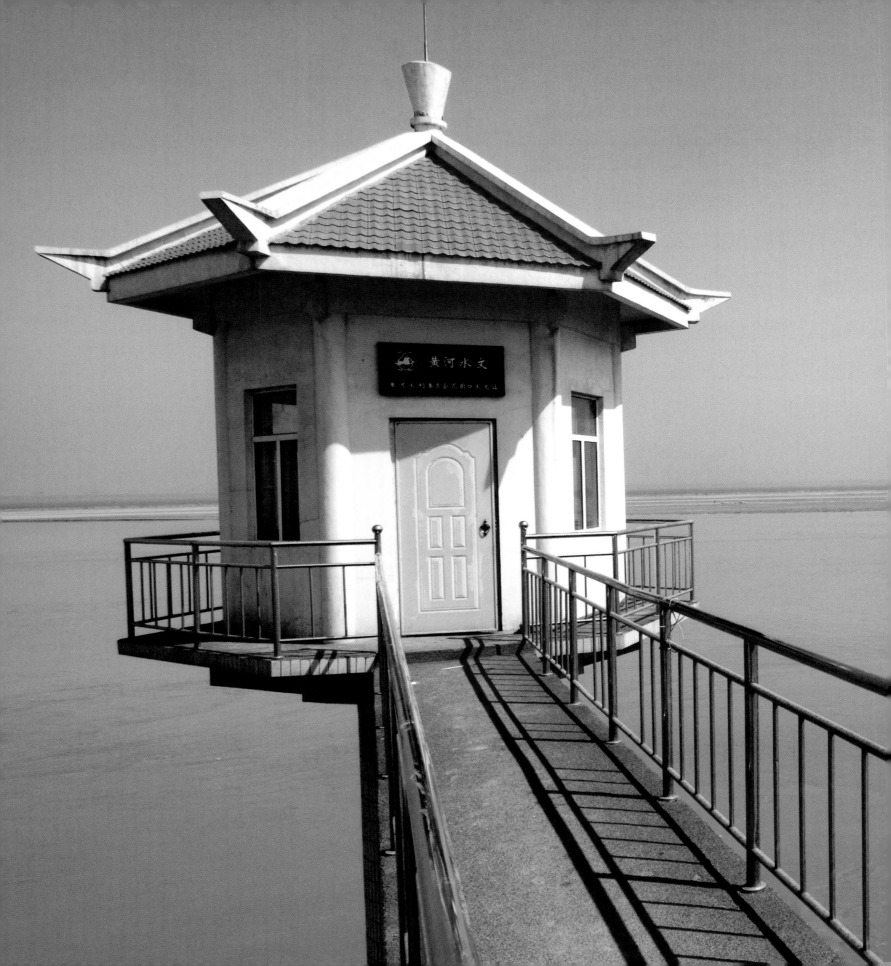

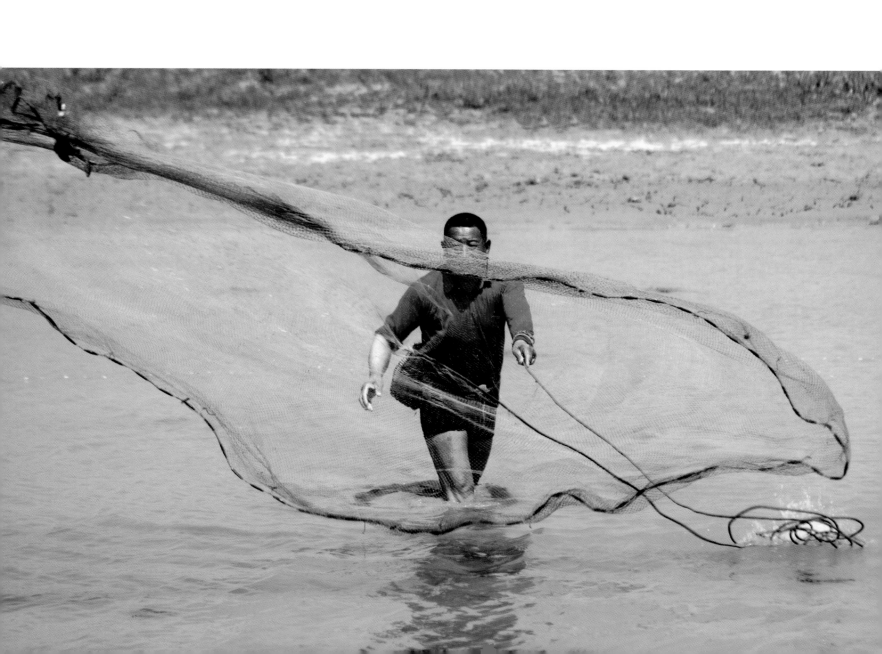

Two fishing scenes, photographed along the Yellow River between Zhengzhou and Kaifeng. The most common species here is carp, but life along the river is suffering increasingly from pollution. All along the course of the river, tens of thousands of chemical factories are disgorging vast quantities of toxic waste, with the result that official estimates from the Asia News Agency report that more than 60% of the water is no longer drinkable. In addition, the volume of water has reduced considerably because of the heavy demands of irrigation in the fields, and of domestic and industrial usage.

OPPOSITE: Men and women have come to Kaifeng from the surrounding countryside for the festival in honour of the Mother-goddess Wang Mu Niang Niang. They are camping out on the vast square in front of the Dragon Pavilion, waiting for the festivities to begin. In the country, traditions and religious beliefs are still cherished.

BELOW: Tai-chi-chuan practice in Kaifeng. At dawn's first light, the parks and gardens are full of people, although the most popular place to practise is on the shores of the many lakes in the city. One group practises its moves in front of Yanqing Temple, a grand complex dating from the 13th century. Tai-chi-chuan, the 'supreme form of combat', is based on the Taoist concept of yin and yang. It began as a form of self-defence, but over the centuries has evolved into a sophisticated type of exercise designed to maintain good health. The practice consists mainly of a series of gentle and circular movements, which imitate combat with an imaginary adversary.

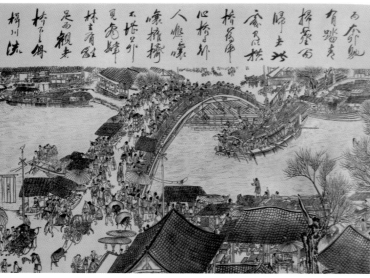

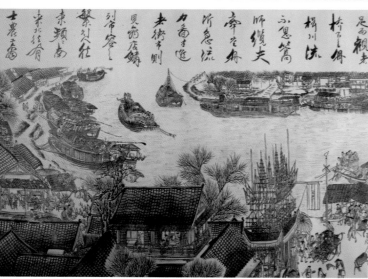

LEFT: The city of Kaifeng is famous for the Qingming Scroll, which measures 5 metres (16 feet) across and depicts festive scenes on the river. Today the work is in the Forbidden City in Beijing. It is representative of a magnificent era in which Kaifeng was famous throughout China for its textiles, ceramics, books, art and calligraphy.

RIGHT: A steep bridge over a canal in the city, resembling the one depicted on the famous scroll.

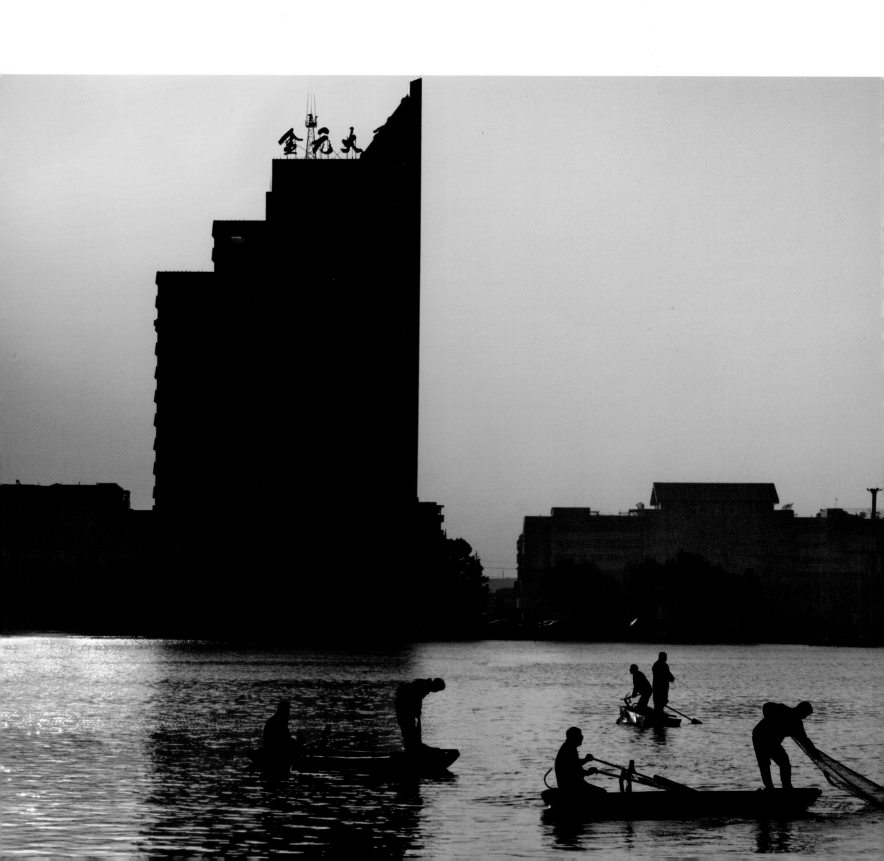

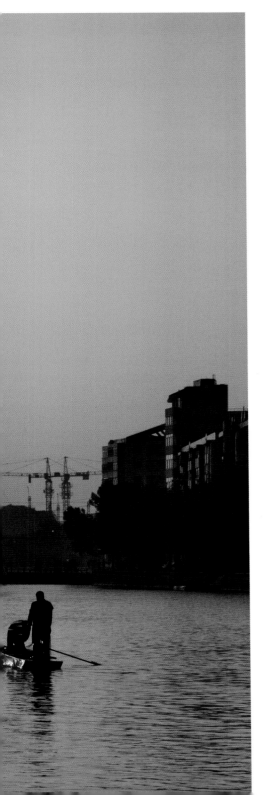

LEFT: A view of fishermen on Boagong Lake in the centre of Kaifeng, taken at first light.

RIGHT: A turtle that has just been caught in the Yellow River. Turtle is a succulent dish for the Chinese, and is very expensive.

OVERLEAF: A view of the Yellow River at Huayuankou. Here, in 1937, the military leader Chiang Kaishek gave the order to breach the dykes of the river, so that the flooding would stop the advancing Japanese troops and inundate the railway line. This drastic action gained him several weeks, but thousands of people lost their lives in the process. A plaque commemorates this tragic loss of life. The river is extremely wide at this point, with one side scarcely visible from the other. In the background you can see the motorway bridge that crosses Henan Province on an east–west axis.

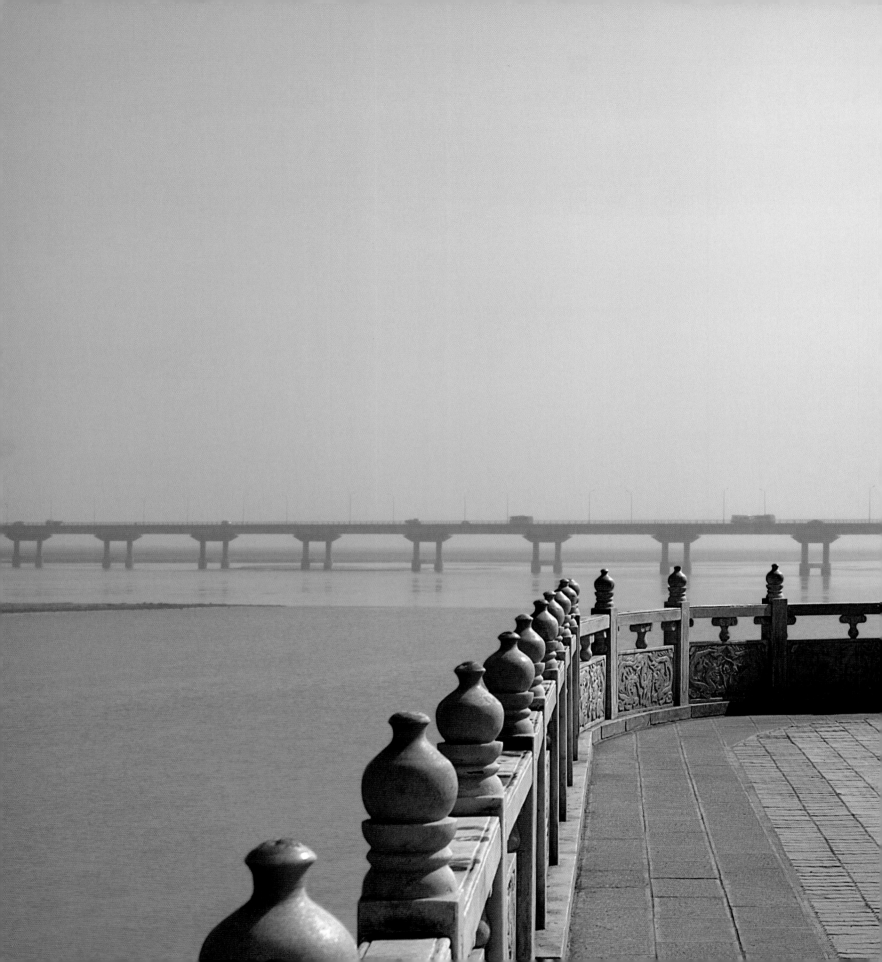

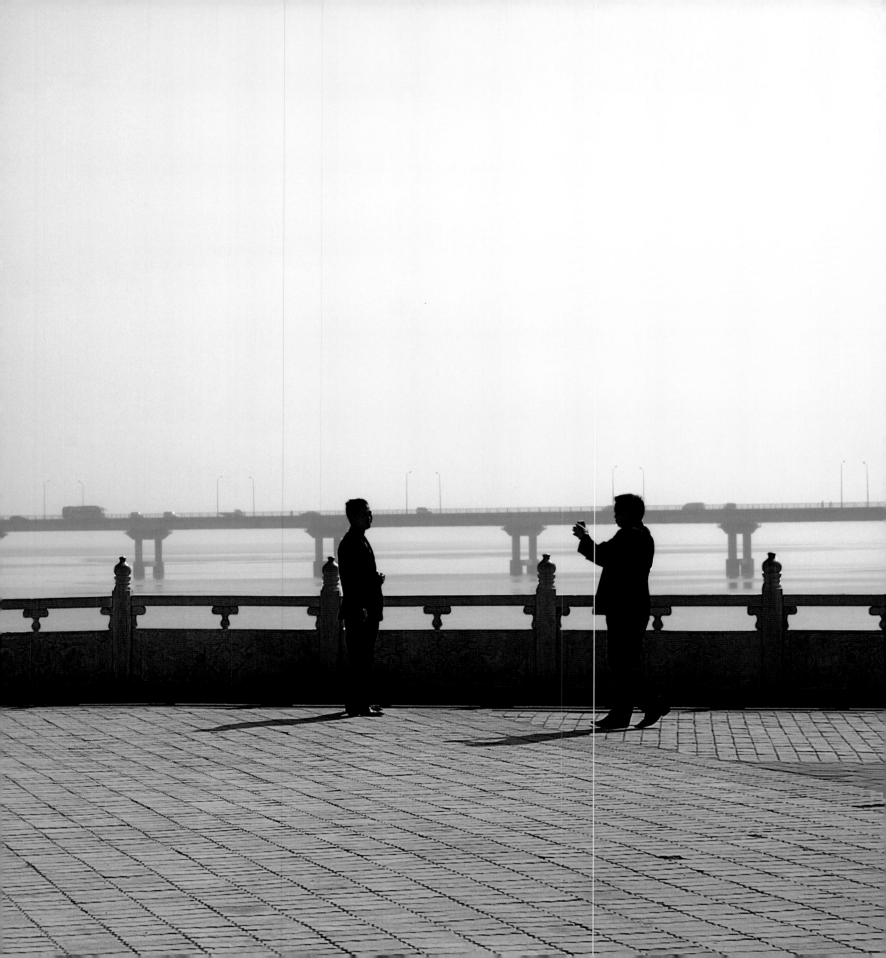

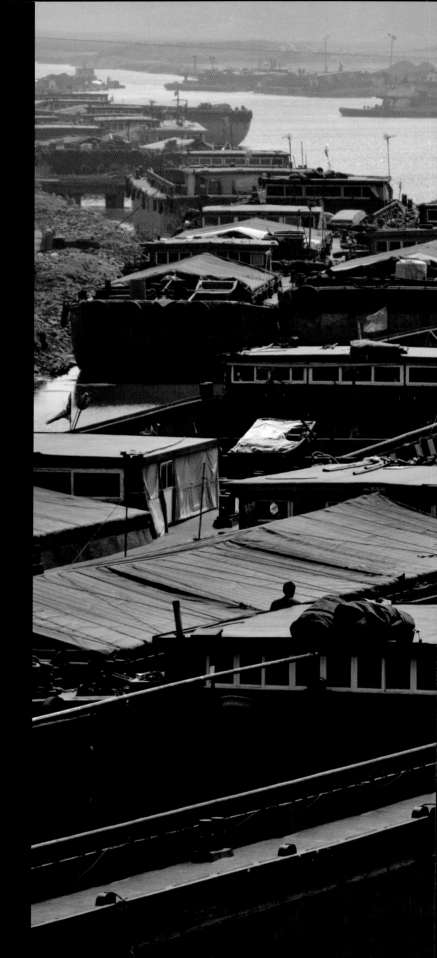

The Land of Confucius and Tao

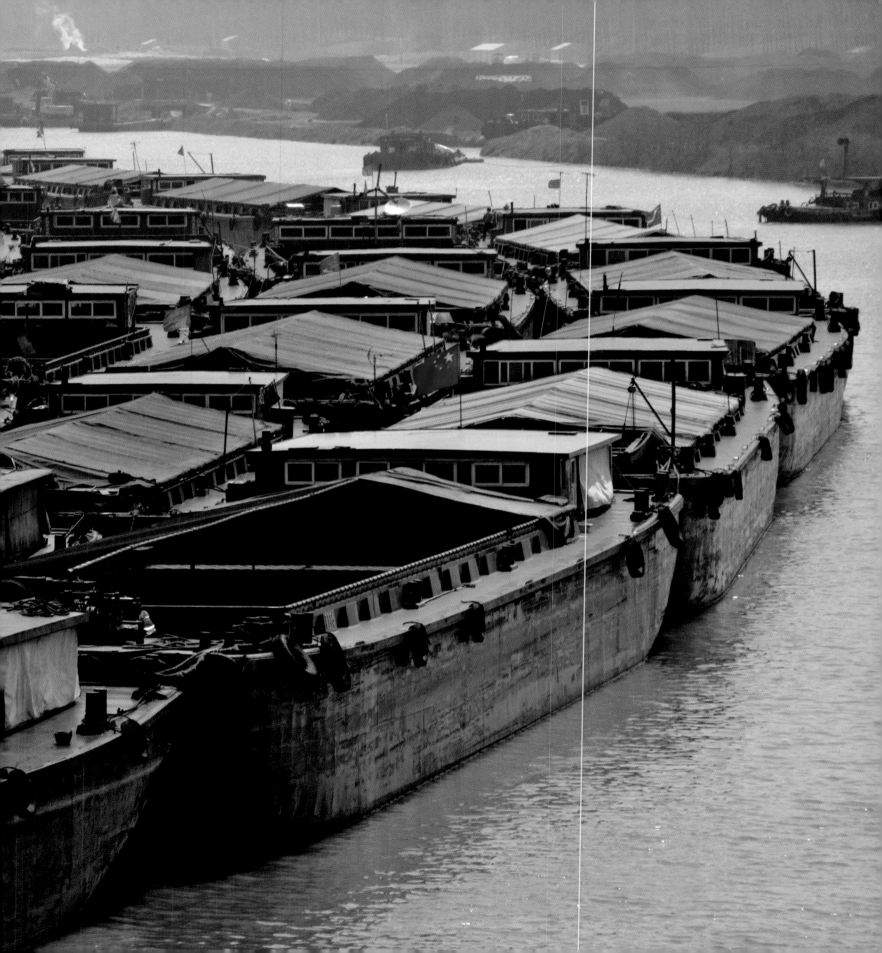

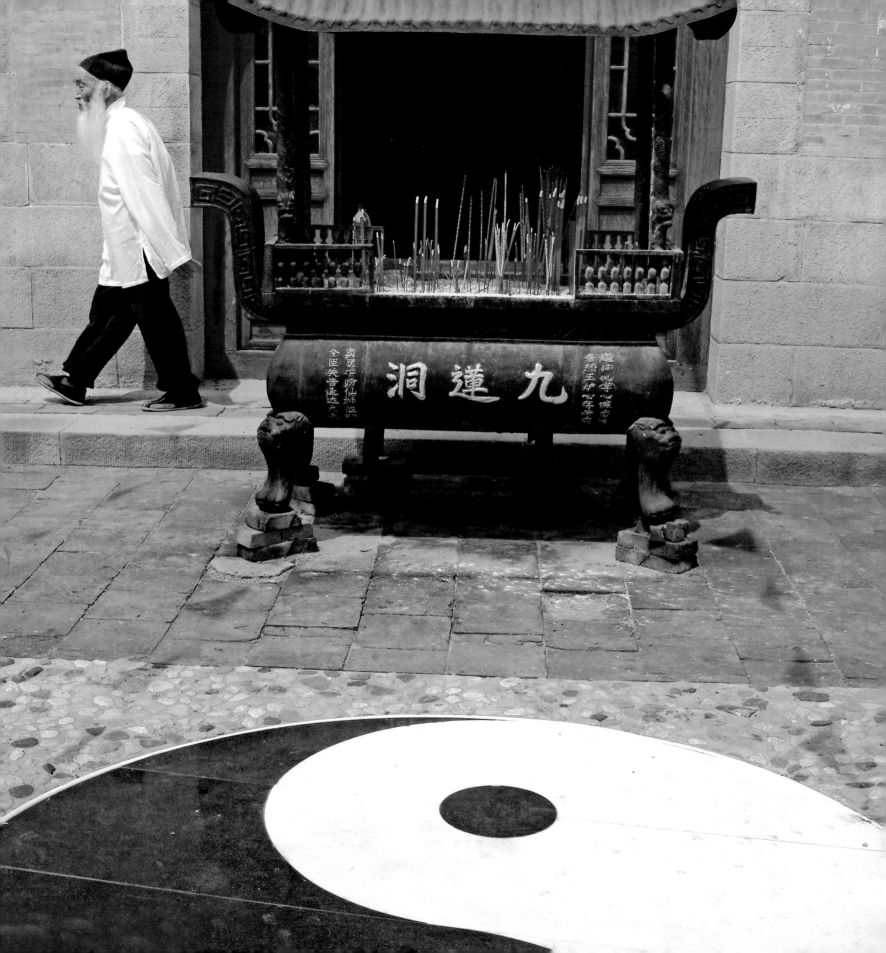

THE FLAT PLAIN STRETCHES AWAY into the distance, a motionless agricultural landscape that continues for kilometre after kilometre. There are peasants in the fields, rows of trees, small tractors, and canals, mostly for irrigation, some of which are as wide as rivers. They form an immense network directing the flow of water away from the great dragon. It is as if the river is haemorrhaging, and although its waters are high during the summer, it is in danger of running dry. Its low volume of water has always been a concern, but the river has nonetheless been a benefactor, fertilizing the fields and feeding millions of hungry mouths. Thanks to the river, the province of Shandong is a fortunate and fertile one. Although industry is growing here, and the province is modernizing, agriculture still plays a crucial role.

The Chinese have always tried to harness the force of the dragon and use it for their own needs. The most ambitious project in the river's history was the excavation of the Grand Canal. It was built over the course of several centuries, in order to connect various rivers and lakes for commercial reasons, and it was finally completed in the 7th century under the Sui dynasty (581–619). During the final stages of completion, half of the workforce of around three million peasants died through starvation and exhaustion. This is the longest canal in the world, longer even than the Panama or Suez canals, flowing between Beijing and Hangzhou, the city to the west of Shanghai. The canal connects the two great rivers of China, the Huang He (Yellow River) and the Yangtze (Blue River). Nowadays the canal resembles a blade of steel slashing through fields of grain. Thousands of enormous barges laden with coal plough their way up and down the river: although a pollutant, coal is the motor driving the Chinese economy. At Jining, a mining area to the south of the Yellow River, at the point where the Grand Canal enters Lake Nanyan, even the air is thick with coal dust. Black is everywhere, from the soles of your shoes to the walls of the houses. 'Our wages are much higher than those of the peasants,' a miner tells me. His hands and face are black when he courteously offers me a seat at a table in a restaurant. 'It's true that our work is harder and much more dangerous, but at least our families do not have to struggle. These days you need more and more money to get by in China.'

It was in this land, not far from the Yellow River, that the great Confucius was born in 551 BC. He died relatively unknown, but after his death his philosophy began to be influential in Chinese society over the

centuries. Qufu, his birthplace, became a sacred place, and his male descendants with the name of Kong (Confucius' real name was Kong Qiu) were granted numerous privileges, including the title of the Duke of Yansheng. For generations his descendants lived in splendour in Qufu, residing in a magnificent palace which still exists, next to the temple which is dedicated to their ancestor. With the fall of the imperial regime, the supremacy of the Kong family came to an end. Of the two last descendants, one fled to Taiwan at the age of eighteen, and the other, a woman, to Beijing. Today Qufu has become another of China's famous tourist attractions. The city has received vast sums of money for restoration: the paving stones have been completely replaced, the old palaces renovated, and the ancient city walls which had been bulldozed have been rebuilt. Now they are surrounded by a channel of water, and willows have been planted on the banks, which bend down to the water's edge, creating a romantic scene. Everything that the Cultural Revolution tried to destroy, because it symbolized the feudal system of the past, has now been restored: the temple, the philosopher's home, and his burial place in the forest, surrounded by age-old juniper trees; all these have become sacred once more. All year round, hordes of visitors flock here, clearly choosing to ignore the ban imposed on the great thinker by the Communists. In a wry quirk of history, pictures of Mao and pictures of Confucius are sold side by side on the souvenir stalls.

A similar scene presents itself 70 kilometres (43 miles) further north, on Mount Tai, the most important mountain relating to Taoism. Over the ages, it was much frequented by emperors and princes, who left a succession of temples in their wake along the crest of the mountain. Today, the original religious zeal towards Tao has given way to superstition: an endless stream of tour groups climbs the mountain in order to leave a locked padlock on the summit, at a height of 1,545 metres (5,069 feet), paying homage to a concept of divinity which might bless them with health, wealth and happiness. Whether Confucius, Tao, or maybe Buddha, it doesn't seem to matter.

Padlocks symbolically chain the desires of the visitors to the summit of the holy Mount Tai, to the north of the city of Tai'an. The mountain is sacred in Chinese history, and over the ages visiting emperors and princes have left their mark here. Mount Tai is in fact the foremost mountain of Taoism, and has been visited by thousands of people in the course of its history. Today, the religious fervour has evaporated on the summit of this mountain and has been replaced by a mixture of popular beliefs and superstitions. People come here also for the simple pleasure of an excursion with family or friends, far from the traffic and the crowds of the cities down on the plain below.

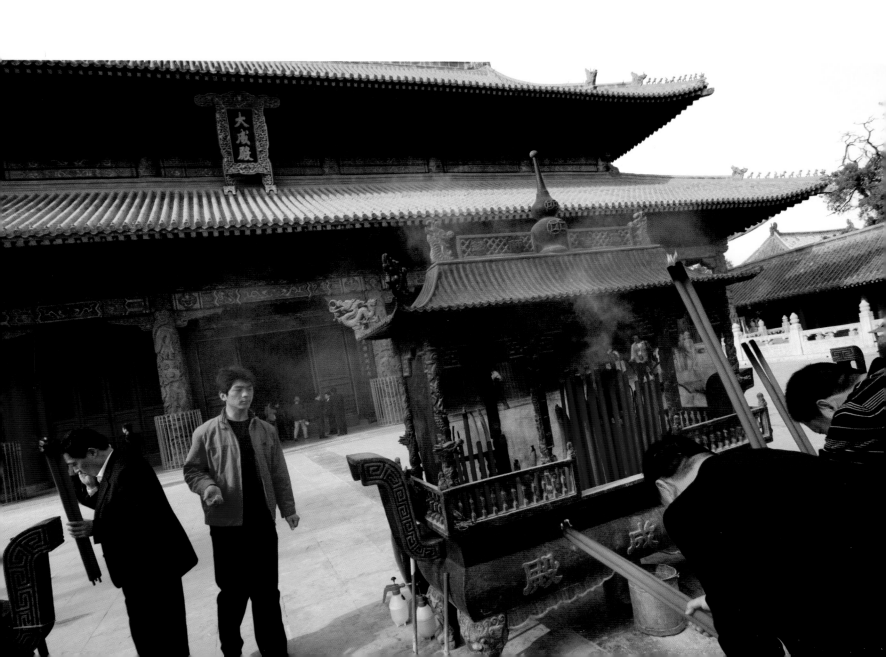

OPPOSITE: The temple dedicated to Confucius in Qufu, the city of his birth. Tourists pray in front of an altar of incense sticks. Over recent years, the rediscovery of religion in China has become big business, often playing on local superstitions. Among the tourists who kneel in front of the altars are the rich Chinese businessmen of the third millennium. They burn bundles of coloured incense sticks, some of them extremely large, which are very costly. They are hoping for continued financial success in the future.

BELOW: The coloured tablets on which the followers of Confucius ask for their wishes to be granted.

OVERLEAF: A photograph of the city walls at Qufu, birthplace of Confucius. The walls have recently been rebuilt, and the city has undergone a complete renovation, particularly on the streets, so as to cope with the influx of tourists on the trail of the great sage who was so influential in Chinese civilization.

PAGES 256–57: Calligraphic inscriptions on Mount Tai, the most sacred mountain for Taoism in China. One dating from the Tang dynasty reads: 'Protect and unite for peace and prosperity.'

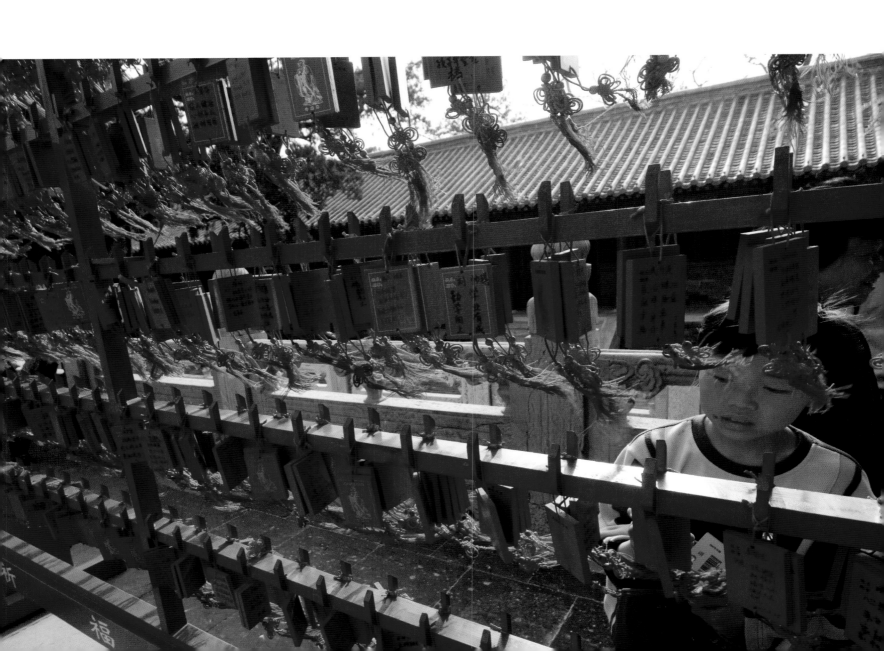

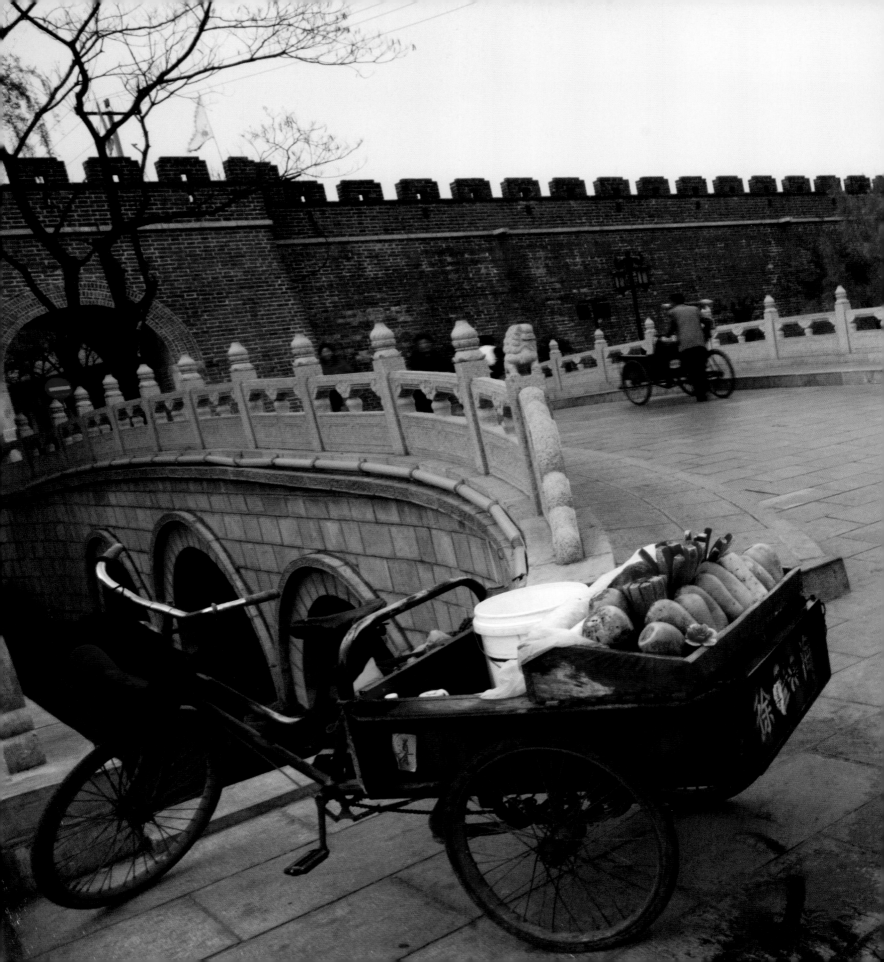

天地同收

大周天冊萬歲登封紀號之文

我高祖在天之神罔不星降當千萬
武藝祖文考...
高宗稽...

上帝記
上帝之休命則不與天符
帝時答馨香具下丕平四育唐氏文武之普孫降昊誕錫新命續茂當緯之
日遘倫謀惡者震無疆之言儉者崇將來之訓自滿者人損自謙者天益苟如是則凱遠易

天地同收
彌
馬

大唐開元十四年歲在景寅九月乙亥朔十二日景成建

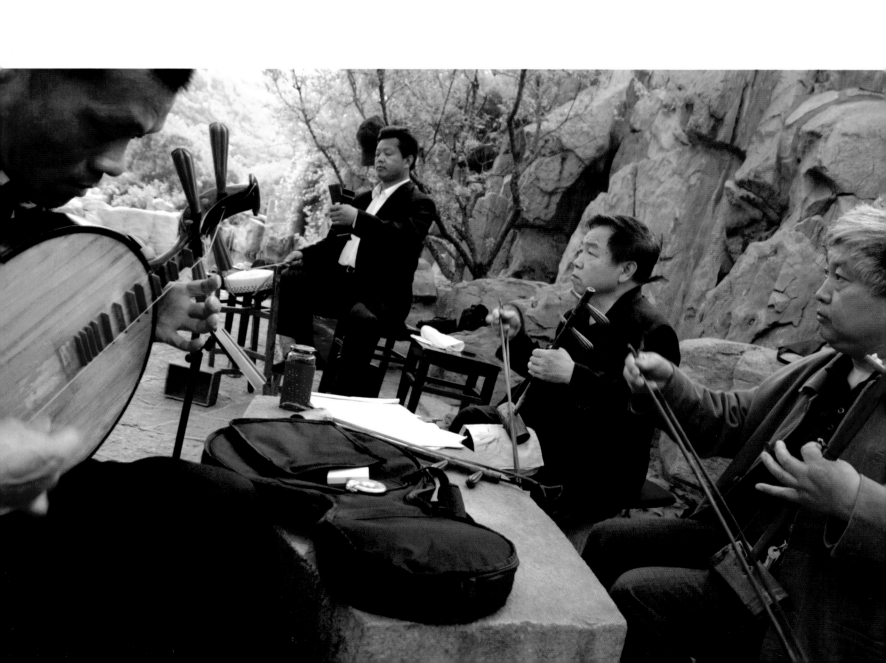

At Jinan, traditional Chinese opera is performed in the gardens around the springs of Baotou, a refreshing meeting-place for its inhabitants. Jinan is a city famous for its springs and waterways.

OVERLEAF: The Yellow River north of Jinan. The low, sandy banks of the river create a tranquil place to escape from the chaos of the big city.

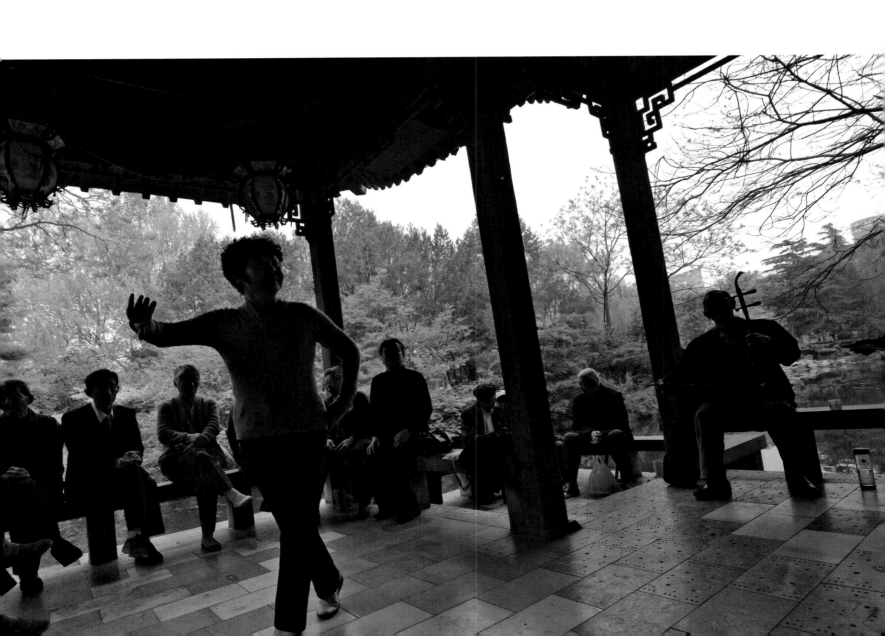

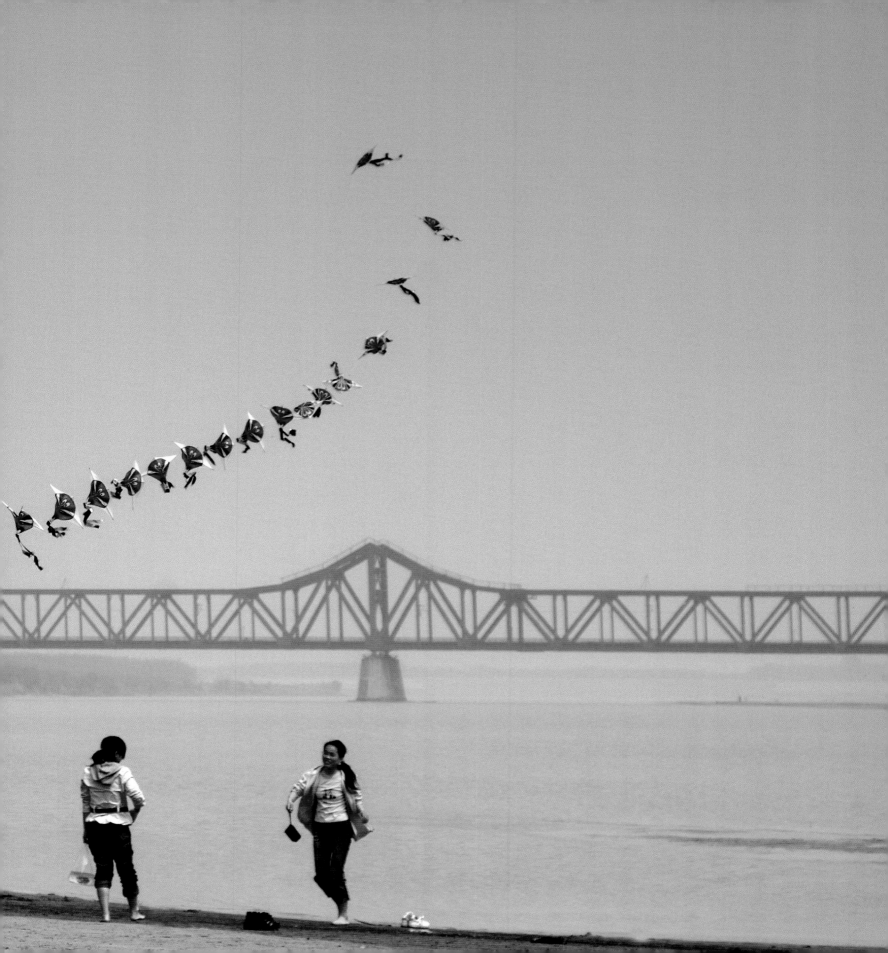

On the last stretch of the river as it heads for the sea, before emptying into the Bo Hai Sea, the course of the Yellow River is restrained by imposing banks as high as hills. Because of its muddy sediments, the bed of the river becomes 10 centimetres (4 inches) higher each year. Along some stretches, the level at which the river flows is higher than the surrounding fields, sometimes by a few metres. Those who built the banks of the river have gone down in popular history as heroes, and many of them are mythological characters who fought the eccentricities of the waters by draining them, excavating canals or creating basins which could be flooded during periods of high water.

The cities along the lower reaches seem to be rural centres which have grown far too rapidly, with wide, dusty streets, and the density of traffic typical of China in its rush towards economic development. They are mega-settlements without a heart, devoid of humanity and soul, and desperate to embrace modernism. These massive urban sprawls are some distance away from the Yellow River: it is simply not safe to have it flowing at the end of your garden. The last city on the estuary before the river empties into the Yellow Sea is Dongying, which has grown rich and prosperous through oil. Its streets are clean and well-lit, and people live in houses with gardens or impressive skyscrapers. China's second oilfield is situated in this remote area, where the great river is finally united with the sea. For several kilometres before you reach the mouth of the river, there are oil pumps looking like enormous birds bending down and pecking for food, extracting the precious liquid from the subsoil. When it finally reaches the sea, the river looks exhausted. Its waters are meagre, and it has lost all sense of grandeur. The river, now thin and muddy, can be crossed via a pontoon bridge, and a few hundred metres further on it disgorges its muddy waters into the clear, blue waters of the sea. The yellow colour disappears into the blue and gradually merges into an infinite horizon. The mythical dragon has finally breathed its last.

The last stretch of the Yellow River as it approaches the Gulf of Bo Hai. The yellow waters are about to disperse at the mouth the river. Laden with sediment they flow sluggishly, seemingly exhausted and desirous of reaching the clear blue waters the sea. The delta area around the mouth of the river has been designated a nature reserve, covering an area of 153,000 hectares (378,070 acres). In the humid climate myriads of birds flourish: there are estimated to be 268 different species here, along with small mammals such as the fox.

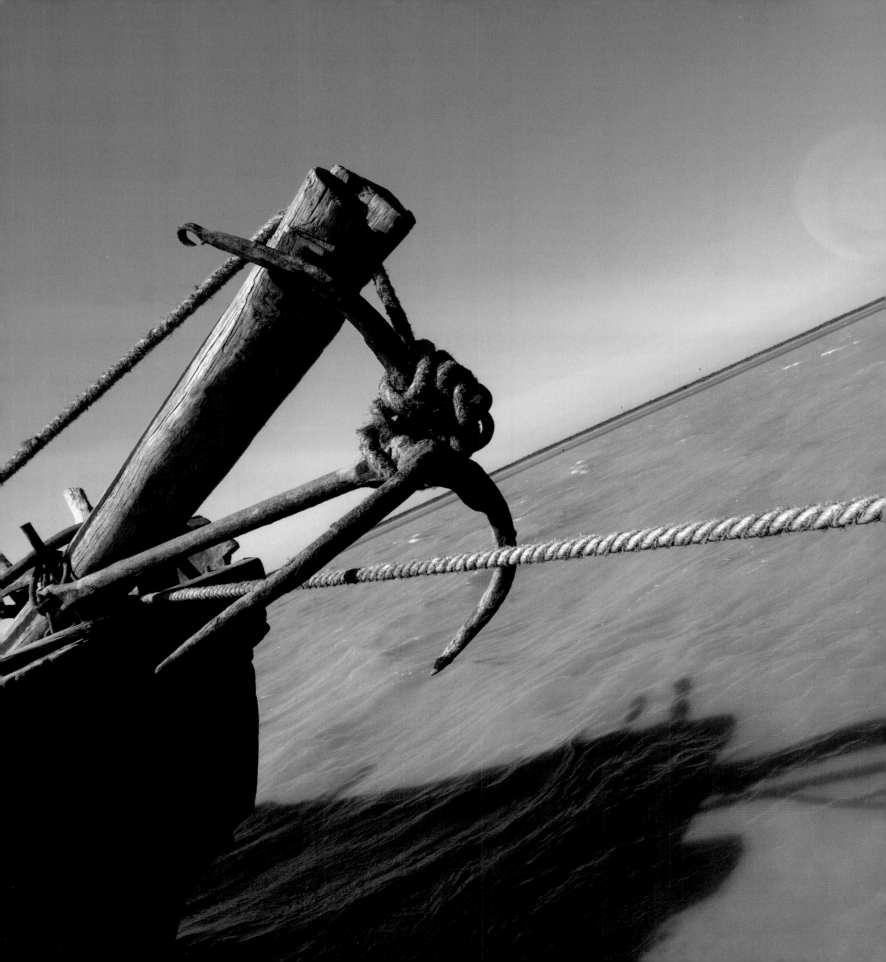

The area almost at the mouth of the river is a favourite haunt for Sunday outings among young people. Some of them have drawn hearts in the sand, testifying to their love. These two love-birds are called Xiao Jie and Zhen Fei.

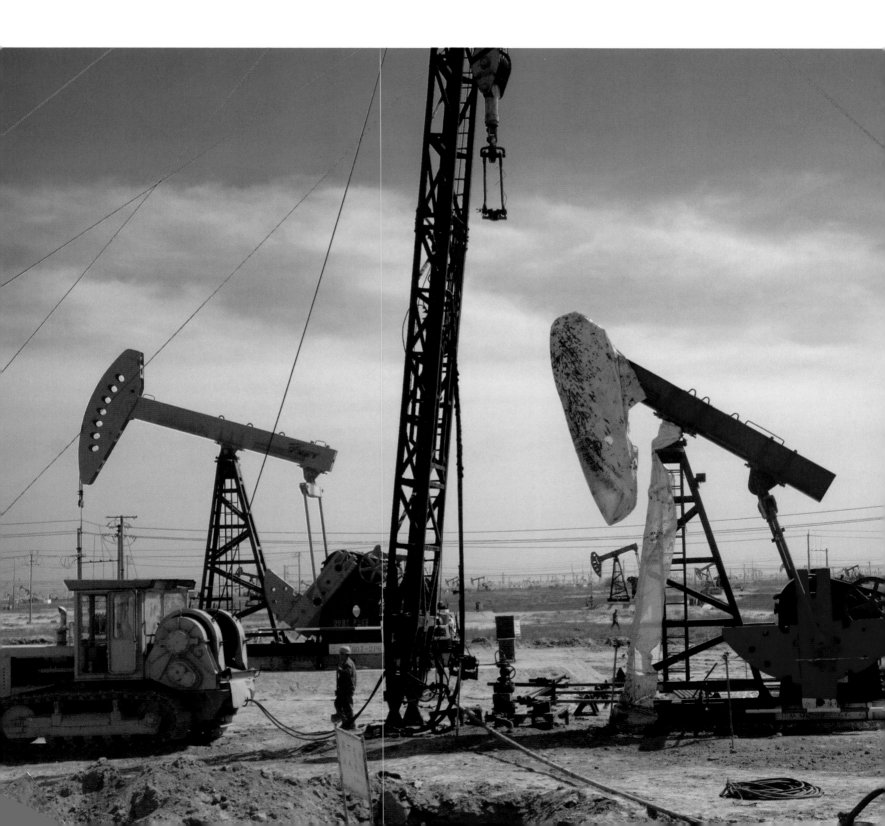

LEFT: The estuary of the Yellow River is an area rich in oil: thousands of oil pumps extract this black gold from the subsoil, resembling giant birds pecking the ground for food.

RIGHT: It is the job of some of the peasants to keep clean the irrigation canals, along which the water flows into the fields, watering the crops of rice and wheat, and the orchards, which extend into the distance as far as the eye can see. In the spring, the area is transformed into a mass of peach blossom.

OVERLEAF: A view of the Yellow River from the motorway bridge not far from the mouth of the river, north of the city of Dongying. The sea is not far away, and the river has finally come to the end of its course.

PAGES 270–71: A port on the estuary during the last hours of daylight. The boats are at rest after a day's fishing out on the waters of the Yellow Sea.

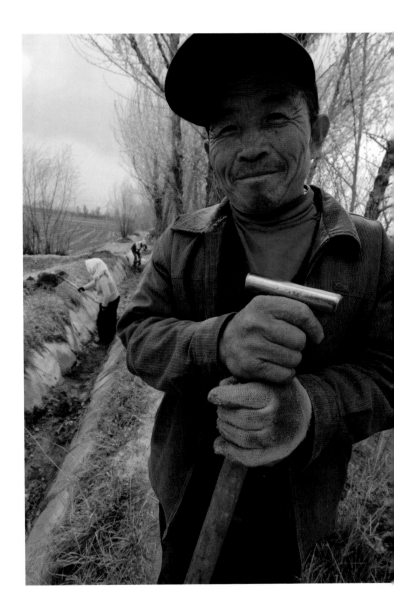

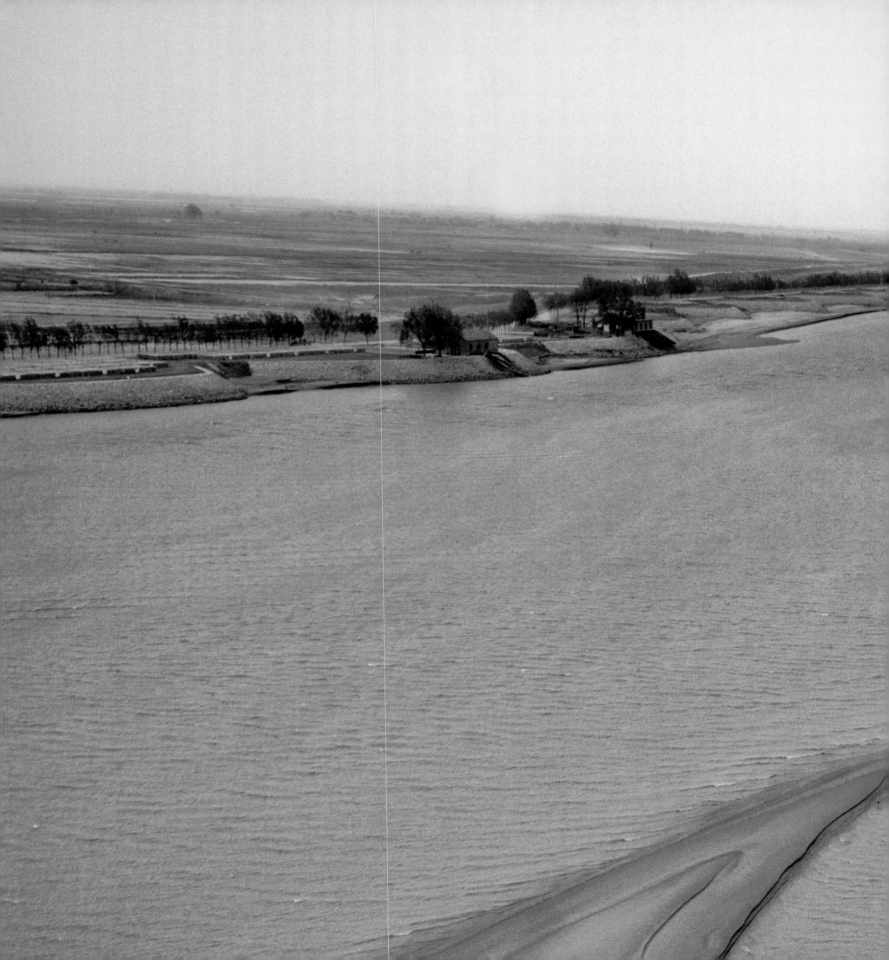

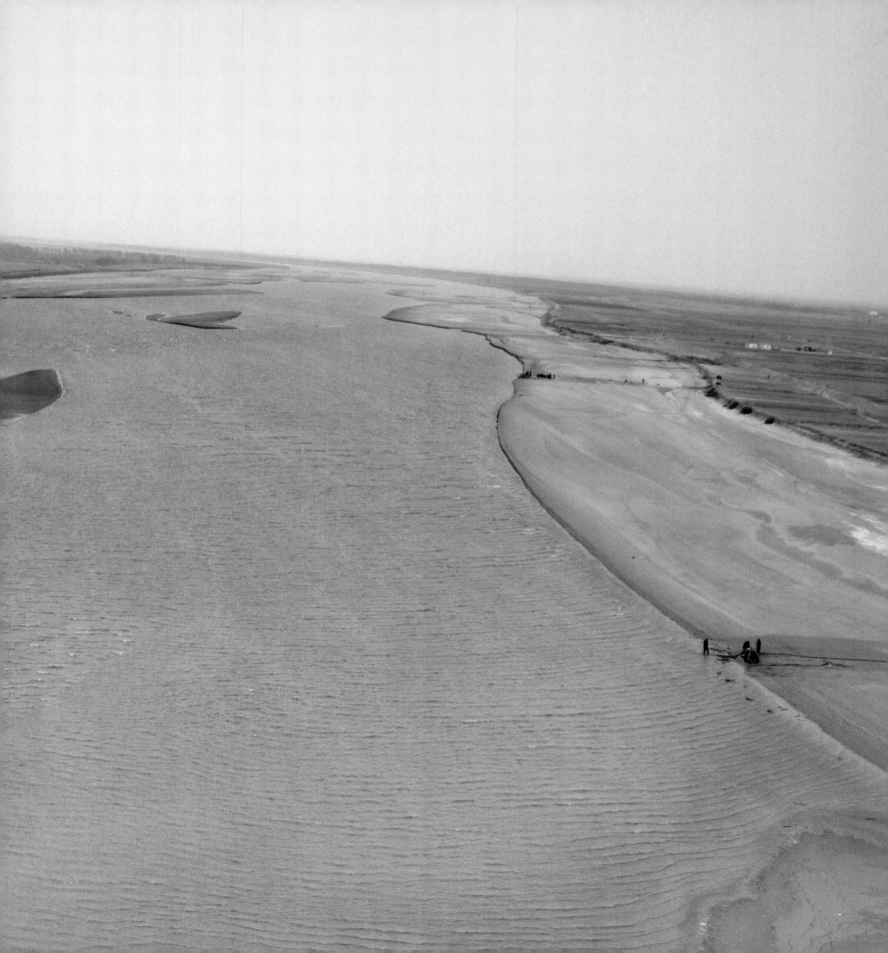

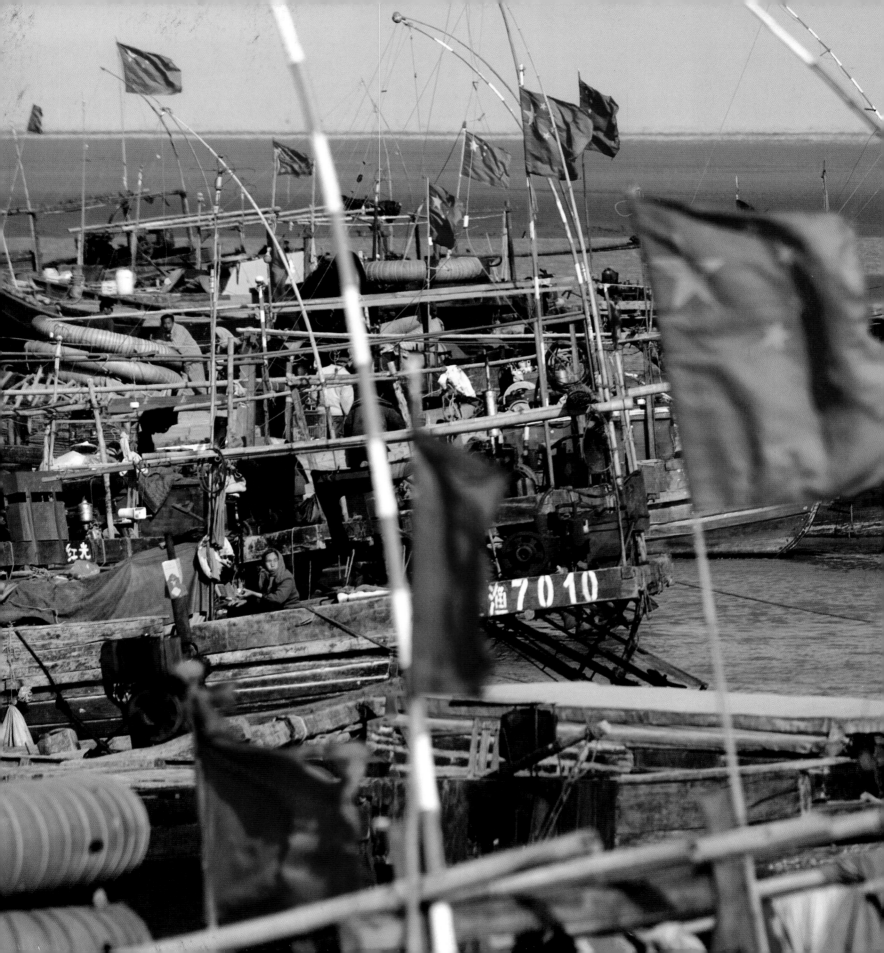

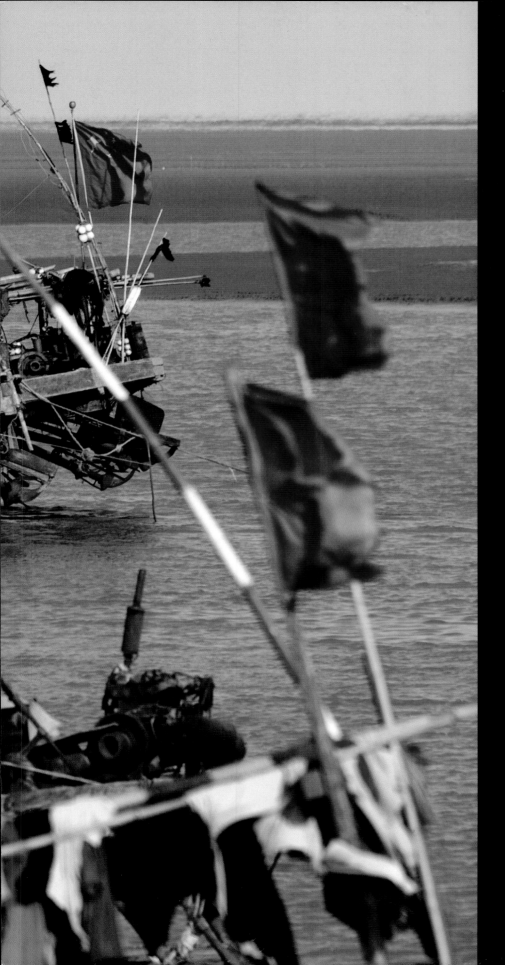

Among the mythical figures of Chinese history, it was the Emperor Yu, known as Yu the Great, who was the first ruler to undertake the colossal task of taming the caprices of the Yellow River. He was the first to use hydraulic engineering to irrigate the fields and rescue the people from the danger of flooding. He was the first to understand that raising the river banks would not be enough to control the river, and that new channels would need to be excavated, in order to take the extra volume when the waters were high. According to the legend, he was the founder of the Xia dynasty, and ruled over China for forty-five years. Yu is thought to have died in 2227 BC. The task of taming the mythical dragon took thirteen years to complete, during which time it was said that he never returned home once. When the work was finally finished, he threw a bronze ox into the river as a talisman against future flooding. From then on, the ability to control the waters so as to maximize their efficiency and minimize the risk of flooding has become synonymous with good government.

Translated from the Italian
Fiume Giallo: L'Anima della Cina
by Clare Costa

First published in the United Kingdom in 2007
by Thames & Hudson Ltd, 181A High Holborn,
London WC1V 7QX

www.thamesandhudson.com

First published in 2007 in hardcover
in the United States of America by
Thames & Hudson Inc.
500 Fifth Avenue, New York
New York 10110

thamesandhudsonusa.com

Photographs © 2007 Aldo Pavan
Original Edition © 2007 Magnus Edizioni SpA, Udine, Italy
This edition © 2007 Thames & Hudson Ltd, London

British Library Cataloguing-in-Publication Data
A catalogue record for this book is
available from the British Library

Library of Congress Catalog Card Number 2007901200

ISBN: 978-0-500-51376-7

Printed and bound in Italy